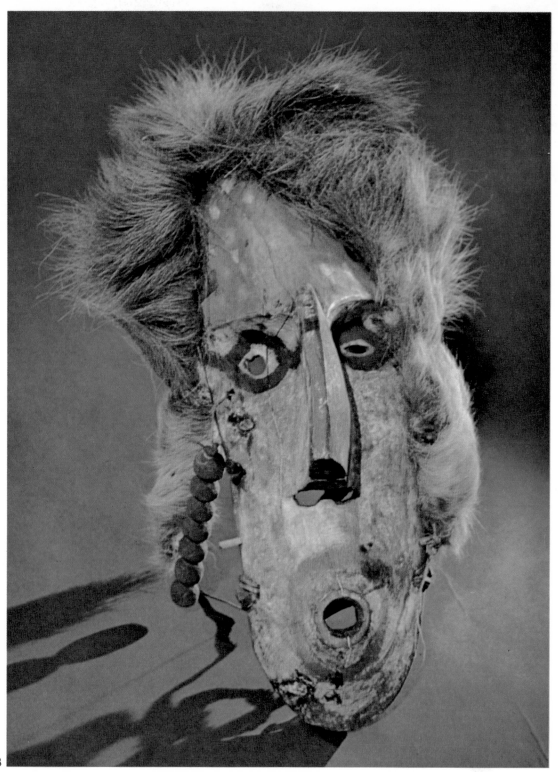

THE FAR NORTH

2000 YEARS OF AMERICAN ESKIMO AND INDIAN ART

HENRY B. COLLINS
FREDERICA DE LAGUNA
EDMUND CARPENTER
PETER STONE

Indiana University Press
Bloomington London
National Gallery of Art, Washington, D.C.

Issued as an exhibition catalog by the National Gallery of Art, 1973; published by Indiana University Press in association with the National Gallery of Art, 1977.

Published in Canada by Fitzhenry & Whiteside Limited, Don Mills, Ontario

Manufactured in the United States of America

Library of Congress Cataloging in Publication Data

Main entry under title:

The Far North.

Catalog of an exhibition held at the National Gallery of Art, March 7-May 15, 1973, and others.

Includes bibliographical references.

1. Eskimos — Alaska — Art — Exhibitions.

2. Indians of North America — Alaska — Art — Exhibitions. I. Collins, Henry Bascom, 1899–II. United States. National Gallery of Art.
E99.E7F28 1977 745 77-3132
ISBN 0-253-32120-4
ISBN 0-253-28105-9 pbk. 1 2 3 4 5 81 80 79 78 77

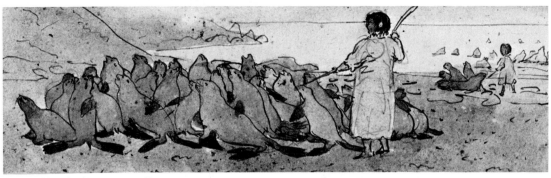

Aleut children herding young sea lions.
Watercolor by Ludovic Choris. Beinecke Rare Book and
Manuscript Library, Yale University

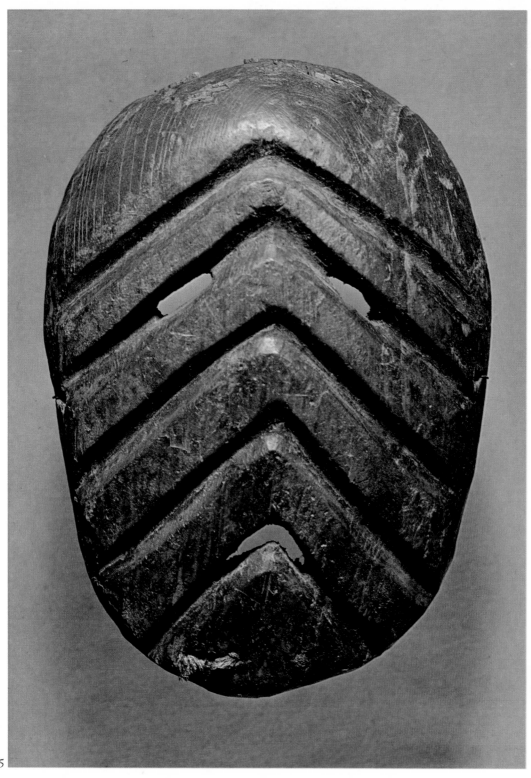

135

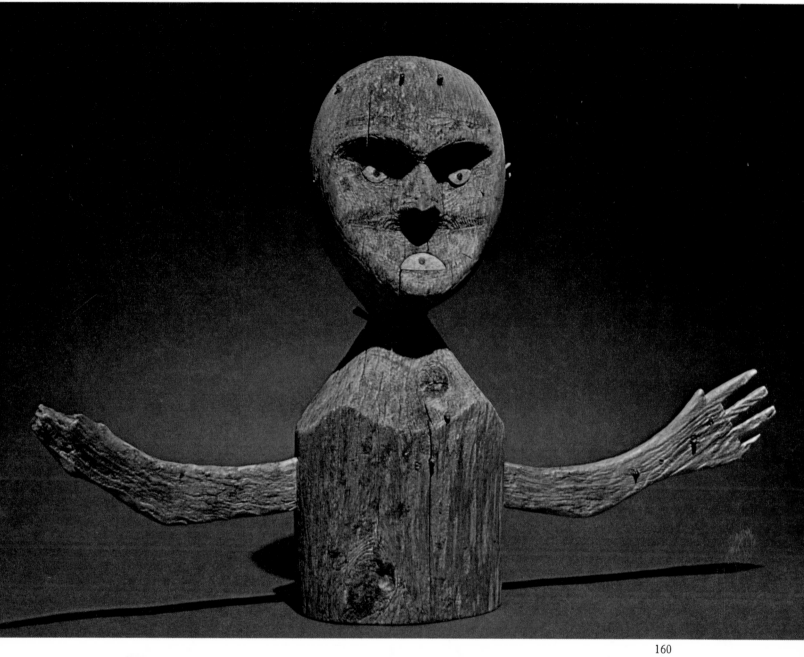

160

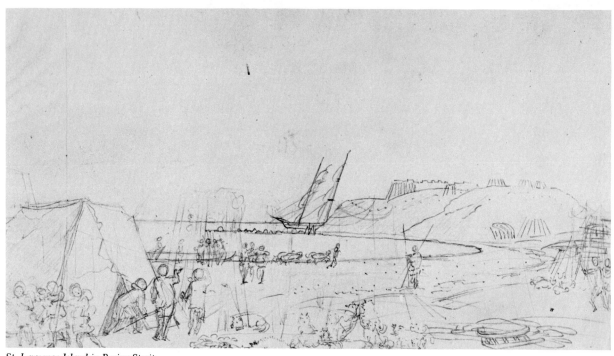

St. Lawrence Island in Bering Strait.
Pencil sketch by Ludovic Choris. Beinecke Rare Book and
Manuscript Library, Yale University

LENDERS TO THE EXHIBITION

Alaska State Museum, Juneau

The American Museum of Natural History, New York

Anchorage Historical and Fine Arts Museum

Bernisches Historisches Museum

The Brooklyn Museum

Danish National Museum, Copenhagen

Deutsches Ledermuseum, Offenbach

Florida State Museum, Gainesville

Glenbow-Alberta Institute, Calgary

Hamburgisches Museum für Völkerkunde und Vorgeschichte

Sheldon Jackson Museum, Sheldon Jackson College, Sitka, Alaska

Linden-Museum, Stuttgart

Robert H. Lowie Museum of Anthropology, University of California, Berkeley

Museum of the American Indian, Heye Foundation, New York

Museum of Anthropology and Ethnography, Leningrad

Museum voor Land- en Volkenkunde, Rotterdam

The Museum of Primitive Art, New York

Museum of the University of Alaska, College

Museum für Völkerkunde, Berlin

National Museum of Finland, Helsinki

National Museum of Man, Ottawa

National Museum of Natural History, Smithsonian Institution, Washington

Peabody Museum, Harvard University

Peabody Museum of Salem, Massachusetts

Portland Art Museum, Oregon

Princeton University, Museum of Natural History

Private Collection, New York

Rautenstrauch-Joest-Museum, Cologne

Royal Scottish Museum, Edinburgh

Sitka National Monument, Alaska

Staatliches Museum für Naturkunde und Vorgeschichte, Oldenburg

St. Joseph Museum, Missouri

Taylor Museum, Colorado Springs Fine Arts Center

Tongass Historical Society, Ketchikan, Alaska

The University Museum, University of Pennsylvania, Philadelphia

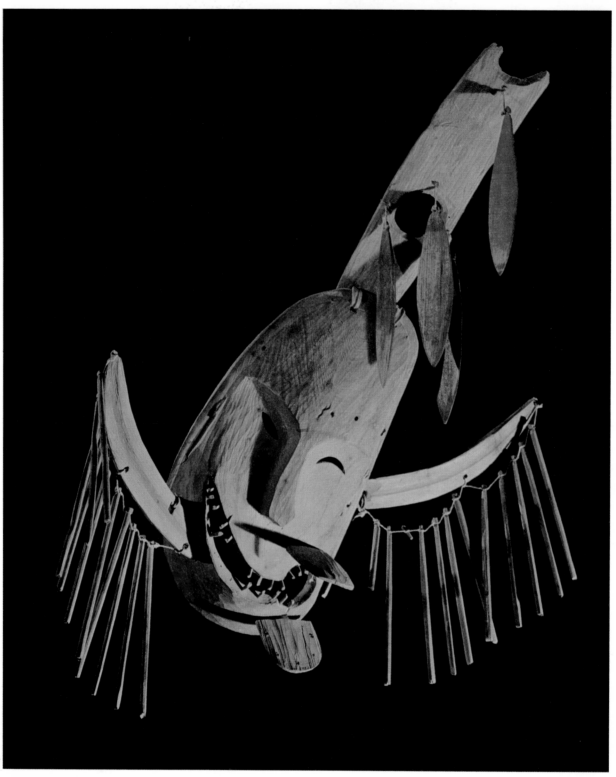

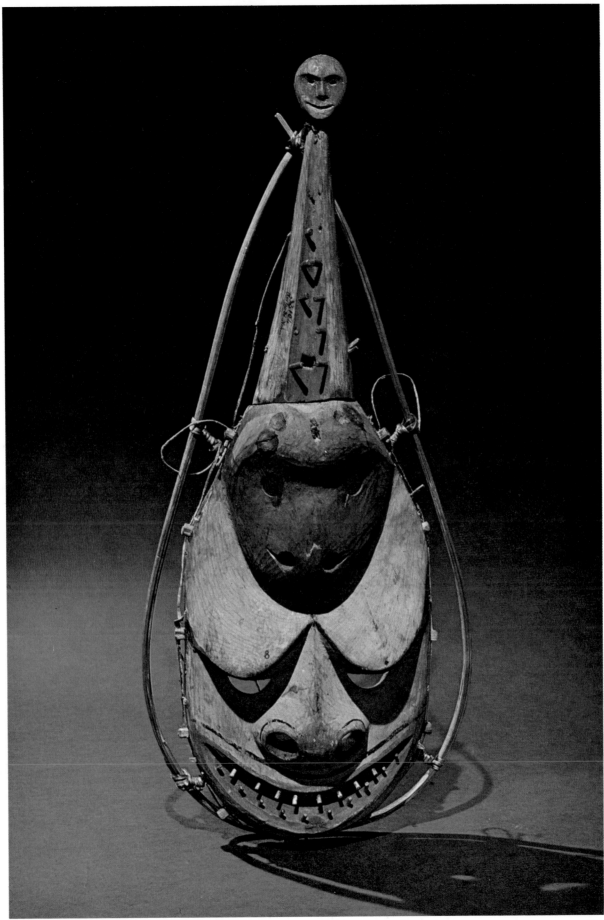

COLOR PLATES

Cover	257	CEREMONIAL HAT, Tlingit (detail)
Frontispiece	178	MASK, Athabaskan
vi	135	MASK, Eskimo
vii	160	BURIAL IMAGE, Eskimo
x	172	MASK, Eskimo
xi	170	MASK, Eskimo
xiv	55	OPEN BASKET, Aleut
xv	58	COVERED CONTAINER, Aleut
xviii	301	SHAMAN'S MASK, Tlingit
xix	247	COVERED BASKET, Tlingit
xxii	294	MASK, Tlingit/Haida
xxiii	315	MASK, Tlingit/Haida
xxvi	349	RATTLE, Tlingit
xxvii	291	MASK, Tlingit
xxx	21	ORNAMENTAL COMB, Eskimo

CONTENTS

ix LENDERS TO THE EXHIBITION

xvi FOREWORD

xx MAP: *Top of the World*

xxiv MAP: *Tribal Distribution*

xxviii MAP: *Location of Sites*

1 ESKIMO ART, HENRY B. COLLINS

2 CATALOG

133 ATHABASKAN ART, FREDERICA DE LAGUNA

165 TLINGIT ART, PETER STONE

227 TLINGIT SHAMANS, FREDERICA DE LAGUNA

281 SOME NOTES *on the Separate Realities of Eskimo and Indian Art*, EDMUND CARPENTER

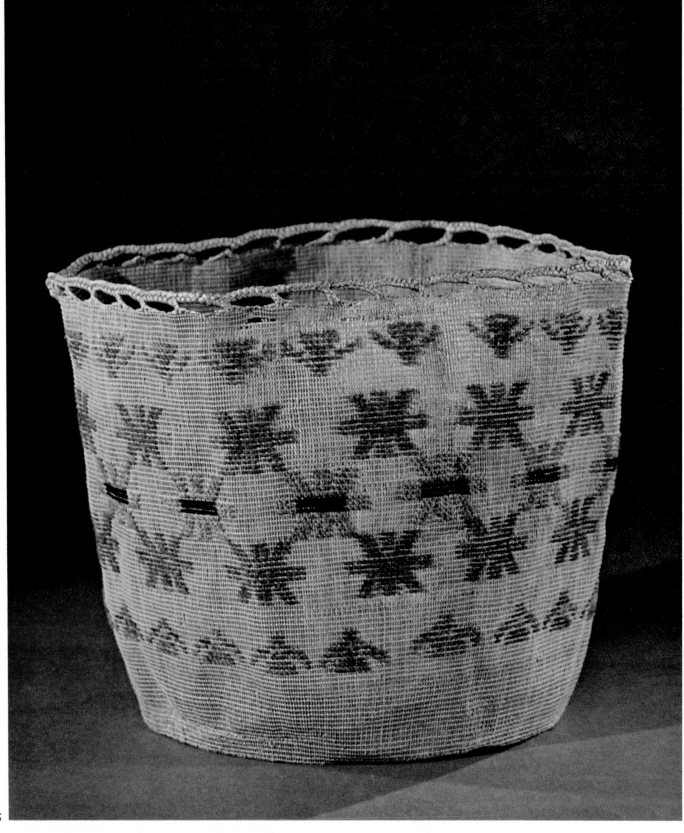

55

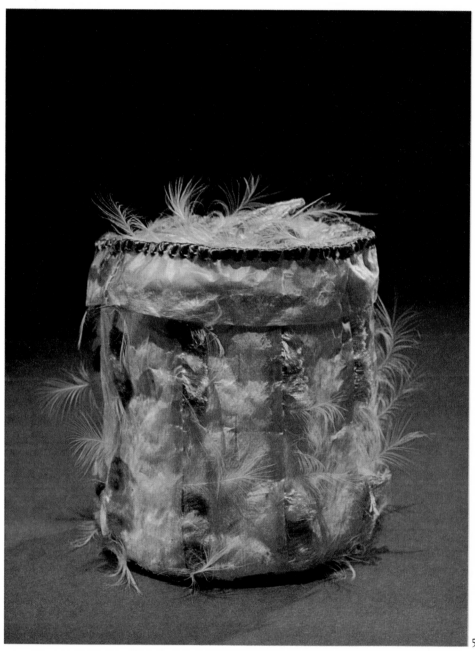

58

THIS exhibition presents a panoramic selection of art from the native cultures of America's far north. It is drawn primarily from the great peninsula now called Alaska—after the native term meaning "the Great Land," a vast geographic area which has played a unique role in the cultural history of our hemisphere. A good measure of the native populations of the Americas probably reached their future homes by way of its former "land bridge," which once linked it with Asia. Today the original Eskimo peoples along the western coasts, and Indian tribes in the interior and southern coasts, continue to occupy their traditional homelands.

The Bering Sea and Arctic Ocean Eskimos share a cultural identity with the entire circumpolar Eskimo population, from Siberia across Canada. But the artistic heritage they share with Alaska's Indians has not been celebrated as a whole in a major international art exhibition.

The material for this exhibit has been drawn from numerous collections. Much of it has not been on permanent display anywhere, and the vast majority has never before been seen in an art museum context. The material ranges from pieces discovered by eighteenth-century explorers to the preservation of clan and family heirlooms by the coastal Indians themselves. It also includes objects discovered through modern archaeological excavation.

The splendid collections formed by the first explorers are in museums in the Soviet Union, Finland and Denmark, countries which detailed several admirals to sail with the expeditions of the Imperial Russian Navy. Other early collections were acquired by national museums in the British Isles and on the Continent, particularly in Germany. The continued exploration of Alaska by both Canada and the United States resulted in important accumulations of material in both Ottawa and Washington. The systematic investigation of Alaskan native cultures by modern ethnologists and archaeologists has been developed mainly by the universities on this continent, often in association with national or regional museums.

The guiding spirit behind this exhibition has been Mitchell A. Wilder, the energetic and distinguished Director of the Amon Carter Museum in Fort Worth, Texas. It was he who responded with alacrity and enthusiasm to the first conception of the exhibition proposed in 1968 by the late René d'Harnoncourt, then a trustee of the Amon Carter Museum. Mitchell Wilder sought and received the expert counsel of Dr. Erna Gunther, former Professor of Anthropology, University of Alaska, whose knowledge of the whole range of Alaskan material is surpassed only by

her enthusiasm for its artistic quality. Mr. Wilder traveled extensively with Dr. Gunther to make the basic selections for the exhibition, and since has handled all technical aspects of the loans and has continued to provide constant guidance and support to the entire project.

In addition, we have been extremely fortunate to have been able to secure the help of two scholars eminent in the fields of Alaskan archaeology and anthropology: Dr. Henry B. Collins, Archaeologist Emeritus of the Smithsonian Institution, and Professor Frederica de Laguna of Bryn Mawr College. Both of these distinguished scholars have furnished the principal texts for the exhibition catalog, as well as entries for a number of the exhibition's most interesting objects. In this collaboration they have been joined by Professor Edmund Carpenter of Adelphi College, an anthropologist of extensive knowledge of Alaskan native peoples and their art.

For help in assembling this exhibition, we would also like to offer our appreciation to the other participating museum directors:

Dr. Francis Newton of the Portland Art Museum, and

Robert L. Shalkop of the Anchorage Historical and Fine Arts Museum.

For consultation and assistance, we are grateful to:

Valerian S. Nesterov, Counselor of the Embassy of the Soviet Union, Washington;

Dr. Clifford Evans, Chairman, Department of Anthropology, Smithsonian Institution, and to his colleagues in the Division of North American Anthropology, Dr. William C. Sturtevant, Supervisor; Dr. William W. Fitzhugh, Curator; Peter Stone, Research Fellow;

Dr. Annette Clark, National Museum of Man, Ottawa, Canada;

James M. Silberman, Conservator and Restorer; and

James Houston, Author and Artist.

We also acknowledge the invaluable contributions made by the members of the staff of both the National Gallery and the Amon Carter Museum to the mounting of the exhibition and the production of its catalog:

Dr. Douglas Lewis, Curator of Sculpture of the National Gallery, who coordinated the selection of material for the exhibition and aided in the compilation of the catalog;

Gaillard F. Ravenel, Museum Curator of the National Gallery, who designed and supervised the installation of the exhibition;

Frances P. Smyth, Associate Editor of the National Gallery, who was production supervisor of the catalog; and

Mrs. Linda Austin, Exhibition Project Secretary and Assistant to Mitchell Wilder of the Amon Carter Museum.

Finally, it is to the lenders to this exhibition, who are listed in this catalog, to whom we all owe our deepest gratitude for making this complex undertaking a reality.

J. Carter Brown
DIRECTOR
NATIONAL GALLERY OF ART

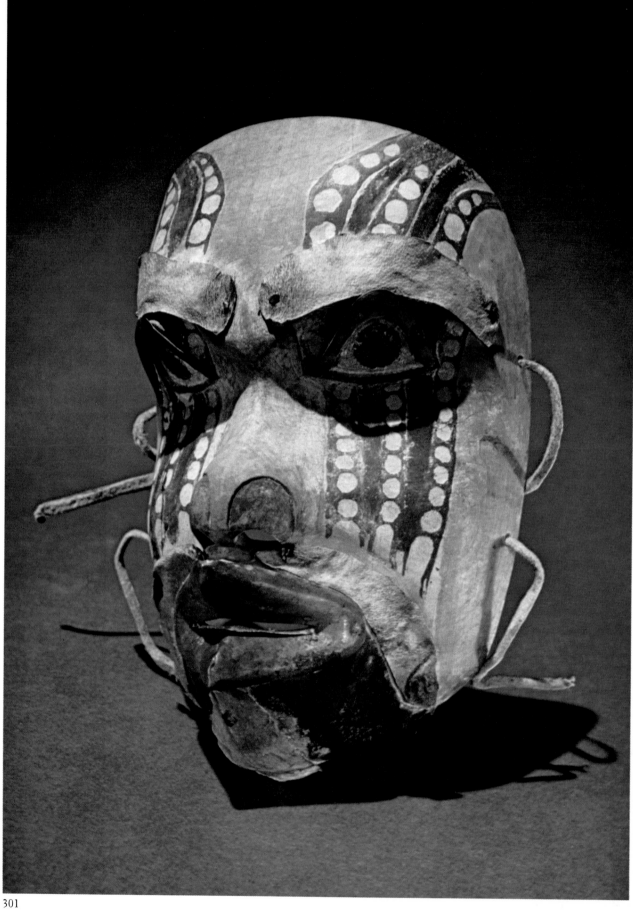

301

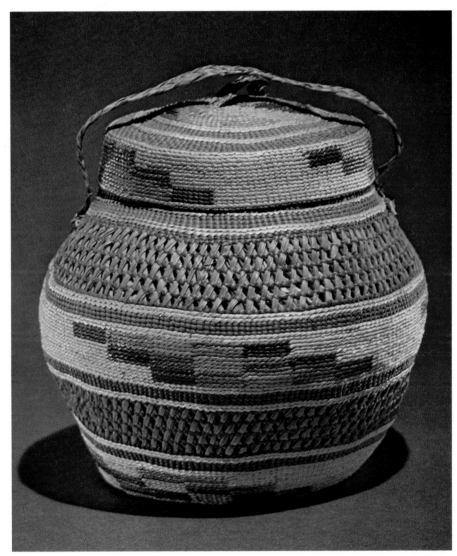

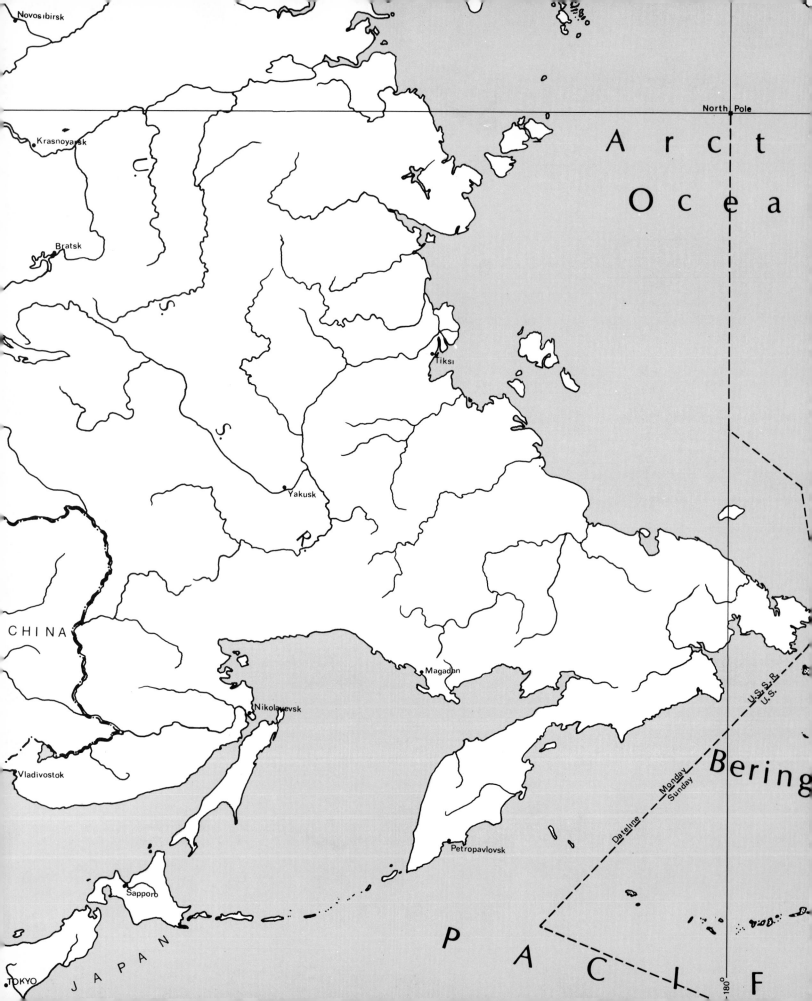

Novosıbirsk

Arct

Ocea

Krasnoyarsk

North Pole

Bratsk

Tiksı

Yakusk

R.

CHINA

Magadan

Nikolaevsk

U.S.S.R.

U.S.

Vladivostok

Bering

Dateline

Monday

Sunday

Petropavlovsk

Sapporo

J A P A N

P A C I F

TOKYO

180°

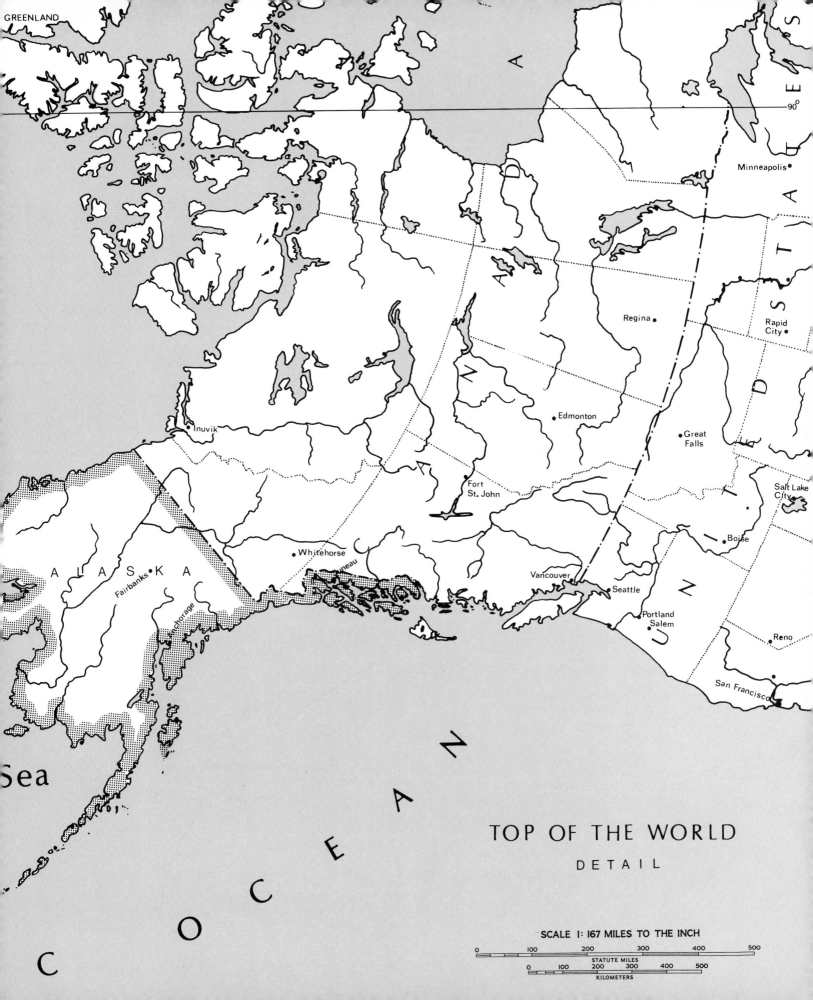

GREENLAND

Minneapolis•

Regina• Rapid
 City•

Edmonton•

Great
Falls•

Inuvik• Salt Lake
 City

Fort
St. John• Boise•

Whitehorse• Juneau

A L A S K A Vancouver•
Fairbanks• Seattle•
Anchorage Portland
 Salem• Reno•

Sea San Francisco•

O C E A N

TOP OF THE WORLD
D E T A I L

C

SCALE 1: 167 MILES TO THE INCH

0 100 200 300 400 500
STATUTE MILES
0 100 200 300 400 500
KILOMETERS

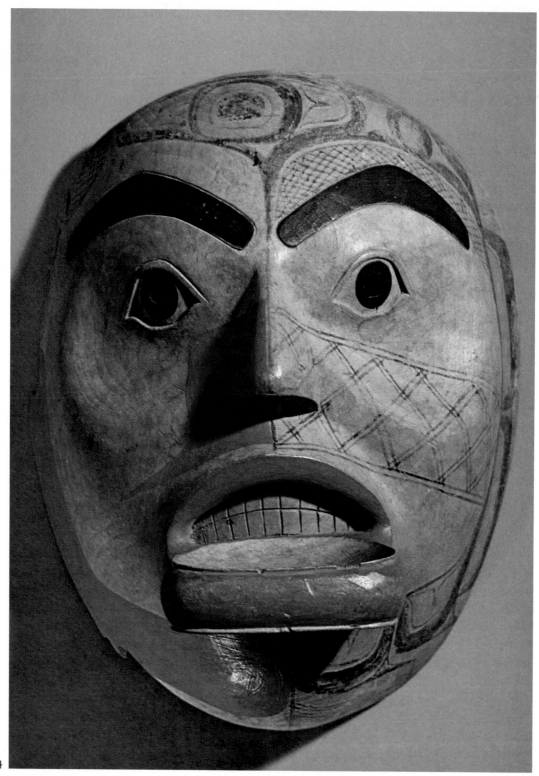

294

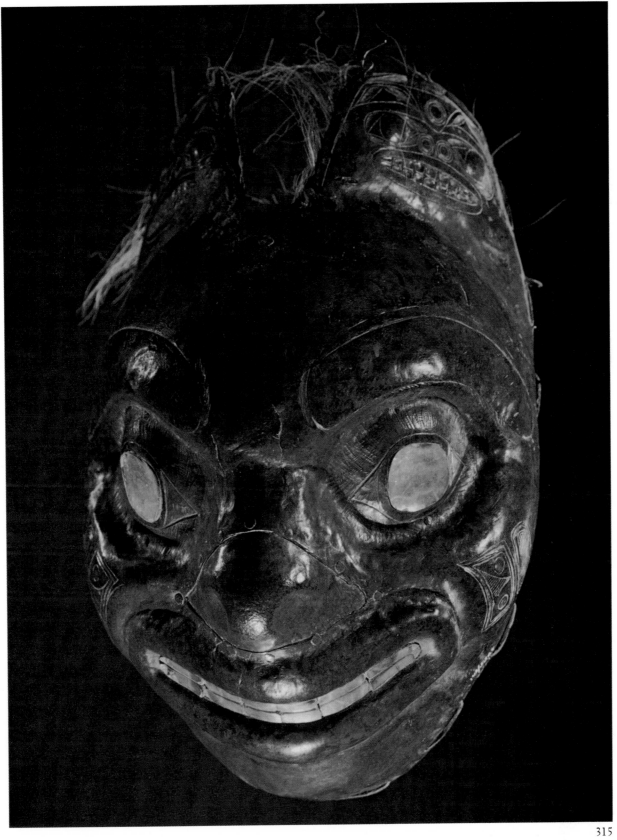

TRIBAL DISTRIBUTION

A T K A

A L E U T

U N A L A S K A A L E U T

A L E U T

Eskimo and Aleut
Athabaskan Indian
Northwest Coast Indian

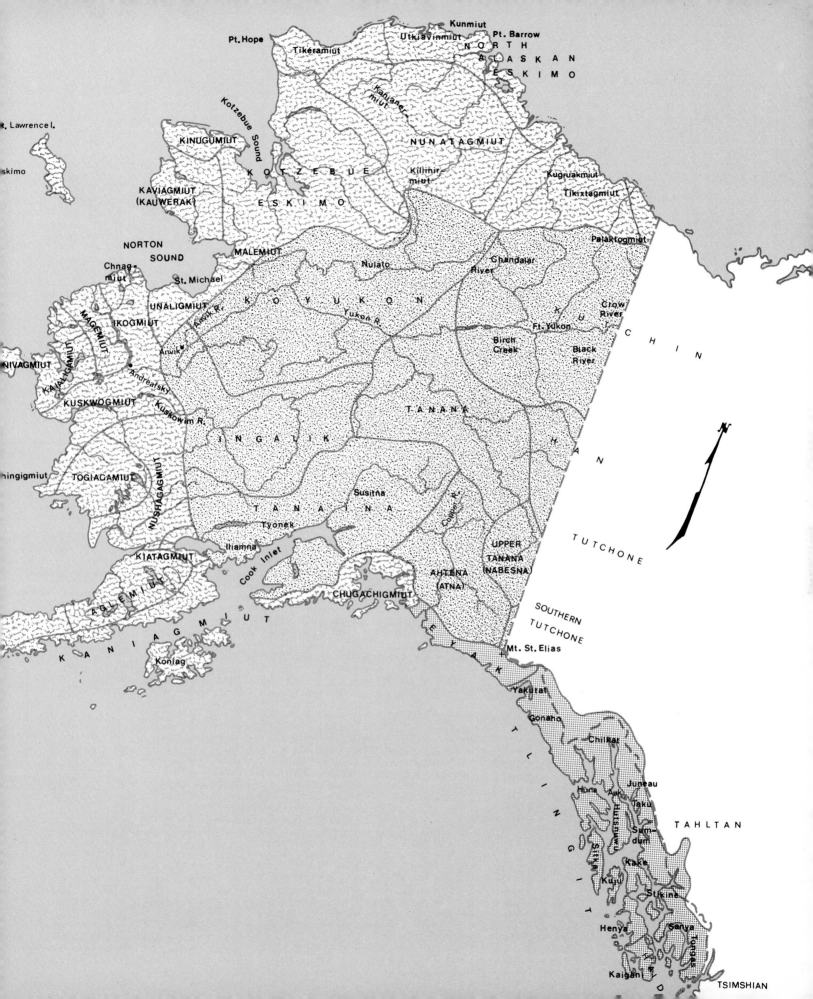

Pt. Hope Kunmiut

St. Lawrence I.

Eskimo

Kotzebue Sound

KINUGUMIUT

Utkiavinmiut Pt. Barrow
NORTH ALASKAN ESKIMO
Tikeramiut
Kanianer-miut

KAVIAGMIUT (KAUWERAK)

KOTZEBUE ESKIMO

NUNATAGMIUT
Killinir-miut

Kugruakmiut
Tikixtagmiut

Palaktogmiut

NORTON SOUND
MALEMIUT
Chnag-miut
St. Michael
UNALIGMIUT
IKOGMIUT
MAGEMIUT
Nulato
Chandalar River
KOYUKON
Anvik R.
Yukon R.
Ft. Yukon
Crow River

Birch Creek
Black River

CHIN

KUCHIN

NIVAGMIUT
KAIALIGMIUT
Anvik
Andreafsky
KUSKWOGMIUT
Kuskowim R.

TANANA
HAN

hinigigmiut
TOGIAGMIUT
NUSHAGAGMIUT
INGALIK
Susitna

Colpher R.

TUTCHONE

KIATAGMIUT
TANAINA
Tyonek
Iliamna
Cook Inlet

UPPER TANANA (NABESNA)
AHTENA (ATNA)
CHUGACHIGMIUT

SOUTHERN TUTCHONE

AGLEMIUT
KANIAGMIUT
Koniag
EYAK
Mt. St. Elias

Yakutat
Gonaho
Chilkat

Juneau
Huna Auk
Taku

TAHLTAN

TLINGIT
Sum-dum
Kake
Kuju
St. kine
Henya Sanya

Kaigan
TSIMSHIAN

349

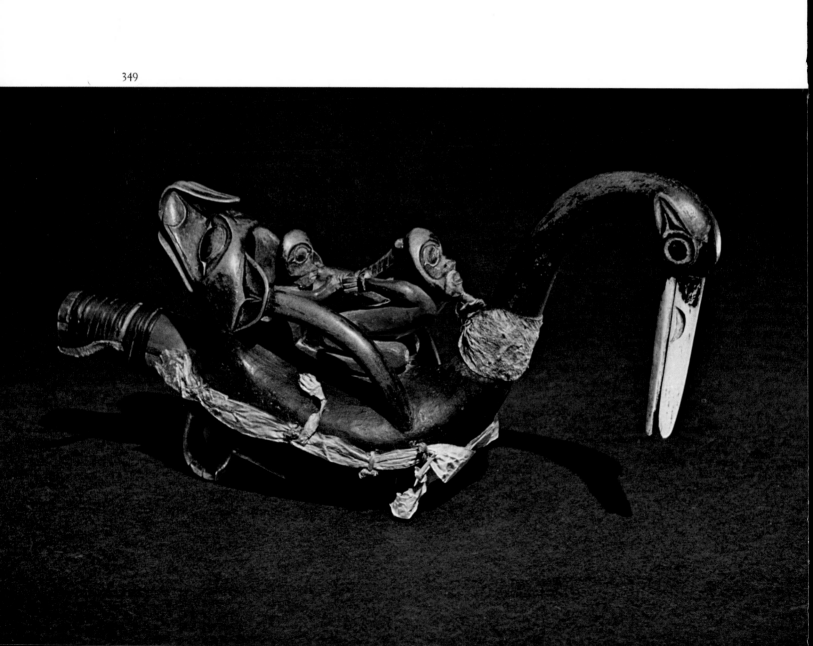

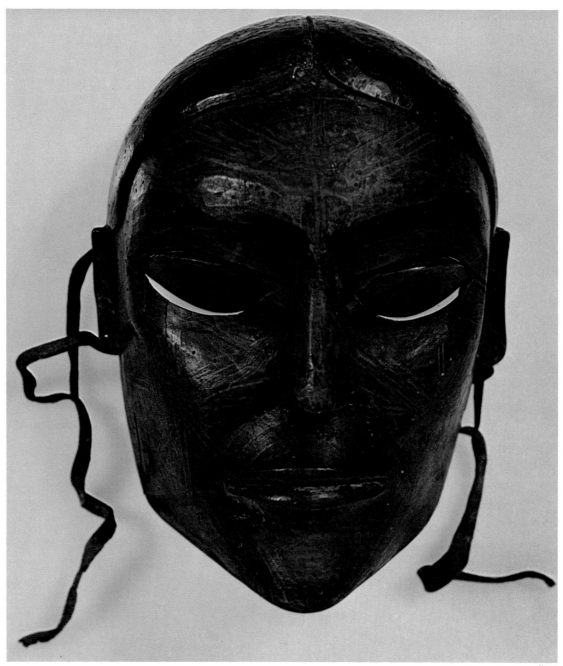

291

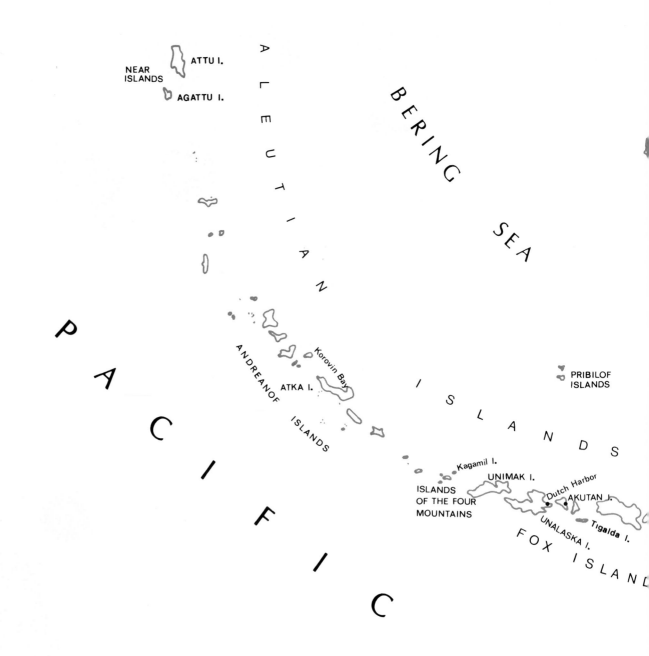

NEAR ISLANDS

ATTU I.

AGATTU I.

A L E U T I A N

BERING SEA

ANDREANOF ISLANDS

Korovin Bay

ATKA I.

I S L A N D S

PRIBILOF ISLANDS

P A C I F I C

Kagamil I.

ISLANDS OF THE FOUR MOUNTAINS

UNIMAK I.

Dutch Harbor

AKUTAN I.

UNALASKA I.

Tigalda I.

FOX ISLAND

O

LOCATION OF SITES

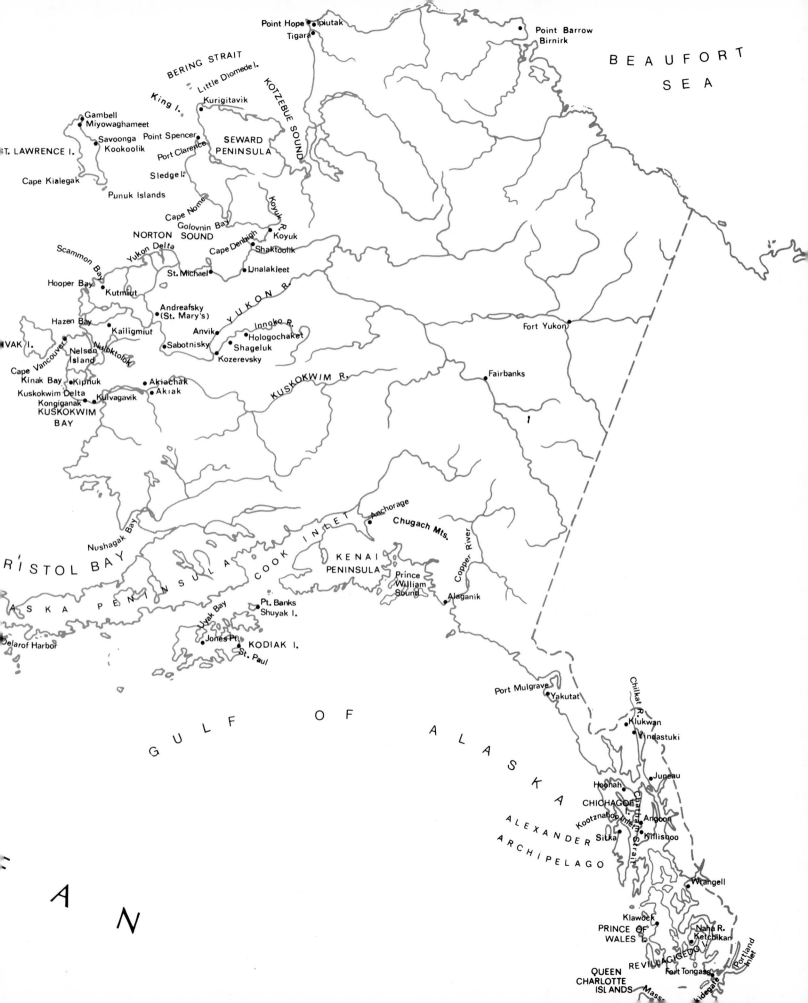

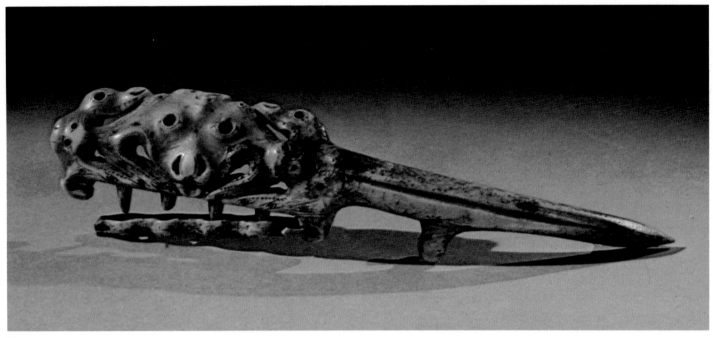

21

ESKIMO ART

HENRY B. COLLINS

T H E exhibition which this catalog chronicles affords dramatic evidence
of the high artistic achievements of the native peoples of our north-
ernmost state. It demonstrates why Alaska must be recognized as one
of the major world centers of primitive art. On first thought this might seem
an unlikely setting for the development of art, for the Arctic is one of
the most severe environments ever faced by man. Nor were living condi-
tions easy in the bitter cold of interior Alaska or on the stormy wind-
swept islands of the Aleutian chain. But there is another and very dif-
ferent side of the picture. When discovered by Europeans in the 18th
century, the North Pacific Coast, Kodiak and the Aleutian Islands, and the
Bering Sea coast of Alaska were three of the most densely populated areas
of the New World. Even the Arctic coast supported a population of
several thousand Eskimos. The Alaskan Eskimos, Aleuts, and Indians had
made the necessary adaptations in clothing, housing, transportation, and
hunting techniques which enabled them to live without hardship in their
respective environments. With its abundant and unfailing food supply
and density of population this far northwestern area became one of the
highest centers of cultural development north of Mexico. Art was its pri-
mary manifestation, an art remarkable for its richness and variety of ex-
pression.

The native population of Alaska consists of two major ethnic divisions:
Eskimo-Aleut and Indian. The Eskimos proper occupy the Arctic coast,
parts of the interior, and the west and southwest coasts from Bering Strait
to the Alaska Peninsula, Kodiak Island, and Prince William Sound. They
also occupy the lower courses of the Yukon, Kuskokwim, and other rivers
flowing into the Bering Sea and the Arctic Ocean. The Alaskan Eskimos,
or Inuit as they call themselves, are part of a far-flung stock extending
from the northeast coast of Siberia across Arctic Canada to Labrador and
Greenland. The Alaskan variant of Eskimo culture is more highly de-
veloped, especially in art, ceremony and some aspects of technology, than
that found in Canada or Greenland. It is also older, for archaeological
excavations have shown that the existing Eskimo cultures of Canada and
Greenland were derived from earlier stages in Alaska. The Eskimo lan-
guage is unrelated to any other in America. It is thought to be remotely
connected with the Chukchi language of northeast Siberia; and several
linguists have attempted, without too much success, to demonstrate a re-
mote relationship between Eskimo and the wide-spread Uralian and Indo-
European languages of the Old World.[1]

The Aleutian pattern of culture is an ancient one, as shown by a radio-
carbon date of 1700 B.C. for an Aleut midden on Umnak Island. It is

instructive to view the art of the Aleuts—in the light of the peculiarities of their ethnic history—as that of a people who shared a common cultural heritage with the Eskimos to the north but who in the relative isolation of their sub-Arctic island habitat developed art forms distinctly their own.

The Alaskan Indians are divided into two major groups, the Athabaskans of the interior and the Tlingit and Haida of the North Pacific Coast. The Athabaskans are the northernmost members of one of the largest linguistic stocks in America. Their southern relatives, speaking the same basic language, include several tribes in Oregon and California and the Navajo and Apache of the Southwest.

The Tlingit and Haida of southeast Alaska are typical representatives of the Northwest Coast province, the most important center of aboriginal American art north of Mexico. Along with the Eyak Indians of the Copper River delta they are grouped with the Athabaskans (Dene) to form what is called the Na-Dene linguistic stock.

Prehistoric Eskimo Cultures in Alaska

IT IS no accident that Alaska, the center of Eskimo art in modern times, was also the area where prehistoric Eskimo art reached its highest development. The prehistoric north Alaskan cultures of the past 2000 years were the source from which the modern Eskimo cultures of Alaska, Canada, and Greenland were derived. These earlier Alaskan people exhibited the same basic pattern of life as that followed in later times. They were hunters, mainly of sea mammals, living in permanent villages along the coast; their houses were partly underground with floors of stone slabs and walls of driftwood timbers and whale bones. Blubber-burning lamps of pottery were used for heating, lighting, and cooking; skin boats—kayaks and umiaks—were used for hunting and traveling, but the dog sled was not known; they subsisted mainly on seals, walrus, whales, caribou, birds, and fish, captured in the same manner and with the same devices—harpoons, darts and the throwing board, bow and arrow, fish spears, lines and sinkers—as those employed by later Eskimos. Their weapons, implements, and utensils, though similar in function and in general type to those used by later Eskimos, were fashioned in more elaborate form and were more frequently decorated.

The ancient Alaskan village sites appear today as frozen mounds, or kitchen middens, that had accumulated over the centuries as generation after generation of Eskimos lived on the same spot, sinking their houses into the piles of refuse left by their ancestors. Some of the Alaska middens are of enormous size. The largest, a mound called Kukuliak on the north shore of St. Lawrence Island, reaches a height of 23 feet and covers an area of 815 by 270 feet; it was established about 1500 years ago and was abandoned in 1876. The Eskimo village on Little Diomede Island in Bering Strait, still occupied today, is on the site of a large midden at least 2000 years old.

The middens contain the bones of animals that had been eaten by the

CATALOG

An object's measurement is of its greatest dimension: height, width or diameter, first in centimeters then parenthetically in inches.

Items marked with an asterisk will be on view only at the National Gallery of Art.

Descriptive entries, identified by the author's initials, have been prepared by the following scholars in those fields represented by objects in this exhibition:

E. C. *Professor Edmund Carpenter*
Adelphi College

H. B. C. *Henry B. Collins*
Archaeologist Emeritus
National Museum of Natural History
Smithsonian Institution

J. C. *Professor John Cook*
University of Alaska

F. de L. *Professor Frederica de Laguna*
Bryn Mawr College

C. D. L. *C. Douglas Lewis*
Curator of Sculpture
National Gallery of Art

Eskimos along with large numbers of artifacts they had lost or discarded. These artifacts—the hunting weapons, tools and household utensils used in daily life—changed gradually in form through the centuries. Some were discontinued, and sometimes new and completely different types of implements were introduced. Changes were especially prominent in art. The older styles of engraving were far more elaborate than those of later times. Through a series of transitional stages one art style succeeded another in prehistoric times, but the basic motifs, in varying form, continued throughout and still remain as the fundamental motifs of modern Eskimo art. We have a remarkably complete and detailed record of change, growth and development of art styles in a single area over a long period of time through the fortunate circumstance of the continuous occupation of the old Eskimo villages around Bering Strait because the frozen ground preserved bone, ivory and even wood and other perishable materials, and because of the ever present urge of Eskimos of all periods to decorate so many of their implements.

On St. Lawrence Island, the Diomedes, and the east and west coast of Bering Strait the culture stages that have been recognized are the Okvik, Old Bering Sea, Punuk, protohistoric, and modern—one stage leading gradually into another. At Point Barrow on the Arctic coast of Alaska the Birnirk culture, an outgrowth of Okvik-Old Bering Sea, became established and, around 1000 years ago, gave rise to the Thule culture. This was a crucial event in Eskimo prehistory, for it was the Thule culture which spread eastward to Canada and Greenland to form the principal basis of modern Eskimo culture in these regions. The sequence of related cultures leading from Okvik to recent Eskimo has been called the Northern Maritime tradition. These are not the oldest Eskimo cultures in the Arctic but they are the ones that provide the most complete record of cultural continuity. With the exception of Ipiutak they are the prehistoric Eskimo cultures most advanced in art.

At Kotzebue Sound on the Arctic coast a sequence of another kind, including several much older cultures, was discovered by the late J. L. Giddings.[2]

To understand the background of modern Eskimo art we must turn to some of the later prehistoric Alaskan cultures—to those of the Northern Maritime tradition where art held a prominent place in an unbroken culture sequence that can be traced over the past 2000 years, to the Ipiutak culture at Point Hope on the Arctic coast, and to the prehistoric cultures of Kodiak and the Aleutian Islands, Cook Inlet, and Prince William Sound.

OKVIK Okvik, the oldest of the Northern Maritime cultures (300 B.C.), takes its name from a site on Punuk Island, off the east end of St. Lawrence Island, discovered by Otto W. Geist in 1931.[3]

The engraved designs on ivory harpoon heads and other implements from Okvik sites seem to represent three more or less distinct sub-styles of different age. In sub-style A, assumed to be the oldest, the decoration consisted mainly of thick, deeply cut, straight or slightly curved lines to

1 GUT SCRAPER
Walrus ivory
13.1 (5 5/32) LONG
Okvik, (Old Bering Sea I),
sub-style "A"
Excavated at House #1 (South House),
Old Hillside Village, St. Lawrence
Island, by Henry B. Collins, 1930
Museum collection, 14 January 1931
Smithsonian Institution, 352 601

Okvik art, the oldest in the Bering Sea area, was essentially a linear style, of which three more or less distinct sub-styles can be recognized. The earliest, (A) of which this ivory scraper for removing fat from walrus and seal intestines is an example, was a rather crude, bold decoration consisting of thick deeply incised lines to which long slanting spurs were attached, and an occasional circle or oval.

Henry B. Collins, *Archaeology of the Bering Sea Region*, 1934, fig. 2; and 1935, pl. 3; also *Archaeology of St. Lawrence Island*, pl. 13.

H. B. C.

which long slanting spurs were attached. This decoration was applied consistently to a particular type of harpoon head that was very thick, almost square in cross section. Sub-style B, a more delicate style, was applied with equal consistency to two other types of harpoon heads that were very thin in cross section. Its most typical motifs were lightly incised, straight, rather short slanting lines, three or more of which often converged to form a tentlike figure; longer single or double lines with tiny spurs attached; broken lines; combinations of heavy and light lines, the heavier line being flanked by one or two light lines and/or broken lines; small circles with central dot set between two or three pairs of lightly incised lines forming long sharp spurs; plug inlays in circular pits representing eyes.

Another very simple motif of styles A and B consists of pairs of short parallel lines often placed above the line hole or on the basal spur of harpoon heads. Despite its extreme simplicity this design may have a special significance as hunting magic. Human figurines from Okvik sites have similar pairs of short parallel lines on the cheeks to indicate tattooing. In placing the identical design on harpoon heads, sometimes as the only decoration, the Okvik Eskimos may have been trying to give their hunting weapons the magical power believed to be inherent in tattooing.

Style C, the most elaborate of the Okvik sub-styles, was characterized by a profusion of long, straight, single or double lines to which tiny triangular spurs, often in pairs, were attached at carefully spaced intervals. The narrow space between such lines often contained tiny spurs, small hatched areas, or straight cross lines forming a kind of ladder design. These spurred lines of Okvik style C were usually arranged in converging fashion to form a tentlike design, with a small circle at the apex. It is an elaboration of the simpler converging line motifs of styles A and B, and it continued as one of the most common designs of later Old Bering Sea and Punuk art.

Okvik sculptural art consisted of human and animal figures, often of bizarre form, and usually decorated with Okvik designs.[4] Of more frequent occurrence, especially on St. Lawrence Island, were human figurines, forty-five of which were found at the Okvik site on Punuk Island, three at Gambell, and two in Siberia. Their most characteristic feature is the stylized form of the head and face, the head usually pointed at the top, the face long and oval with narrow pointed chin and very long straight nose. The most famous of these ivory figurines is the "Okvik Madonna," that of a woman with beautifully sculptured face and a curious twisted "smile" who is nursing an infant or small animal, the body of which is broken off.[5]

Three Okvik figurines recently excavated on Punuk Island differ from the others in having most of the body surface covered with engraving. The female figure (No. 2) is also unusual in having the breasts shown as elevated circles, and in the more than explicit representation of the genitalia. The deeply incised curved lines, long sharp spurs, and oval designs on the chest and back are those of Okvik sub-style A, while the two spurred circles near the shoulders and the converging line motifs on the

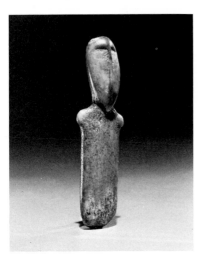

2 HUMAN FIGURE
Walrus ivory
9.35 (3 11/16) HIGH
Okvik, (Old Bering Sea I)
St. Lawrence or Punuk Islands?
Museum purchase
Museum of Primitive Art, 58.5

cheek and left leg are more like sub-style B. The circles forming the breasts and navel, together with the long down-curving arc on the abdomen, could have had a secondary meaning as the eyes, nose, and mouth of a grotesque face.

In contrast to the body, the face of the figurine is carefully modeled, recalling in some degree that of the "Okvik Madonna", though it lacks the structural control and sensitivity of the latter. There is nothing aesthetically pleasing about the figurine. It might seem, indeed, as if the artist were striving for the opposite effect when he carved this armless torso with narrow shoulders and enormously expanded hips, abnormally short, bowed legs and gaping, over-sized genitalia. There seems to have been a deliberate effort to show a woman with exaggerated sexual organs in association with an ill-proportioned body and none too pleasing face. One might even surmise that this is a 2000-year-old rendering of the vagina dentata myth, widespread among American Indians and Siberians, that tells of a dangerous woman whose toothed vagina killed men who had intercourse with her.

One of the basic differences between early and later Eskimo cultures throughout the Arctic is that chipped stone implements predominated in the older cultures, rubbed slate in the later. The stone implements at the five old sites at Gambell, St. Lawrence Island, illustrate this tendency. At the oldest, the Hillside site, where the art and artifacts were either Okvik or early Old Bering Sea, chipped stone blades outnumbered those of rubbed slate 242 to 140. At the next oldest site, Miyowagh, chipped stone blades were present, but as a minority element compared with slate. At the three later sites—Punuk or protohistoric—only implements of rubbed slate occurred.

It is highly significant that the oldest known examples of Okvik art were found in association with ancient forms of stone implements. This was at the Battle Rock site discovered by Giddings (1961, 1967) at Cape Krusenstern, just north of Kotzebue. The engraved art at Battle Rock consisted of long deep curving lines to which very long sharp spurs were attached. Except for being larger and more deeply incised, these designs on antler artifacts are identical with those of the oldest Okvik art, sub-style A, found on ivory harpoon heads and other artifacts from St. Lawrence Island and northeastern Siberia.[6] Antler arrowheads at Battle Rock were like those from Ipiutak and Okvik sites. Its stone implements are described by Giddings as midway between the ancient Denbigh Flint complex and Ipiutak and very similar to those of the Norton culture. Battle Rock is considered to represent the earliest aspect of Norton culture and to date around 600 B.C. The occurrence of Okvik art and artifacts in this context, centuries earlier than on St. Lawrence Island and in association with a flint industry derived from Denbigh, suggests that Okvik, like other early Arctic cultures, had its place in a cultural sequence beginning with the Denbigh Flint complex of 3000 B.C.

OLD BERING SEA STYLE II This style (300 A.D.) has the same distribution as Okvik, and occurs at the same sites. Several artifacts

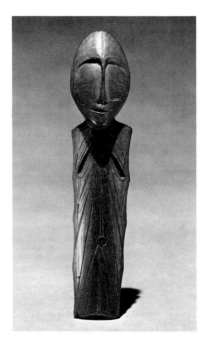

3 FEMALE FIGURE
Walrus ivory
14.6 (5 3/4) HIGH
Okvik, (Old Bering Sea I), sub-style "A", with traces of transition to sub-style "B"
Discovered on St. Lawrence Island, October 1972
Museum purchase, 1972
Alaska State Museum

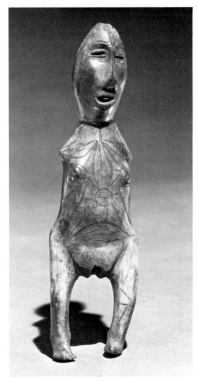

4 FEMALE FIGURE
Walrus ivory
17 (6 11/16) HIGH
Okvik, (Old Bering Sea I),
 sub-styles "A" and "B"
Collected by Brian Rookok,
 Punuk Islands, 1970
Museum purchase, 1971
University of Alaska Museum,
 UA 71-9-1

The rather linear, unelaborated incised lines making up the decoration on this figurine would stamp it as belonging to the Old Bering Sea style I or Okvik phase (about 100 B.C.). The lack of spurred elements attached to the lines would indicate Okvik, as does the long, narrow nose. Although rudimentary arms are a common trait of Eskimo ivory and wood figurines, the finished legs and feet are not common. A second look at the feet indicates that they are not feet, but paws; particularly bear paws. The only other such elaborately decorated figurine (also at the University of Alaska Museum) has been associated with a bear motif and it may well be that this, too, represents a bear mother in connection with a ceremonial or symbolic concern with the common Eskimo belief in a powerful bear spirit.

J. C.

with OBS style II decoration were found in a house ruin at Gambell overlying Okvik pieces between and below the floor stones. Okvik sub-style C and OBS style II are closely linked. The somewhat random converging line motif of the earlier art, with a small circle at the apex of a series of spurred lines, appears in OBS style II as a more careful arrangement, employing most of the same motifs to achieve a more elegant version of the same basic design (No. 8). This was true of OBS style II as a whole. Single and double lines, broken lines, small circles and other elements of Okvik style C were more carefully organized and skillfully rendered to form the graceful and elaborate designs of OBS style II. The long straight spurred lines so typical of Okvik style C were rarely used, but small spurs were often attached to circles, to short transverse lines, and to deeply-cut slanting or slightly curving lines that served to mark off panels in the surface decoration. Circles became larger and curving lines, which had no important part in Okvik art, were used increasingly to separate individual units and unify the total design in the more sophisticated engravings of OBS style II.

The important point, however, is that both styles employed most of the same basic elements. The blending was so complete that in many cases it is difficult to say whether an object is decorated in Okvik style C or OBS style II. One of the most diagnostic OBS implements, a harpoon head with two side blades, two line holes, and a three-pronged basal spur, is usually decorated in OBS style II but sometimes in Okvik style C. Another elaborate type of Okvik harpoon head, decorated in Okvik style B or C, continues in exactly the same form into OBS with a typical style II decoration.

Late Okvik and early OBS art had another point in common. Both had an urge to fill every available space with engraving, a kind of *horror vacui* such as one sees in some other primitive arts, for example Melanesian. The art that succeeded OBS style II showed a notable freedom from this tendency.

OLD BERING SEA STYLE III The art styles thus far considered, Okvik and OBS style II, were both found at the Hillside site, oldest of the five sites at Gambell, St. Lawrence Island, under stratigraphic conditions that clearly indicated Okvik to be the older.[7] OBS style III is essentially a modification and simplification of the more variable style II. The overall surface decoration is reduced and primary emphasis is given to graceful flowing lines and concentric circles and ellipses surmounting rounded elevations. The circles and ellipses, besides being elevated, are larger than those of style II. They often have a small plug of ivory or baleen at the center and, on harpoon heads especially, they are usually arranged in pairs so as to suggest the eyes of an animal. In contrast to the somewhat crowded designs of style II, parts of the ivory surface were left plain and smooth. The result was a more balanced and harmonious arrangement of the overall design, with bilateral symmetry the primary aim.

PUNUK (900 A.D.) The Punuk culture takes its name from an old site, a sixteen-foot-high midden on Punuk Island, off the east end of St. Lawrence.[8] The midden, containing Punuk material from top to bottom, had no connection with the much older Okvik site only a few hundred yards away, discovered later by Otto W. Geist. The Punuk culture centered on St. Lawrence and the Diomede Islands and occurred on both sides of Bering Strait and at a single site near Point Barrow. Punuk sites are larger and more numerous than Old Bering Sea, indicating a larger population, especially on St. Lawrence Island, during this period.

At Gambell, artifacts and art representing the earliest stage of Punuk were found overlying Old Bering Sea in the Miyowagh midden. The next oldest site, Ievoghiyoq, was a pure Punuk site containing materials of a somewhat later type. The next site, Seklowwaghyaget, was another pure Punuk site, of its latest phase, when harpoon heads were in the last stage of development into the modern form and the straight line motifs of late Punuk art were scarcely distinguishable from those of the modern Alaskan Eskimos.

Many of the Punuk implements, mainly utilitarian types such as picks, mattocks, baleen pails, meat hooks, and drills, were exactly the same as those of the Old Bering Sea culture. Other classes of OBS artifacts changed in form during the Punuk stage. These included, in addition to harpoon heads and art: bird darts, arrowheads, fish line sinkers, ice creepers, knives, adzes, ivory runners for hand-drawn sleds, needle cases, and "winged" objects; and implements of chipped stone were almost entirely replaced by those of rubbed slate. Many other new types made their appearance in the Punuk stage, as direct imports from the Siberian mainland: bird bolas, wrist guards, bow braces and sinew twisters for the sinew-backed bow, slat armor, bone and ivory daggers, sealing scratchers, fish hooks, heavy ivory net sinkers, iron-pointed engraving tools, many ornaments and toys.

The Punuk was in all essential respects a stone age culture, for its knives, scrapers, adzes, harpoons and arrows were provided with stone blades, which are found in great numbers in the middens. However, the Punuk Eskimos knew the use of metal. This is shown by the presence of a few iron-pointed engraving tools at Punuk sites (No. 31) and by the nature of the engravings on Punuk artifacts. The rather variable lines and free-hand circles and ellipses of OBS art could have been and presumably were made with stone tools. In contrast, the deeply incised precise lines and mechanically perfect circles of Punuk art could have been produced only with metal tools.[9]

In Early Punuk, stylistic changes in art were closely correlated with changes in the forms of harpoon heads, just as in Okvik and Old Bering Sea. The earliest Punuk harpoon heads at Miyowagh, though smaller, had retained the structural features of Old Bering Sea, except for the basal spur (No. 32). In OBS heads the basal spur (the lower end of the harpoon head) was complex and elaborate. Beginning with Early Punuk the spur became smaller and increasingly simple in form. Surface orna-

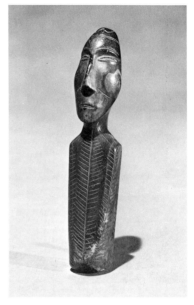

5 HUMAN FIGURE
Walrus ivory
12.5 (4 15/16) HIGH
Okvik, (Old Bering Sea I)
Punuk Islands
Museum purchase, 1972
Anchorage Historical and Fine Arts
 Museum, 72.34

mentation followed the same pattern of simplification. On OBS harpoon heads the deeply incised lines that descended from the upper end, dividing the rich surface decoration into panels, became the simple lines of Early Punuk which, following precisely the same path, constituted the whole design. Accompanying the lines were dots, small drilled pits at the center of two rounded elevations to right and left of the line hole in exactly the same position as the elevated circles and ellipses, with central dot, on the harpoon heads of the Old Bering Sea period. In later stages of Punuk the incised lines on harpoon heads ceased to be a direct reflection of Old Bering Sea; instead, they became more numerous and angular and less adapted to the surface contours they decorated.

Another remarkable example of developmental change is shown in the class of artifacts called winged objects which, in differing but structurally related forms, persisted from Okvik through Old Bering Sea to Late Punuk.[10] They consisted of a central body and a pair of outer wings which, in OBS, had somewhat the form of a butterfly. Through gradual reduction of the wings and modification of the central section this graceful bilobed form developed into the trident shape of Early Punuk (No. 17) and that in turn into the "turreted" form of Late Punuk (No. 18). The accompanying decoration in each case is consistent with the form. The few Okvik examples are smaller than the others and do not reveal the structural blending exhibited by the OBS and Punuk forms.

Winged objects of all periods, however, have two features in common. All have a socket in the base for a wooden shaft (some have been found with part of the shaft in place) and a small notch or pit at the upper end of the projecting central element. This notch has nothing to do with decoration but does provide a clue to the function of the winged objects. They were probably attached to the butt end of a harpoon propelled by a throwing board, to act as a "wing" and counterbalance for the heavy harpoon head and socket piece at the fore end. The purpose of the small notch would be to engage the ivory tip of the throwing board. It might be noted that the Greenland Eskimos put bone wings, though of quite different form, at the butt end of harpoons cast with a throwing board.

Several styles and sub-styles of Punuk art can be recognized from the harpoon heads and other decorated artifacts at the Gambell sites. The earliest were the rather lightly incised lines on harpoon heads already mentioned, similar lines with short spurs, isolated dots or dots at the ends of lines, and (rarely) freehand circles. Later Punuk designs consisted of more deeply incised lines; small nucleated spurred circles made with bit or compass; long very deep lines, usually in pairs, with short deep oblique spurs like gouges (No. 34); single or connected Y figures; three or more closely spaced lines forming bands; the "ladder" design; the alternate spur design—pairs of lines with inward-pointing alternating spurs—and the derivative zig-zag, the negative design that results when the alternating spurs are thickened and converted into small triangles. In the latest stages of Punuk art the decoration consisted of repetitive arrangements of the same design element, in contrast to earlier Punuk where they were usually incorporated into an overall connected design. Later, even this simplified

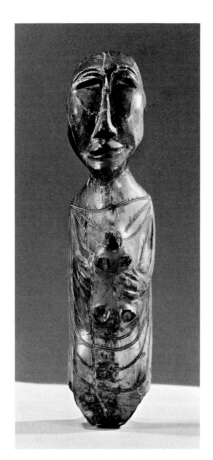

figure a

art disappeared and for the past few centuries Eskimo culture on St. Lawrence Island has been devoid of art.

As we have seen, the earliest, very simple Punuk art may be regarded as an outgrowth of Old Bering Sea, just as early Punuk harpoon heads developed from preceding OBS forms. However, later Punuk art in several respects rather closely resembles Iron Age art of northern Europe and Asia. A number of new cultural traits of Siberian origin introduced on St. Lawrence Island during the Punuk period, together with art, indicate that the Punuk culture was in a considerable degree the result of cultural influences received from Siberia.

Punuk played an important role in the development of modern Alaskan Eskimo art. The primary basis of Eskimo culture in the Bering Sea area, from Norton Sound to Bristol Bay, was the Norton-Near Ipiutak culture of the Alaska mainland, but the greater part of its engraved art was derived from Punuk. This was the source of the designs so characteristic of the area—the circle and dot, dot at the end of a line, the spurred line, Y figures, alternate spur design and bands of encircling lines, seen on so many of their ivory ornaments, implements and utensils.

Just as in Late Punuk, these design elements appear as separate units or, if connected, are repetitive, whereas in Early Punuk they had formed part of a connected design. Modern Eskimo engraving in the Bering Sea area may be regarded as essentially a disintegrated form of Punuk art.

BIRNIRK AND THULE (500–1000 A.D.) Birnirk and Thule were not represented as distinct cultural stages on St. Lawrence Island but harpoon heads of these periods occur at Punuk sites, Birnirk in association with Early Punuk and Thule with later Punuk.

The Birnirk culture takes its name from an old site near Point Barrow where Vilhjalmur Stefansson made limited excavations in 1912. Later excavations at Birnirk and other sites by J. A. Ford (1959) have provided full information on cultural development in the Barrow region from Birnirk times to the present. In contrast to Okvik-OBS and Punuk, which were concentrated in the Bering Strait area, particularly St. Lawrence Island and northeast Siberia, the Birnirk culture is restricted mainly to the Arctic coasts of Siberia and Alaska. Its basic affinities were with Okvik-OBS and Early Punuk.[11]

As mentioned earlier, Birnirk is of particular importance because it was the stage of culture directly ancestral to Thule, which formed the principal basis of all modern Eskimo culture from northern Alaska to Greenland. The first clear evidence of a Birnirk to Thule transition was found at Kurigitavik, a Thule-Punuk site at Cape Prince of Wales, Bering Strait.[12] In the upper and middle levels of this midden were found numbers of typical Thule harpoon heads corresponding exactly to those from Thule sites in Canada. Lower in the midden were harpoon heads which had some of the characteristics of the Birnirk type, and finally at the base of the midden, eighty-six inches deep, was a typical Birnirk head.

The Birnirk and Thule cultures are not notable for their art. Unlike the Okvik, Old Bering Sea and Punuk Eskimos, these Arctic coast people

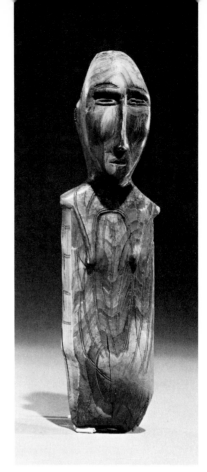

6 FEMALE FIGURE
Walrus ivory
20 (7 7/8) HIGH
Okvik, (Old Bering Sea I),
 sub-style "B"
Discovered on St. Lawrence Island,
 October 1972
Museum purchase, 1972
Alaska State Museum

This figure, one of the largest and most impressive of such rare human figures from the earliest stage of Alaskan Eskimo culture, closely resembles the famous "Okvik Madonna" in the collection of the University of Alaska (fig. a). This newly discovered figure shares with its better-known sister the same sensitivity of expression, and imaginative realization, not only of the features, but also of the shoulders, breasts and pendant collars. (Unique to her, however, is the apparently pregnant belly.) Both figures are delicately incised with parallel lines engraved in long, sweeping curves, ornamented with short spurs (single on the University example, but doubled in the present example) and developed on the back of the newly discovered figure in a pattern of gently looped curves evocative of the flowing garment with heavier shoulder decorations in which the figure is depicted.

C. D. L.

had no urge to make elaborate carvings or to decorate their harpoon heads, knife handles, and other implements. Thule's one contribution, and an important one, was pictographic art, to be described later; a few simple examples of these realistic engravings, which were to become the dominant art form in northern Alaska in the historic period, have been found at prehistoric Thule sites in Alaska, Canada, and Greenland.

The few decorated Birnirk objects that have been found bear simple designs consisting of spurred lines, alternate spur motif, curved double lines, rows of dots or broken lines, drilled pits, and (rarely) the circle and dot. Nevertheless it is possible to recognize a distinctive Birnirk "style," the principal features of which were rows of dots and small arc-like figures—bands of two curved spurred lines flanked by dotted lines (No. 30). This Birnirk ornamentation has its closest analogy in a few, and not entirely typical, decorated OBS objects from Miyowagh, St. Lawrence Island.[13]

While there can be no doubt that Birnirk was the stage of Alaskan culture leading directly into Thule, the exact time and place where Thule broke off and moved eastward to Canada is not known. It probably occurred not at Barrow itself or anywhere on the north coast of Alaska but further to the east around Coronation Gulf in the Canadian Arctic.[14] This is suggested by the presence of two types of harpoon heads, like those from Alaska, at the oldest known Thule sites at Coronation Gulf and elsewhere in Arctic Canada and Greenland. One was a barbed form derived from an earlier Birnirk type. The other was a barbless harpoon head corresponding to one of the most prominent Punuk types (Type III [a] x) on St. Lawrence Island. It was equally prominent at Kurigitavik, the Thule-Punuk site at Cape Prince of Wales.

I refer to this site as Thule-Punuk because it represents a blending of these two contemporaneous prehistoric Eskimo cultures. Originating from Birnirk, it displays the basic characteristics of what has been called Western Thule. Its barbed harpoon heads were either Birnirk-like or typically Thule. The more numerous barbless harpoon heads and the many decorated objects at Kurigitavik were either identical with or closely similar to those of the Punuk culture of St. Lawrence Island.

Another site closely related to Kurigitavik, called Nukleet,[15] is another illustration of the key role of Punuk and Thule in the development of modern engraved art in Alaska. The Nukleet site, at Cape Denbigh on Norton Sound, was occupied from the 13th through the 18th century. As mentioned earlier, Punuk art disappeared completely on St. Lawrence Island where it had been most typically represented. This was not the case at Nukleet. Nukleet incised art consisted entirely of Punuk and Thule motifs: circle and dot, spurred lines, alternate spur and ladder designs, bands of straight lines, and Y figures. This art style, like Nukleet material culture as a whole, is identical with that of the modern Norton Sound Eskimos, and forms part of a culture pattern which Giddings describes as "literally an extension backward in time of the culture of the modern Norton Bay people."[16]

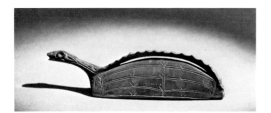

7 BIRD-SHAPED WOMAN'S
 KNIFE HANDLE
Walrus ivory
9.5 (3 3/4) LONG
Okvik sub-styles "B" and "C"
Discovered on St. Lawrence Island,
 October 1972
Museum purchase, 1972
Alaska State Museum

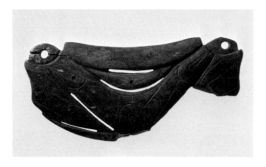

8 ENGRAVED GORGET OR
 PECTORAL
Walrus ivory
11.6 (4 9/16) LONG
Old Bering Sea II
Excavated from first layer of midden
 below the South House, Old Hillside
 Village, St. Lawrence Island, by
 Henry B. Collins, 1930
Museum collection, 14 January 1931
Smithsonian Institution, 352 701

Okvik and Old Bering Sea art employed the same design elements but the later art placed greater emphasis on curved lines and circles, so arranged as to display a balanced symmetry.

Collins, *Archaeology of the Bering Sea*, 1934, fig. 2; and 1935, pl. 3; also *Archaeology of St. Lawrence Island*, pls. 13 and 14.

H. B. C.

IPIUTAK (350 A.D.) Ipiutak, at Point Hope on the Arctic coast of Alaska, discovered in 1939 by Helge Larsen, Froelich Rainey, and Louis Giddings, is the most remarkable Eskimo site ever found in the Arctic. It is the largest in the circumpolar area, its art is the most advanced, and the problems it poses are the most difficult. The Ipiutak site was a huge village of more than 600 semi-subterranean houses arranged in long rows on the crests of five old beach ridges.

None of the houses overlapped, and the thin deposit of refuse in and around them indicate a short period of occupancy, probably no more than one season. Despite the size of the site there are no discernible differences in age of the houses or the artifacts they contain. The houses and 138 burials are those of a single culture period, exhibiting a "uniform character . . . which ties not only all the houses but the houses and burials into a single unit."[17]

Ipiutak is not a part of the cultural continuum thus far described, the series of related sequential cultures leading from Okvik-OBS to modern Eskimo. Ipiutak was related in some manner to Okvik-OBS, as would be expected of two roughly contemporaneous cultures in the same general area, but there were also important differences between the two. Some Ipiutak implements were identical with those of Okvik-OBS and others are closely similar, but the bulk of Ipiutak artifacts have their own individual stamp. The same is true of Ipiutak engraving.

The motifs of Ipiutak art were those of Okvik-OBS—circle and dot, spurred circles, circular and oval panels, straight or curved lines, combinations of light and heavy lines, broken lines, double lines, spurred lines, jet inlays comparable to those of baleen and ivory in OBS—and some of the most elaborate Ipiutak engravings closely resemble OBS style II. For the most part, however, the decorative elements of Ipiutak are differently arranged to form designs of a distinctive character which only in a general way resemble Okvik-OBS.

The connections between the two cultures are shown in another way. Winged objects, which were so characteristic of Okvik-OBS, were not a part of Ipiutak culture. However, two fragments of these objects bearing typical OBS ornamentation were found at Ipiutak. These and a few other objects with Okvik and OBS decoration, including a typical Okvik harpoon head, socket piece, and bird dart prong, are evidently relics of an earlier period, indicating the prior existence of Okvik-OBS. In contrast, no diagnostic Ipiutak artifacts have been found at Okvik-OBS sites.[18]

Excavations by Soviet archaeologists in northeastern Siberia have revealed quantities of richly decorated artifacts of the Okvik and Old Bering Sea periods, especially harpoon heads and winged objects, but no traces of Ipiutak. Instead, cultural resemblances between Ipiutak and the Old World turn up far to the west of Bering Strait, in the Iron Age cultures of northern Siberia and Europe. The most striking feature of Ipiutak art is its bizarre ivory carvings—"open work" objects resembling pretzels, chains and link ornaments, non-functional swivels, and animal figures, especially heads, often depicting fantastic rather than real animals

9 HARPOON HEAD WITH
 INSET BLADES
Walrus ivory and chert
11.9 (4 11/16) LONG
Old Bering Sea II
Excavated from the Northeast Beach
 Cut at Kukulik, St. Lawrence
 Island, by Otto W. Geist, 1935
University of Alaska Museum,
 UA 72-49-2

In terms of both form and ornamentation, this is a good example of a harpoon head belonging to the early part of the Old Bering Sea phase of the Eskimo tradition. The curvilinear motif with a profusion of spurred elements and broken lines indicate a chronological placement in Collins's Old Bering Sea style II. The trifurcate spur and double line holes would suggest early style II, dating the specimen at about 100 A.D.

J. C.

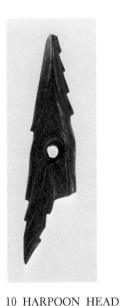

10 HARPOON HEAD
Walrus ivory
11.95 (4 11/16) LONG
Old Bering Sea II
Museum purchase (in Seattle) by
Henry B. Collins, 1929
Smithsonian Institution, 348 123

The harpoon head with which Eskimos
capture the sea mammals on which
their livelihood depends is also a tool
that greatly aids the archaeologist in
his task of establishing regional
chronologies and tracing culture
change. The harpoon is a complex
implement, the component parts of
which vary from region to region and
from one time period to another. This
is especially true of the toggle harpoon
head, several examples of which are
shown here. These implements have
undergone continuous change from the
Okvik, Old Bering Sea, and Punuk
periods to modern times.

The oldest harpoon heads were
complicated and variable in form and
were decorated with the elaborate
designs of Okvik or Old Bering Sea art.

H. B. C.

(Nos. 19–29). As Larsen and Rainey have shown,[19] these animal carvings, especially of the bear and the mythological griffin, and the incised ornamentation accompanying them, are very similar to the forms and designs of Scytho-Siberian art of northern Siberia. Ipiutak art was intimately connected with shamanism. The pretzellike carvings, swivels, and chains, almost all of which were found with burials, were probably shamans' regalia, the ivory equivalents of similar iron objects which Siberian shamans attached to their skin garments.

The loon held a special interest for the Ipiutak Eskimos. Many of the open work ivory objects and link ornaments found with burials were carved in the form of a loon's head. And in one of the Ipiutak burials, that of a male skeleton with ivory and jet inset eyes, there was also the skull of a loon equipped with the same artificial eyes of ivory and jet. This is archaeological evidence of the special place the loon held in northern folklore and religion. In American Indian and Siberian mythology he was the creature, the earth-diver, who brought up bits of the primordial ocean bottom to form the world. More specifically the loon was the principal helping spirit or animal helper who conducted the Siberian shaman on his journeys to the underworld; figures of loons were one of the most frequent objects attached to the Siberian shaman's robe, and wooden carvings of loons were set up on posts over the shaman's grave.

The Ipiutak burial of a man and a loon, both provided with permanent ever-seeing eyes, might also be a reflection of the mythological theme of the loon as a sight-restoring medium. A widespread myth among northern Indians and Eskimos tells of a blind man who asks a loon to restore his vision. This the loon does by diving repeatedly into a lake with the blind man until the latter finally regains his full sight. The Ipiutak burial of a man and loon, both with artificial eyes, suggests an ancient belief in the loon not only as a companion in an underworld flight but also as a creature who brings everlasting vision.[20]

Perhaps the most spectacular works of art at Ipiutak are the strange "masklike carvings" (No. 20). This and two more elaborate examples consist of flat sections of ivory neatly fitted together to form the outline of a human or human-animal face.[21] They were found with burials and had evidently been mounted on a wooden background, only traces of which remain. There is a striking general resemblance between these composite ivory carvings and composite "demon masks" found in tombs at An-yang, the Shang dynasty capital in northern China.[22] The ancient Chinese masks were made of sections of marble and mother of pearl forming the outline of a human-animal face with mouth, nose, eyes, eyebrows, ears, and horns. They had been set in as inlays on a wooden backing and placed in graves. These composite Chinese and Eskimo masks, generally similar in form and identical in function, suggest that cultural influences from ancient China had contributed to the formation of the Ipiutak culture in Alaska.

The anomalous position of Ipiutak on the north coast of Alaska—as the largest settlement known in the Arctic and yet something apart from

the cultural continuum that links northern Alaska with Canada and Greenland—is counterbalanced by the many indications of cultural ties, including art, between Ipiutak and southwest Alaska. As mentioned before, the primary basis of Eskimo culture in the Bering Sea coastal area from Norton Sound south to Bristol Bay is the Norton culture of western and northern Alaska and the closely related Near Ipiutak, a culture stage at Point Hope related to but earlier than Ipiutak. It is in Ipiutak proper, however, that we find the closest parallels with modern Bering Sea art. The geometric elements of modern Bering Sea art such as bands of encircling lines, circle and dot, circle at the end of a line, Y figures, and spurred lines are clearly of Punuk origin. Representative motifs and carvings of the Bering Sea area such as schematic human faces, eyes shown as goggles, animal carvings, bird's heads, and link ornaments are very similar to those of Ipiutak.

SOUTH ALASKA South Alaska, the most densely populated area of the far north in historic times, is also the area where prehistoric cultures extend deepest into the past. People who could have been proto-Aleut lived on Anangula Island in the Aleutians 8000 years ago, and archaeological sites on Kodiak Island and the Alaska Peninsula which could have been those of proto-Eskimo people have been found dating from 3500 to 2000 B.C. But these very early sites have yielded nothing more than stone implements. Important as they are for showing continuities, changes, and relationships in stone typologies, they tell us little of the way of life and culture of these early peoples. For this we must rely on excavations at later sites which reveal stages of culture demonstrably ancestral to those of the present Eskimos and Aleuts.

Prehistoric Eskimo and Aleut culture in South Alaska is basically similar but in many ways very different from that of the north. The way of life was the same—that of a hunting people utilizing the varied resources of its environment, primarily those of the sea but also of the land. Yet in their hunting practices, arts, and manufactures the southern Eskimos and Aleuts developed their own distinctive patterns. Harpoon heads and some other implement types were generally similar to those of the north but fundamental differences appear in such features as killing whales with a poisoned lance, the prevalence of barbed darts over toggle harpoon heads, composite fish hooks and grooved stone sinkers, composite harpoon heads and sockets, specialized forms of slate blades, and large round or oval lamps. On the whole, there are greater differences between South Alaska and Bering Strait than between Bering Strait and Greenland. In contrast to this sharp distinction between South Alaskan cultures and those of the Northern Maritime tradition at Bering Strait and the Arctic coast, the southern cultures had distinct affinities with the Norton-Near Ipiutak tradition of western and northern Alaska.

Cultural changes in South Alaska were less pronounced and less frequent than in the north. Aigner has demonstrated changes in art and bone artifacts over a long period of time at a single site in the Aleutians.[23] But in general there is no record in South Alaska of continuous, wide-

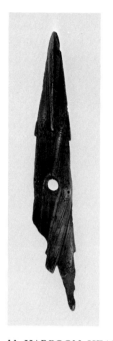

11 HARPOON HEAD
Walrus ivory
14.6 (5 3/4) LONG
Old Bering Sea III, transitional from Old Bering Sea II, of which vestiges are apparent in the engraved decoration
Collected in the Diomede Islands by E. P. Herenden
Acquired for the Museum ethnology collections, 1881
Smithsonian Institution, 46 374

Old Bering Sea style III was a simplification or adaptation of style II; curved lines became more bold and flowing, and were accompanied by lightly incised and broken lines, for contrast; circles became larger and were usually slightly raised so as to suggest the eyes of an animal. The graceful, flowing ornamentation is accentuated by the soft, rich shades of cream, chocolate brown or almost black which the ivory has assumed through centuries of burial in the frozen soil.

H. B. C.

spread change in which the art styles and implement types of one culture lead directly to the next, as at Bering Strait. Consequently it is not possibly usually to speak of South Alaskan art styles in relation to sharply defined culture stages or sequences.

Frederica de Laguna's excavations at Cook Inlet and Prince William Sound have traced the development of the southernmost form of Eskimo culture from around 700 B.C. to the present.[24] Three culture periods, called Kachemak Bay I, II, and III, were recognized in this area. Incised ornamentation was rare, only an occasional artifact being decorated with straight lines, spurred lines, or compass-made circles. A few human heads and animal figures were skillfully carved in ivory. Stone plaques and beach pebbles were engraved with fine line crosshatching, and pictographs of red hematite were painted on cliff walls. Large stone lamps with a human or animal figure carved in high relief inside the bowl were the most notable feature of Pacific Eskimo art (No. 45). Artificial bone eyes found in the eye sockets of skeletons afford a direct parallel with Ipiutak.

Hrdlička's excavations on Kodiak Island, and Heizer's detailed description of the artifacts,[25] give a full picture of prehistoric Eskimo culture in this area in the 1st millennium A.D. Handsomely carved and decorated stone lamps are perhaps the most characteristic feature of Kodiak culture. Most are oval or petaloid in shape, many with incised or relief decoration on the rims, sides and bottoms but especially on the inside of the bowl. The decoration takes the form of stylized animal heads, sunken or raised areas in the shape of an arc or circle, whale flukes, a median ridge or depression, or two rounded knobs suggestive of female breasts (No. 44).

Art of quite another kind is seen in crude designs representing conventionalized human figures engraved on flat slate beach pebbles.[26] Found in great numbers on Kodiak, these incised pebbles have only the merest suggestion of a human face—a Y-like figure with drooping ends representing the nose and eyebrows rising from several short horizontal lines forming the mouth. In the most typical examples there is also the suggestion of a beard, rather explicit rendering of beaded hair ornaments, and lines and figures of many kinds representing clothing. Careless and disorderly as they are, these scratchy designs can be seen to represent the elaborate hair ornaments and decorated skin and feather clothing worn by the early Kodiak Islanders.[27] The constant feature of these engravings —the stylized human face—occurs also in rock paintings in Prince William Sound and the Northwest Coast, and they also recall the schematic human faces of Ipiutak.

In striking contrast to these crude engravings, which are no more than stylized graffiti, are a number of small human and animal figures skillfully carved in ivory and bone. A small ivory bear (No. 42) is an example of sculptural abstraction, while another small carving (No. 46) portrays realistically the placid features of an Eskimo woman. The ivory carving shown as No. 47 is a miniature mask, with four holes for cord attachments. Its squarish, almost realistic features approach those of two other Kodiak heads that are true portrait carvings, the finest examples of realistic Eskimo sculpture known.[28]

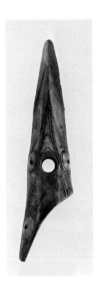

12 HARPOON HEAD
Walrus ivory
11.7 (4 19/32) LONG
Old Bering Sea III
Excavated from lower half of second
 cut in South Midden, Cape Kialegak,
 St. Lawrence Island, by Henry B.
 Collins, 1929
Museum collection, 21 December 1929
Smithsonian Institution, 346 906

At the mouth of the Kuskokwim, Larsen (1950) discovered sites of what is now called the Norton culture, closely related to Near Ipiutak. A stone lamp from one of these sites illustrates the relationship, previously mentioned, between Norton-Near Ipiutak and modern Eskimo culture in the Bering Sea region. On the bottom of the lamp was incised a schematic human face with short line tattoo marks like those on schematic faces at Ipiutak. The nose was formed by another Ipiutak design—a straight vertical line flanked by two opposed arc-shaped lines with ends pointing outward. This design, used alone, is frequently incised on the inside of pottery lamps of the modern Bering Sea Eskimos, where it may be a female sex symbol.

In the Aleutian Islands the excavations of Jochelson (1925), Hrdlička (1945), Laughlin (1952, 1958, 1966), Spaulding (1962), and Bank (1953) have revealed the prehistoric patterns of Aleut culture. The early Aleuts, unlike the northern Eskimos, rarely decorated their bone and ivory artifacts. Almost every harpoon head and hundreds of other artifacts made by the Okvik, Old Bering Sea, and Ipiutak Eskimos were decorated in their respective styles of engraving. But of the thousands of bone and ivory artifacts that have been excavated in the Aleutians only a very small percentage are decorated. This is true of South Alaska in general. The early Aleuts and southern Eskimos, like those of later times, applied their artistic skills mainly to wood carving and painting, weaving, and basketry: perishable materials which, except in dry burial caves in the Aleutians, have not been preserved.

The fourteen large and fifty-five smaller islands of the Aleutian chain, extending some 900 miles westward from the Alaska Peninsula, had a dense population, estimated at around 20,000, when discovered by the Russians in 1741. Almost every island was inhabited, with thirty-one villages reported on Agattu, thirteen on Unalaska and many more on the other islands. Judging from the large number of old village sites the Aleut population was equally dense in prehistoric times. In an area as large as this, some degree of cultural diversity is to be expected. The prehistoric Aleutian sites cover a time span of over 3500 years. One of them, Chaluka on Umnak Island, was occupied throughout this period, others are known to overlap in age and still others represent some particular more limited period. There are clear indications of regional differences in prehistoric Aleutian culture, but these have not been elucidated by island-by-island comparisons, and only one local sequence, that established by Laughlin and his coworkers on Umnak Island, has been traced in detail.[29]

Quimby postulated three periods of prehistoric Aleutian art on the basis of artifacts excavated on Amaknak Island, near Unalaska.[30] The earliest style consisted of vertical arrangements of X's, short cross lines, and slanting lines deeply incised on barbed projectiles. These designs are generally similar to those of the Dorset culture of the eastern Arctic. Also present was the simple Okvik motif of pairs of short parallel horizontal lines. Later motifs included nucleated circles and long closely-spaced vertical lines with neatly arranged inward pointing triangular spurs, usually in groups of three. These long lines with inner spurs are very similar to

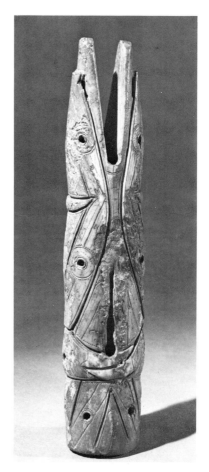

13 HARPOON SOCKET PIECE
Walrus ivory
20.8 (8 3/16) LONG
Old Bering Sea II
Discovered on St. Lawrence Island,
 October 1972
Museum purchase, 1972
Alaska State Museum

those of Okvik sub-Style C. Another parallel with Dorset art is a human head carved above the tang of barbed harpoon heads and sockets, comparable to similar heads on Dorset toggle harpoon heads. A characteristic feature of late prehistoric Aleutian art, found at several sites, is a proliferation of very small compass-made circles.

Aigner's careful analysis of the bone artifacts from the deep Chaluka midden on Umnak Island revealed four main cultural units or levels radiocarbon dated from 1700 B.C. to 1700 A.D.[31] The art sequence differed from that just described, indicating not only an age difference but probably also inherent cultural differences between the two sites.

Arts of the Modern Alaskan Eskimos

14 WINGED OBJECT
Walrus ivory, some lines re-engraved
17.3 (6 3/4) LONG
Old Bering Sea II and III
Collected on St. Lawrence Island by
 Grace M. Crosson, 1952–55
Gift of Helen Hartigan, in memory of
 Miss Crosson
Alaska State Museum, II-A-3757

Paralleling the developmental changes in harpoon heads were those that occurred in ivory carvings referred to as "winged objects." These curious objects are found in large numbers at prehistoric Eskimo sites in Alaska and Siberia but are unknown elsewhere in the Arctic. They were probably attached to the butt end of a harpoon propelled by a throwing board, to act as a "wing" and provide a counterweight for the heavy toggle head and socket at the fore end. Beginning in Okvik as a small winged form, they developed, as in this piece, into a larger, more graceful butterfly shape. In the early Punuk stage the wings became narrower and inclined upward instead of outward, gradually assuming the form of a trident. This in turn developed into the "turreted" form of late Punuk (see No. 18).

H. B. C.

SINCE Western civilization came to them late, the Bering Sea Eskimos maintained their original way of life up to the last quarter of the 19th century, longer than any other Eskimos in Alaska. When E. W. Nelson arrived at St. Michael, Norton Sound, in June 1877 to take up his duties as weather observer with the U. S. Signal Corps, the Bering Sea Eskimos were still holding their elaborate mask festivals. Many of the masks and other works of Eskimo art in this exhibition were collected by Nelson during the four years he lived and traveled in Alaska.[32]

MASKS The elaborately carved and painted masks of the lower Yukon and adjacent areas of Alaska represent one of the highest achievements of Eskimo art. Better than any other class of objects they display not only the technical virtuosity and high artistic skills of these gifted people but also provide insight into their religious beliefs and conceptions of the universe.

The masks were usually made by shamans or by carvers working under their direction, and were worn by dancers in elaborate winter ceremonials such as the Messenger Feast and the Bladder Festival. Essentially the masks represent spirits—the spirits or souls (*inua*) of animals, those of the shaman's spirit helpers or of creatures he has seen in visions or on his visits to the spirit world; other masks represented the spirits of deities such as the Sun and Moon, or of inanimate objects or places. The purpose of the masks was either apotropaic—to exorcise evil spirits and ward off misfortune of any kind that threatened the community—or to honor and appease the souls of game animals that had been killed, thus insuring a plentiful supply of food in the future.

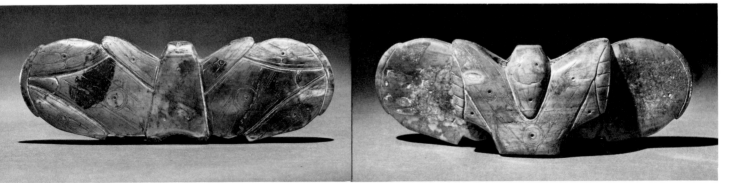

In revealing the visage of the fantastic creatures inhabiting the spirit world to which only he had access, the shaman drew upon his imaginative powers to produce plastic images of life forms as different as possible from those of the existing world. His aim was to carve a human or animal face, recognizable as such, but whose features were so unreal and distorted as to excite awe and amazement at his ability to see and control such strange beings. Some Bering Sea masks showed a naturalistic human face with only a few whimsical features added. Most, however, were grotesque in the extreme—surreal creations with eyes that did not match, one eye replaced by an entire small face (No. 171), superimposed animals or animal heads, and every conceivable distortion of mouth, nose, face, and head. Several examples of these highly imaginative and complex Bering Sea masks are included in this exhibition.

Masks were worn only by men. Their dance movements were rapid and vigorous as they jumped and stamped the floor in time to the drum beats and singing. Women used finger masks (Sheldon Jackson, II F. 2 AB)—small wooden disks with holes for the fingers and decorated with feathers. Their dance movements were extremely graceful and restrained. In some dances the women formed a chorus line, sitting in a row swaying their bodies and moving their arms in perfect unison. When they danced standing, their feet never left the floor, only the arms and upper part of the body moving rhythmically to the accompaniment of the music.

Almost all masks were painted, either in white or soft shades of green and grayish blue, or in bolder tones of red and black to accentuate selected features or areas. Narrow hoops of wood or willow root often encircled the face, and attached to these or to the face itself were various kinds of appendages—feathers, wooden figures of birds, fishes, or mammals, and human hands, arms, and legs. Many masks had rows of feathers or a halolike fringe of caribou hair surrounding the face. Some masks had movable covers or doors that would swing open to reveal the *inua* of the animal it represented. A mask showing a human face inside a bird's mouth (No. 165) illustrates the Eskimos' belief in an original close kinship between men and animals. In ancient times, it was believed, a bird or mammal could be transformed into a man by lifting up its beak or muzzle, revealing his human face.

Masks of the northern Eskimos were less ornate in form; they were painted more simply and lacked the elaborate appendages of the Bering Sea masks.[33] Many had no paint or attachments at all. Some Point Hope masks are plain and portraitlike (No. 137); in others bold relief carving and distortion of selected facial areas achieve a restrained, abstract sculptural quality not usually seen in the south. In one old mask from Point Hope an abstract representation of a human face was produced by five deep, bold, slanting incisions and three down-slanting perforations for eyes and mouth. Another mask from the Arctic coast (No. 134) is similar but has round and bulbous eyes.

At the southern margin of Eskimo territory, Prince William Sound, some masks were unpainted, abstract, and stylized, the constant features being a prominent wedge-shaped nose, very high forehead, heavy over-

front

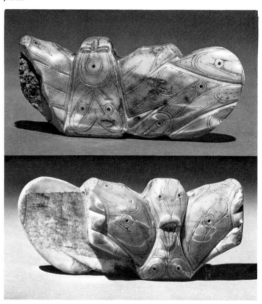

15 WINGED OBJECT
Walrus ivory
12.1 (4 3/4) LONG
Old Bering Sea II, with traces of
 transition to Old Bering Sea III
Discovered at Kialegak, near Southeast
 Cape, St. Lawrence Island, 1945;
 purchased from the native store, 1946,
 by Mrs. Alice Green
Sheldon Jackson Museum, II.Z.29

This richly decorated example carries elaborate patterns of engraving which were asymmetrical across the two sides on both front and back; the smaller rear side is reminiscent of some aspects of Ipiutak engraving (see No. 19). The exterior contours of this piece show considerable signs of modern reshaping and regularization, and the high polish is in part a later addition; but the quality of the engraving makes it a beautiful specimen.

C. D. L.

hanging eyebrows and a wide V-shaped slit for the mouth (Nos. 141, 144). Others had similar features but were painted and had encircling hoops to which feathers were attached (No. 142).

Some Kodiak masks resembled these in facial structure and also had surrounding hoops and feather and wooden attachments.

Early Aleutian dance masks illustrated by Sauer were completely or almost realistic, showing beard, mustache, and pendant beaded ornaments.[34] Entirely different from these are the strange masks from Aleutian burial caves described by Pinart and Dall.[35] Their most conspicuous features are an enormous nose, high forehead, prominent chin and wide mouth (No. 53). Eyes are in the form of an incised circle or a slit. An interesting feature, almost never seen on Eskimo masks, was a prominent circle, spiral, or rectangular or circular design painted in red or green on the forehead between the eyebrows. Spiral designs were incised or painted in soft green on the forehead, above the nostrils, and on the cheeks. In some cases a narrow incised panel, enclosing round, triangular, or diamond-shaped designs, ascended from the edge of the mouth toward the eyebrow. The painted designs and structural features of these masks are unique, in no way resembling the dance masks of the Aleuts and Eskimos. The artists' intention seems to have been to depict a ferocious but purely human face, quite unlike the grotesque, fanciful, or humorous faces on Eskimo masks. In a way these Aleutian mortuary masks recall fierce-visaged Japanese temple guardians or the terrifying face masks worn by Japanese warriors.

There is nothing in the archaeological record to indicate that masks were used by the earliest Eskimos. They are conspicuously absent at Okvik, Old Bering Sea, and Punuk sites on St. Lawrence Island where wooden objects are found in abundance, preserved by the frozen soil. The evidence is less conclusive for Ipiutak and Norton culture sites, where few wooden objects have been preserved. Parts of three wooden masks found at Kurigitavik, the Thule-Punuk site at Wales, show that masks were used, though probably rarely, in prehistoric times.

IVORY AND WOOD CARVING The Alaskan Eskimos display a skill in ivory carving and decoration unequaled in the Arctic. This is shown by an endless variety of objects such as earrings, hair ornaments, belt fasteners, and combs; of objects connected with sewing—needle cases, thimble holders, bodkins, and work bag fasteners; of tools and implements such as bucket and box handles, skin scrapers, arrowshaft straighteners, harpoon sockets, drag handles, harpoon rests, fish lures, toggles; and snuff tubes, pipes, dolls and small human and animal figures (Nos. 86–107). Objects such as these are much more characteristic of modern than of prehistoric Eskimo culture, although the prototypes of many of them are to be found in Okvik-Old Bering Sea, Punuk, and

16 WINGED OBJECT
Walrus ivory with composite inlays
20.3 (8) LONG
Old Bering Sea III
Collected by Captain Joe Bernard
c. 1909–10?
University Museum, Philadelphia,
NA/4245

This harpoon tailpiece rivals a comparable example in the Smithsonian Institution, as the most perfect representative of its type. Delicately engraved with a curvilinear interlace pattern on the front, its decoration changes to a stylized winged figure in low relief with a prominently sculptured face and head, on the reverse.

front C. D. L.

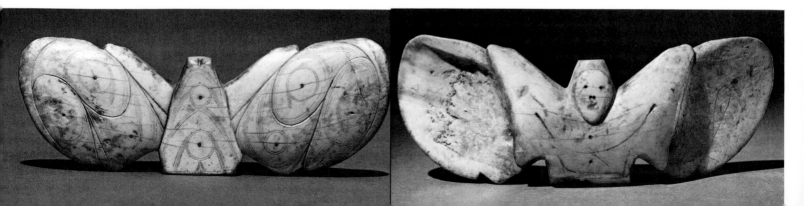

Ipiutak. As mentioned before, the Punuk culture was the source of the geometric ornamentation applied to objects of this kind, while certain representative motifs were derived from Ipiutak.

The Bering Sea and Pacific Eskimos were noted for the excellence of their wooden bowls and containers: food bowls, trays, ladles and spoons; boxes of various shapes and sizes with neatly fitting lids for holding tools and trinkets, snuff, tobacco, and paint. Other skillfully made wooden objects were hunting helmets and visors, snow goggles, and painted boat paddles.

Some bowls were carved in one piece but most of them had a separate concave bottom and sides made of a strip of wood that had been steamed, bent into shape and neatly pegged together where the ends overlapped. Many of the wooden containers were made in the shape of an animal and embellished with bead and ivory inlays. These handsomely carved wooden utensils are another example of the superior artistic achievement of the modern Eskimos as compared with those of prehistoric times. No small containers such as these, and no composite wooden vessels have been found at prehistoric sites. The Okvik, Old Bering Sea, and Punuk Eskimos made composite utensils of the same type but they had flat wooden bottoms and sides of baleen. Only the ivory handles of these baleen vessels were decorated, never the vessels themselves.

Most of the wooden objects made by the Bering Sea Eskimos, especially bowls and ladles, were painted red; many also had figures of game animals or mythological creatures painted in black on the inside. A favorite motif on bowls and ladles was the *palraiyuk*, a fabulous man-eating monster resembling an alligator or dragon. A representation of this creature, painted on a wooden bowl, is shown in No. 113.

CLOTHING AND WEAVING The skin garments of the Eskimos are tailored with utmost skill and often tastefully decorated with inset bands, hems, and tassels. A waterproof garment called a *kamleika* was made from long ribbonlike strips of seal intestines. These were sewn together in horizontal bands and decorated at the seams with tufts of feathers or other material. A garment of this kind from St. Lawrence Island (No. 82) is decorated at the seams with feathered crests of the crested auklet.

The most elaborately decorated clothing was that of the Pacific Eskimos and Aleuts. Their parkas, made from the skins of cormorants, puffins and other sea birds and of various kinds of mammals, were embellished with strips and tassels of colored leather, ermine and sea otter fur, eagle down, cloth, and beads.

On Kodiak Island the men wore conical basketry hats, woven from strips of spruce root. They were richly ornamented with painted designs, dentalium, white and colored beads, and bunches of sea lion whiskers.

17 WINGED OBJECT
Fossil ivory
16.1 (6 5/16) LONG
Early Punuk, showing elements of
 transition from Old Bering Sea III
Museum of the American Indian,
 Heye Foundation, 3/2523 *front*

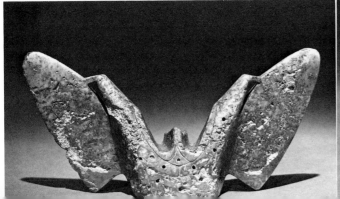
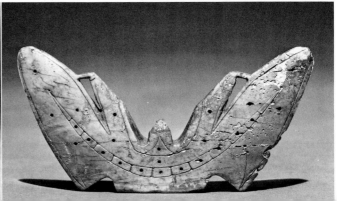

South of Bering Strait, Eskimo men wore wooden visors and conical helmets to protect their eyes from the glare of the sun when hunting at sea. The conical helmets were made from a single piece of driftwood scraped thin, bent around and sewed together at the back. Some were painted white or red with a cluster of feathers at the back; other decorative features were flat ivory attachments in the form of a long-beaked bird's head and narrow ivory panels, carved with openwork circular figures, rising horizontally on either side of the hat.

The most elaborate hunting helmets were those of the Kodiak Eskimos and Aleuts. The Aleutian helmets had long visors that projected far in front of the hunter's face. The back was nearly vertical and the stitches that bound the ends together were covered by a long narrow ivory band, at the top of which was a hollow enlargement that fitted over the pointed crown of the hat. Surface ornamentation consisted of painted designs: encircling bands of black, red, and greenish blue, bold spirals, and realistic figures of men and animals. Carved ivory figures of birds, mammals, and humans, and clusters of large glass beads were attached to the top and sides; a row of sea lion whiskers, strung with beads and feathers, projected from the rear (No. 64).

A constant feature of the Aleutian helmet was a flat ivory plaque on either side, the upper end round and carved in the form of a scroll, the lower end tapering like a bird's beak. These plaques, decorated with a wide variety of circular motifs, have been interpreted as conventionalized figures of the long-beaked bird's heads on Eskimo hunting helmets. An alternative explanation, one that conforms with the known tendency of the Eskimo artist to give life meaning to preexisting conventional forms, would be that the simpler Eskimo helmet ornament was a later adaptation. It could have been a copy of the original Aleutian ornament with the scroll replaced by an incised concentric circle with inner dot resembling a bird's eye; at the same time the narrow tapering end was divided into two halves, giving the whole ornament the appearance of a bird's head.

Eskimo women in the Bering Sea area made a wide variety of woven grass mats and bags. Their baskets, usually with a flat or conical lid, were neatly made by the coiling method (Nos. 110, 111).

The Aleuts and Pacific Eskimos excelled all others in weaving and basketry. Beautifully woven and decorated mats served as bed covers, screens, and other household furnishings, and many kinds of bags and containers were made of woven grass and other fibers. The tightly woven baskets of this area are among the finest in aboriginal America. Most beautiful of all were those of the western Aleutian Islands; from the silky fibers of a beach grass (*Elymus mollis*), the women wove baskets which for technical perfection and elegance have no equal anywhere (Nos. 55–57).

Aleut women also made basketlike containers from strips of seal intestine, scraped very thin until they were translucent. They were tastefully decorated at the seams with tufts of downy feathers and colored yarn (Nos. 58–60).

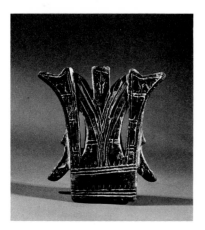

18 TURRETED OBJECT
Fossil ivory
7 (2 3/4) WIDE
Late Punuk
Excavated at
 Island, by Otto W. Geist
Museum collection, 1931
University of Alaska Museum,
 1-1931-975

PICTOGRAPHIC ART About 200 years ago a new Alaskan art style—small pictorial engravings on ivory—appeared suddenly around Bering Strait. It consisted of small silhouette engravings that illustrated every aspect of Eskimo life: men in skin boats harpooning whales and walrus, caribou being shot with bow and arrow, men driving dog sleds, hunters creeping up on basking seals or spearing them at their breathing hole, masked men dancing, or men wrestling, running foot races, or fighting with bow and arrows. Many of the engravings show the Eskimo winter house with smoke rising from the roof, elevated caches, summer tents, fish drying on racks, and fish nets stretched out for drying. Those showing sailing vessels and Eskimo hunters with firearms can be dated after 1848, when the first American whaling vessel passed through Bering Strait.

Some of the engravings are supposed to represent hunting tallies—rows of caribou, seals, walrus, whales, bears, wolves, whale flukes or the stretched out skins of game animals—showing the number of animals a man had killed. The rows of animals often form undulating, rhythmical patterns, showing that the artist was concerned with achieving an aesthetic, ornamental effect as well as recording his prowess as a hunter (Nos. 120–127).

Sea monsters and other mythological creatures were among the forms of life depicted in the engravings. A hunting tally (No. 123) records not the number of whales or walrus a man had killed; it commemorates a more heroic feat, showing eight dead sea monsters, lying on their backs with their multiple legs in the air.

Alaskan pictorial art was narrowly restricted in its range. It was produced only at Bering Strait and the coastal areas immediately adjacent, from Norton Sound northward to Kotzebue Sound. It had its greatest vogue in the second half of the 19th century, after the arrival of American whalers in 1848. However, a few examples excavated from late Thule sites in the Canadian Arctic, and others from Thule-Punuk sites in Alaska, show that it was a truly aboriginal art style that originated around Bering Strait in late prehistoric times.

Five of the seven Alaskan pieces were excavated at the Thule-Punuk site, Kurigitavik, and another midden at Cape Prince of Wales, where a total of 126 decorated objects were found. These few realistic engravings from Wales and the geometric ornamentation with which they were associated provide, I believe, an answer to the question of the origin of Eskimo pictographic art.

The Wales engravings are quite simple; most of them were attached to a base line, others were free-standing. They were not engraved on drill bows but on a wrist guard, adz handle, blubber pounder, a two-pronged grass comb or shredder, and an unidentified object. The practice of engraving the designs on long objects such as drill bows and bag handles

19 ORNAMENTAL BAND
Walrus ivory
26.9 (10 19/32) LONG (approximately 1 cm. lost from excavated length by curvature due to drying)
Ipiutak
Excavated from burial in prehistoric village site at Ipiutak, near Point Hope, by Froelich Rainey, 1940
Museum collection, 1940
American Museum of Natural History, 60.1-7702

The most remarkable and most puzzling of all prehistoric Eskimo cultures is the Ipiutak, which flourished on the Arctic coast of Alaska around the 4th century A.D. Only a little later than Old Bering Sea, it was closely related to the latter, sharing its basic art motifs and many other features. Yet in other respects Ipiutak was quite different; it possessed a wealth of curious ivory carvings unknown to other Eskimos.

H. B. C.

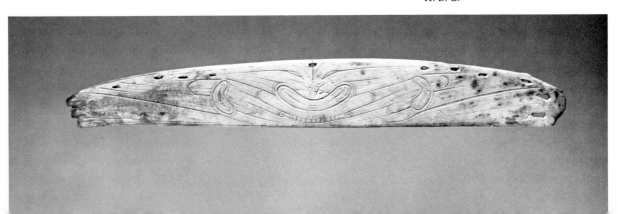

came later, probably in the 17th or 18th century. The prehistoric Wales engravings included the figure of a man standing with upraised arms, his torso a large crosshatched triangle; another man of the same shape stands with bow and arrows beside a caribou; four men in a umiak harpooning a whale; two men dancing; and in the most elaborate example, a man in a kayak with his upraised hands attached to a long border line, two polar bears whose legs are short vertical lines (spurs) attached to the same line, and two men in kayaks throwing bird spears at a loon. The simplicity of these few forms is in striking contrast to the complexity and variability of the geometric ornamentation on many other artifacts.

The relatively complex and highly variable geometric art at Wales, its mutability, and the tendency for the designs to take on the appearance of realistic art, seem to represent the late prehistoric formal background from which Eskimo pictorial art emerged. Examples are bold Y figures becoming thickened to look exactly like whale flukes, attached to a base line; smaller Y's with a dot at the top converting them into something like a simple schematic figure of a man with upraised arms; inverted triangles with a short line ending in a dot rising from the broad upper end and upraised projections like arms extending from the corners, giving the geometric motif a distinctly human form. Neatly incised hatchured triangles were a favorite motif, the larger ones having the exact shape of the hatchured triangles forming the torsos of some of the incised human figures.

A few other objects have triangular spurs rising from a base line along with carefully formed designs suggestive of houses and swimming birds. The two Wales sites represent a period within the time span of the Thule and Punuk cultures when non-representative art was highly variable and experimental. When we see that some of the strictly geometric motifs were altered in such a way as to suggest if not actually portray a life form, and when some of the actual pictographs have the shape of prevailing geometric elements, it seems probable that Eskimo pictographic art came into existence at this time, and in this area, as an outgrowth of geometric ornamentation.

Pictographic art epitomizes the history of the north Alaskan Eskimos during the 19th century—first the hunting of sea mammals with harpoons and caribou with bow and arrow, then the arrival of the white man in his three-masted ships, bringing firearms, then Lapp herders and domesticated reindeer. The pictorial record did not end here. In the last decades of the 19th century the engraved figures became thicker and heavier, a style that Dorothy Jean Ray, who has traced the development of Eskimo pictorial art, calls modified engraving style.[36]

In the 1890s the art underwent a more profound change. The figures, engraved mostly on cribbage boards and entire walrus tusks, became fully pictorial. Human figures, which had been shown earlier as no more than a line or a thickened body with straight lines for arms and legs were fully clothed fine line etchings of real Eskimos. Humans, animals, sea ice and landscapes were shown in perspective with delicate shading, representation of animals, ice floes, mountains and other land forms. While these

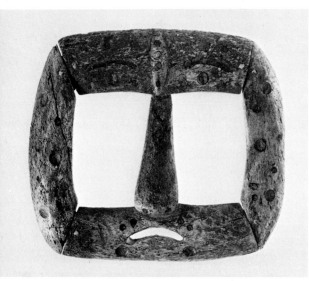

20 BURIAL MASK
Bone
13.8 (5 7/16) WIDE
Ipiutak
Discovered in prehistoric village site at
 Ipiutak, near Point Hope
National Museum of Man, Ottawa,
 IX-F-9913
Engraved with shallow cavities, this unpublished piece is simpler and more abstract in shape and decoration than its more elaborate related example, on permanent exhibition at the American Museum of Natural History (fig. b).

C. D. L.

scenes were being engraved on walrus ivory; similar scenes, far more complete in detail, were being produced in a wholly new medium—paper, pen and ink and watercolors provided by teachers in the newly-established government schools. While many of the ivory engravings of this period are to be found in museums and private collections, few of the water-color and pen and ink sketches have been preserved. George E. Phebus' recent book *Alaskan Eskimo Life in the 1890s as Sketched by Native Artists* (1972) describes the only known remaining collection of these watercolors and drawings, the last authentic, traditional works of art by the Alaskan Eskimos.

1. The Aleutian language is externally so different from Eskimo that for many years its relationship to the latter was not recognized. Later studies have shown however that Eskimo and Aleut are members of the same linguistic stock, now called Eskaleut. In physical type and culture the Aleuts' basic affinity with Eskimo is more readily apparent; they exhibit facial, cranial, and bodily characteristics that are essentially Eskimo, just as their skin boats, clothing, weapons and utensils correspond in a general way with those of other Eskimos.

2. The Kotzebue sequence did not depend on vertical stratigraphy, that is, cultural materials of different ages found superimposed in deep long-occupied middens as at Bering Strait, but on individual house ruins and camp sites scattered over the surface of a long succession of old beach ridges. The eight cultures found on the old beaches included two that were new to Eskimo archaeology—Choris, radiocarbon dated at 1000 B.C. and Old Whaling, 1800 B.C. The oldest culture on the Kotzebue beaches was the Denbigh Flint Complex (3000 B.C.), which Giddings had first discovered at Cape Denbigh on Norton Sound, and which is now generally regarded as a stage of culture directly ancestral to Eskimo. The older cultures of the Kotzebue sequence are of primary importance for Eskimo archaeology, but they left very little in the way of art.

3. Froelich G. Rainey, *Eskimo Prehistory: The Okvik Site on the Punuk Islands*, Anthropological Papers, American Museum of Natural History, 37, (New York, 1941), part 4. It has also been found at the oldest of five prehistoric sites at Gambell on the west end of St. Lawrence Island (Collins 1937), on Little Diomede Island in Bering Strait, at Point Hope on the Arctic coast (Larsen and Rainey 1948), and on the northeast coast of Siberia (Rudenko 1961; Aroutiounov and Sergheev 1969). A deeply patinated artifact with Okvik decoration found at an old site near Kuskokwim Bay could indicate the existence of the Okvik culture in southwest Alaska (Collins 1959).

4. Henry B. Collins, *Archaeology of St. Lawrence Island, Alaska*, Smithsonian Miscellaneous Collections, 96, (Washington, D.C., 1937), no. 1, pl. 12, 12; pl. 14, 3–5; p. 53; Rainey, *Eskimo Prehistory*, fig. 24, 5, 6; fig. 25, 1–4; S. A. Aroutiounov and D. A. Sergheev, *Ancient Culture of the Asiatic Eskimos*, (Moscow, 1969), (in Russian), figs. 98–100.

5. Rainey, *Eskimo Prehistory*, fig. 27; Henry B. Collins, "The Okvik Figurine: Madonna or Bear Mother?," *Folk, Dansk Etnografisk Tidsskrift*, 11–12, (Copenhagen, 1969/70), pp. 125–32.

6. Henry B. Collins, "The Arctic and Sub-Arctic," in *Prehistoric Man in the New World*, ed. Jesse D. Jennings and Edward Norbeck, (University of Chicago Press, 1964), pp. 85–114.

7. Collins, *St. Lawrence Island*. At the next oldest site, a large midden called Miyowagh, no examples of Okvik art were found. Of the seventy-two objects bearing Old Bering Sea decoration at Miyowagh almost half were OBS style II, the others being what I have called OBS style III. The stratigraphic evidence suggested but did not conclusively prove priority for style II. The assumption of an age difference rests mainly on stylistic evidence.

8. Collins, *St. Lawrence Island*.

9. The source of the metal was undoubtedly Siberia. Iron had been in use in China and central Asia for many centuries, and from references in Chinese literature it is known to have been in the possession of barbarian tribes of eastern Asia north of Korea in the second century A.D. There was thus ample opportunity for small quantities of iron to have reached Bering Strait a thousand years ago.

10. Henry B. Collins, "Eskimo Cultures," *Encyclopedia of World Art*, 5, (New York: McGraw-Hill Book Co. Inc., 1962), cols. 1–28.

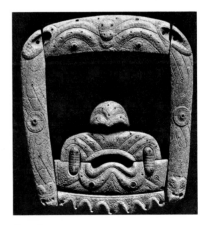

figure b

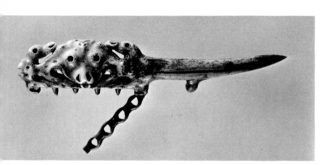

21 ORNAMENTAL COMB
Walrus ivory
26.4 (10 3/8) LONG
Ipiutak
Discovered at Point Spencer,
 Seward Peninsula
University of Alaska Museum,
 UA 72-49-1

Both the type of artifact and its
artistic style place it within the Ipiutak
phase of the Eskimo tradition—about
1600 years ago. The main figure is
that of a bear with its head between
its paws, although there are four sub-
sidiary visages, one of which may also
be a bear—looking at the main figure
upside down. The others are inter-
preted as seals. The use of this artifact
is unknown. Two others were found at
Point Hope, where the Ipiutak phase
was first discovered. These were simply
described as rakelike implements. Dr.
Helge Larsen of the Danish National
Museum has hypothesized that it is a
comb for use in cleaning a bear skin
preparatory to certain ceremonies.

Illustrated in color

11. Ford found that Birnirk had seventy-five traits in common with these cultures and only twelve with the geographically closer Ipiutak culture at Point Hope. As shown by its implement typology Birnirk was an outgrowth of Okvik-OBS, but the sequential development cannot be traced in detail. This probably occurred in northeastern Siberia where Okvik, OBS, and Birnirk materials are found in abundance.

12. Henry B. Collins, *Outline of Eskimo Prehistory*, Smithsonian Miscellaneous Collections, 100, (Washington, D.C., 1940), pp. 533–92.

13. Collins, *St. Lawrence Island*, pl. 15, 1; pl. 17, 3.

14. William E. Taylor, Jr., "Hypothesis on the Origin of the Canadian Thule Culture," *American Antiquity*, 28, no. 4, (1963), pp. 456–64.

15. J. Louis Giddings, *The Archaeology of Cape Denbigh*, (Providence: Brown University Press, 1964).

16. Giddings, *Cape Denbigh*, p. 118.

17. Helge Larsen and Froelich Rainey, *Ipiutak and the Arctic Whale Hunting Culture*, Anthropological Papers, American Museum of Natural History, 42, (New York, 1948), p. 162.

18. Basic differences between the two cultures are shown by the complete absence at Ipiutak of such typical western Eskimo features as rubbed slate implements, lamps, pottery, bow drills, and implements connected with whale hunting. However, the absence of these features at Ipiutak has no chronological significance, for an earlier stage of culture at Point Hope, called Near Ipiutak, had slate implements, lamps, pottery, and whaling harpoon heads. In one respect—its stone typology—Ipiutak is an example of a culture of no great antiquity that had perpetuated a much more ancient pattern of culture. Its chipped stone implements were undoubtedly derived from the 5000 year-old Denbigh Flint complex and are also very similar in form to those from early Neolithic sites around Lake Baikal in Siberia. Moreover, some of the most characteristic Ipiutak implements—side-bladed arrows and lances—are directly comparable to those of the Siberian Neolithic and European Mesolithic.

19. Larsen and Rainey, *Arctic Whale Hunting Culture*.

20. In addition to ivory eyes some of the Ipiutak burials had ivory nose plugs and mouth covers, a mortuary practice suggestive of the ancient Chinese custom of closing the body openings with plugs and covers of jade; some Siberian tribes had a similar custom (Larsen and Rainey 1948: 120, 158).

21. Larsen and Rainey, *Arctic Whale Hunting Culture*, pls. 54, 55.

22. Henry B. Collins, "Composite Masks: Chinese and Eskimo," *Anthropologica*, n.s., 11, nos. 1–2, (1971), pp. 271–78.

23. J. S. Aigner, "Bone Tools and Decorative Motifs from Chaluka, Umnak Island," *Arctic Anthropology*, 3, no. 2, (1966), pp. 57–83.

24. Frederica de Laguna, *The Archaeology of Cook Inlet, Alaska*, (Philadelphia: University Museum, 1934); Frederica de Laguna, *Chugach Prehistory: The Archaeology of Prince William Sound, Alaska*, (Seattle: University of Washington Press, 1956).

25. Robert F. Heizer, *Archaeology of the Uyak Site, Kodiak Island, Alaska*, Anthropological Records, University of Alaska, 17, (1956), no. 1.

26. Heizer, *Uyak Site*, fig. 31; Donald W. Clark, "Incised Figurine Tablets from Kodiak, Alaska," *Arctic Anthropology*, 2, (1964), no. 1, pp. 118–34.

27. E. L. Keithan, "About Slate Figurines," *American Antiquity*, 19, (1953), no. 1, p. 81; K. Birket-Smith, *Early Collections from the Pacific Eskimo*, Nationalmuseets Skrifter, Ethnografisk Raekke (Copenhagen), 1, (1941).

28. Heizer, *Uyak Site*, pl. 84, *b*, *e*.

29. William S. Laughlin and W. G. Reeder, eds., "Studies in Aleutian-Kodiak Prehistory, Ecology, and Anthropology," *Arctic Anthropology*, 3, (1966), no. 2, pp. 1–211.

30. George I. Quimby, "Periods of Prehistoric Art in the Aleutian Islands," *American Antiquity*, 11, (1945), no. 2, pp. 76–9; George I. Quimby, "Prehistoric Art of the Aleutian Islands," *Fieldiana: Anthropology*, 36, no. 4, (Chicago: Natural History Museum, 1948), pp. 77–92.

31. Aigner, "Bone Tools and Decorative Motifs."

32. E. W. Nelson, *The Eskimo About Bering Strait*, Smithsonian Institution, Bureau of American Ethnology, 18th Annual Report, (Washington, D.C., 1899).

33. James W. VanStone, "Masks of the Point Hope Eskimo," *Anthropos: International Review of Ethnology and Linguistics*, (Fribourg, Switzerland, 63/64, (1968/69), pp. 828–40.

34. Martin Sauer, *An Account of a Geographical and Astronomical Expedition to the Northern Parts of Russia . . . performed by Commodore Joseph Billings in the Years 1785–1794*, (London, 1802).

35. A. L. Pinart, *La Caverne d'Aknanh, Ile d'Ounga (Archipel Shumagin, Alaska)*, (Paris, 1875); William H. Dall, *On the Remains of Later Pre-Historic Man Obtained from Caves . . . of the Aleutian Islands*, Smithsonian Contributions to Knowledge, no. 318, (Washington, D.C., 1878).

36. Dorothy Jean Ray, *Graphic Arts of the Alaskan Eskimo*, Indian Arts and Crafts Board, U.S. Department of the Interior, (Washington, D.C., 1969).

22 TUBULAR ANIMAL HEAD
Antler bone with inlaid bead(?)
 forming one eye
38.9 (15 5/16) LONG
Ipiutak
Excavated from burial in prehistoric
 village at Ipiutak, near Point Hope,
 by Froelich Rainey, 1940
Museum collection, 1940
American Museum of Natural History,
 60.1-7453

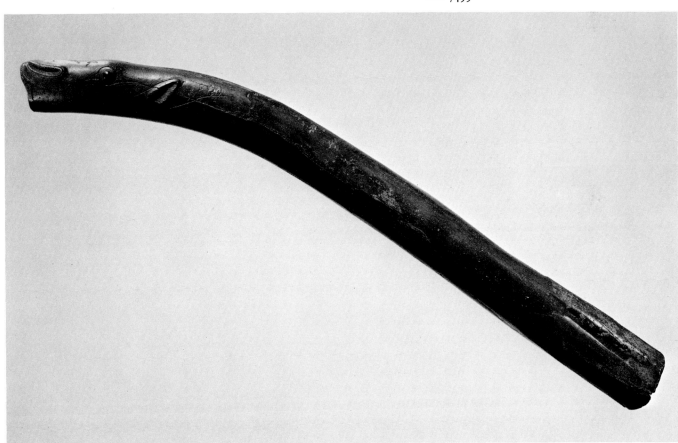

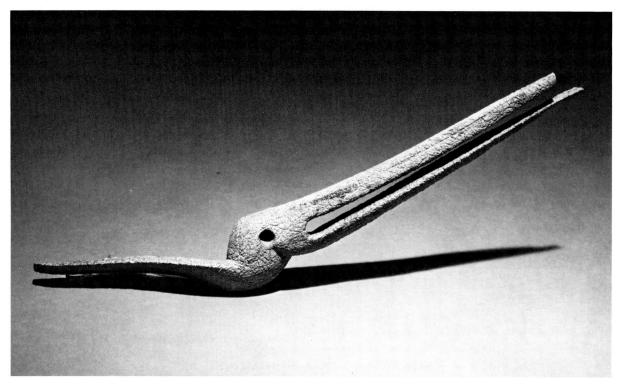

23 LOON'S HEAD
Walrus ivory
31.5 (12 3/8) LONG
Ipiutak
Excavated in phehistoric village site
 at Ipiutak, near Point Hope, by
 Froelich Rainey, 1945
Museum Expedition collection, 1945
American Museum of Natural History,
 60.2-3975

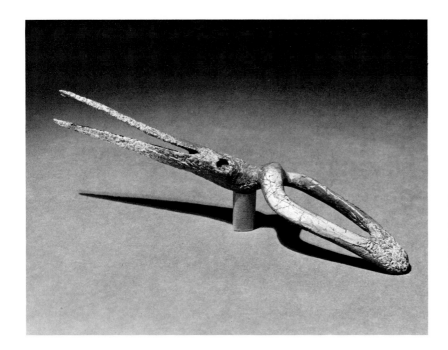

24 SPIRAL ORNAMENT WITH
 LOON'S HEAD
Walrus ivory
20.3 (8) LONG
Ipiutak
Excavated from prehistoric village site
 at Ipiutak, near Point Hope, by
 Froelich Rainey, 1940
Museum collection, 1940
American Museum of Natural History,
 60.1-7582

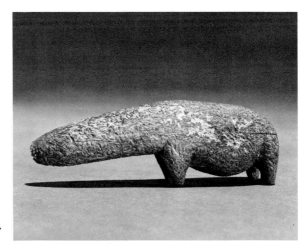

25 POLAR BEAR
Walrus ivory
13.1 (5 1/8) LONG
Ipiutak
Excavated from prehistoric village site
 at Ipiutak, near Point Hope, by
 Froelich Rainey, 1945
Museum Expedition collection, 1945
American Museum of Natural History,
 60.2-4293

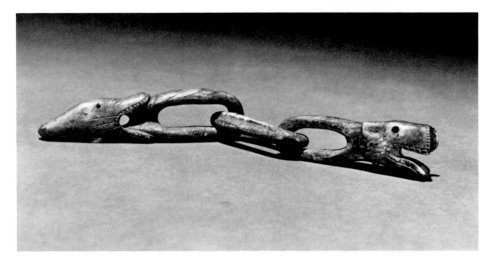

26 CHAIN WITH TWO
 ANIMAL HEADS
Walrus ivory
22.1 (8 11/16) LONG
Ipiutak
Excavated from prehistoric village site
 at Ipiutak, near Point Hope, by
 Froelich Rainey, 1940
Museum collection, 1940
American Museum of Natural History,
 60.1-7457

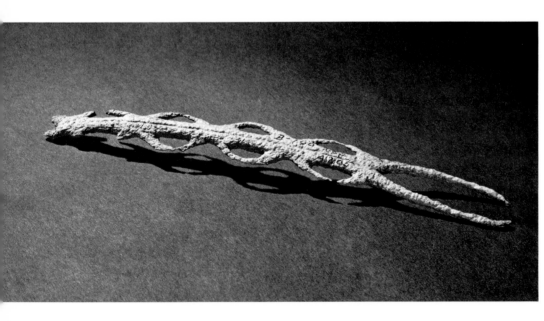

27 ORNAMENT
Walrus ivory or bone
24.7 (9 3/4) LONG
Ipiutak
Excavated from prehistoric village site
 at Ipiutak, near Point Hope, by
 Froelich Rainey, 1945
Museum Expedition collection, 1945
American Museum of Natural History,
 60.2-4205

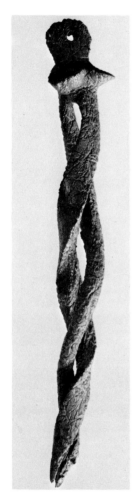

28 SPIRAL ORNAMENT WITH
 HEAD AT EITHER END
Walrus ivory
23.2 (9 1/8) LONG
Ipiutak
Excavated from prehistoric village site
 at Ipiutak, near Point Hope, by
 Froelich Rainey, 1945
Museum Expedition collection, 1945
American Museum of Natural History,
 60.2-4180

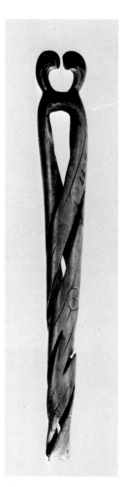

29 SPIRAL ORNAMENT WITH
 TWIN BIRDS' HEADS
Walrus ivory
18.1 (7 1/8) LONG
Ipiutak
Excavated from prehistoric village site
 at Ipiutak, near Point Hope, by
 Froelich Rainey, 1945
Museum Expedition collection, 1945
American Museum of Natural History,
 60.2-4177

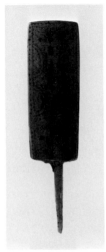

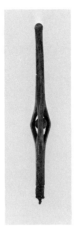

**30 ENGRAVED OBJECT
(COMB?)**
Walrus ivory with composite inlays
10.9 (4 9/32) LONG
Birnirk
Excavated from floor of entrance to
 House C, Mound A, Birnirk, by
 James A. Ford, 1957
Museum collection, 3 March 1958
Smithsonian Institution, 399 134

James A. Ford, *Eskimo Prehistory in the
 Vicinity of Point Barrow, Alaska,* 47, pt. 1,
 Anthropological Papers of the American
 Museum of Natural History, (New York,
 1959) fig. 104c.

31 ENGRAVING TOOL
Walrus ivory with iron point
9 (3 9/16) LONG
Thule-Punuk
Excavated from cut 5 at Kurigitavik,
 Cape Prince of Wales, by Henry B.
 Collins for the National Geographic
 Society, 1936
Gift to the Museum, 11 November
 1936
Smithsonian Institution, 393 598

Around a thousand years ago the rich
curvilinear art of the Old Bering Sea
culture was replaced by a simpler style,
the Punuk, which foreshadowed
modern Alaskan Eskimo art. The
Punuk culture was partly an outgrowth
of Old Bering Sea and partly the re-
sult of new influences from Siberia.
Iron, in very small quantities, reached
Bering Strait at this time, and was
used mainly as tips for engraving tools
like this example, a number of which
have been found at Punuk sites.

H. B. C.

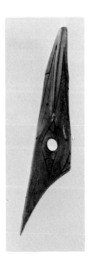

33 HARPOON HEAD
Walrus ivory
10.6 (4 9/32) LONG
Early Punuk
Excavated from lower half of second
 cut, South Midden, Cape Kialegak,
 St. Lawrence Island, by Henry B.
 Collins, 1929
Museum collection, 21 December 1929
Smithsonian Institution, 346 901

32 LARGE HARPOON HEAD
Walrus ivory
21.1 (8 5/16) LONG
Punuk
Excavated at Miyowaghameet, near
 Gambell, St. Lawrence Island, by
 Moreau B. Chambers, 1933
Museum collection, 4 December 1933
Smithsonian Institution, 371 846

Punuk art bears witness to the new
engraving technique. Its lines are
deeply and evenly incised, and the
circles, unlike the freehand circles and
ellipses of Old Bering Sea, were
mechanically perfect, made with metal
bits or compasses (see Nos. 33 and
34). In its later stages, Punuk art
became more rigid, consisting mainly
of bands of straight lines, spurred lines,
circles, and bold Y figures (see Nos.
35, 36 and 38), closely resembling the
incised ornamentation of the modern
Bering Sea Eskimos.

Collins, *Archaeology of St. Lawrence Island*,
 pl. 72.
H. B. C.

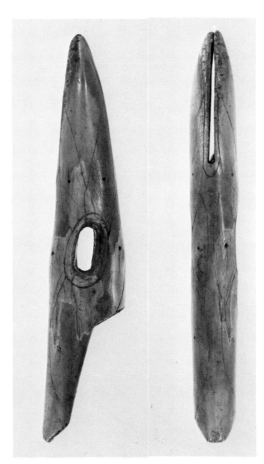

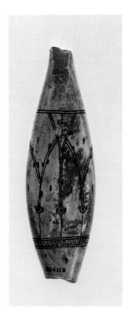

34 FISH-LINE SINKER
Walrus ivory
12.1 (4 13/16) LONG (both ends
 broken off)
Punuk
Collected near Savoonga, St. Lawrence
 Island
Museum purchase (in Seattle), 4 May
 1932
Smithsonian Institution, 364 113

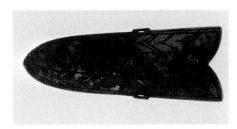

35 WRIST GUARD
Walrus ivory
10.8 (4 1/4) LONG
Punuk
Collected near Savoonga, St. Lawrence
 Island
Museum purchase (in Seattle), 4 May
 1932
Smithsonian Institution, 364 055

36 WRIST GUARD
Walrus ivory
10 (3 15/16) LONG
Punuk
Excavated from old village at Gambell,
 St. Lawrence Island, by Henry B.
 Collins, 1928
Museum collection (by transfer from
 the Bureau of American Ethnology),
 8 January 1929
Smithsonian Institution, 342 744

Henry B. Collins, *Smithsonian Museum
 Calendar*, 81, (1929), no. 14.

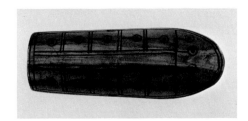

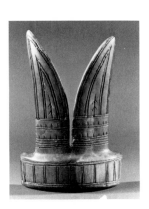

37 WRIST GUARD
Walrus ivory
7.6 (3) LONG
Punuk
Collected on St. Lawrence Island, by
 Otto W. Geist, 1926
University of Alaska Museum,
 1-1926-603

This is a good example of a middle
Punuk wrist guard. The ornamentation
is typically Punuk; deep incision of
paired lines, some straight, some curv-
ing with an overall spare feeling. The
two flanges of the guard place the
specimen in the middle part of the
Punuk period, i.e., about 900 A.D.

J. C.

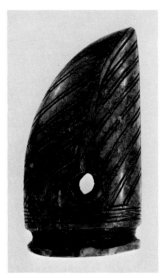

38 ENGRAVED OBJECT
Walrus ivory
11.9 (4 11/16) LONG
Punuk
Collected by Aleš Hrdlička
Transfer, 7 November 1929
Smithsonian Institution, 349 502

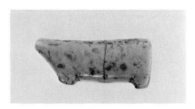

42 CARVING OF A BEAR
Walrus ivory
6.2 (2 7/16) LONG
Kodiak
Excavated from site at Jones Point,
 Uyak Bay, Kodiak Island, by Aleš
 Hrdlička, 1932
Museum collection, 3 December 1932
Smithsonian Institution, 365 585

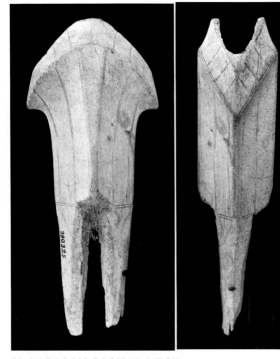

39 HARPOON SOCKET PIECE
Bone
16.7 (6 9/16) LONG
Excavated from "low site," Agattu
 Island, western Aleutians, by Aleš
 Hrdlička, 1937
Museum collection, 6 October 1937
Smithsonian Institution, 390 325

Prehistoric Eskimo and Aleutian
culture in South Alaska, while basi-
cally similar to northern Eskimo,
differed from it in many ways. Features
of prehistoric and modern South
Alaskan culture that set it apart from
the northern Eskimo pattern include
large round and oval stone lamps,
whaling with poisoned lance, prev-
alence of barbed darts over toggle
harpoon heads, composite fish hooks
and grooved stone sinkers, specialized
forms of slate blades, emphasis on
decoration of clothing and the person,
high development of woodworking,
painting, and especially of weaving.

 The early Aleuts, unlike the north-
ern Eskimos, rarely decorated their
bone and ivory artifacts. Incised art
consisted of vertical arrangements of
X's, short cross lines and slanting lines.
Other design elements were nucleated
circles and bands of long closely
spaced vertical lines as in No. 39.
Lances and darts were multibarbed and
elaborate in form (No. 40).

H. B. C.

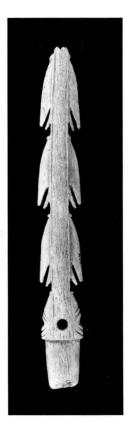

40 BARBED DART
Bone
18.2 (7 1/8) LONG
Collected on Amaknak Island, off the
 northeast coast of Unalaska, Fox
 Islands, by Aleš Hrdlička, 1937
Museum collection, 6 October 1937
Smithsonian Institution, 389 967

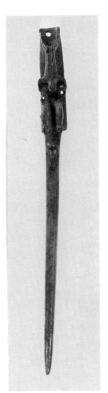

41 PENDANT ORNAMENT
 OR PIN
Walrus ivory
18.2 (7 1/8) LONG
Collected from an ancient village site
 near Dutch Harbor, Unalaska, Fox
 Islands, by Mr. and Mrs. R. W.
 Kenton
Gift to the Museum, 7 December 1940
Smithsonian Institution, 382 149

This piece depicts two seals and a
human figure.

43 OIL LAMP
Stone
21.9 (8 5/8) LONG
Collected at old village site, Korovin
 Bay, Atka Island, 1864
Gift of Mrs. Maria G. Bowman,
 18 October 1944
Smithsonian Institution, 387 644

Handsomely carved and decorated
stone lamps were one of the most
characteristic features of prehistoric
Kodiak culture. The early Kodiak
Eskimos also excelled in bone and
ivory sculpture. Their work ranged
from the abstract, as in a small
featureless ivory bear (No. 42) to
portraitlike representations of the
human face (No. 46).

H. B. C.

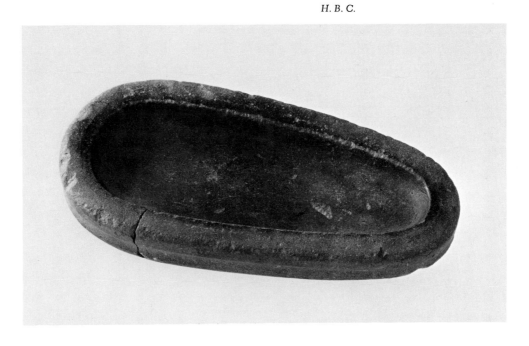

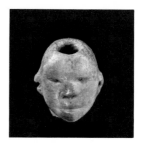

46 CARVED HUMAN FACE
Walrus ivory
3.4 (1 11/32) HIGH
Kodiak
Excavated from site at Jones Point,
 Uyak Bay, Kodiak Island, by Aleš
 Hrdlička, 1932
Museum collection, 3 December 1932
Smithsonian Institution, 365 583

44 OIL LAMP
Stone
22.9 (9) LONG
Kodiak
Excavated from prehistoric village site,
 Jones Point, Uyak Bay, Kodiak Island,
 by Aleš Hrdlička, 1934
Museum collection, 29 January 1935
Smithsonian Institution, 377 861

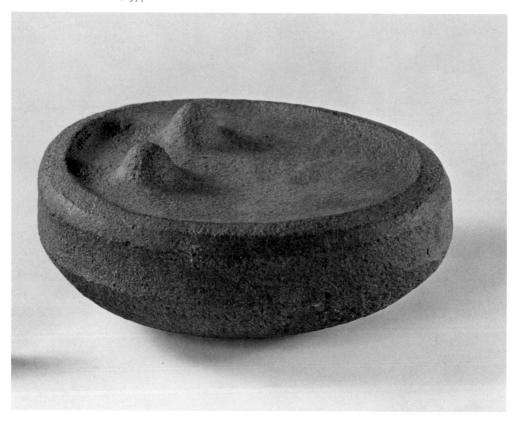

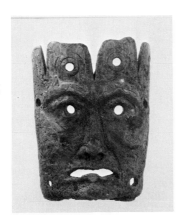

47 COSTUME ORNAMENT IN THE
FORM OF A HUMAN HEAD
Walrus ivory
8.4 (3 5/16) HIGH
Kodiak
Excavated from site at Jones Point,
Uyak Bay, Kodiak Island, by Museum
 Expedition, 1931
Museum collection, 11 December 1931
Smithsonian Institution, 363 740

45 OIL LAMP WITH
 HUMAN FIGURE
Stone
42 (16 1/2) LONG
Cook Inlet (or Kodiak?)
Museum of the American Indian,
 Heye Foundation, 4/9236

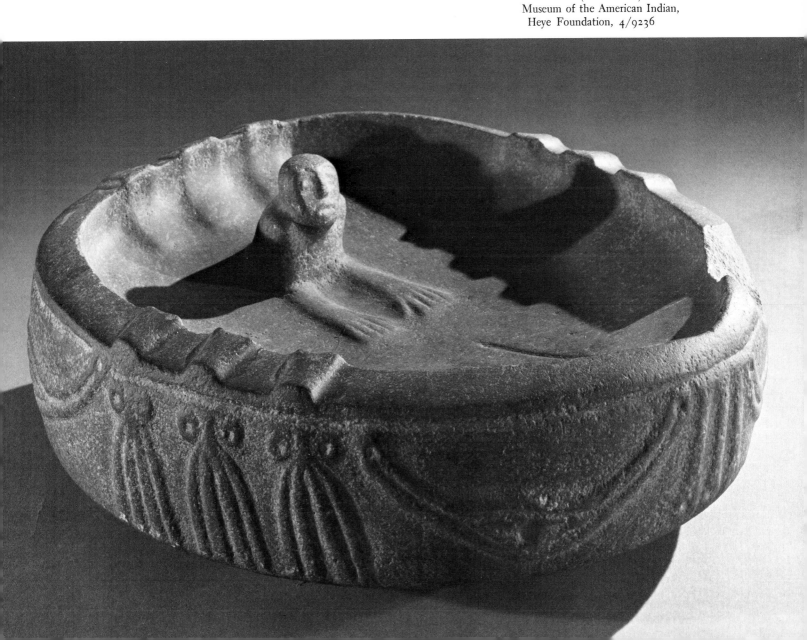

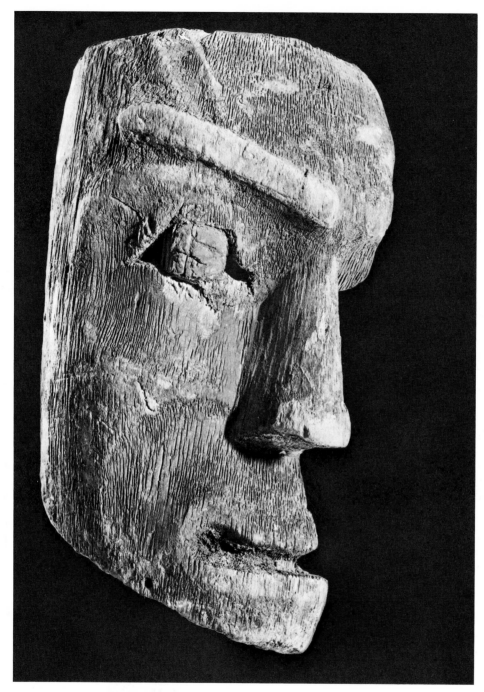

48 HUMAN MASK*
Wood
32 (12 5/8) HIGH
Aleutian Islands
Rautenstrauch-Joest-Museum, Cologne,
 49828

not in exhibition

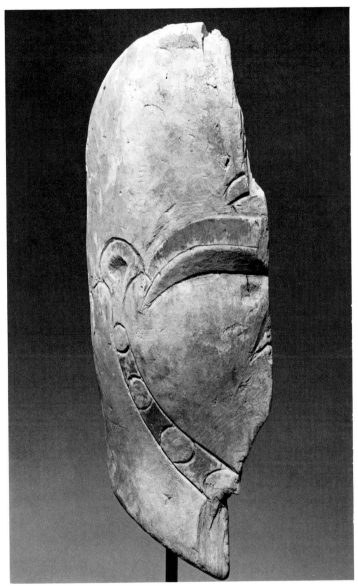

49 HUMAN MASK*
Wood, with purple-red, green, and
 black pigment
28.6 (11 1/4) HIGH
Found in an archaeological deposit
 (presumably on a cave floor), Delarof
 Harbor, Unga Island, Shumagin group
Smithsonian Institution, 13 002

This fragment, one of the rare ex-
amples known to survive with its pig-
mentation unchanged, reveals the
delicate but extensive coloring of these
early masks. It is interesting to com-
pare the detail of the preserved facial
tattoo, perhaps representing an octopus
tentacle, with the similar motif on No.
296; traces of comparable incised
decorations, though now lacking their
color, are visible on the two following
fragments.

C. D. L.

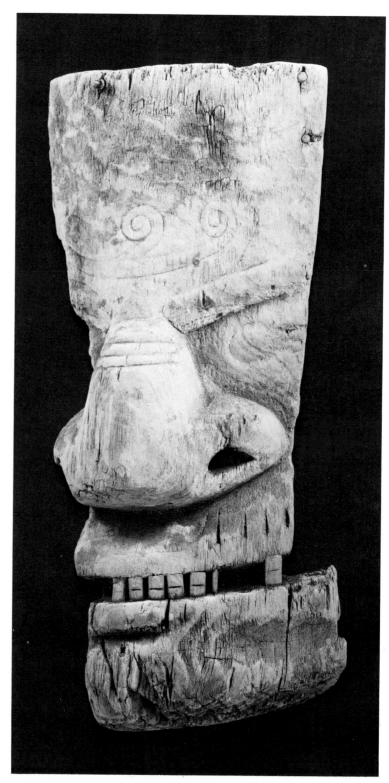

50 HUMAN MASK*
Wood, formerly inset with hair
 moustache; stained with modern
 preservative
34 (13 3/8) HIGH
Found in an archaeological deposit
 (presumably on a cave floor), Delarof
 Harbor, Unga Island, Shumagin
 group
Smithsonian Institution, 13 082

51 HUMAN MASK*
Wood, with traces of pigment; stained
 with modern preservative
30.5 (12) HIGH
Found in an archaeological deposit
 (presumably on a cave floor) Delarof
 Harbor, Unga Island, Shumagin group
Smithsonian Institution, 13 082

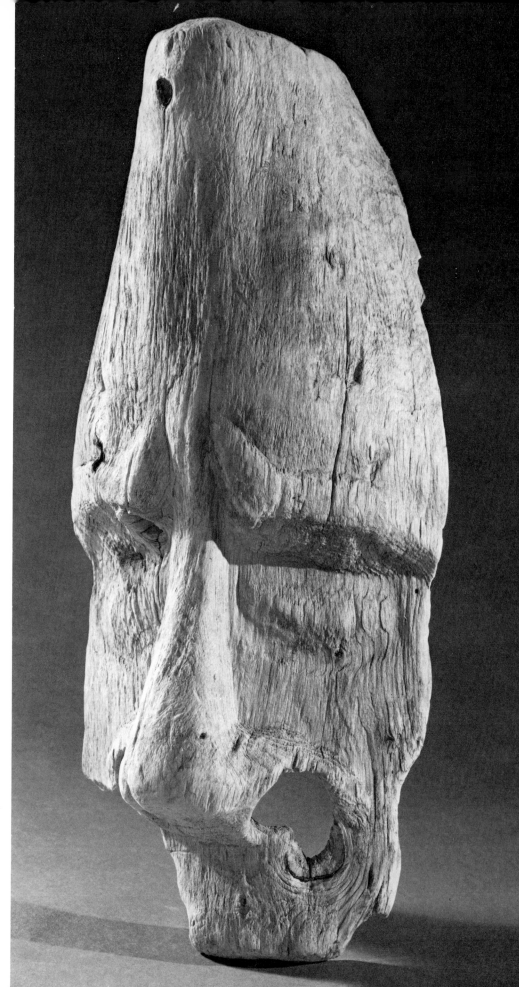

52 HUMAN MASK*
Wood
50.1 (19 3/4) HIGH
Discovered in prehistoric cave on
Tigalda Island, Krenitzin Islands,
Aleutians, by Harley Stamp
Museum of the American Indian,
Heye Foundation, 7/5905

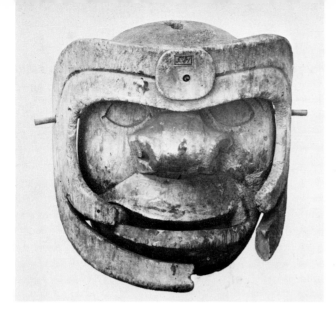

figure c

53 HUMAN MASK
Wood
31 (12 1/4) HIGH
Collected at Atka, Andreanof Islands,
 by Capt. I. Archimandritov, Imperial
 Russian Navy, 1840
Museum of Anthropology and
 Ethnography, Leningrad, 538.2

The pegs around the chin of this mask
presumably helped support a helmet-
like visor, similar to the one preserved
on its companion example, No. 538.1
in the same Museum (fig. c).

C. D. L.

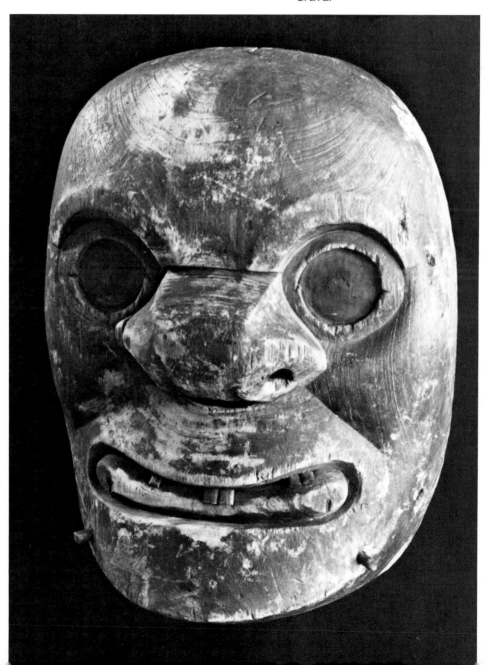

54 HUMAN MASK
Wood
31.7 (12 1/2) HIGH
Possibly Kodiak?
Presumably collected by Rev. Sheldon
 Jackson in the late 19th century
Sheldon Jackson Museum, III.X.16

This expressive mask, similar in its traces of fire damage, breakage, and surface erosion to prehistoric Aleut masks found in the lower Aleutian chain, also bears similarities to masks produced more recently on nearby Kodiak Island, principally by the Koniag Eskimo. The characteristic forms of its eyebrow ridges, especially, seem transitional between the prehistoric example from Cologne (No. 48), and the more rigidly stylized Smithsonian example (No. 141).

C. D. L.

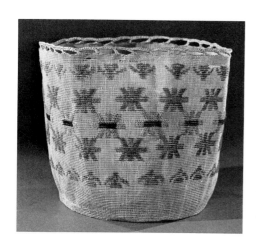

55 LARGE OPEN BASKET
Wild rye, colored yarns
26 (10 1/4) HIGH
Aleutian Islands, probably Attu;
 Emmons Collection?
Alaska State Museum, II-F-84
Illustrated in color

57 COVERED ATTU BASKET
Wild rye, with decorations overlaid in
 silk floss
12 (4 3/4) HIGH
Woven at Atka by Agrafania Zoachny,
 the Attu wife of the chief, 1915;
 Ella D. Smith Collection
Museum purchase, Rauch Fund
Alaska State Museum, II-F-138

This basket presents a striking example
of the fine weaving characteristic of
the women of Attu.

C. D. L.

56 COVERED ATTU BASKET
Beach grass (?), with designs over-
 laid in dyed wool; metal rattle
17 (6 3/4) HIGH
Near Islands, probably Attu or Agattu,
Aleutian Islands
Collected by Mrs. Mary A.
 Frothingham, 1908
Peabody Museum, Harvard University,
 45-20-10/27656

The rattle is woven into the pro-
truding handle on the cover, and
sounds when the basket is opened.

C. D. L.

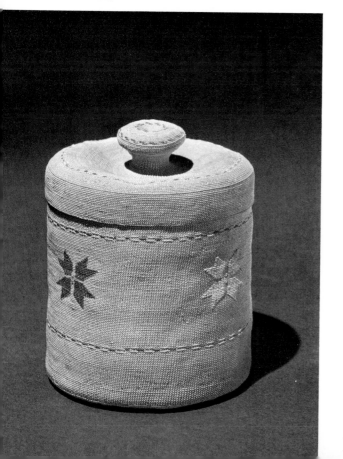

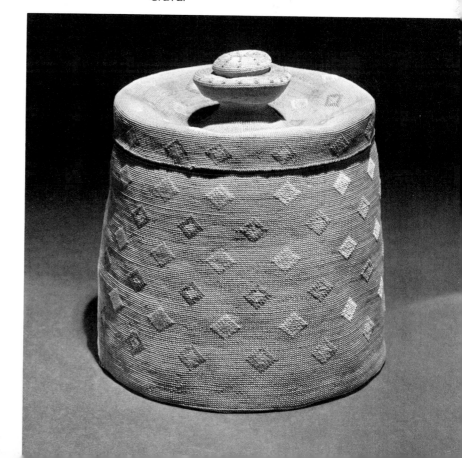

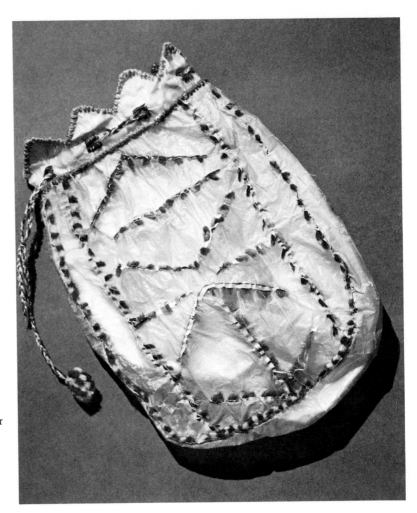

59 BAG WITH DRAWSTRING
Walrus intestines, dyed skin strips,
 colored yarns, eagle down, sewn over
 white trade cloth lining
19 (7 1/2) HIGH
Probably collected by Rev. Sheldon
 Jackson in the late 19th century
Sheldon Jackson Museum, II.X.6
 (cataloged as Eskimo)

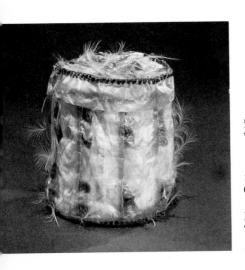

58 COVERED CONTAINER
Walrus intestines, colored yarns, eagle
 down, with white trade cloth sewn as
 support
14 (5 1/2) HIGH
Collected at Akutan, Krenitzin Islands,
 by Comdr. Ralph Burns, 1949
Loaned by Aileen Jones
Tongass Historical Society, AJ x 67
Illustrated in color

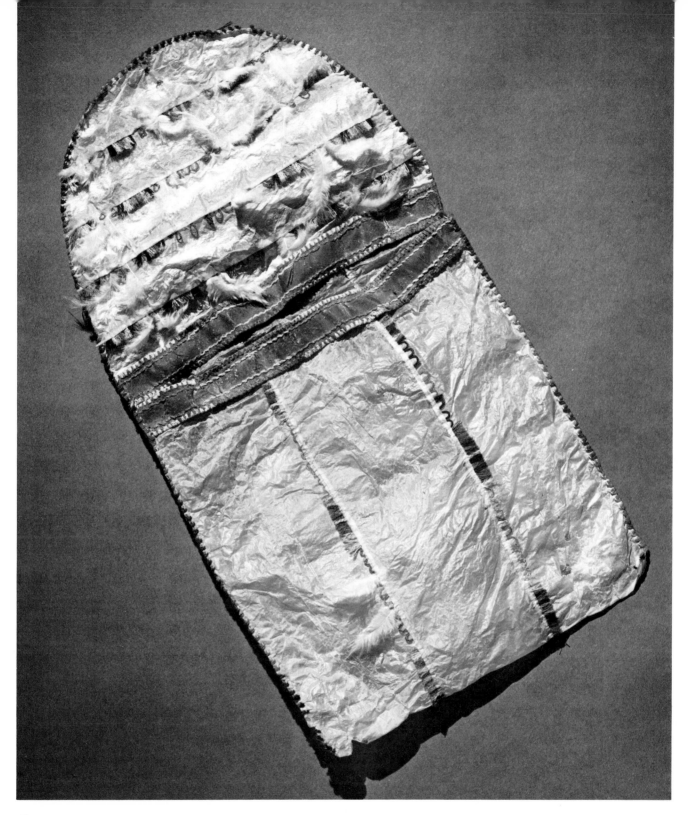

60 BAG WITH DECORATED
 FLAP
Walrus and seal intestines, dyed skin,
 colored yarns, and eagle down
38.1 (15) HIGH WITH FLAP OPEN
Probably collected by Rev. Sheldon
 Jackson in the late 19th century
Sheldon Jackson Museum, III.B.3

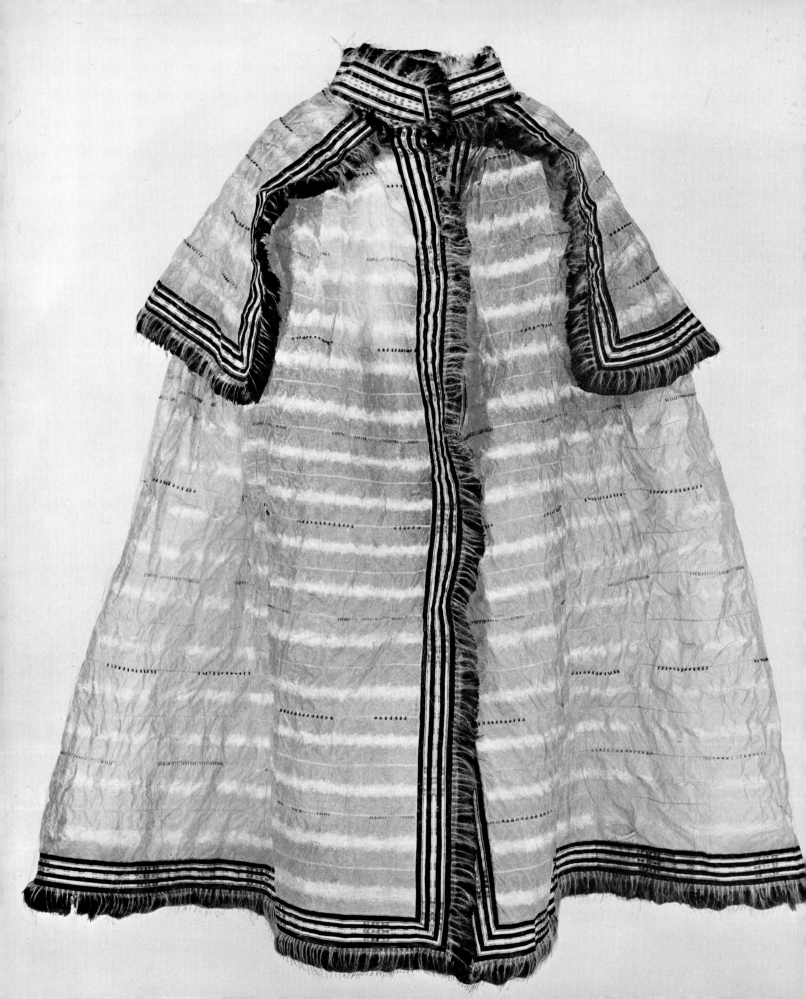

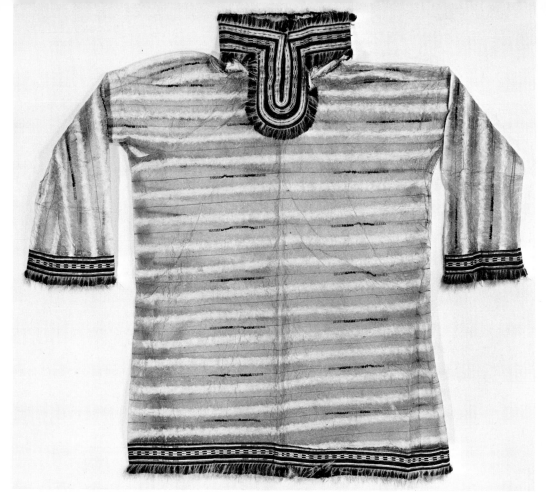

61 WATERPROOF
 OVERGARMENT
Walrus intestines, gut and skin strips,
 white thread, colored yarn, cormorant
 feathers, and eagle down
125 (49 1/4) HIGH
Collected in the Pribilof Islands by
 Arvid Adolph Etholén of Finland,
 Rear Admiral in the Imperial Russian
 Navy, and Administrator of Russian
 America, before 1847
National Museum of Finland, 275

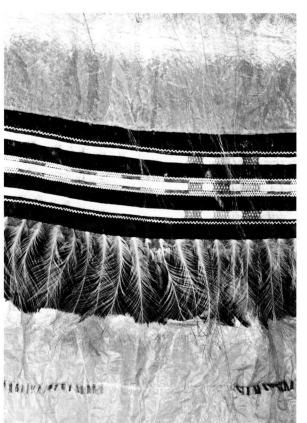

62 WATERPROOF CAPE
Walrus intestines, gut and skin strips,
 white thread, colored yarn, cormorant
 feathers, eagle down, and plumes of
 white hair
141 (55 1/2) HIGH
Collected in the Pribilof Islands by
 Arvid Adolph Etholén of Finland,
 Rear Admiral in the Imperial Russian
 Navy, and Administrator of Russian
 America, before 1847
National Museum of Finland, 283

Perhaps produced to Etholén's com-
mission, this form of cape with over-
mantle and decorated collar, edges,
and hem, reflects the design of Russian
garments of the period.

C. D. L.

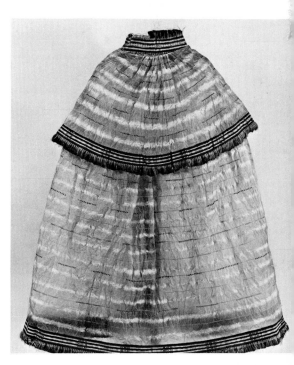

63 HUNTING HAT
Wood, pigment, ivory ornaments, sea
 lion whiskers, feathers, and trade
 beads
43.5 (7 1/8) LONG
Aleutian Islands or Kodiak, collected
 by Andrei Khlebnikov, c. 1810
Museum of Anthropology and
 Ethnography, Leningrad, 563.1

64 HUNTING HAT
Wood, pigment, ivory ornaments, sea
lion whiskers, and trade beads
38 (15) LONG
Aleutian Islands or Kodiak
Museum of Anthropology and
Ethnography, Leningrad, 4104.7

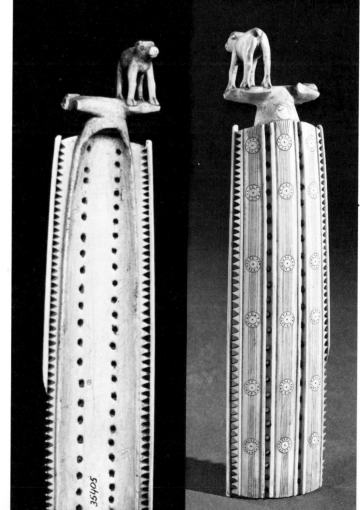

**65 WHISKER-HOLDER
DECORATION FROM THE
BACK OF A HUNTING HAT**
Engraved walrus ivory, with black and
red pigment
24.8 (9 3/4) HIGH
Aleutian Islands
Museum voor Land- en Volkenkunde,
Rotterdam, 35405

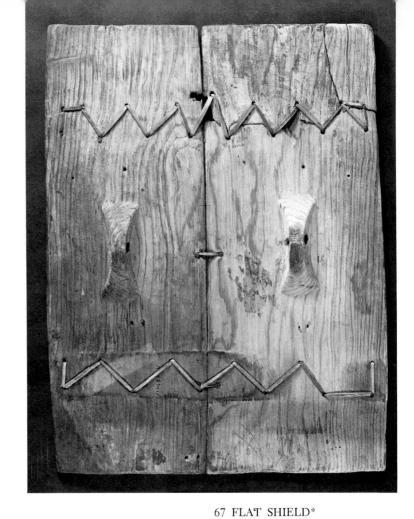

67 FLAT SHIELD*
Wood (stained with modern preserva-
tive), with pigment (retraced),
modern rawhide lashings
69 (27 3/16) HIGH
Collected on Kagamil Island, Islands of
the Four Mountains, by Aleš
Hrdlička, 1937
Museum collection, 6 October 1937
Smithsonian Institution, 389 861

**66 VOLUTE DECORATION
FROM THE SIDE OF A
HUNTING HAT**
Engraved walrus ivory, with black and
red pigment
16.2 (6 3/8) HIGH
Aleutian Islands
Museum voor Land- en Volkenkunde,
Rotterdam, 34866

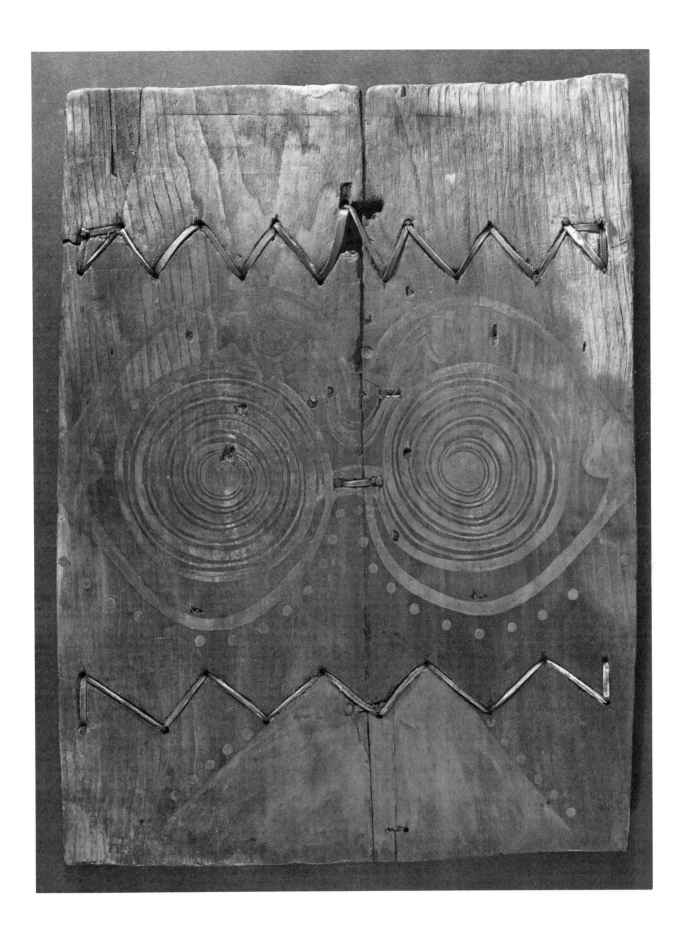

68 THREE-MAN BIDARKA*
Wood, sealskin, gut, with colored
 yarns and trade beads
51.4 (20 1/4) LONG
Collected on Kodiak Island by
 W. H. Dall
Museum collection, 28 December 1874
Smithsonian Institution, 16 275

Examples of the arrow or spear case
lashed to the side of this bidarka, and
the seal decoy helmet worn by its cen-
tral figure, may be seen in the follow-
ing two entries; the gut parkas worn
by the sailors are paralleled by No. 82.
C. D. L.

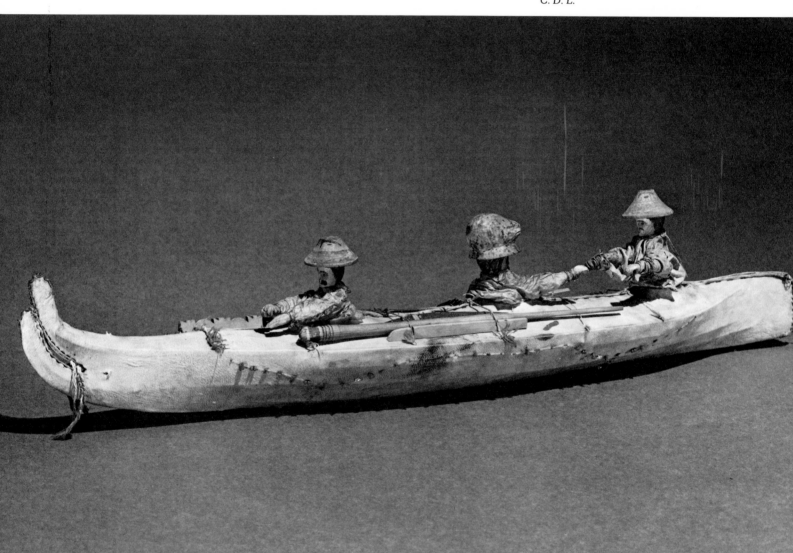

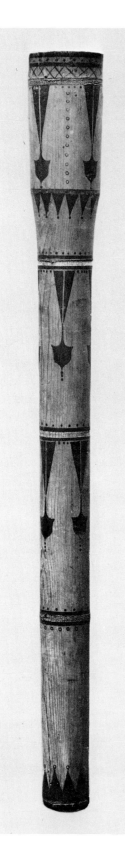

69 ARROW CASE
Wood, with red and black pigment
 bound with woven string
93.6 (36 7/8) LONG
Collected on Kodiak Island by H. J.
 Holmberg of Finland, 1851
Danish National Museum, 1.B.174

70 SEAL DECOY HELMET
Wood, with white, red, and black
 pigment, rawhide chin strap
25.4 (10) LONG
Collected on Kodiak Island by Edward
 G. Fast, 1867–68
Museum purchase, 1869
Peabody Museum, Harvard University
69-30-10/64700

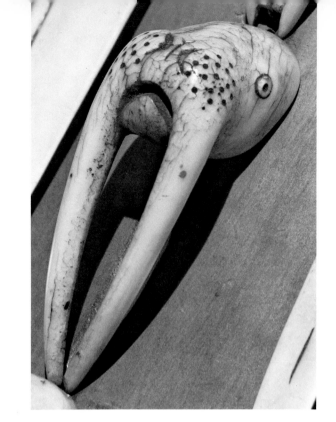

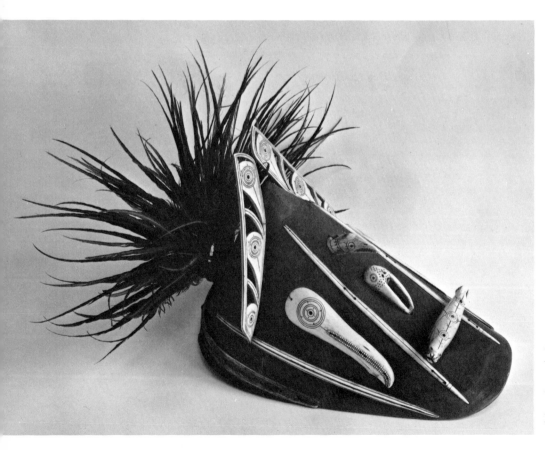

71 HUNTING HAT
Wood, ivory, cormorant feathers
37 (14 1/2) LONG
Collected on St. Lawrence Island by
 Ilia G. Vosnesenski, 1843
Museum of Anthropology and
 Ethnography, Leningrad, 593.51

72 HUNTING HAT
Wood, ivory
33 (13) LONG
Collected on Norton Sound by
 François Mercier, 1886
National Museum of Man, Ottawa,
 IV.E.92

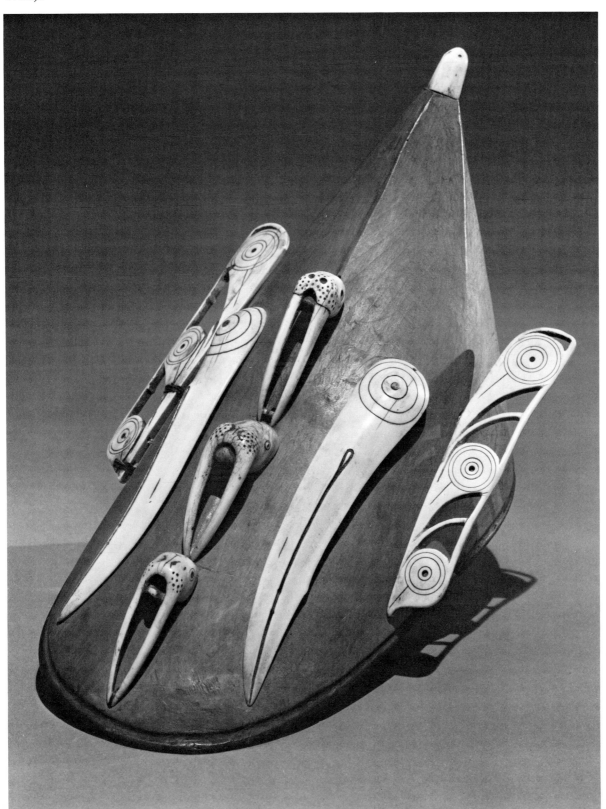

73 HUNTING HAT
Wood, with traces of white pigment,
ivory, braided fiber, buckskin straps
35 (13 3/4) LONG
Collected on the Lower Kuskokwim
River by Rev. Sheldon Jackson in the
late 19th century
Sheldon Jackson Museum, II.S.34

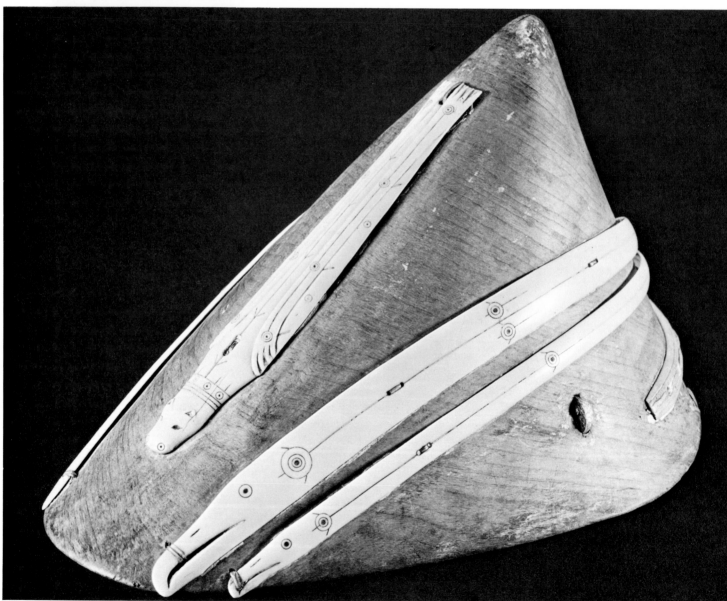

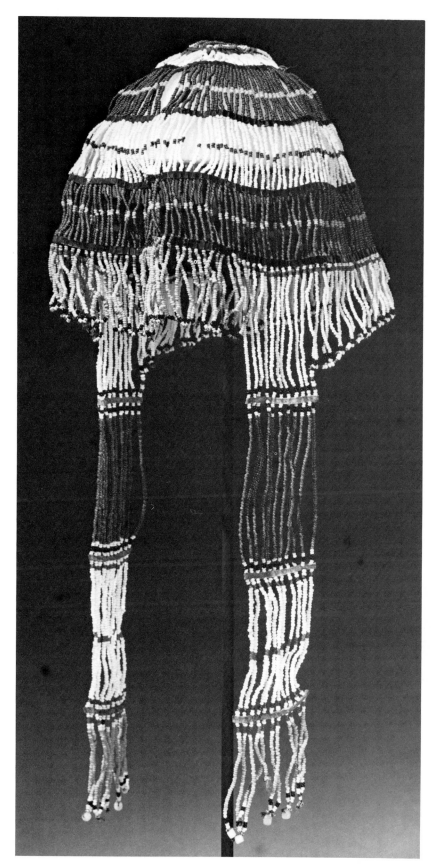

74 BEAD CAP WITH PENDANT
 SIDES
Dyed skin, twine, and trade beads
42 (16 1/2) HIGH
Collected at Akiak, on the Lower
 Kuskokwim River
Gift of Mrs. Cecelia Thiele
Alaska State Museum, II-A-1428

76 COSTUME ORNAMENT*
Engraved ivory, black pigment
6.7 (2 5/8) LONG
Collected at Kongiganak, on
 Kuskokwim Bay, by E. W. Nelson
Smithsonian Institution, 37 745

Bureau of American Ethnology, 18th Annual
 Report, (1899) part I, pl. XXV-2, p. 68.

75 BEAD NECKLACE
Trade beads braided over fiber (?)
 and fabric core
55.2 (21 3/4) LONG
Collected at Kutmiut, Scammon Bay,
 by William J. Fisher
Smithsonian Institution, 72 485

Collected as a component part of a
larger headdress, now dispersed.

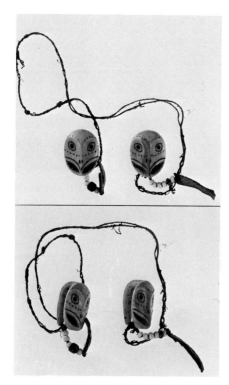

77 PAIR OF EAR ORNAMENTS
 CONNECTED BY CHIN
 STRAP*
Engraved ivory, with red and black
 pigment, braided fiber, and trade
 beads
Each component 2 (3/4) HIGH;
 total 30 (11 3/4) LONG
Collected at Kaialigumiut, on the
 Manopiknak River (Hazen Bay),
 Yukon Delta, by E. W. Nelson
Smithsonian Institution, 37 261

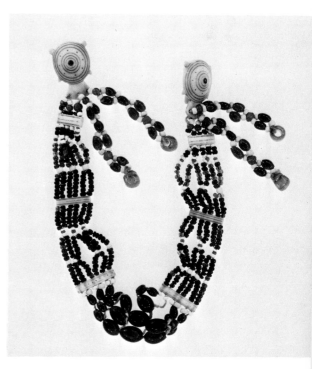

78 PAIR OF EAR ORNAMENTS
 CONNECTED BY NECKLACE
Engraved ivory, with black and red
 pigment, inlaid with metal, twine,
 and trade beads
Each component 3 (1 3/16) HIGH;
 total 33 (13) LONG
Collected on Nunivak Island by Henry
 B. Collins and T. D. Stewart, 1927
Museum collection, 29 November 1927
Smithsonian Institution, 340 332

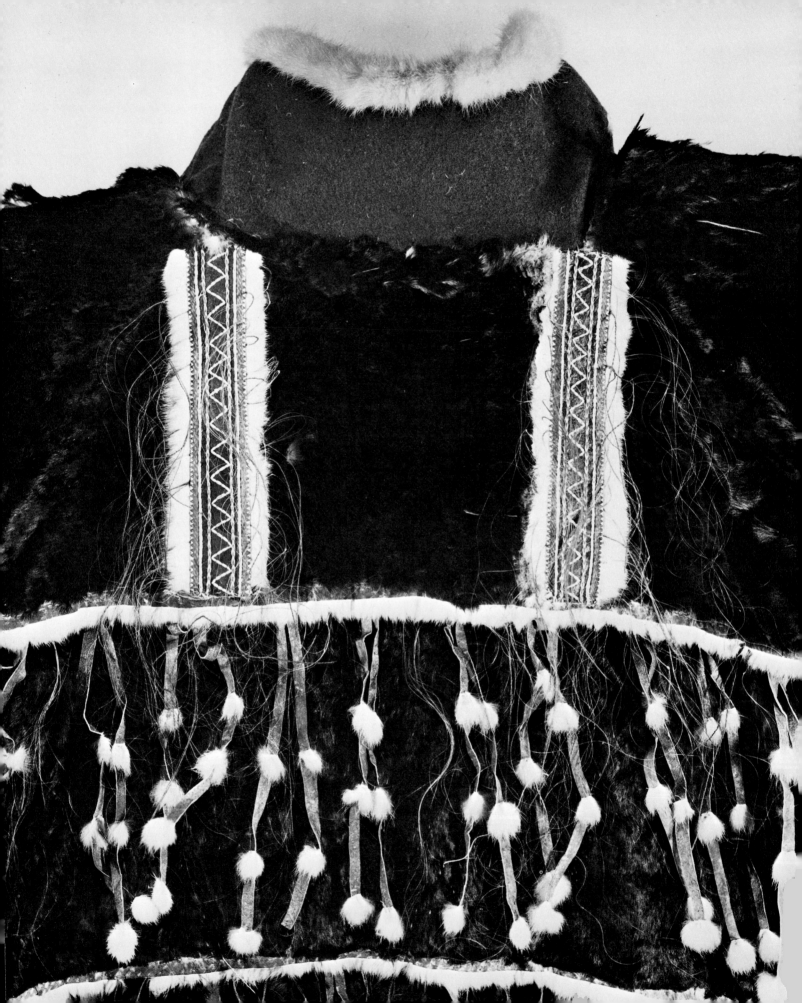

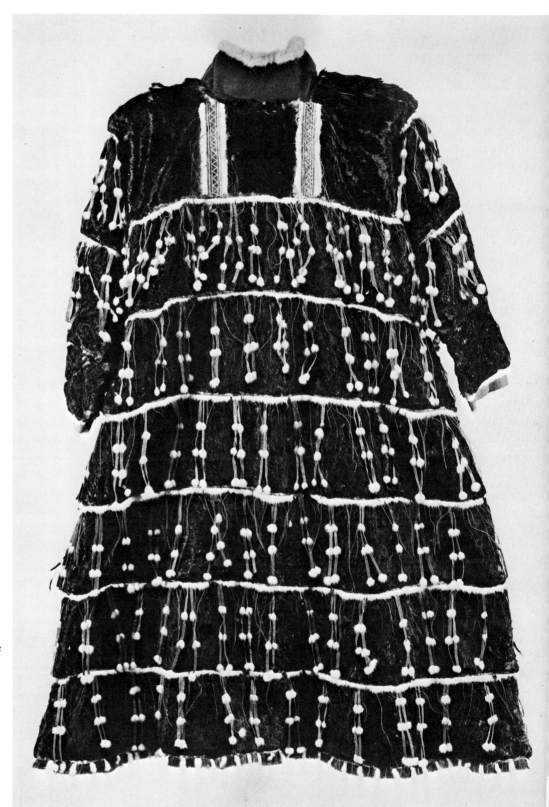

79 SHORT-SLEEVED GOWN
Cormorant skins and down strips,
 down collar and tufts, bearskin hem,
 skin strips, red and black trade felt,
 red and white thread, and white trade
 cotton lining
151 (59 1/2) WIDE
Collected from the Koniag Eskimo on
 Kodiak Island by Arvid Adolph
 Etholén of Finland, Rear Admiral in
 the Imperial Russian Navy, and Ad-
 ministrator of Russian America,
 before 1847
National Museum of Finland, 81

80 SHORT-SLEEVED GOWN
Puffin skins
124.5 (49) HIGH
Collected from the Koniag Eskimo on
 Kodiak Island by Arvid Adolph
 Etholén of Finland, Rear Admiral in
 the Imperial Russian Navy, and
 Administrator of Russian America,
 before 1847
National Museum of Finland, 85

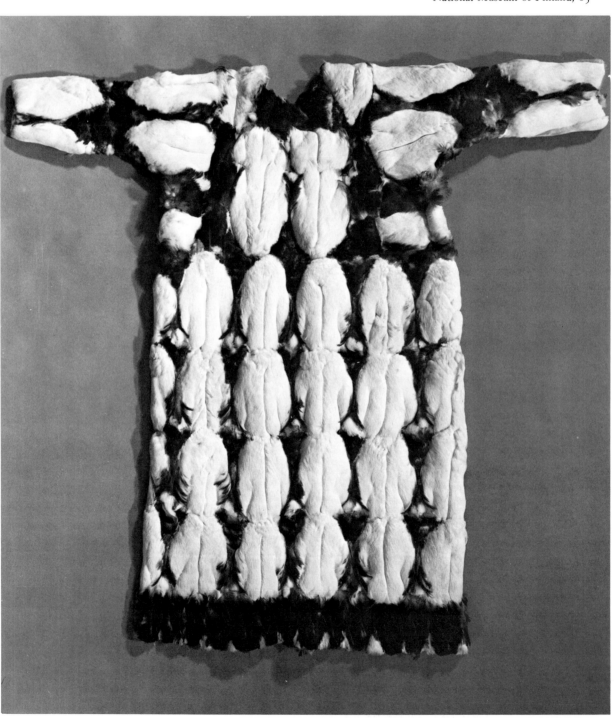

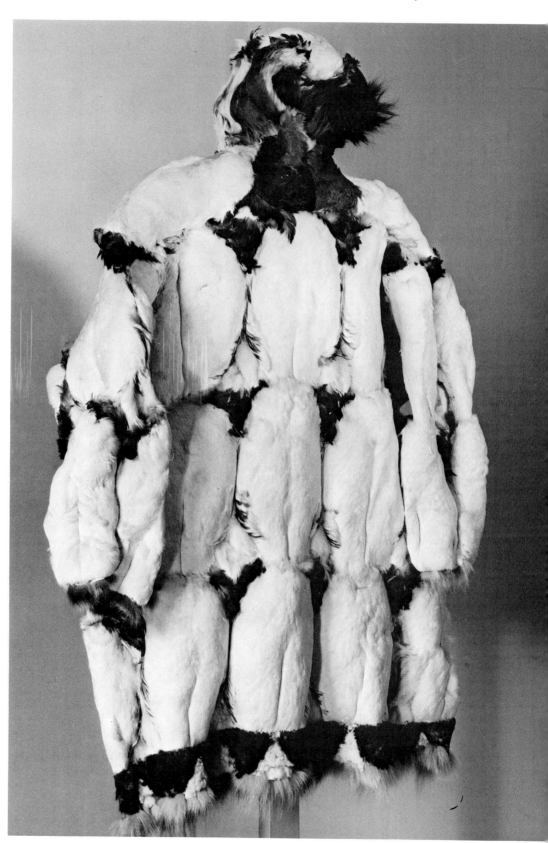

81 HOODED PARKA*
Puffin skins, light and dark red fox fur
110.5 (43 1/2) HIGH
Southwestern Alaska
Deutsches Ledermuseum,
 Offenbach, 1392

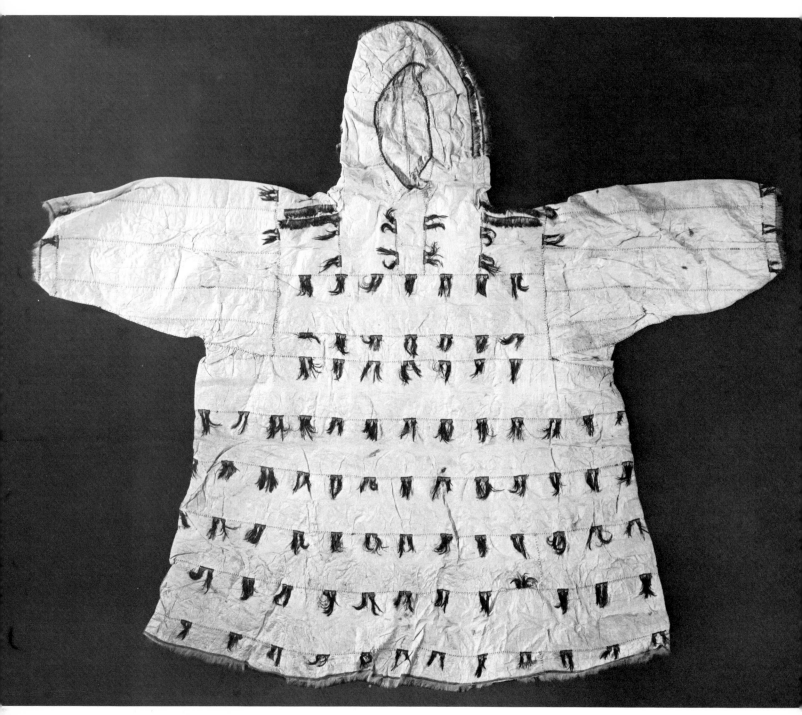

82 HOODED PARKA
Seal and walrus gut, crested auklet
 feathers, bird beaks, gut and skin
 strips, and thread
148 (58 1/4) WIDE
St. Lawrence Island?
Museum purchase, Holmes Fund
Smithsonian Institution, T-1087

83 WATERPROOF HOOD
Salmon skin and hide, with gut thread
59 (23 1/4) HIGH
Presumably collected by Rev. Sheldon
 Jackson in the late 19th century
Sheldon Jackson Museum, II.B.77

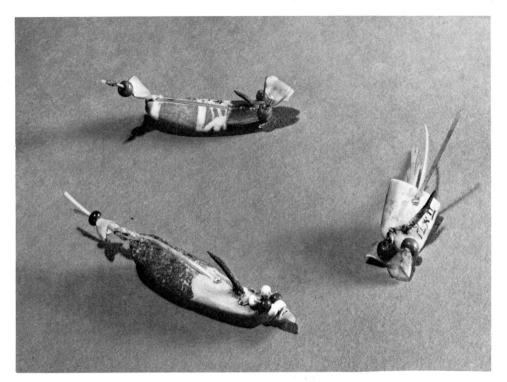

84 THREE FISHING LURES
Stones, bone, gut filament, bird beaks,
 trade beads, and metal
6.4 (2 1/2) LONG; 6 (2 3/8) LONG;
 4.5 (1 3/4) LONG
Presumably collected by Rev. Sheldon
 Jackson in the late 19th century
Sheldon Jackson Museum, II.X.71 a,
 II.X.179, II.X.71 k

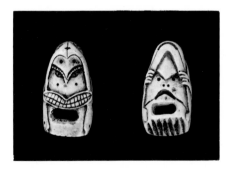

85 SPEAR GUARD*
Engraved ivory with black pigment
4.4 (1 3/4) HIGH
Collected at Kaialigumiut, on the
 Manopiknak River (Hazen Bay),
 Yukon Delta, by E. W. Nelson
Smithsonian Institution, 176 086 b

Bureau of American Ethnology, *18th Annual
 Report*, (1899), part I, fig. 73, p. 227.

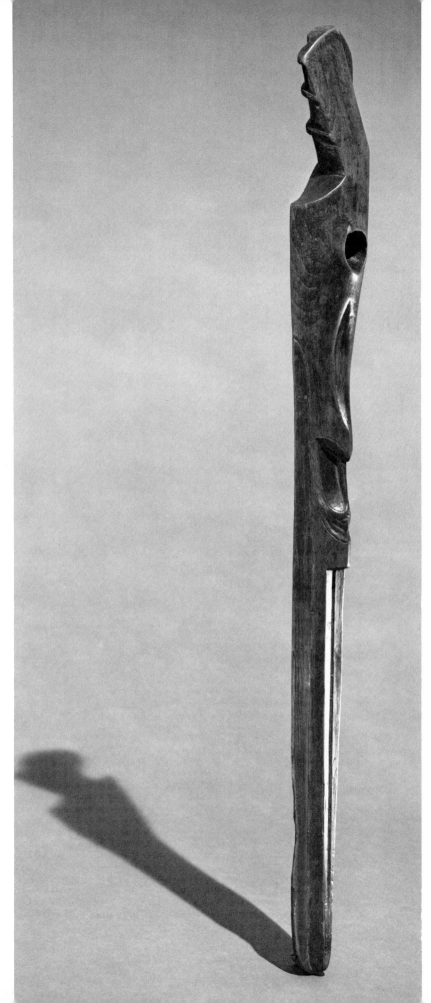

86 SPEAR-THROWER CARVED
 WITH HUMAN FACES
Wood, with inlaid ivory socket
48.6 (19 1/8) LONG
Collected on Kodiak Island by Edward
 G. Fast, 1867–68
Museum purchase, 1869
Peabody Museum, Harvard University,
 69-30-10/1715

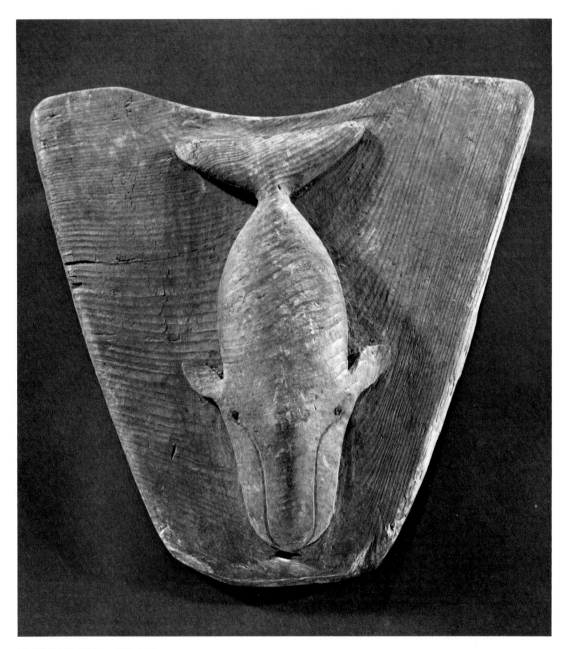

87 UMIAK SEAT, WHALE
 FETISH
Wood, inlaid with wooden pegs, varie-
 gated stone inset under whale from
 the back
27 (10 5/8) LONG
Collected at Sledge Island, Seward
 Peninsula, by W. B. VanValin, 1916
University Museum, Philadelphia
 NA 4788

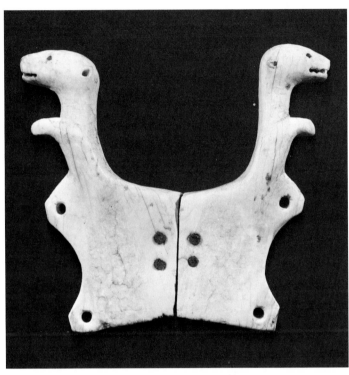

89 HARPOON REST FROM
 UMIAK PROW
Ivory, inlaid with bone and wood,
 traces of red and blue pigment
15.1 (6) HIGH
Inscribed on the reverse with ink in a
 19th-century hand: "Eskimo Mask
 [sic] from Kinak Bay[?] [. . .] pre-
 sented by Rev. Sheldon Jackson."
Sheldon Jackson Museum, II.D.35

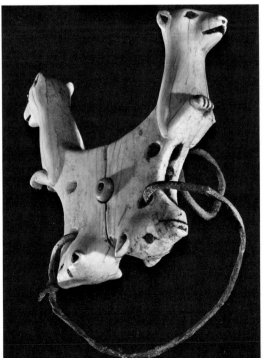

88 HARPOON REST FROM
 UMIAK PROW
Ivory, inlaid with bone, trade bead,
 and metal; rawhide lashings
12.4 (4 7/8) HIGH
Collected by David Kimball
Gift of the heirs of David Kimball,
 May 1899
Peabody Museum, Harvard University,
 99-12-10/53129

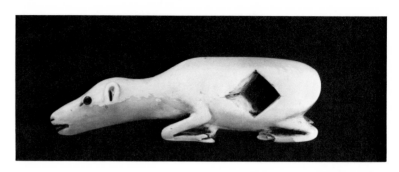

90 ARROW-STRAIGHTENER IN
 THE FORM OF A KNEELING
 REINDEER*
Ivory with beads(?) inlaid as eyes
14.6 (5 3/4) LONG
Collected at Cape Denbigh, Norton
 Bay, by E. W. Nelson
Smithsonian Institution, 176 245

92 POLAR BEAR
Ivory, with bone(?) inlaid as eyes
12.1 (4 3/4) LONG
Collected by Mrs. F. Carrington
 Weems
Peabody Museum of Salem, E 46905

94 BIRD CARVING WITH
 HUMAN FACE*
Engraved ivory with black pigment
3.8 (1 1/2) LONG
Collected at Cape Vancouver (Nelson
 Island) by E. W. Nelson
Smithsonian Institution, 43 572

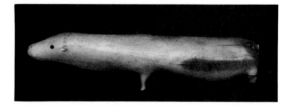

95 SHORT-EARED OWL*
Ivory, with inlaid beads as eyes
3.6 (1 7/16) LONG
Collected on the Koyuk River, Norton
 Bay, by E. W. Nelson
Smithsonian Institution, 44 073

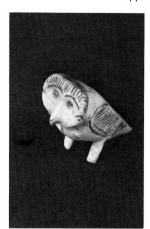

91 POWDER FLASK
Engraved ivory with brown pigment;
 wooden stopper
13.3 (5 1/4) HIGH
Collected on Kotzebue Sound by
E. W. Nelson
Smithsonian Institution, 48 560

Bureau of American Ethnology, *18th Annual
 Report*, (1899), part I, pl. XLIV-28,
 p. 106.

93 SEAL CARVING*
Engraved ivory with black pigment
 and inlaid with bone and whiskers
12.7 (5) LONG
Collected on Bristol Bay by Charles
 L. McKay
Smithsonian Institution, 55 909 E

U. S. National Museum Annual Report,
 1895, pl. 56, fig. 2, p. 840.

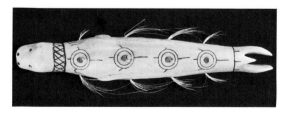

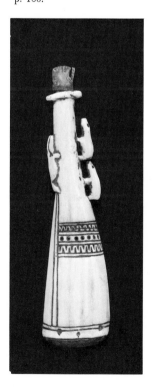

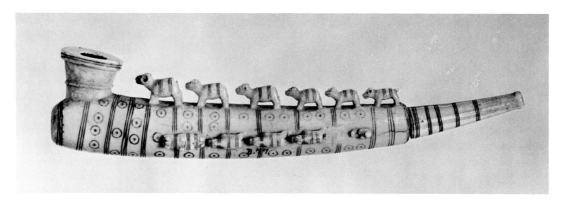

96 PIPE WITH ANIMAL AND
 HUMAN FIGURES
Engraved ivory with black pigment
25.6 (10 1/8) LONG
Hamburgisches Museum für
 Völkerkunde und Vorgeschichte,
 B. 77

97 PIPE
Engraved ivory with black pigment
40.3 (15 7/8) LONG
Collected in 1816
Museum purchase, 1922
University Museum, Philadelphia,
 NA 9388

This piece depicts a polar bear, another
animal, and eleven men.

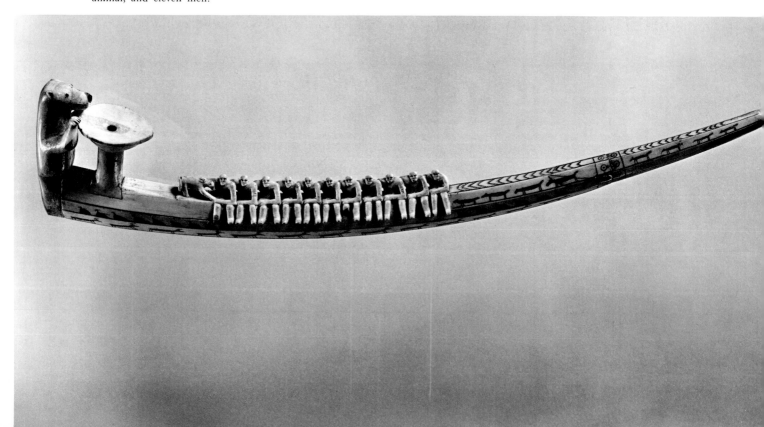

98 PIPE
Engraved ivory with red and black
 pigment
21 (8 1/4) LONG
Collected at Gambell, St. Lawrence
 Island, by F. Seymour Hersey, 1914
Gift of F. Seymour Hersey
Peabody Museum, Harvard University,
 64-29-10/43868

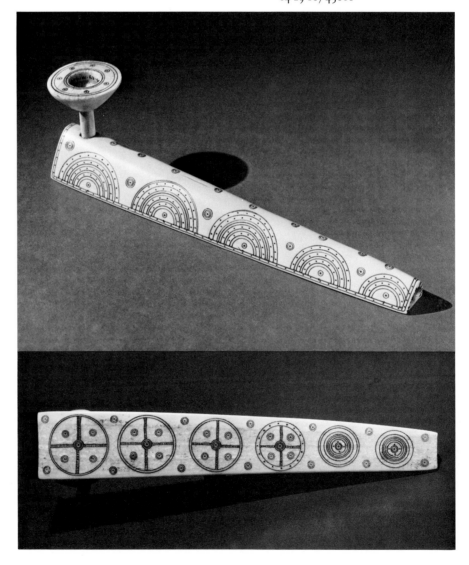

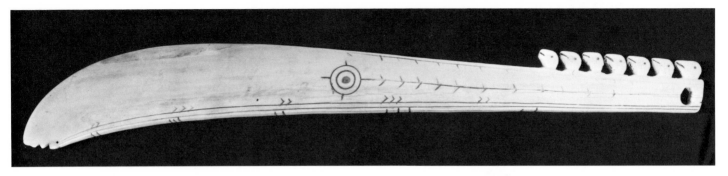

99 SNOW KNIFE*
Engraved ivory with black pigment
36.1 (14 1/4) LONG
Collected at Kongiganak, on
 Kuskokwim Bay, by E. W. Nelson
Smithsonian Institution, 36 576

U. S. National Museum Annual Report,
 1895, pl. 15, fig. 4, p. 776.

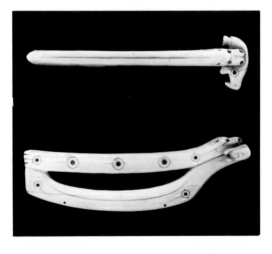

100 KNIFE HANDLE*
Ivory, with bone inlays and metal pin
12.1 (4 3/4) LONG
Collected at Spigunugumut by E. W.
Nelson; inscribed "Drawn 1889
 W. H. D[all]"
Smithsonian Institution, 37 960

The carving shows what may be a
polar bear swimming with a baby
walrus in its mouth.

U. S. National Museum Annual Report,
 1890, pl. 66, fig. 3, p. 416.

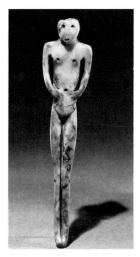

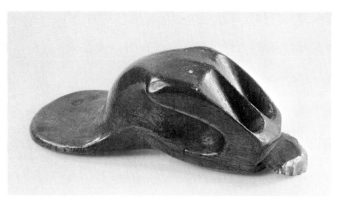

101 LEFT-HANDED SKIN SCRAPER
Wood and chipped stone
15.4 (6 1/16) LONG
Victor Justice Evans Collection
Bequest of V. J. Evans,
 28 March 1931
Smithsonian Institution, 360 429

102 NEEDLE CASE IN THE FORM OF A FEMALE FIGURE
Walrus ivory
13.5 (4 5/16) LONG
Collected by Curtis Chase
Anchorage Historical and Fine Arts
 Museum, 71.35.2

The figure is tubular, being bored through with a regular cavity approximately 7 mm. in diameter; since this cavity opens through the outer shell along the deep crevice carved between the legs in the rear, and since its rounded edges at both top and bottom show considerable signs of wear, it is clear that in this instance the needles were stored on a strip of leather, which was run through the cavity and secured. Similar needle cases in human form have been collected from the vicinity of Barrow, though they are usually shorter: the present example is unusual in the length of its legs.

H. B. C.
C. D. L.

103 NEEDLE CASE IN THE FORM OF A FISH
Engraved ivory with red and black
 pigment, wood
15.6 (6 1/8) LONG
Peabody Museum of Salem, E 37906

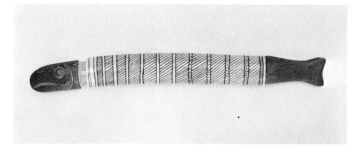

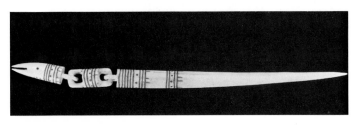

106 PUNCH OR AWL WITH
 CHAIN-HEAD PENDANTS*
Engraved ivory with black pigment
17.7 (6 15/16) LONG
Collected in the "Big Lake" region,
 Yukon-Kuskokwim Delta, by E. W.
 Nelson
Smithsonian Institution, 36 634

Bureau of American Ethnology, *18th Annual
 Report*, (1899), part I, pl. XLVI-8, p. 110.

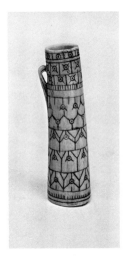

104 NEEDLE CASE WITH
 PIERCED HANDLE
Engraved ivory with red and black
 pigment; inset wooden bottom
8.3 (3 1/4) HIGH
Collected on Norton Sound by
 François Mercier, 1888
National Museum of Man, Ottawa,
 IV.E.119

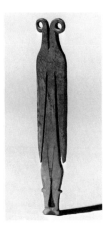

105 THIMBLE HOLDER IN THE
 FORM OF A
 FEMALE FIGURE
Walrus ivory
9.8 (3 7/8) LONG
Excavated from Tigara Mound, Point
 Hope, by Froelich Rainey, 1945
Museum Expedition collection, 1945
American Museum of Natural History,
 60.2-4755

107 "HOUSEWIFE'S FASTENER"
 FOR BAG OR POUCH
Engraved ivory with black pigment
 and inlaid with metal
13.4 (5 1/4) LONG
Presumably collected by Rev. Sheldon
 Jackson in the late 19th century
Sheldon Jackson Museum, II.X.283

108 PATCHWORK BAG
Skins and natural fibers
24 (9 1/2) WIDE
Collected at Port Clarence, Seward
 Peninsula, by Rev. Sheldon Jackson,
 1891
Sheldon Jackson Museum, II.X.154

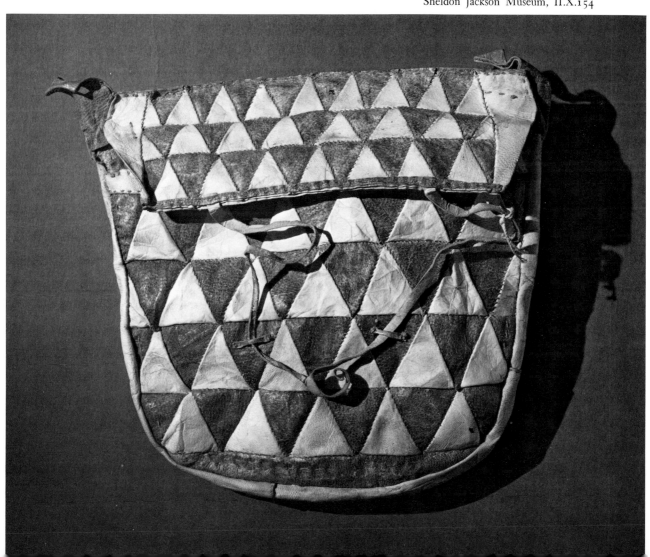

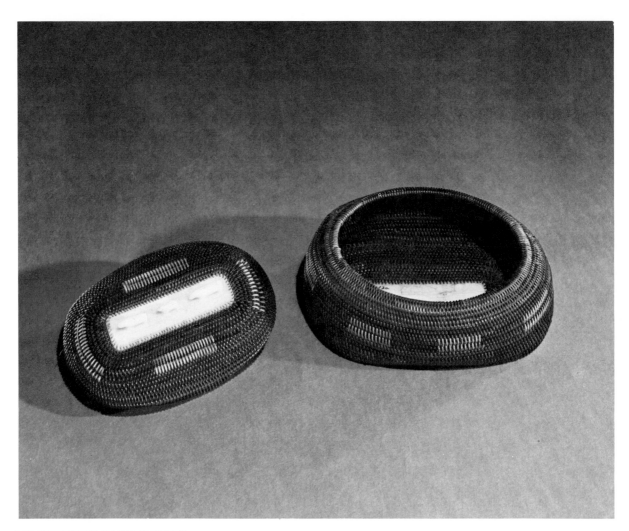

109 COVERED BASKET WITH
 THREE POLAR BEARS
Black and white baleen and ivory
13 (5 1/8) LONG
Point Barrow
Presumably collected by Rev. Sheldon
 Jackson in the late 19th century
Sheldon Jackson Museum, II.V.2

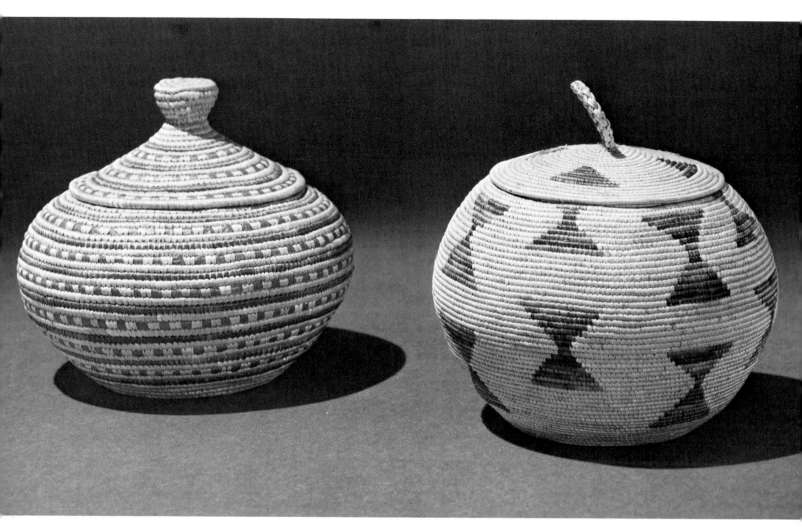

111 COIL BASKET
Beach grass, partly dyed purple, and
 seal gut, dyed red
17 (6 3/4) DIAMETER
Collected at Kipnuk, Kinak Bay, 1959
Museum purchase, 1959
Alaska State Museum, II-A-3156

110 COIL BASKET
Beach grass, partly dyed green
16.5 (6 1/2) HIGH
Collected at Hooper Bay by the Hon.
 Mr. Ulaskey, 1950
Gift of Dr. Dorothy Novatney
Alaska State Museum, II-A-4812

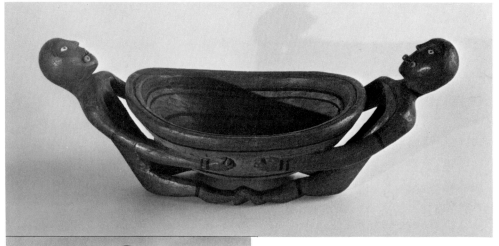

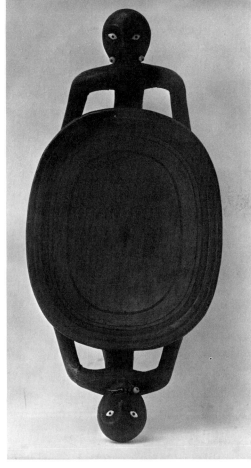

112 DISH SUPPORTED BY TWO
 HUMAN FIGURES
Wood, with black and red pigment,
 bone and ivory inlays
23 (9) LONG
Collected on the Lower Yukon River
 by Ilia G. Vosnesenski, 1845
Museum of Anthropology and
 Ethnography, Leningrad, 493.45

113 DISH*
Wood, with red and black pigment,
 bone inlays
35.2 (13 7/8) LONG
Collected in the "Big Lake" region
 Yukon-Kuskokwim Delta, by E. W.
 Nelson
Smithsonian Institution, 38 677

Two human heads are shown, with
an outline drawing of a mythical
creature. No. 114 shows only a
mythical creature.

Bureau of American Ethnology, *18th Annual
 Report*, (1899), part I, pl. XXXI-8, p. 80.

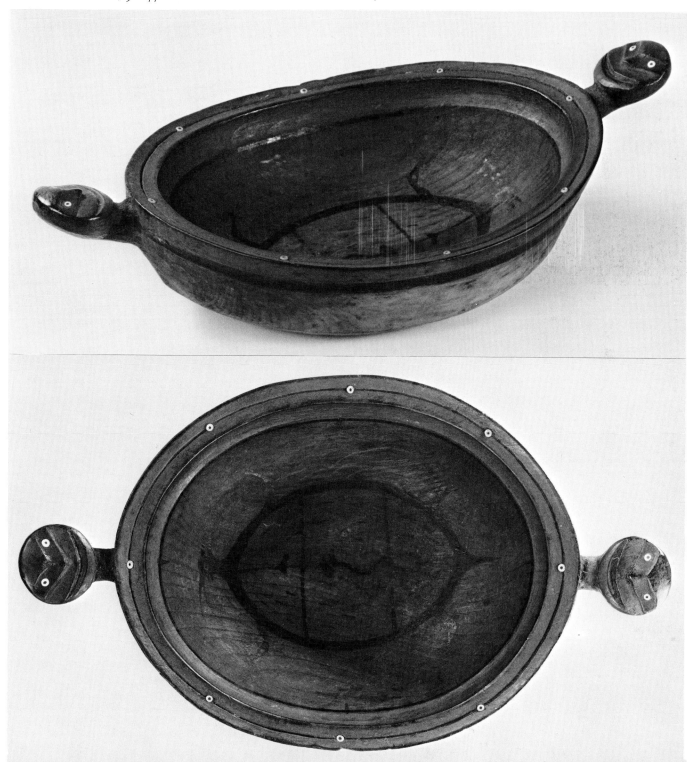

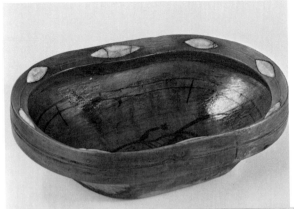

114 LARGE DISH*
Wood, with red and black pigment,
 bone inlays
35.6 (14) LONG
Collected at Nuloktolok (Nelson
 Island), by E. W. Nelson, 1878
Smithsonian Institution, 38 642

Bureau of American Ethnology, *18th Annual
 Report*, (1899), part I, pl. XXXII-8, p. 82;
 and fig. 165, p. 448.

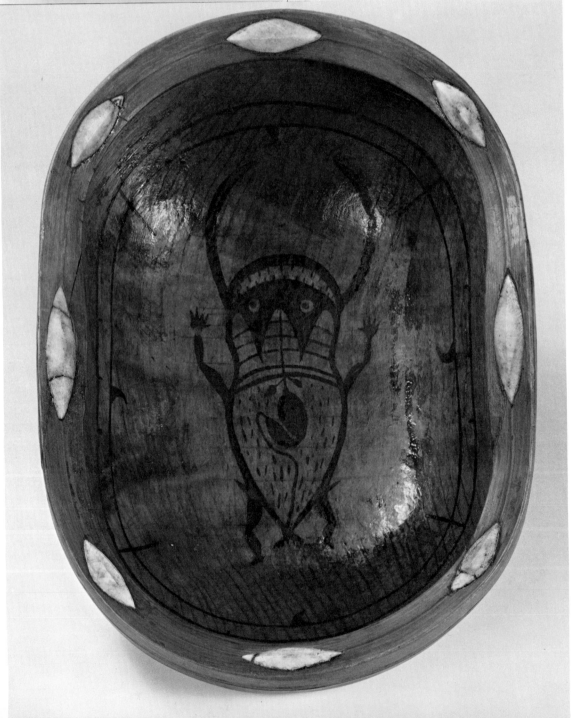

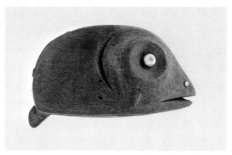

115 TOBACCO BOX: FISH OR
 SMALL ANIMAL*
Wood, with red pigment, and inset
 ivory engraved with black pigment
9 (3 1/2) LONG
Collected at Kulvagavik, on
 Kuskokwim Bay, by E. W. Nelson
Smithsonian Institution, 36 282

Bureau of American Ethnology, *18th Annual
 Report*, (1899), part I, pl. LXXXVI-13,
 p. 270.

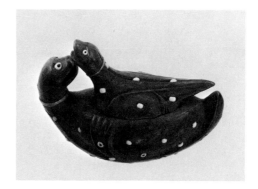

116 TOBACCO BOX:
 TWO SEALS*
Wood, with ivory and bone inlays
10.2 (4) LONG
Collected at Russian Mission, Lower
 Yukon River, by E. W. Nelson
Smithsonian Institution, 48 839

Bureau of American Ethnology, *18th Annual
 Report*, (1899); part I, pl. LXXXVI-12,
 p. 270.

117 TOBACCO BOX: SEAL
 CARRYING ITS YOUNG*
Wood, with inlaid beads
24.1 (9 1/2) LONG
Collected at St. Michael, Norton
 Sound, by L. M. Turner, 1874–77
Smithsonian Institution, 129 247

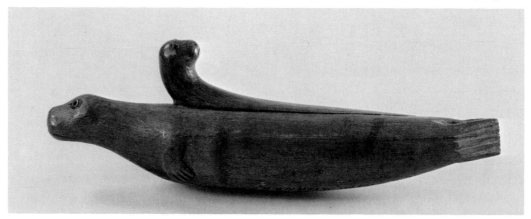

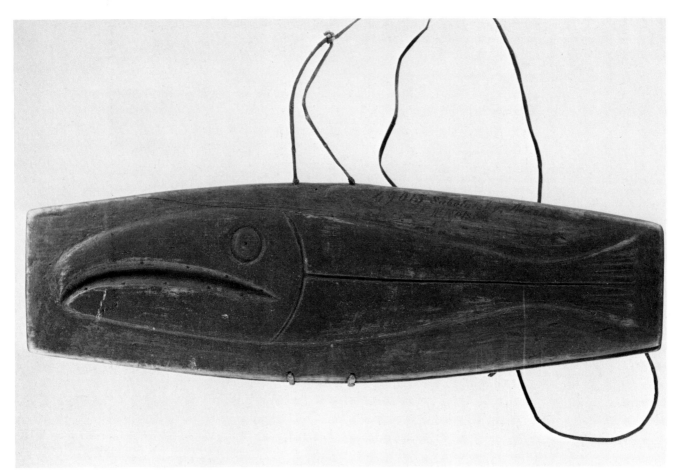

118 TACKLE BOX WITH
 SALMON CARVED ON
 SIDES*
Wood, with red and black pigment
 and rawhide straps
34.3 (13 1/2) LONG
Collected at Sabotnisky (Marshall),
 Lower Yukon River, by E. W.
 Nelson
Smithsonian Institution, 49 015

Bureau of American Ethnology, *18th Annual
 Report*, (1899), part I, pl. XLII-9, p. 102.

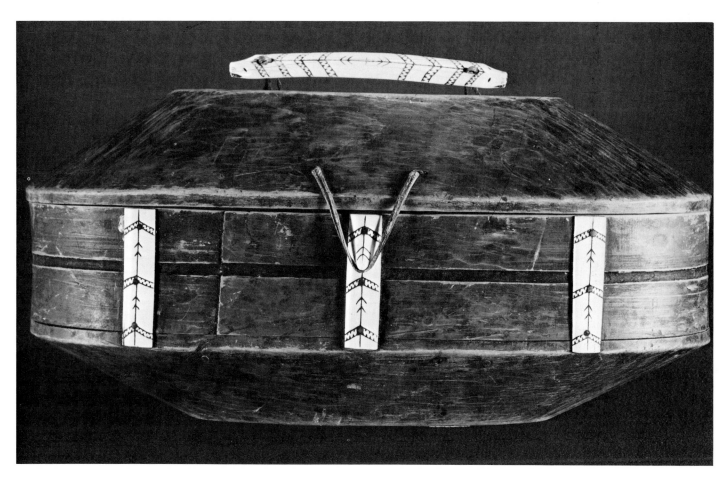

119 TOOL CHEST
Wood, with red and black pigment,
 carved and engraved ivory, and raw-
 hide fittings
37 (14 1/2) LONG
Presumably collected by Rev. Sheldon
 Jackson in the late 19th century
Sheldon Jackson Museum, II.X.55

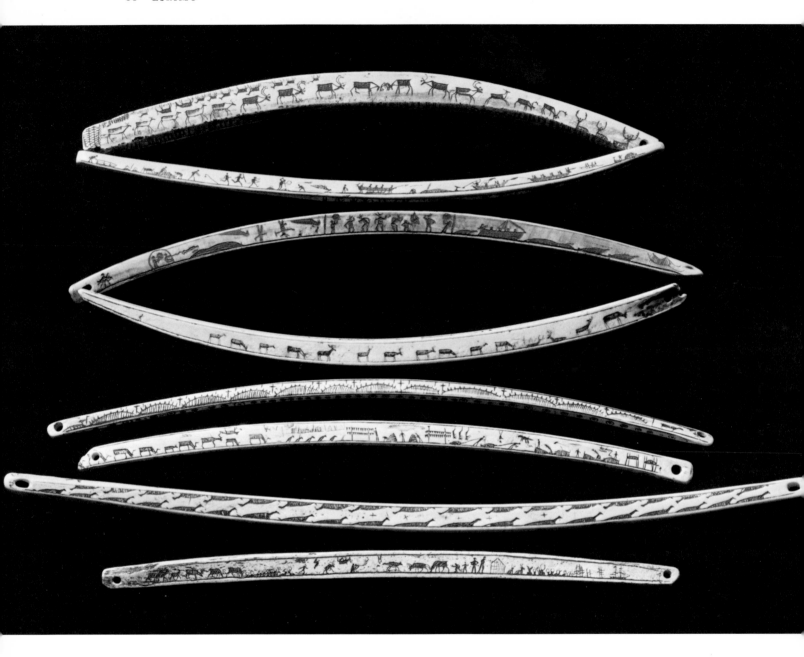

122 DRILL BOW
Engraved ivory with brown pigment
34.2 (13 1/2) LONG
Deutsches Ledermuseum, Offenbach,
11574

127 DRILL BOW*
Engraved ivory with black pigment
34.6 (13 5/8) LONG
Collected on Golovnin Bay, Norton
Sound, by E. W. Nelson
Smithsonian Institution, 176 172

125 DRILL BOW
Engraved ivory with black pigment
37.5 (14 3/4) LONG
Collected on Kotzebue Sound by
E. W. Nelson
Museum collection, 1882
Smithsonian Institution, 48 522

124 DRILL BOW*
Engraved ivory with black pigment
36.2 (14 1/4) LONG
Collected at Shaktoolik, Norton Sound,
by E. W. Nelson
Smithsonian Institution, 43 810

123 DRILL BOW
Engraved ivory with brown pigment
39 (15 3/8) LONG
Inscribed "Nome"
Smithsonian Institution, T-1076

121 DRILL BOW
Engraved ivory with brown pigment
36.1 (14 1/4) LONG
Museum voor Land- en Volkenkunde,
Rotterdam, 34875

126 DRILL BOW
Engraved ivory with brown pigment
46.6 (18 3/8) LONG
Collected on Kotzebue Sound by
E. W. Nelson
Museum collection, 1882
Smithsonian Institution, 48 523

120 BOX HANDLE OR
 DRILL BOW*
Engraved bone with black pigment
33.6 (13 1/4) LONG
Collected at Cape Nome by E. W.
Nelson
Museum collection, December 1880
Smithsonian Institution, 44 366

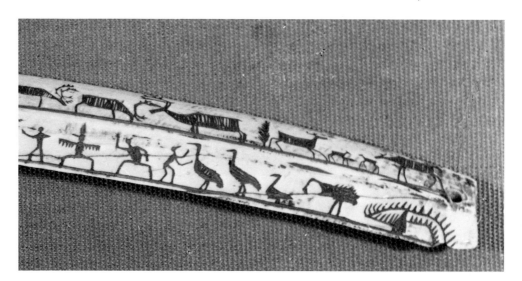

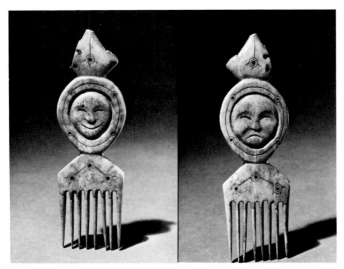

128 COMB WITH MALE AND
 FEMALE FACES
Ivory, with composite inlays
11.1 (4 3/8) HIGH
Smithsonian Institution, T-1066

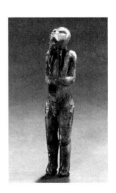

129 HUMAN FIGURE WITH
 WALRUS TUSKS*
Ivory
7.6 (3) HIGH
Collected at Barrow and presented by
 C. D. Bower to James A. Ford
Museum collection, 3 March 1958
Smithsonian Institution, 401 800

130 MALE HUMAN FIGURE
Wood
15.3 (6) HIGH
Collected on Little Diomede Island
 by E. W. Nelson
Smithsonian Institution, 63 645

This figure is unusual among Alaskan
Eskimo carvings of the early modern
period, which normally show human
figures both clothed and with greater
stylization.

C. D. L.

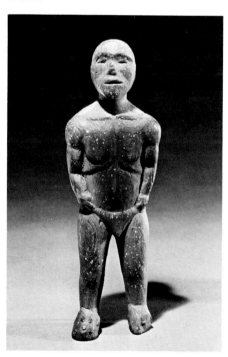

131 HUMAN FIGURE WITH
 BLUE LABRETS
Ivory, inlaid with bone and trade beads
12.4 (4 7/8) HIGH
Possibly from vicinity of Point Banks,
 Shuyak Island?
Museum of the American Indian,
 Heye Foundation, 5/9838

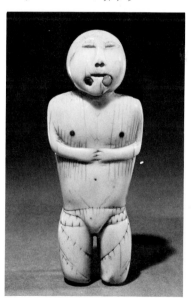

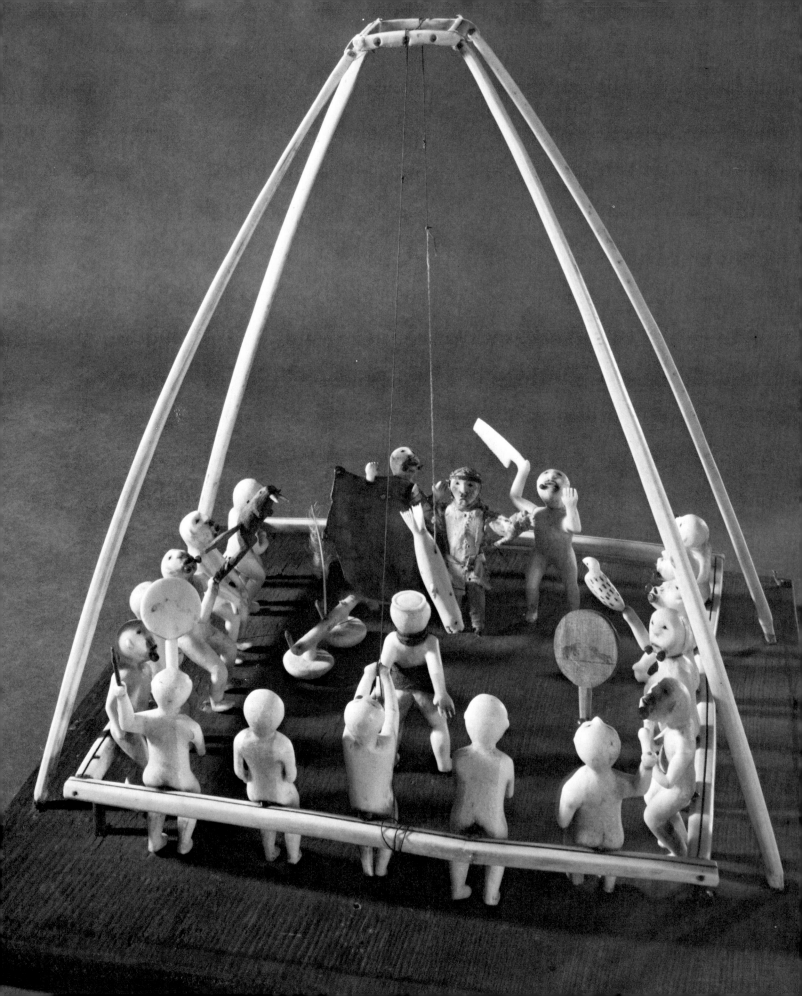

132 MODEL OF "KASHIM" OR
DANCE HOUSE
Wood, with red and black pigment,
ivory engraved with black and red
pigment, deerskin, trade cloth and
beads, fiber and string
43 (17) LONG
Collected on the Kuskokwim River by
Adolph Neumann, 1890
Sheldon Jackson Museum, II.S.1

133 SHORT DANCE MASK
WITH ANIMAL FACE
Wood and woven fiber strap
15.2 (6) WIDE
Collected at Point Barrow by E. A.
McIlhenny
Gift of the collector
University Museum, Philadelphia,
41781

134 FISHING OR WHALING
 FETISH: FLOAT OR
 TOGGLE?
Wood, inlaid with bone
11.1 (4 3/8) HIGH
Collected probably near Point Hope
 ("at a Bay between Behring's Straits
 [sic] and Icy Cape"—see below) by
 John Dolan, mariner, June 1860
Museum purchase from J. Halbert,
 Dublin
National Museum of Ireland,
 1881:2862
Accompanied by the original label with
 the autograph of the collector:

 An Esquimaux Idol got by me
 from the Natives at a Bay between
 Behring's Straits and Icy Cape—
 I took it out of their boat as they
 were away. The Boats are a sort
 of wicker work covered with Walrus
 hide—I think the name was 'Plover
 Bay'
 About 73° N. I was with the Ship
 'William C. Nye' Whaler—in June
 1860.
 John Dolan, Mariner,
 15 January 1862
Although Mariner Dolan applied a
Siberian place name ["Plover Bay"] to
a stretch of the Alaskan coast; his dis-
covery seems certain to have taken
place in the near vicinity of Point
Hope, as can also be judged by com-
paring his "Idol" with the form of the
following entry.

C. D. L.

135 MASK
Wood, with traces of fiber inserts in
 chin
21.2 (8 3/8) HIGH
Possibly to be dated near the 1860s?
 (See preceding entry)
Collected at Point Hope by Helge
 Larsen, 1939
Danish National Museum, P.6386
Illustrated in color

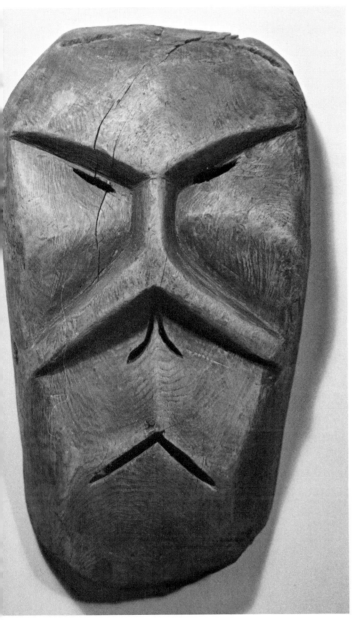

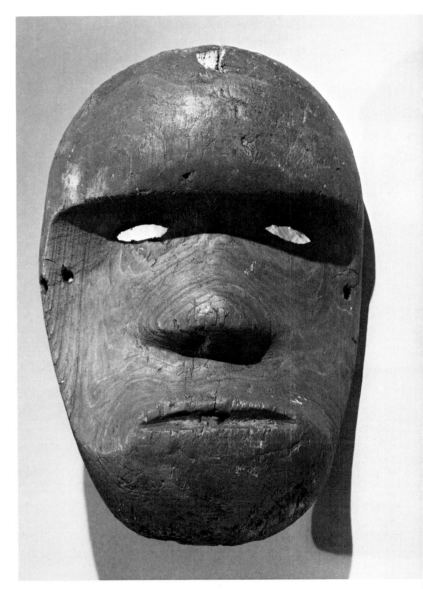

**136 MASK WITH WHALE'S
 TAIL DESIGN**
Wood, traces of fiber cord, and
 fragments of nails
28.3 (11 1/8) HIGH
Point Hope?
Presumably collected by Rev. Sheldon
 Jackson in the late 19th century
Sheldon Jackson Museum, II.K.82

Cavities in the top and bottom edges
of this abstract mask indicate they
once held decorative appendages.

C. D. L.

137 HUMAN MASK
Wood
26 (10 1/4) HIGH
Point Hope
Presumably collected by Rev. Sheldon
 Jackson in the late 19th century
Sheldon Jackson Museum, II.K.163

The curves in the profile of this mask,
an example of the abstracting tenden-
cies of Point Hope carvers, suggest
figure styles from distant parts of the
Pacific coasts.

C. D. L.

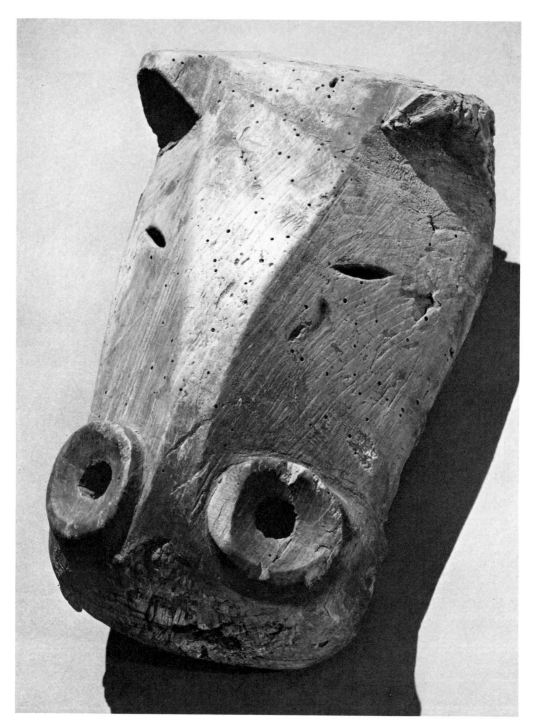

138 ANIMAL-HEAD MASK
31.5 (12 3/8) HIGH
Point Hope
Presumably collected by Rev. Sheldon
 Jackson in the late 19th century
Sheldon Jackson Museum, II.K.161

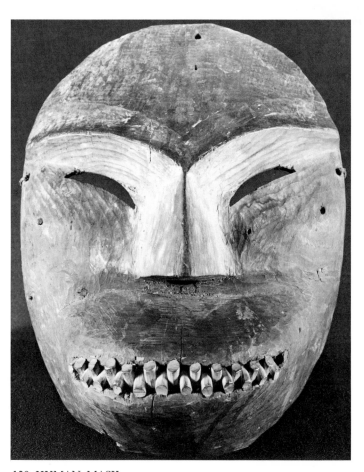

139 HUMAN MASK
Wood, with red, black and white pig-
ment, and rawhide strap
22.5 (8 7/8) HIGH
Collected on King Island by Rev.
 Sheldon Jackson, 1893
Sheldon Jackson Museum, II.E.3

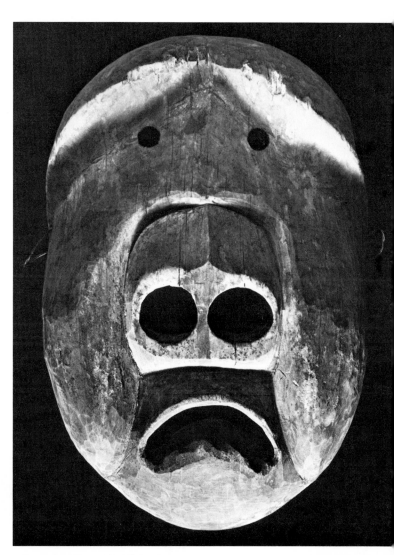

140 HUMAN(?) MASK WITH
 EXAGGERATED NOSE AND
 CHEEKS
Wood
25.7 (10 1/8) HIGH
King Island?
Collected by Axel Rasmussen
Portland Art Museum, 48.3.381

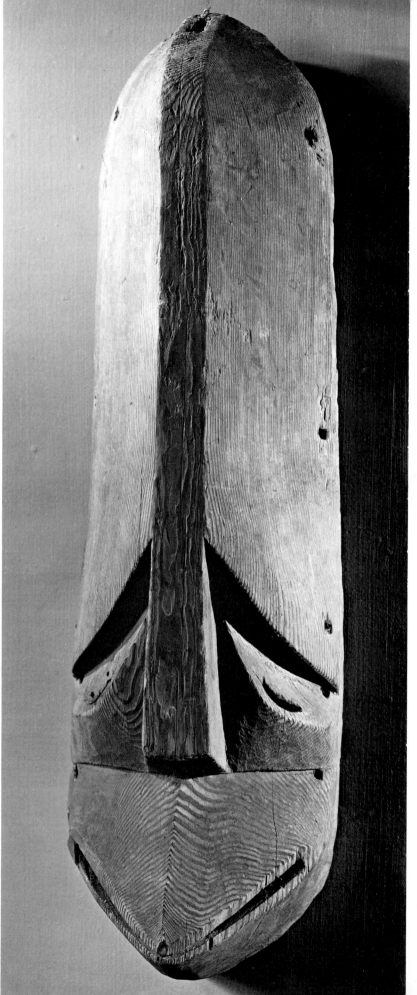

141 HUMAN MASK
Wood, with red and black pigment
60.4 (23 3/4) HIGH
Collected at St. Paul, Kodiak Island,
 by William J. Fisher
Museum collection, 1884
Smithsonian Institution, 74 690

The powerful but simple forms of this
mask make it a classic of its type, with
clear parallels with prehistoric and
later Aleut masks (Nos. 48 and 54).

C. D. L.

142 HUMAN MASK
Wood, with red, black, blue and
 white pigment, twine, and eagle down
49.5 (19 1/2) HIGH
Chugach (Prince William Sound)
Presumably collected by Rev. Sheldon
 Jackson in the late 19th century
Sheldon Jackson Museum, II.P.5

Reminiscent of the Smithsonian ex-
ample from Kodiak (No. 141) in its
vertical stylization, the coloring of this
mask also recalls a parallel Chugach
example in the same collection (No.
145).

C. D. L.

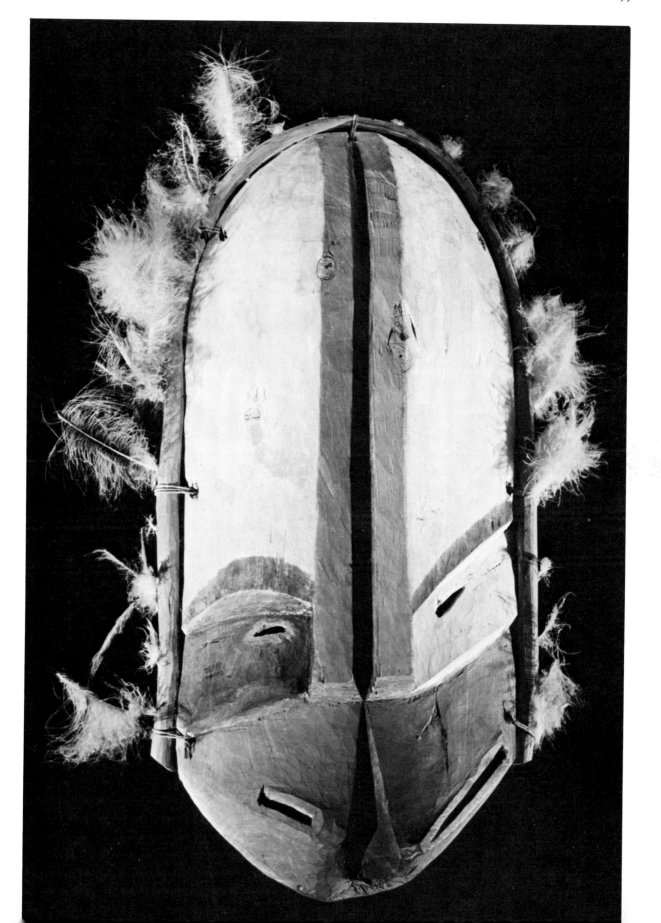

143 HUMAN MASK
Wood, with black and red pigment
36 (14 1/8) HIGH
Chugach (Prince William Sound)
Presumably collected by Rev. Sheldon
 Jackson in the late 19th century
Sheldon Jackson Museum, II.CC.2

144 HUMAN MASK*
Wood
51.5 (20 1/4) HIGH
Kodiak Island or Alaska Peninsula
Collected at Douglass (Kaiayakak or
 Kaguyak, Alaska Peninsula, on
 Shelikof Strait, opposite Kodiak
 Island) by William J. Fisher
Smithsonian Institution, 74 694

Identical (even to the pierced
tetrahedral sustaining boss on the re-
verse) to the example collected by the
same donor on Kodiak Island (No.
141), this mask represents a classic of
a hybrid Aleut-Koniag-Chugach style.

C. D. L.

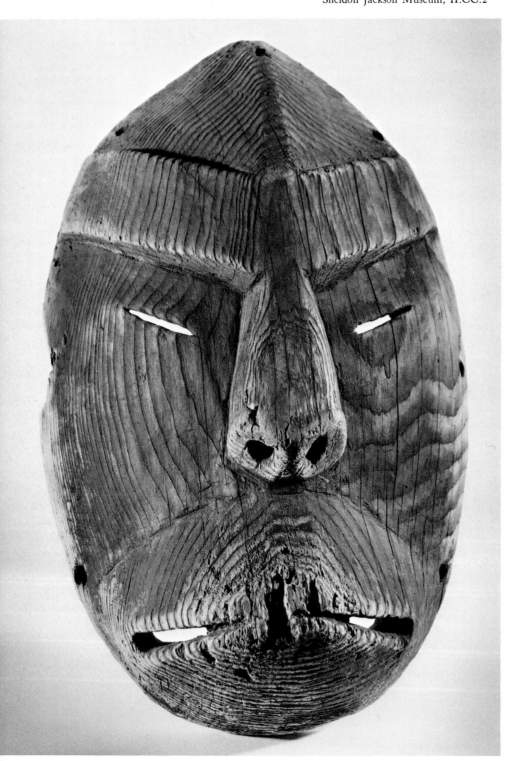

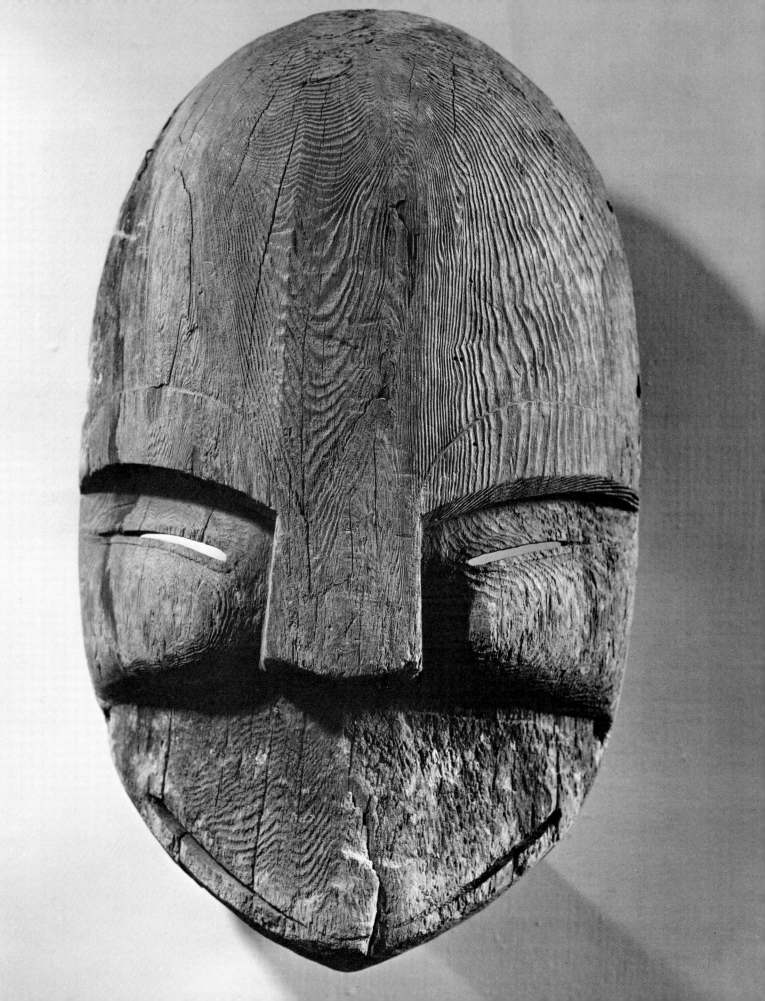

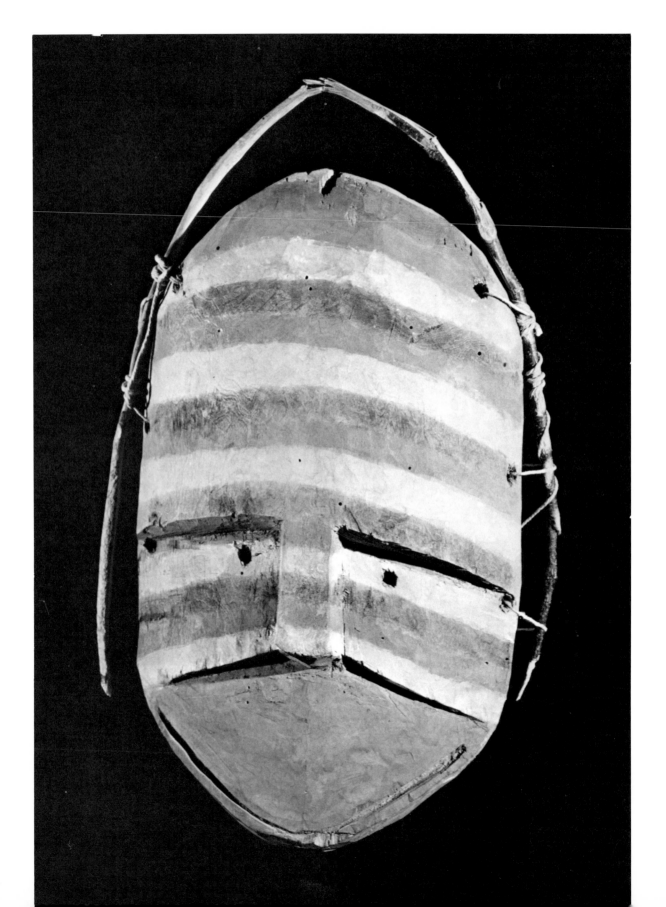

145 HUMAN MASK
Wood, with black, red and white pig-
ment, recently supplemented with a
twig and modern twine in place of a
former encircling willow band
36.3 (13 7/8) HIGH (excluding twig)
Chugach
Presumably collected by Rev. Sheldon
Jackson in the late 19th century
Sheldon Jackson Museum, II.CC.3

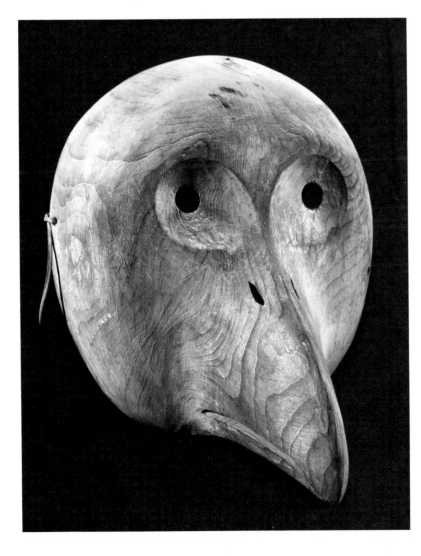

146 BIRD MASK
Wood, with white pigment and
rawhide strap
19 (7 1/2) HIGH
Unalakleet, Norton Sound
Possibly collected by Henry Neumann,
c. 1890?
Sheldon Jackson Museum, II.R.2

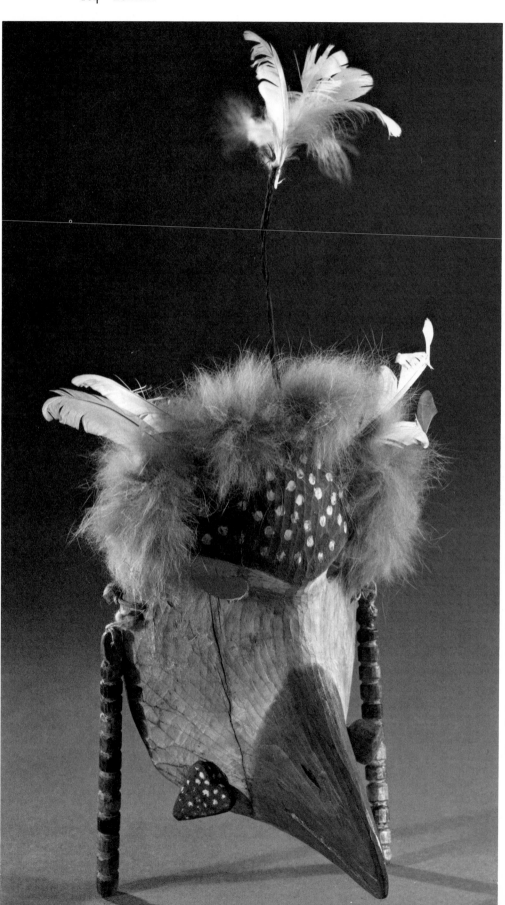

147 CROW MASK
Wood, with black, white, red and
 green pigment, red fox fur, crow and
 ptarmigan feathers, with modern
 string
50.5 (19 7/8) HIGH
Collected at St. Michael, Norton
 Sound, by E. W. Hawkes, 1913
National Museum of Man, Ottawa,
 IV.E.880

148 MASK: THE MOUNTAIN
 SPIRIT
Wood, with red, black and white pig-
 ment, gut strips dyed red, gull
 feathers and eagle down, braided
 fiber, and rawhide strap
70 (27 1/2) HIGH
Collected at St. Michael, Norton
 Sound, by Henry Neumann, 1890
Sheldon Jackson Museum, II.G.7

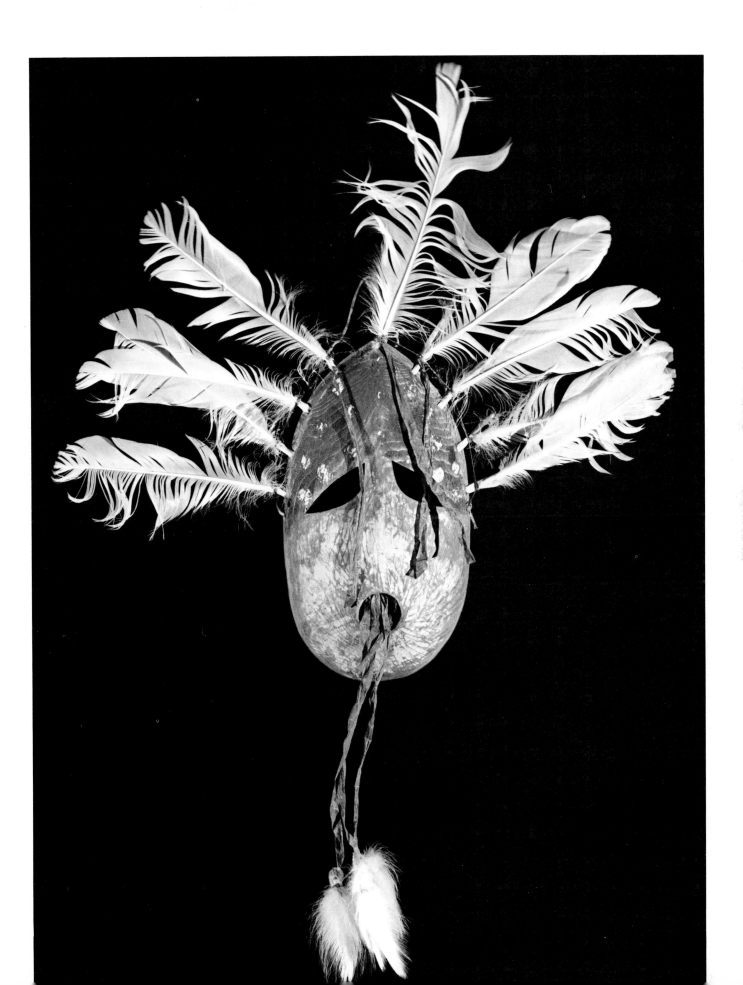

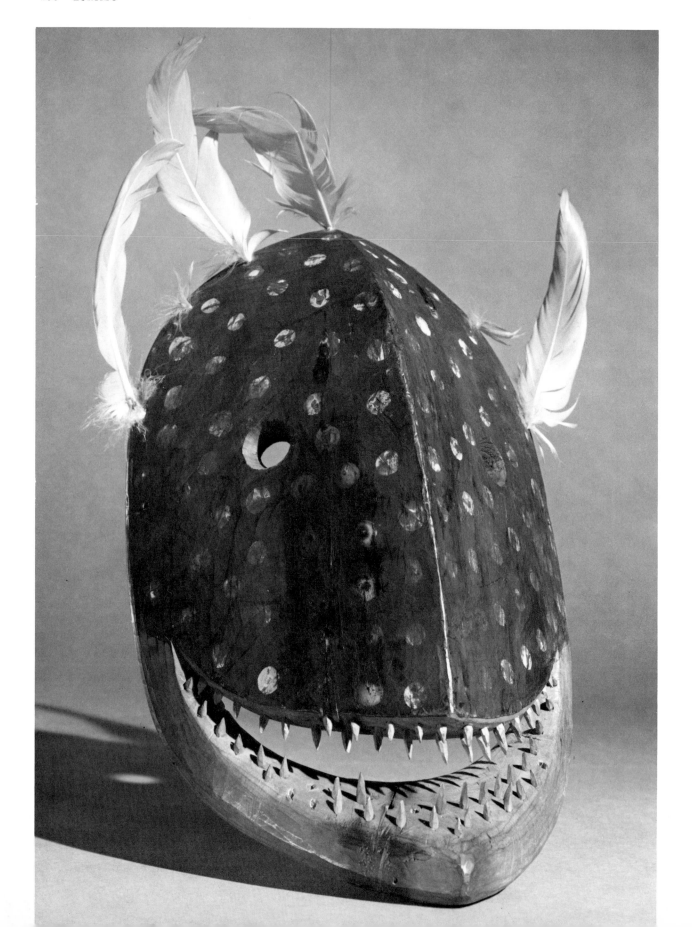

149 BLACKFISH MASK*
Wood, with black, red and white pig-
 ment and feathers
37 (14 1/2) HIGH
Collected on the Lower Yukon River
 or Norton Sound, by J. H. Turner,
 c. 1890–91
Deposited by the collector, 1892
Smithsonian Institution, 153 622

150 OWL MASK
Wood, with blue, white and black
 pigment, jaeger feathers with eagle
 down, and rawhide strap
40 (15 3/4) HIGH
Collected on the Lower Yukon River
 by Rev. Sheldon Jackson, in the late
 19th century, as one of a pair.
Sheldon Jackson Museum, II.H.14

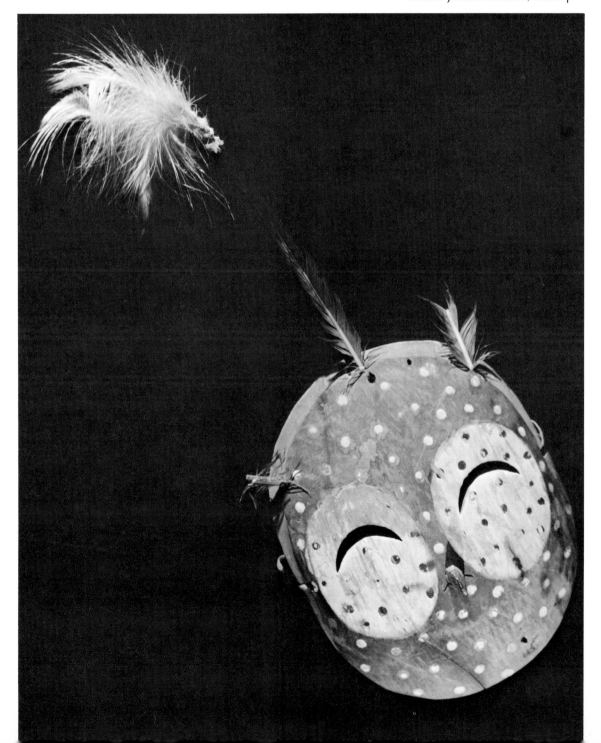

151 MASK
Wood, with red and white pigment,
 jaeger feathers and baleen strips with
 eagle down, sealskin, and rawhide strap
56 (22) WIDE
Collected on the Lower Yukon River
 or Nelson Island, by Rev. Sheldon
 Jackson in the late 19th century
Sheldon Jackson Museum, II.H.2

152 MASK
Wood, with green, white and red
 pigment, feather strips and eagle
 down
52 (20 1/2) HIGH
Collected on the Lower Yukon River
 by Rev. Sheldon Jackson in the late
 19th century
Sheldon Jackson Museum, II.H.3

The conical, puckered "mouth" of this
mask should be compared with that on
the preceding example, and with No.
148; in heavier and cruder shapes it
is a recurring motif on Athabaskan
Indian masks from the Anvik region
farther up the Yukon, as discussed in
Nos. 177 and 178.

C. D. L.

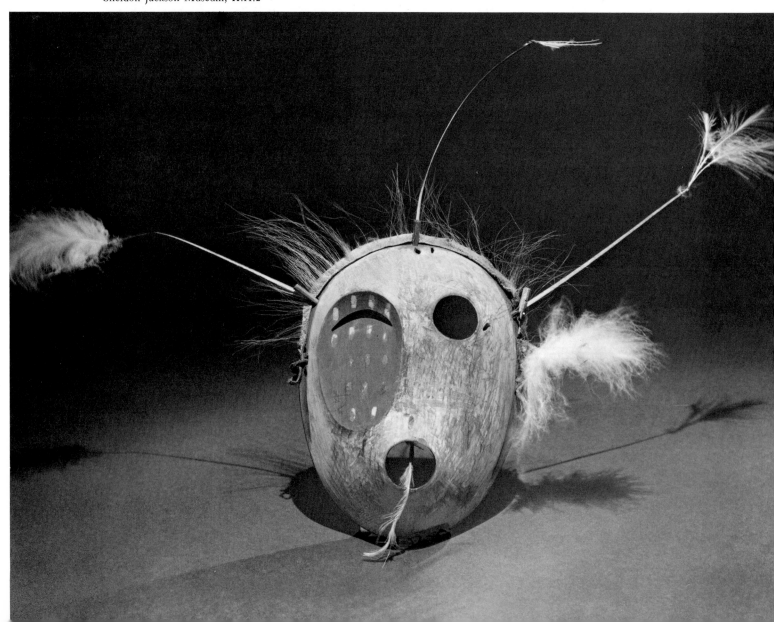

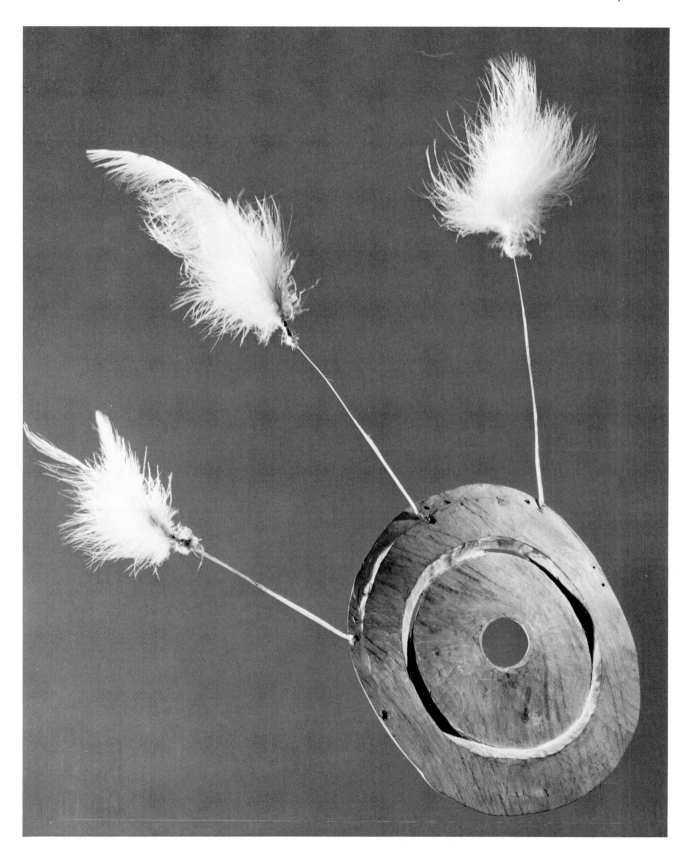

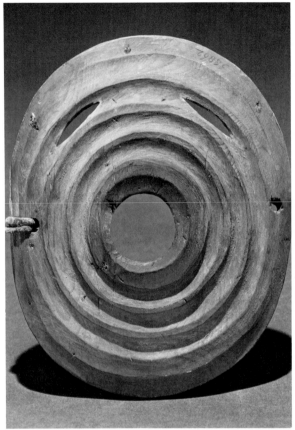

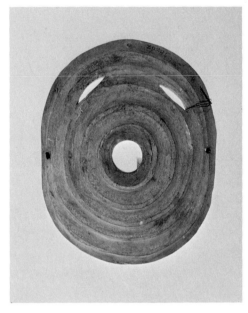

figure d

153 MASK*
Wood, with red pigment and rawhide
 strap
18.4 (7 1/4) HIGH
Collected at Razboinski, on the right
 bank of the Lower Yukon River, by
 E. W. Nelson
Museum collection, 29 December 1879
Smithsonian Institution, 38 862

This mask is typical of Eskimo culture
of the Lower Yukon in forming one
of an almost identical pair, the pendant
being slightly more elongated and
having a smaller central aperture, as
well as four concentrically carved ring
ridges. Both pieces formerly possessed
three plumes inset with pegs in holes
along the upper edge, identical with
the preceding example. The present
pair and the following pieces may be
seen as variations on a similar type
(fig. d).

C. D. L.

154 HUMAN MASK
Wood, with red, blue-green, and traces
 of white pigment, white and brown-
 barred feathers
34.3 (13 1/2) HIGH
Collected at Andreafsky (St. Mary's),
 the Lower Yukon River, by Rev.
 Sheldon Jackson, 1893
Sheldon Jackson Museum, II.B.80

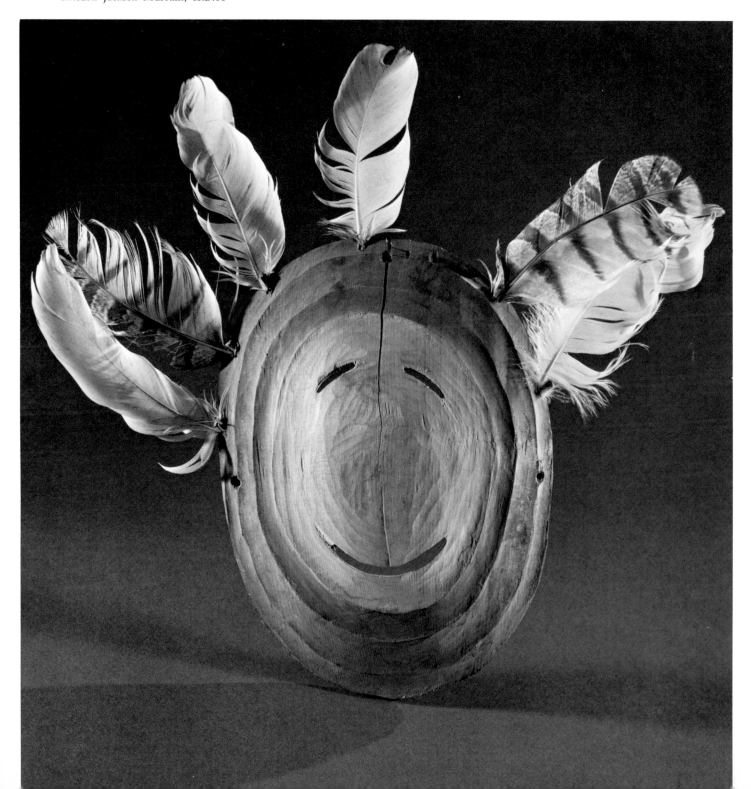

155 HUMAN MASK

Wood, with white, black and red pigment, animal teeth, sea gull and jaeger feathers with eagle down, and rawhide straps

82.5 (32 1/2) WIDE

Collected at Andreafsky by Rev. Sheldon Jackson, 1893

Sheldon Jackson Museum, II.B.8

This mask is a classic example of the famous Eskimo type in which the symbolic central image is surrounded by attendant forms on concentric back-plates or fiber rings, frequently decorated as in this example by crowns of feathers.

C. D. L.

The village of Andreafsky on the Lower Yukon River (present-day St. Mary's) occupies the position of a crossroads with relation to the native Eskimo cultures which surround it. The Ingalik (Athabaskan-speaking) Indians used it as a trading and access point for their lands in the interior further up the Yukon, especially along the Anvik River, which meets the Yukon at the settlement of the same name.

The Andreafsky and the Anvik masks are often remarkably similar in their formal types, and the rich representation of both loaned to this exhibition from the Sheldon Jackson Museum makes it possible to link with the same areas certain masks from other collections. The following pages present a series of these masks, the examples from Andreafsky being compared frequently with other specimens from unspecified points on the Lower Yukon or Kuskokwim Rivers, and from the coastal regions surrounding this delta peninsula, from Norton Sound through Nunivak Island to Bristol Bay.

C. D. L.

156 FOREHEAD MASK: A GANNET OR LOON

Wood, with white, black and red pigment, sea gull feathers, baleen strips with eagle down, willow bands, skin and woven fiber lashings and straps

80 (31 1/2) LONG

Collected at St. Michael, Norton Sound, by Rev. Sheldon Jackson, 1892

Sheldon Jackson Museum, II.G.11

Representative of another classic type with stylized appendages, this mask is fitted just behind the neck with a strong horizontal bar which the wearer would hold in his teeth, thus carrying the mask at a 45-degree angle above his forehead. An interesting feature is the bird's secret "spirit" face, hidden inside the moveable outer head, at the base of the neck.

C. D. L.

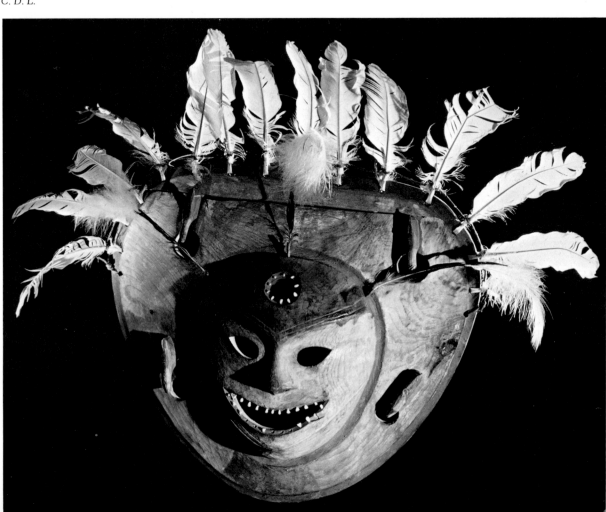

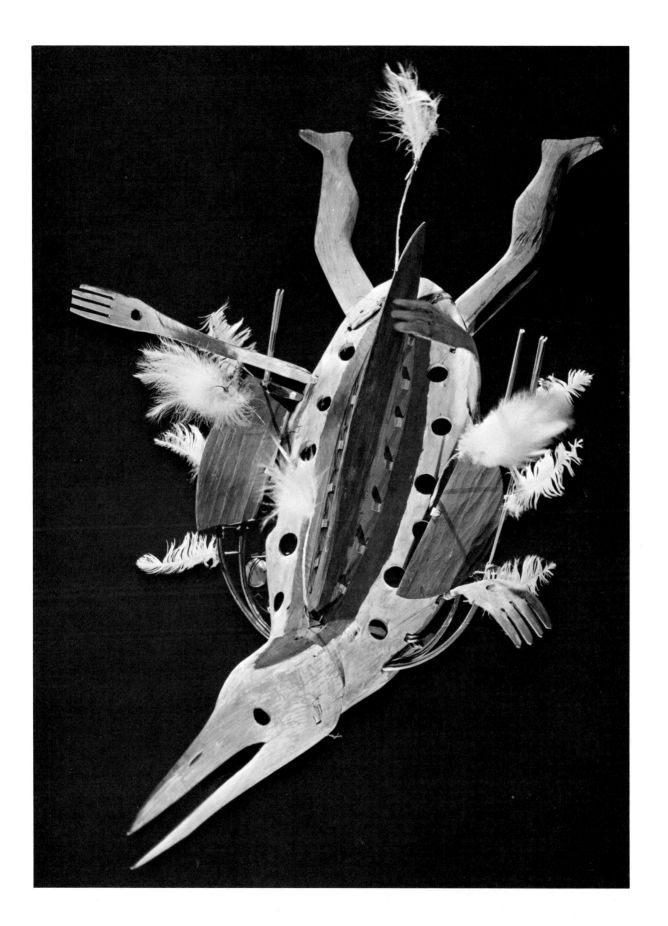

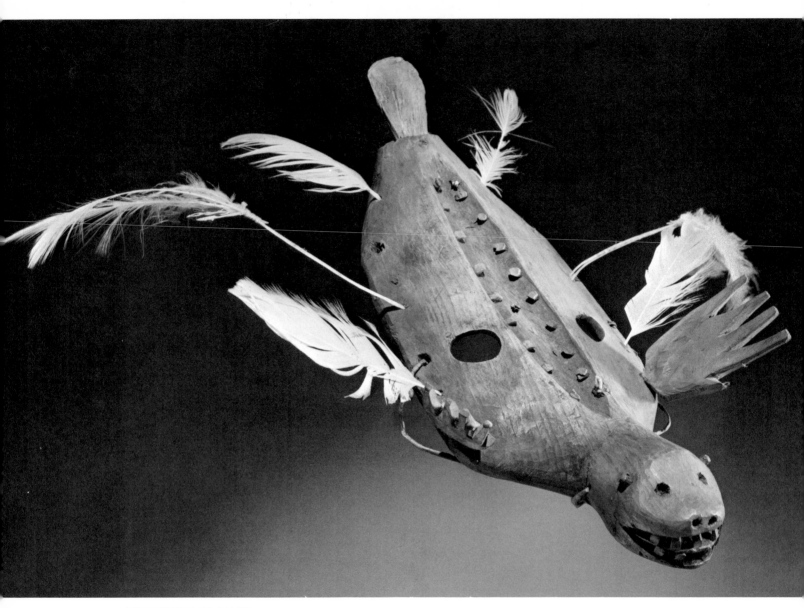

157 FOREHEAD MASK
Wood, with gray-green and red pig-
 ment, sea gull feathers, baleen strips
 with eagle down, and rawhide strap
38 (15) LONG
Presumably collected by Rev. Sheldon
 Jackson in the late 19th century
Sheldon Jackson Museum, II.B.98

Similar to the preceding example, but
also to masks with auxiliary heads or
faces from the Lower Yukon and
Andreafsky, this mask probably comes
from the general area of Norton Sound
or the Yukon Delta. It represents a
small animal with exposed backbone.

C. D. L.

158 MASK
Wood, with red and white pigment,
 gut strips dyed red, sea gull feathers,
 and modern string
29.8 (11 3/4) HIGH
Probably Norton Sound
Collected by Arthur W. Whitcher,
 September 1919
Peabody Museum of Salem, E 17.703

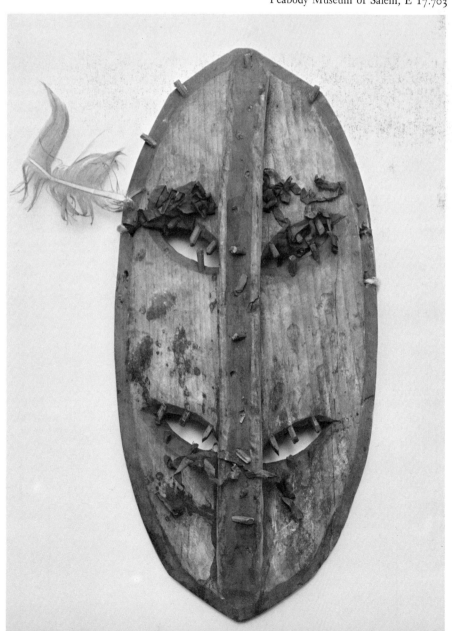

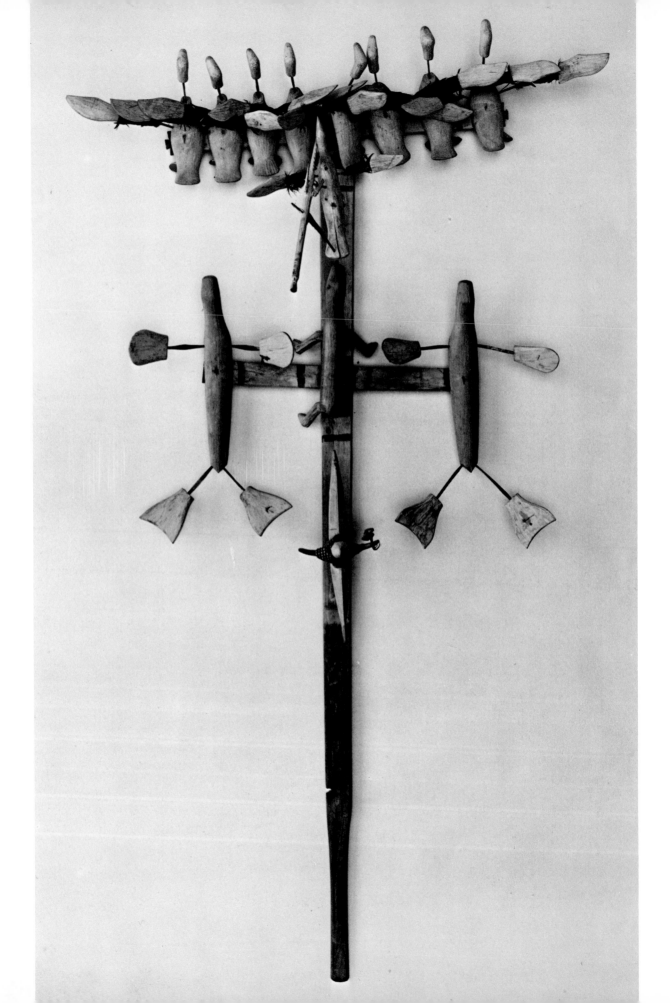

159 DANCE STAFF OR
 INSIGNIA
Wood, with red, white and green
 pigment, black feathers, baleen(?)
 strips, trade gingham, and string
145 (57 1/8) LONG
Collected on Nunivak Island by Knud
 Rasmussen
Danish National Museum, P.33.127

This dance staff or insignia is carved
with birds, seals, caribou, a man in a
kayak, and a harpoon.

160 BURIAL IMAGE*
Wood, with red pigment, inlaid with
 wood and bone features
71 (28) WIDE (height shortened by
 modern saw cut at base)
Collected at Akiachak on the
 Kuskokwim River by Aleš Hrdlička
Deposited by the collector,
 7 November 1930
Smithsonian Institution, 351 076

Sculptures of similar form with much
enlarged heads and comparable inlaid
features (such as one in the National
Museum of Man at Ottawa IV. G. 13),
have been found as far away as the
Diomede Islands in Bering Strait.

C. D. L.
Illustrated in color

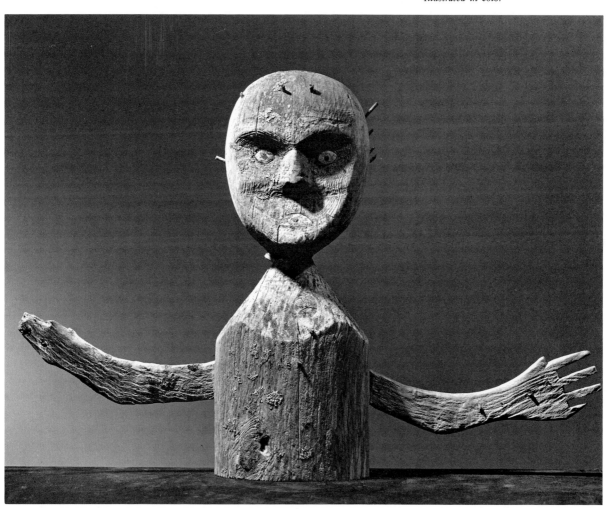

161 MASK: SHAMAN'S SPIRIT
 ASTRIDE A BEAVER
Wood, with white, red, green and
 black pigment, jaeger feathers, willow
 bands, gut fiber lashings, and twine.
88.9 (35) LONG
Lower Kuskokwim River; inscribed
 with the date "September 1881"
Hamburgisches Museum für
 Völkerkunde und Vorgeschichte,
 36:52:1

The exposed body of the shaman's
helpful spirit, split open to show its
internal organs, is typical of the
Eskimos of the Lower Kuskokwim.
The expressive use of paint, with a
sea-green for the beaver, white for the
spirit figure, and red for its innards, is
heightened by the graphic use of black
for outlining. Also attached to the rim
of the mask are four feathered ap-
pendages suggestive of the animal's
limbs. In addition, two feathered
paddles rise from the spirit's shoulders.

Wolfgang Haberland, *Nordamerika, In-
dianer, Eskimo, Westindien* (Baden-Baden:
Holle Verlag, 1965), p. 39.

F. de L.

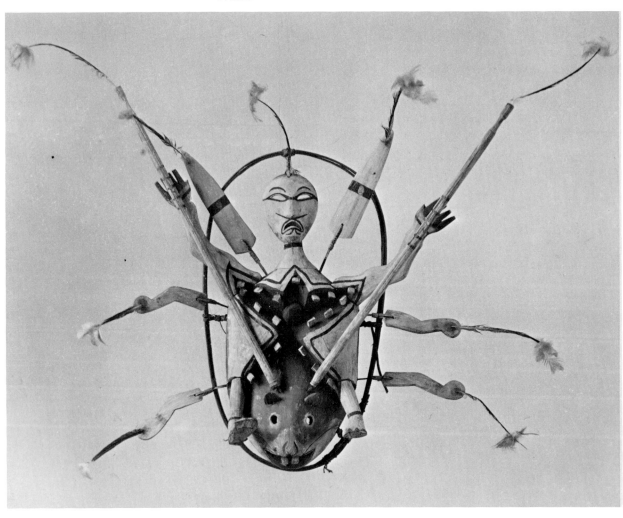

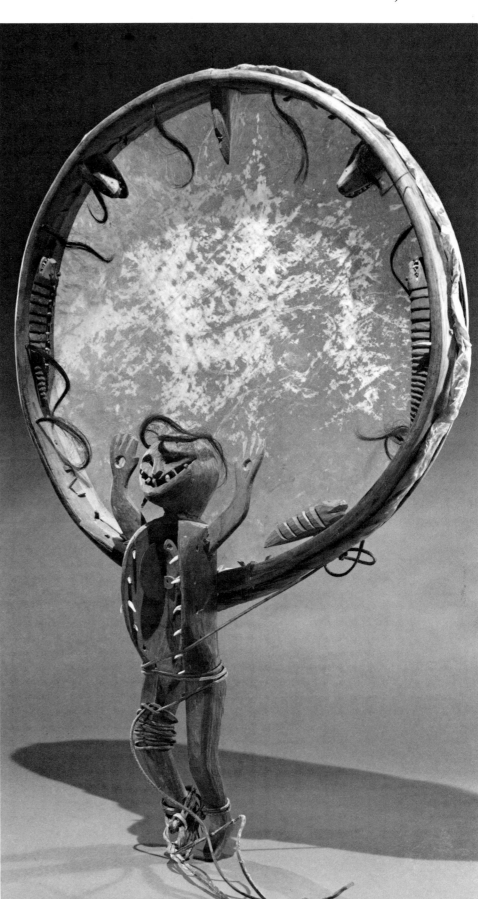

162 SHAMAN'S DRUM WITH
 SPIRIT FIGURE
Wood, with red and black pigment,
 walrus stomach, human hair, animal
 teeth, fiber and rawhide lashings and
 straps
83 (32 3/4) HIGH
Lower Yukon or Kuskokwim River ?
Presumably collected by Rev. Sheldon
 Jackson in the late 19th century
Sheldon Jackson Museum 2.X.24

The exposed body of the shaman's
spirit relates interestingly to the pre-
ceding example, while its materials and
techniques also resemble Eskimo
images from Andreafsky and Norton
Sound.

C. D. L.

163 MASK*

Wood, with white, black and red
 pigment, willow bands, brown
 feathers, baleen and fiber lashings
70.5 (27 3/4) HIGH
Lower Kuskokwim River or Bristol
 Bay?
Formerly in the collections of the
 Museum of the American Indian,
 Heye Foundation (15/4343) and
 Claude Lévi-Strauss
Museum of Primitive Art, 63.167

The form and position of the strongly
projecting bird's head recall examples
(such as No. 156) from Norton
Sound; but the bolder and heavier
elements of this mask are generally
closer to those of the Kuskokwim
spirit-and-beaver mask, (No. 161) as
well as to No. 164 probably from
Nushagak on Bristol Bay.

C. D. L.

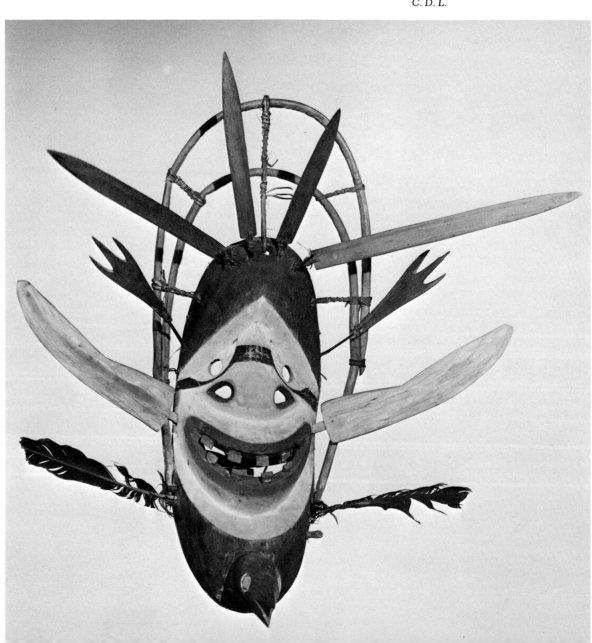

164 MASK

Wood, with white, black and red
 pigment, willow bands, ivory, baleen
 strips, gut, and vegetable fiber
64 (25 1/4) HIGH
Collected (in the region of Nushagak
 Bay?) before 1898
Donated by the Alaska Commercial
 Company (successor to the Russian
 American Company)
Robert H. Lowie Museum of
 Anthropology, 2-5852

This mask probably represents a
shaman's walrus spirit.

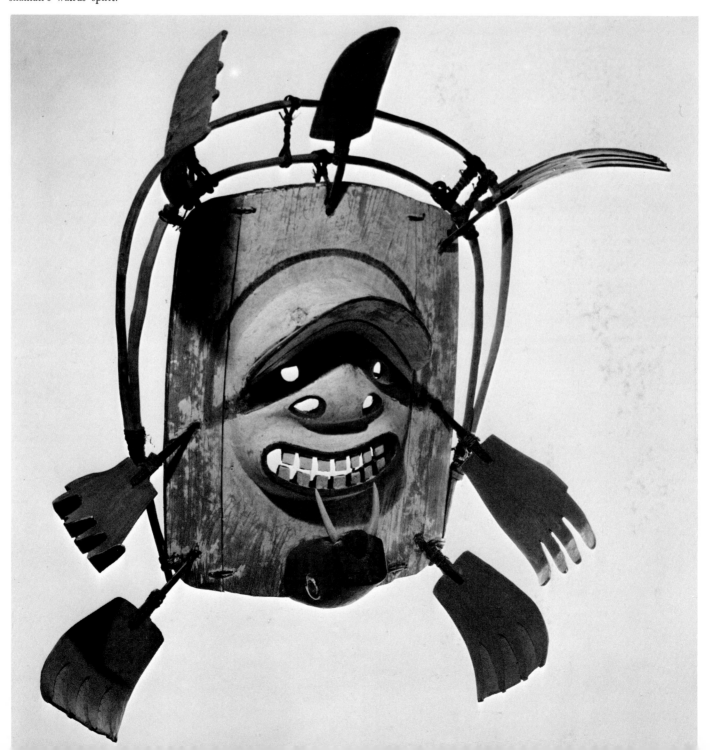

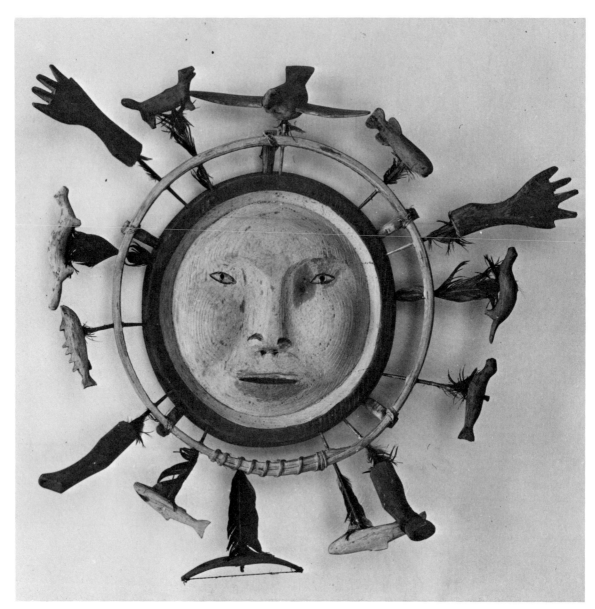

166 MASK
Wood, with red, green and black
 pigment, black feathers
66 (26) HIGH
Collected on Nunivak Island by Knud
 Rasmussen
Danish National Museum, P.33.109

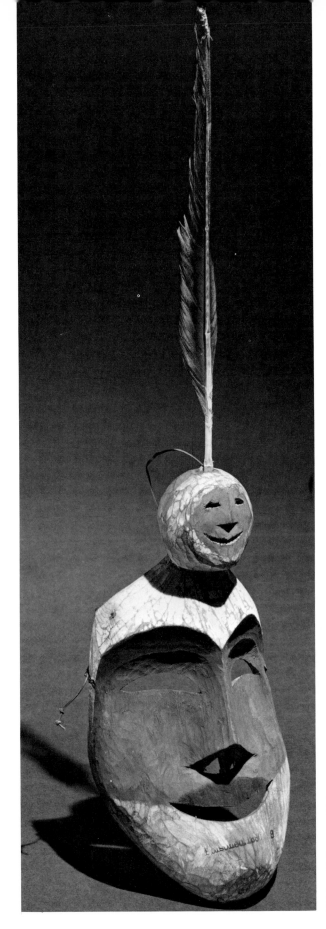

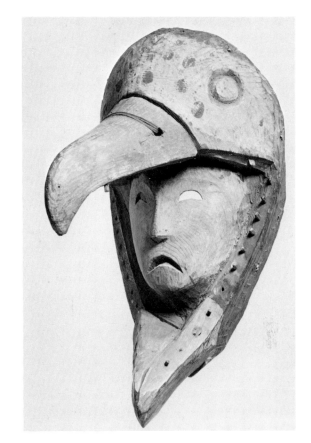

165 MASK
Wood, with white and red pigment
 and seal-gut lashing
38 (15) HIGH
Probably collected c. 1880
Donated by the Alaska Commercial
 Company
Robert H. Lowie Museum of
 Anthropology, 2-4597

The concept of this mask, with a
spirit face looking out from a bird's
head, is similar to that of the gannet
mask from St. Michael (No. 156).
The present example, once embellished
with feather plumes at the top, also
exhibits the speckled fingertip-painting
typical of that area (see Nos. 147–
149).

C. D. L.

167 MASK*
Wood, with red, black and white
 pigment, black feather, gut and
 fiber strips
63.5 (25) HIGH
Collected at Cape Vancouver (Nelson
 Island) by E. W. Nelson
Museum collection, December 1880
Smithsonian Institution, 43 772

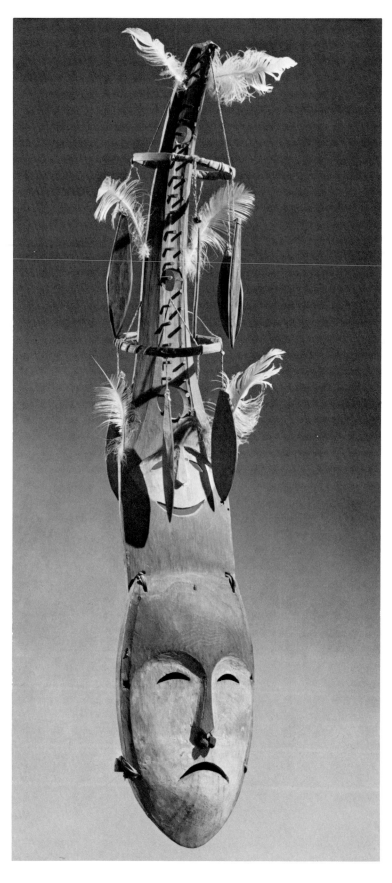

168 MASK
Wood, with white, red and green
 pigment, willow bands, rawhide
 lashings, eagle down, trade beads, and
 twine
71 (28) HIGH
Collected at Andreafsky by Rev.
 Sheldon Jackson, 1893
Sheldon Jackson Museum, II.B.47

This mask depicts a shaman's(?) face
with crest of smaller face and elaborate
headdress. The headdress is repeated in
No. 169, while the form of the face
compares closely with that of an
Ingalik Athabaskan mask, No. 181.

C. D. L.

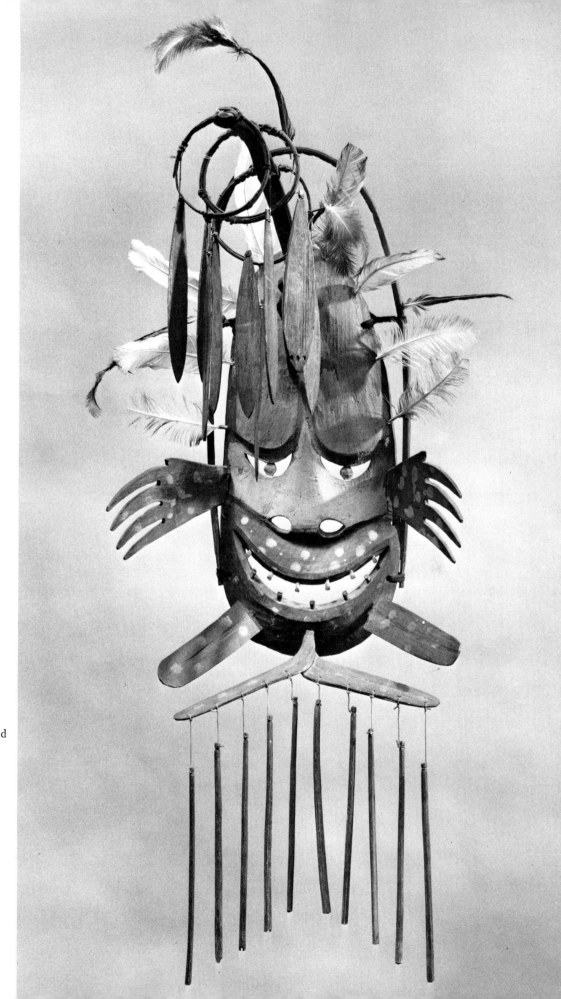

169 MASK*
Wood, with black, red and ochre
 pigment, willow bands, sea gull and
 jaeger feathers with eagle down,
 vegetable fiber and twine lashings
113 (44 1/2) HIGH
Formerly in the collection of the
 Museum of the American Indian,
 Heye Foundation (9/3393)
Museum of Primitive Art, 61.39

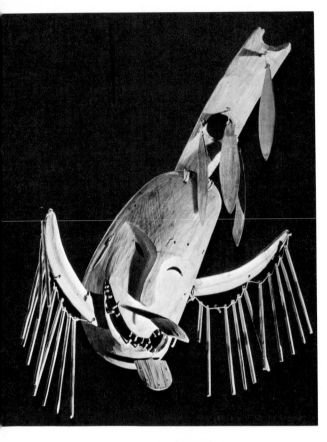

172 MASK
Wood, with red, black and white
 pigment, vegetable fiber, and twine
61 (24) HIGH (top of headdress
 broken off)
Collected at Andreafsky by Rev.
 Sheldon Jackson, 1893
Sheldon Jackson Museum, II.B.45

This mask combines elements of the
pendant hoop headdresses from Nos.
168 and 169, together with the lateral
wings and feather decorations found
also on Athabaskan Indian examples
from Anvik and the Innoko River, such
as Nos. 177 and 181.

C. D. L.
Illustrated in color

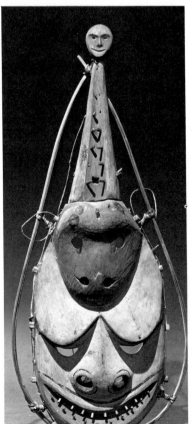

170 MASK*
Wood, with red, green, black and
 ochre pigment, willow band, vegetable
 fiber, gut strips, and rawhide strap
77.5 (30 1/2) HIGH
Collected south of the Lower Yukon
 River by E. W. Nelson
Museum collection, 6 November 1878
Smithsonian Institution, 33 104

This mask depicts a face with crest of
animal head, an elongated body and
smaller face. Although the original
cataloger's inscription assigns this mask
to "Norton Sound," it shares many
characteristics with the shaman's spirit
and beaver mask from the Lower
Kuskokwim River (No. 161), which
lies directly south of the Lower Yukon.

C. D. L.
Illustrated in color

171 MASK*
Wood, with red, green, black and
 ochre pigment, willow bands,
 vegetable fiber, and gut strips
48.5 (19 1/4) HIGH
Collected in western Alaska by E. W.
 Nelson
Museum collection, 6 November 1878
Smithsonian Institution, 33 114

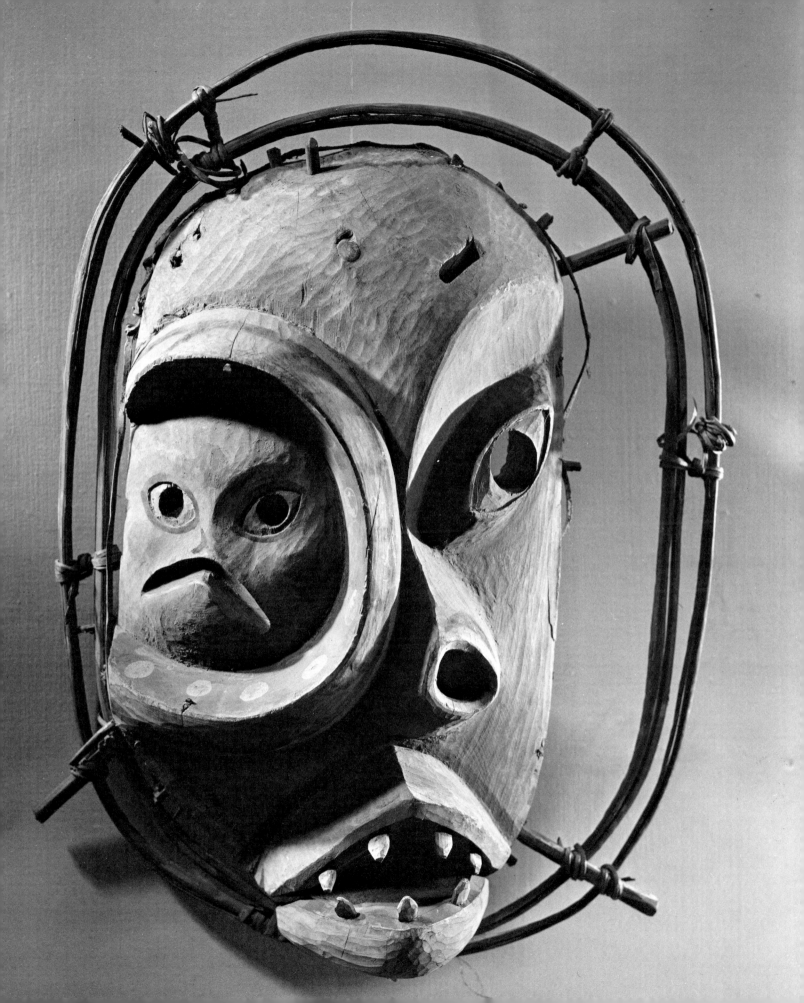

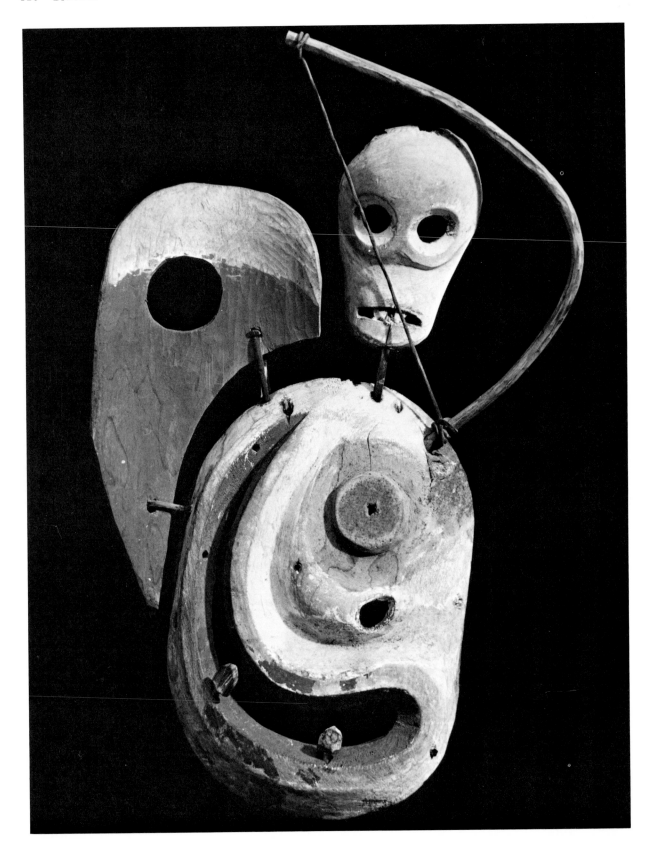

173 MASK
Wood, with white, red, green and
 black pigment, vegetable fiber and
 rawhide lashings
42.2 (16 5/8) HIGH
Collected on the Lower Yukon River,
 presumably from the vicinity of
 Andreafsky, before 1898
Donated by the Alaska Commercial
 Company
Robert H. Lowie Museum of
 Anthropology, 2-5854

This celebrated mask, one of the best
known and most admired works of
Eskimo art, may perhaps be associated
with the Andreafsky region through
certain parallels with No. 172, al-
though it may well surpass any of the
documented works from that region.

C. D. L.

174 MASK
Wood, with black, white and red
 pigment, jaeger feather, and gut strip
35.5 (14) HIGH
Collected (presumably in the region of
 Andreafsky) before 1898
Donated by the Alaska Commercial
 Company
Robert H. Lowie Museum of
 Anthropology, 2-6442

This teardrop-shape mask shows a face
in a circle. The mask's features, re-
ducing the human face to a series of
geometric shapes which complement
their enclosing circle, recall the two
preceding examples.

C. D. L.

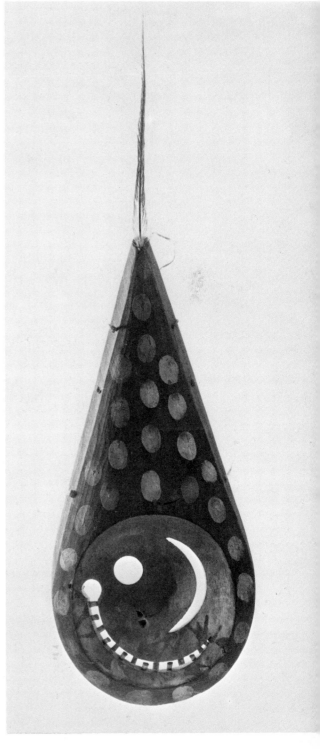

175 MASK
Wood, with gray-green and red
 pigment, sea gull feathers, and braided
 fiber hanging strap
82 (32 1/4) HIGH
Collected at Andreafsky by Rev.
 Sheldon Jackson, 1893
Sheldon Jackson Museum, 2.B.74

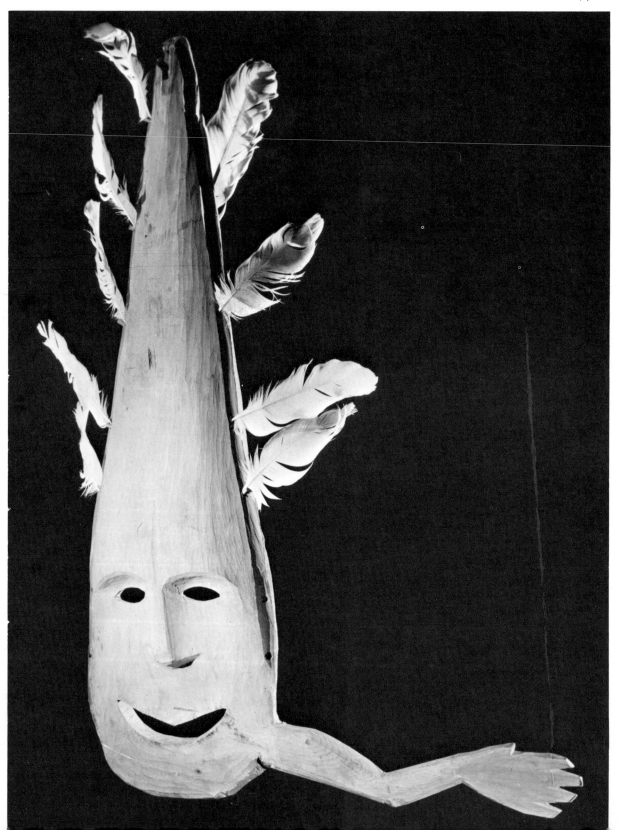

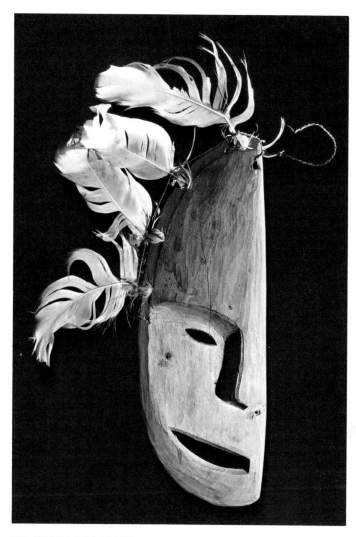

176 HALF-MAN MASK
Wood, with red and blue-green
pigment, sea gull feathers, and
braided fiber
35 (13 3/4) HIGH
Collected at Andreafsky by Rev.
 Sheldon Jackson, 1893
Sheldon Jackson Museum, 2.B.11

The very existence of these "half-
masks," (discounted by some modern
students as halves of complete masks),
is here affirmed by two examples, quite
obviously carved in this form, from
both the Eskimo region of Andreafsky
and the Ingalik Indian area of Anvik.
The present Eskimo example exhibits
certain aspects of No. 175.

C. D. L.

REFERENCES

Bank, Theodore P. "Cultural Succession in the Aleutians." *American Antiquity*, 19, (1953), no. 1, pp. 40–9.

Collins, Henry B. *Prehistoric Art of the Alaskan Eskimo.* Smithsonian Miscellaneous Collections, 81, Washington, D.C., (1929), no. 14.

——. *An Okvik Artifact from Southwest Alaska and Stylistic Resemblances between Early Eskimo and Palaeolithic Art.* Polar Notes. Occasional Publications of the Stefansson Collection, Dartmouth College Library. Hanover, N.H., 1959, pp. 13–27.

Ford, James A. *Eskimo Prehistory in the Vicinity of Point Barrow, Alaska.* Anthropological Papers, American Museum of Natural History, New York, 47, (1959), part 1.

Geist, Otto W. and Froelich Rainey. *Archaeological Excavations at Kukulik, St. Lawrence Island, Alaska.* Miscellaneous Papers, University of Alaska, 2, (1936). Washington, D.C.: U.S. Department of the Interior.

Giddings, J. Louis. "Cultural Continuities of Eskimos." *American Antiquity*, 27, (1961), no. 2, pp. 155–73.

——. *Ancient Men of the Arctic.* New York: Alfred A. Knopf, 1967.

Hoffman, W. J. *The Graphic Art of the Eskimos.* U.S. National Museum Annual Report for 1895. Washington, D.C., 1897.

Hrdlička, Aleš. *The Anthropology of Kodiak Island.* Wistar Institute of Anatomy and Biology. Philadelphia, 1944.

——. *The Aleutian and Commander Islands and their Inhabitants.* Wistar Institute of Anatomy and Biology. Philadelphia, 1945.

Ivanov, S.V. "Aleut Hunting Headgear and its Ornamentation." *Proceedings of the 23rd International Congress of Americanists.* New York, 1930, pp. 477–504.

Jochelson, Waldemar. *Archaeological Investigations in the Aleutian Islands.* Carnegie Institution of Washington. Publication No. 367. Washington, D.C., 1925.

de Laguna, Frederica. "A Comparison of Eskimo and Palaeolithic Art." *American Journal of Archaeology*, 36, (1932), no. 4, pp. 477–511; 37, (1933), no. 1, pp. 77–107.

Lantis, Margaret. *Alaskan Eskimo Ceremonialism.* American Ethnological Society, Monograph 11. New York: J. J. Augustin, 1947.

Larsen, Helge. "Archaeological Investigations in Southwestern Alaska." *American Antiquity*, 15, (1950), no. 3, pp. 177–86.

Laughlin, William S. *The Aleut-Eskimo Community.* Anthropological Papers, University of Alaska, 1, (1952), no. 1, pp. 25–46.

——. "Neo-Aleut and Paleo-Aleut Prehistory." *Proceedings of the 32nd International Congress of Americanists.* Copenhagen, 1958, pp. 516–30.

Lot-Falck, Eveline. "Les Masques Eskimo et Aléoutes de la Collection Pinart." *Journal de la Société des Américanistes*, n.s., 46, (1957), pp. 5–43.

Murdock, John. *Ethnological Results of the Point Barrow Expedition.* 9th Annual Report, Smithsonian Institution, Bureau of American Ethnology. Washington, D.C., 1892.

Oswalt, Wendell H. "Traditional Storyknife Tales of Yuk Girls." *Proceedings, American Philosophical Society*, 108, (1964), no. 4, pp. 310–36.

——. *Alaskan Eskimos.* San Francisco: Chandler Publishing Co., 1967.

Ray, Dorothy Jean. *Artists of the Tundra and the Sea.* Seattle: University of Washington Press, 1961.

——. *Eskimo Masks: Art and Ceremony.* Seattle: University of Washington Press, 1967.

Rudenko, S.I. *The Ancient Culture of the Bering Sea and the Eskimo Problem.* Anthropology of the North: Translations from Russian Sources, no. 1. Arctic Institute of North America, 1961.

Spaulding, Albert C. *The Current Status of Aleutian Archaeology.* Memoir 9, Society for American Archaeology, 1953, pp. 29–31.

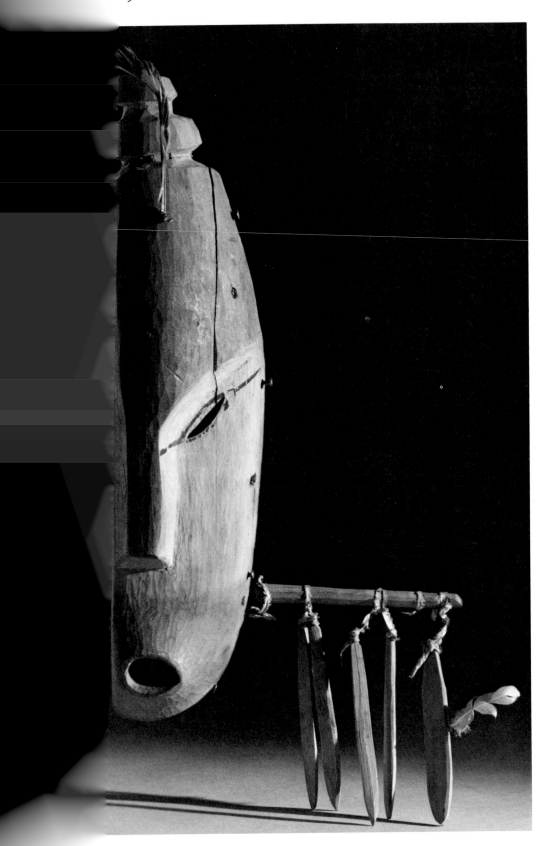

177 HALF-MAN MASK
Wood, with red, gray and black
 pigment, brown and gray feathers,
 skin lashings, and nails
68 (26 3/4) HIGH
Ingalik
Collected at Anvik on the Lower
 Yukon River by J. W. Chapman,
 1903
American Museum of Natural History,
 60/5118

This mask represents the mythical
Half-Man (or "Half-Face"), a tradi-
tional figure in the Ingalik Mask
Dance. Two figures, wearing masks
that are identical, dance together. The
Half-Man, who lives in the mountains,
uses a crutch, for he has only one arm
and one leg. Despite this handicap, he
is supposedly the greatest hunter and
consequently the richest man.

F. de L.

This mask exemplifies the formal
characteristics which bind it to the
Eskimo art downriver to the west: the
conical, puckered mouth may be com-
pared to Nos. 148 and 151–152, while
the wing with pendant feathers recalls
No. 172, and the form closely
parallels No. 176.

C. D. L.

ATHABASKAN ART

Ingalik, Athabaskans of the middle and lower Yukon River,
the Innoko River, and the Kuskokwim.

FREDERICA DE LAGUNA

THESE Athabaskan tribes are unusual in having adopted many of their ceremonial and social customs from the neighboring Eskimo of the lower Yukon and Norton Sound, with whom they traded. Thus, they have abandoned the clan system, based on matrilineal descent, which is characteristic of the other Athabaskan tribes of Alaska, adopting instead a bilateral family structure like that of the Eskimo. They build *kashims*, large buildings which serve as halls in which guests are entertained, dances and feasts given, and which the men of the village use as a club house. In their most important ceremonies, they make use of rather elaborate paraphernalia, including masks. In style, these are very hard to distinguish from those of their Eskimo neighbors, although the latter are on the whole more elaborate.

The masks used by the Ingalik are of three kinds: small forehead masks worn by messengers sent to invite guests from a nearby village, finger masks held by women when dancing with the men, and large masks covering the whole face. The latter are carved and worn only by men, although they may represent such traditional mythological figures as Dog Salmon Woman or Berry Woman. In the great mask dance, formerly given several times a year to honor the animals, to amuse guests, and to win prestige for those who distribute gifts, there are more serious masks, carved by men who have dreamed of the animal or mythical character depicted. One of the subjects for such a mask is the Half-Man, who lives in the mountains, and uses a crutch because he is missing one arm and one leg. There are also fundamentally humorous masks, such as those representing the rather ignorant, unsophisticated "Up-River Indians," or even modern subjects like a "Russian," or an "Outside Indian." Such characters appear and dance between the more serious performances.

Some masks are so heavy that they have a wooden crosspiece to be grasped in the teeth, in addition to the cords around the head. Narrow masks may lack eyeholes, the performer being able to peer around the edge of the mask. For each mask, or set of masks, songs are composed and the accompanying dances are carefully rehearsed. Such songs, like the masks, are theoretically composed by the dreamer, but most of the songs and dances are traditional, like the characters appearing in their dreams.

Masks representing birds or animals are frequently decorated with feathers, or small legs and wings attached in incongruous places. The human face in the center of many masks represents the creature's anthropomorphic soul.

133

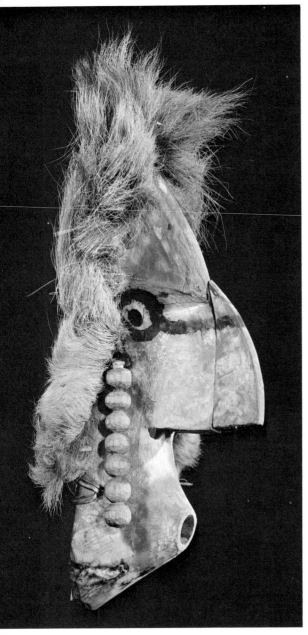

Ceremonies may also include large hollow wooden figures of animals or fish with a lighted lamp inside that are pulled across the *kashim* on wires. Instead of masks, shamans may use stuffed animals or stuffed birds in this way.

Many of the older ceremonies have been abandoned and there seems to be a tendency to combine feasts in honor of the dead with ceremonies in honor of the animals. In such cases, small clay lamps are lit in memory of each deceased person for whom the ceremony is given. Dancing is to the beat of tambourine drums.

Although fire can be used in shaping the block of green spruce from which masks are carved, the shavings and the mask itself, if discarded, must never be burned. When not in use they are usually stored in the owner's cache. Because one cache full of masks at Hologochaket on the Innoko River collapsed, the old masks were thrown away, and a new set made. It was for this reason that I was able to secure the discarded masks and photograph their replacements in 1935.

John W. Chapman, "Notes on the Tinneh Tribe of Anvik," *Congrès International des Américanistes*, 15e Session, 1906. Quebec, 2, (1907), pp. 14–38.

Cornelius Osgood, *Ingalik Material Culture*, Yale University Publications in Anthropology, no. 22, 1940; Cornelius Osgood, *Ingalik Social Culture*, Yale University Publications in Anthropology, no. 53.

Frederica de Laguna, "Indian Masks from the Lower Yukon," *American Anthropologist* 38 (1936) 4, pp. 569–85, pl. 17–20. figs. 1–3.

178 MASK
Wood, with gray, black, red, yellow
and white pigment, skin, vegetable
fiber, wolf's hair, string, and nails
66 (26) HIGH
Ingalik
Collected at Anvik by J. W. Chapman,
1903
American Museum of Natural History,
60/5093
Illustrated in color

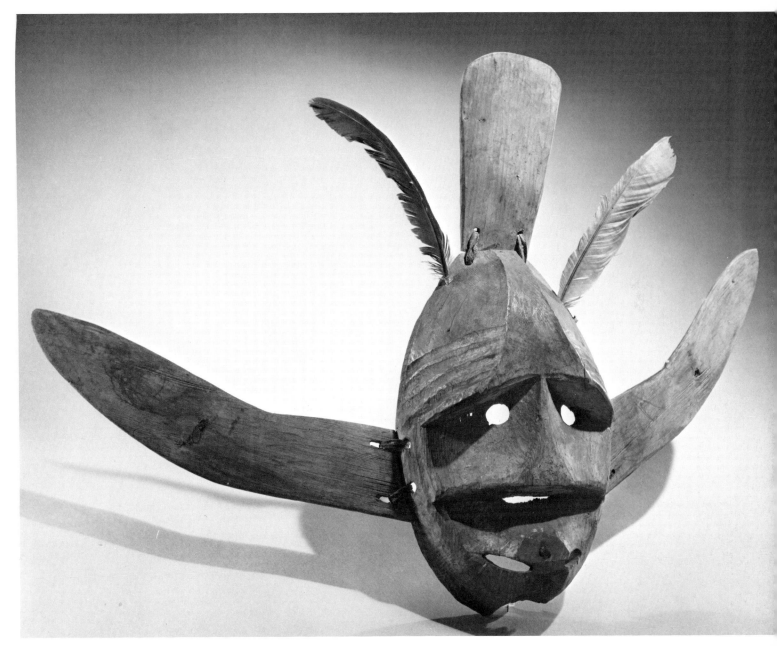

179 MASK
Wood, with gray, brown and white
 pigment, vegetable fibers (partly re-
 placed with rawhide), and feathers
63.5 (25) WIDE
Ingalik
Collected at Anvik by J. W. Chapman,
 1903
American Museum of Natural History,
 60/5114

This mask, with wings and a crest,
resembles the classic Koniag and
Chugach masks from the southern
coast: another indication of the wide
range of Eskimo prototypes emulated
by their Indian neighbors.

C. D. L.

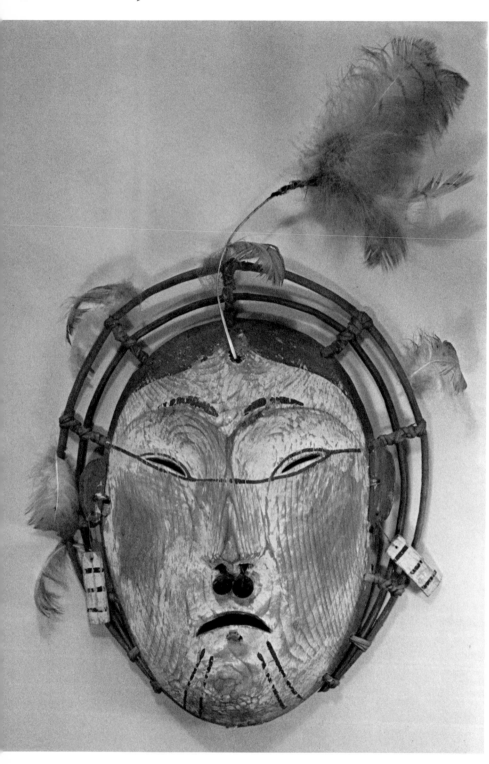

181 MASK
Wood, with white and black pigment,
 willow bands, vegetable fiber, white
 feathers, and trade beads
37 (14 1/2) HIGH
Ingalik
Collected from the Indian village at
 Kozherevsky, left bank of the Yukon
 opposite Holy Cross, by Father
 Barnum, 1893
Sheldon Jackson Museum, II.L.1

This mask depicts a shaman's(?) face
with tattoo lines and nose beads. A
contemporary inscription inside calls
the beads "labrets," and the ear
pendants "magic feathers." The face
closely recalls another Andreafsky
type, represented in No. 168.

C. D. L.

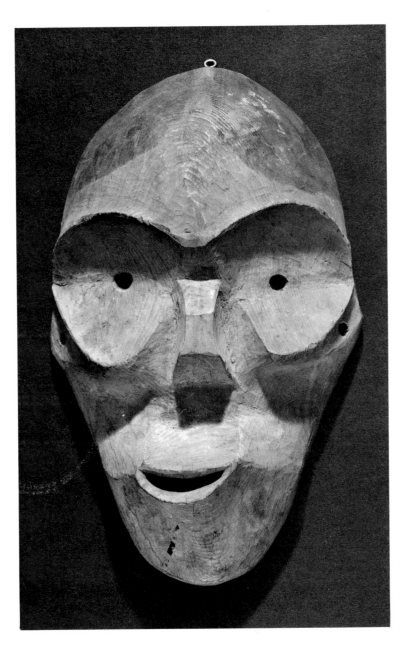

180 MASK REPRESENTING
 MOTHER OF THE
 MOSQUITOES"
Wood, with black and brown pigment
27.3 (10 3/4) HIGH
Ingalik
Collected at Anvik by J. W. Chapman,
 1903
American Museum of Natural History,
 60/5110

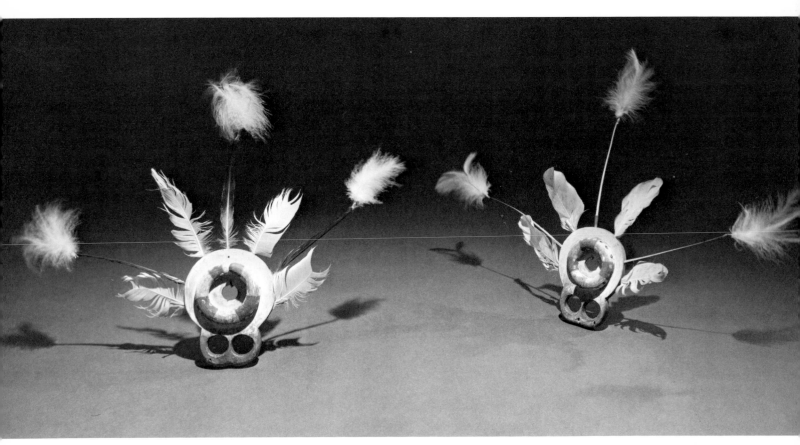

182 PAIR OF FINGER MASKS
Wood, with white, blue-gray and red
 pigment, sea gull feathers, and eagle
 down
a: 56 (22) WIDE
b: 51 (20) WIDE
Ingalik
Collected at Anvik by Rev. Sheldon
 Jackson, c. 1893
Sheldon Jackson Museum, II.F.2

183 MASK
Wood, with white, black and red
 pigment, sea gull feathers, and gut
 strap
34.5 (13 5/8) HIGH
Ingalik
Lower Yukon or Innoko Rivers
Museum purchase (in Paris), 1936
Hamburgisches Museum für
 Völkerkunde und Vorgeschichte,
 36:52:6

This mask is apparently of Ingalik
manufacture, for use in the mask
dance, a ceremony held primarily to
honor and increase the numbers of
valuable animals.

According to Ingalik Indians at
Hologochaket on the Innoko who were
still giving this ceremony in 1935, one
of the dances in it was performed by a
masked figure representing the Dog
Salmon Woman who entered the
kashim, preceded by three men,
carrying a fish trap. She was flanked
by two men wearing masks representing
terns or sea gulls, birds that accom-
pany the salmon runs. The Dog
Salmon Woman dragged behind her a
stuffed loon, a bird that appears on
the Yukon after the salmon have
begun to ascend the river.

John W. Chapman, "Notes on the Tinneh
 Tribe," 15th International Congress of
 Americanists, Quebec, 1906, in *Comptes
 Rendu,* 1907, 2, pp. 7–38; Frederica de
 Laguna, "Indian Masks from the Lower
 Yukon," *American Anthropologist,* 38,
 (1936), pp. 569–85; Cornelius Osgood,
 Ingalik Social Culture, Yale University
 Publications in Anthropology no. 53, 1958.

F. de L.

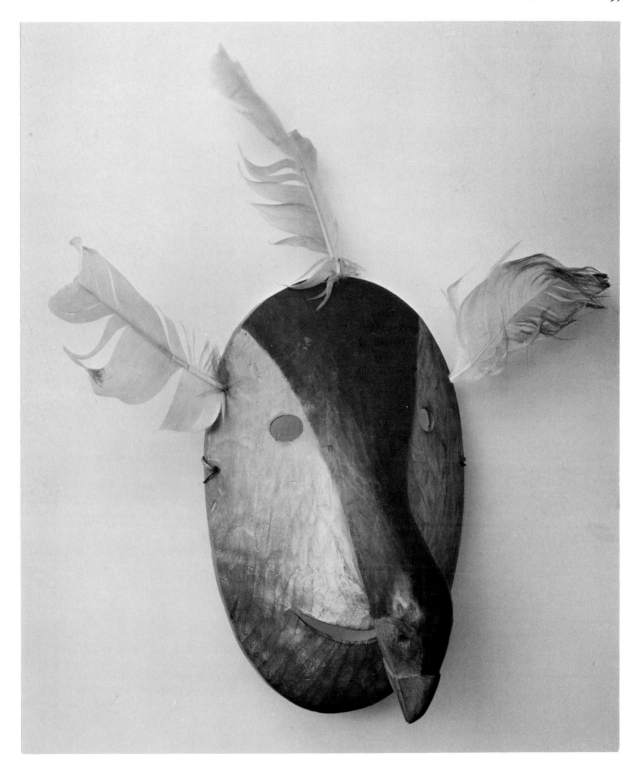

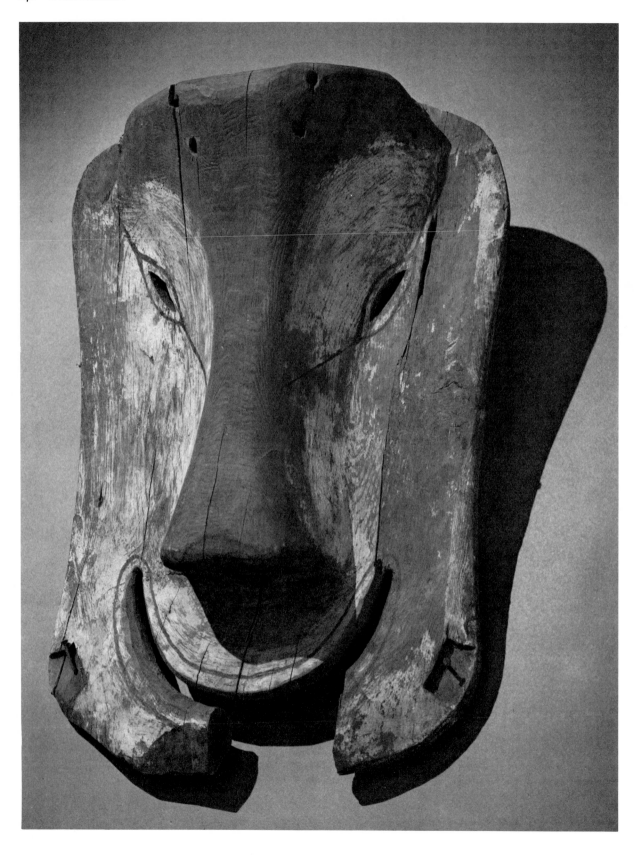

185 MASK PROBABLY
 REPRESENTING A
 "MOOSE-MAN"

Wood, with green, white and black
 pigment, remnants of willow pro-
 jections, and nails
48.5 (19 1/8) HIGH
Ingalik
Made by the master-carver Sunday at
 Hologochaket (Holikachuk) on the
 Innoko River; collected at Holikachuk
 by Frederica de Laguna, 1935
Museum Expedition collection, 1935
University Museum, Philadelphia,
 35-22-41

One of the dances performed in the
mask dance at Hologochaket was said
to have been performed by three
persons. One informant said that the
central dancer was a caribou, flanked
by two black bears; another said that
the central dancer was a moose and
that his partners were Moose-Men. The

mask in question belonged to the old
set that had been discarded, and while
identified by one Indian as representing
a black bear, it seems much more
likely that it was one of the Moose-
Men, especially when compared with
the new masks made to replace it.

These masks are large and heavy
and were supported by a headband
and by a crossbar, gripped in the
wearer's teeth. The eyeholes are too
high and far apart to be serviceable,
so that the wearer must have peered
out through the nostrils. A hole
through the septum suggests that a
pendant may have been attached here.

de Laguna, "Indian Masks from the Lower
Yukon," p. 583.

F. de L.

184 FIGURE
Wood, with red and black pigment,
 vegetable fiber reinforced with twine,
 and nails
60 (23 5/8) LONG
Ingalik
Collected at Anvik by Rev. Sheldon
 Jackson, c. 1893
Sheldon Jackson Museum, II.F.3

This carved figure represents a jaeger
or tern.

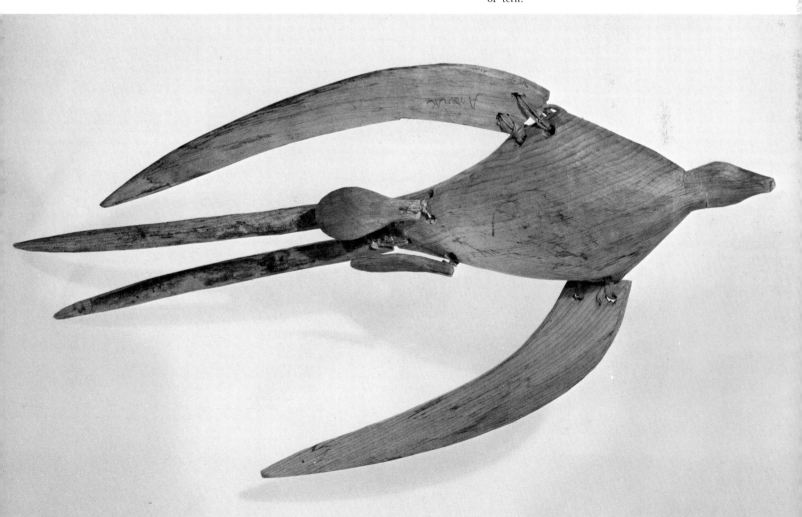

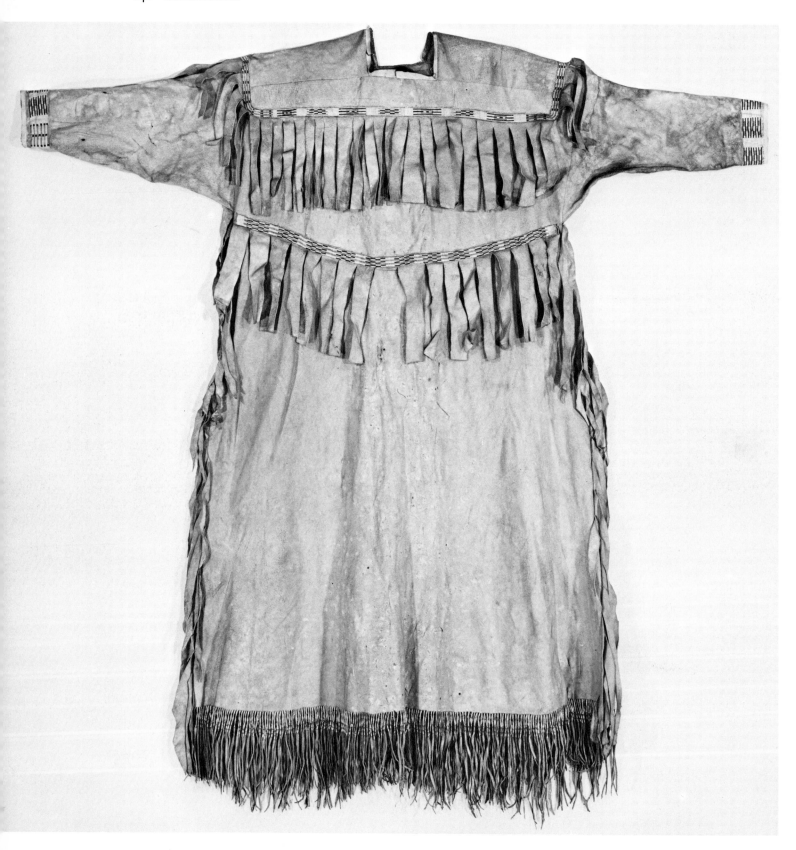

187 FRINGED TUNIC
Buckskin, white, black and brown
 porcupine quills, and thread
146 (57 1/2) HIGH
Tanaina
Collected by Arvid Adolph Etholén of
 Finland, Rear Admiral in the Imperial
 Russian Navy, and Administrator of
 Russian America, before 1847
National Museum of Finland, 174

186 PAIR OF FOX MASKS
Wood, with red, black and white
 pigment
54 (21 1/4) LONG
58 (22 7/8) LONG
Ingalik
Made by the master-carver Sunday at
 Hologochaket (Holikachuk) on the
 Innoko River; collected by Frederica
 de Laguna at Holikachuk, 1935
Museum Expedition collection, 1935
University Museum, Philadelphia,
 35.22.50; 35.22.51

This pair of masks, from which the
legs are missing, formed a set painted
to represent the red fox. The masks
were worn with the animals' heads
down. The round human face in the
center of the body represents the
animal's "spirit owner," or anthropo-
morphic soul.

They are very similar to a fox mask
made at Anvik on the Lower Yukon
River, except that the latter was worn
with the animal's head up. These
masks lack eyeholes, but are narrow
enough so that the dancer can look
around them.

de Laguna, "Indian Masks from the Lower
 Yukon," p. 582; Osgood, *Ingalik Social
 Culture*, fig. 11, upper R.

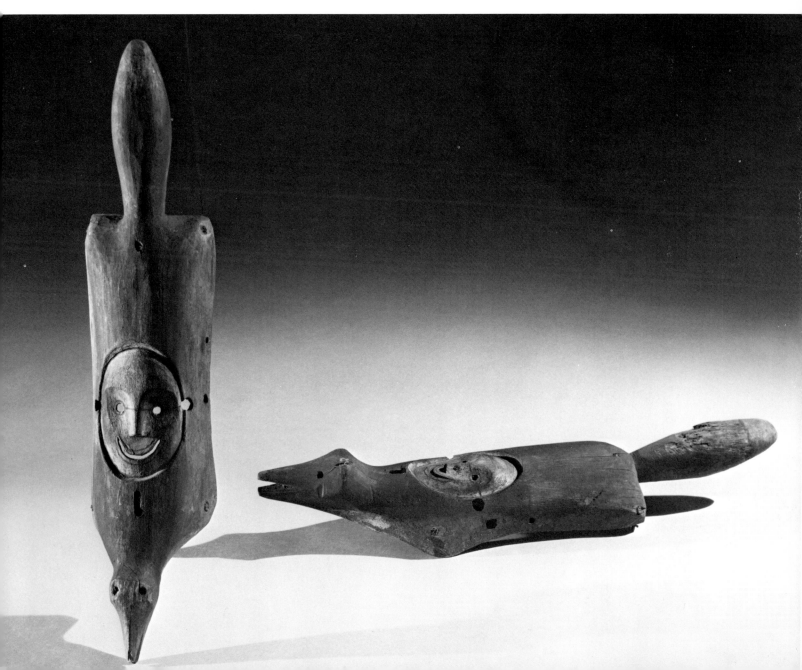

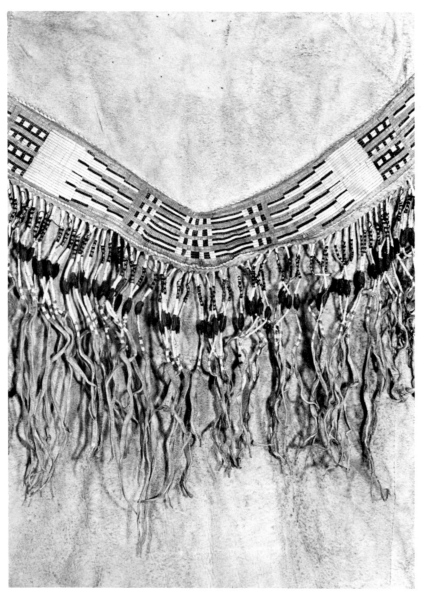

188 DECORATED GOWN
Buckskin, porcupine quills, seeds, fox
fur, eagle down, and thread
134 (52 3/4) HIGH
Tanaina
Collected on Kenai Peninsula (Cook
Inlet) by Arvid Adolph Etholén of
Finland, Rear Admiral in the Imperial
Russian Navy, and Administrator of
Russian America, before 1847
National Museum of Finland, 167

The pointed cut at the bottom of this
garment indicates that it probably came
from the upper part of Cook Inlet,
where women wore dresses of this
kind over combination footwear-
trousers.

The Helsinki collection also
possesses (173) an almost exactly
similar gown, slightly longer, with a
pattern of quill work decoration
almost identical with the preceding
example, but lacking the eagle-down
tufts which embellish the present
garment (fig. e).

Cornelius Osgood, *The Ethnography of the
Tanaina*, Yale University Publications in
Anthropology, 16, (New Haven: Yale Uni-
versity Press, 1937), esp. pl. 5, and pp.
46–7.

F. de L.

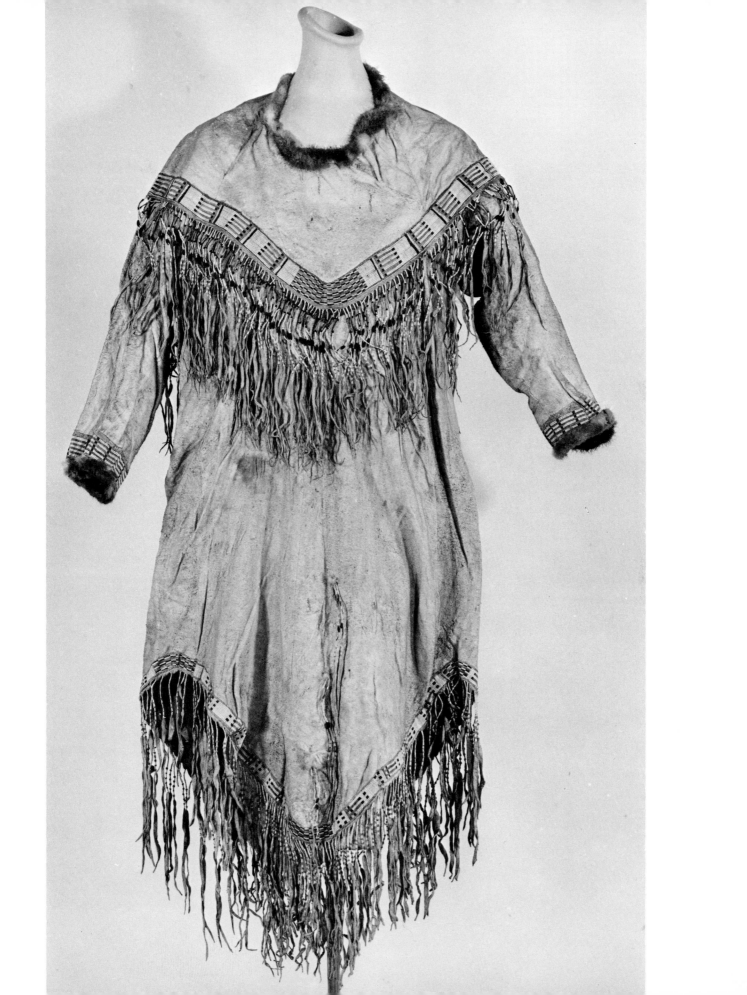

189 THREE-PIECE COSTUME
Tunic: Buckskin, porcupine quills,
 seeds, red pigment, eagle down,
 rabbit(?) skin at collar and cuffs,
 and fiber
143.5 (56 1/2) HIGH
Trousers: Buckskin, porcupine quills,
 fiber and trade buttons
120 (47 1/4) LONG
Hood: Buckskin, fragments of bird
 or fish(?) skin, porcupine quills,
 beads, red pigment, and fiber
63.5 (25) LONG
Tanaina
Kenai Peninsula (Cook Inlet)
Hamburgisches Museum für
 Völkerkunde und Vorgeschichte:
 37:35:2 (tunic), 37:35:4 (trousers),
 37:35:6 (hood)

These objects are without known
provenance or any data concerning the
collector. They resemble, nevertheless,
garments of the Tanaina Athabaskans,
especially of the upper part of Cook
Inlet, where the bottoms of the coats
or shirts are cut into points in front
and behind and where elaborate
decoration in the form of porcupine
quill work and fringing is common.

The coat resembles one illustrated
by Osgood (1937, pl. 5, C); the
trousers with decorative stripe and
garterlike attachments are also like a
pair (pl. 4, A) from Knik on the
upper Inlet, except that the latter have
hard soles and these apparently lack
soles (presumably cut out because they
were worn). Osgood's trousers are for
a woman and are in the Staatliches
Museum für Völkerkunde in Berlin
(IV-A-6146), collected at Knik in
1883 (probably by Captain Jacobsen).

The hood resembles one also illus-
trated by Osgood (1937, pl. 3, F)
like the shirt now in the Washington
State Museum, Seattle. The fringes
are to protect the neck from
mosquitoes.

Osgood, *The Ethnography of the Tanaina.*
F. de L.

190 THREE-PIECE COSTUME*
Tunic: Suede buckskin, white and dyed
 porcupine quills, seeds, and fiber
132 (52) HIGH
Trousers with attached moccasins:
 Suede buckskin, porcupine quills,
 polychrome fibers
123 (48 1/2) LONG
Hood: Suede buckskin, white and dyed
 porcupine quills, beads, and fiber
51 (20) LONG
Collected (presumably from the
 Kutchin Indians) on the Mackenzie
 River, by Bernard R. Ross
Gift of the collector, 13 June 1925
Smithsonian Institution: 328 766
 (tunic), 328 767 (trousers with
 moccasins), 328 768 (hood)

Although it is not certain this
costume was produced by the Kutchin
Indians based in Alaska, it appropri-
ately represents the high quality of
such work produced by the large
Kutchin population in Alaska, as well
as in the Yukon and Northwest
Territories. A parallel costume, similar
in design and execution to the
Smithsonian example, is in the collec-
tion of the American Museum of
Natural History (Caspar Whitney
collection, gift of Mrs. Morgan
Wing Jr., 1949 (fig. f).

C. D. L.

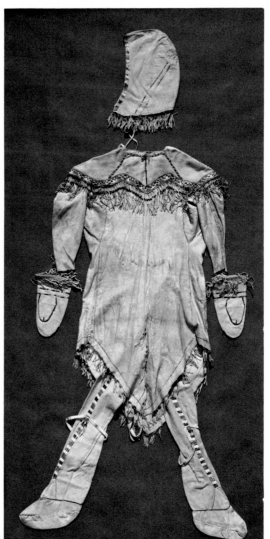

figure f

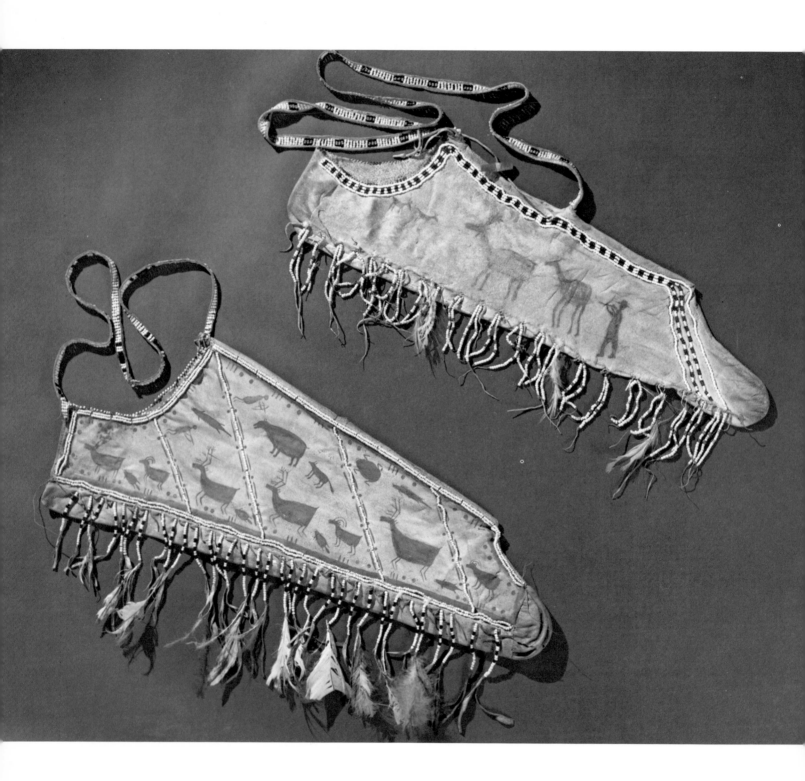

191 TUNIC WITH BEADWORK
 DECORATION
Buckskin, fox fur, porcupine quills,
 red pigment, trade beads
143.5 (56 1/2) HIGH
Hamburgisches Museum für
 Völkerkunde und Vorgeschichte,
 37:35:1

193 QUIVER
Buckskin, with red pigment, wood,
 feathers, rawhide and fiber lashings,
 trade beads, and thread
113 (44 1/2) LONG
Collected (probably in Cook Inlet) by
 Ewald Julius Schnieder, on the
 U.S.S. *Thetis*, 1888
Alaska State Museum, II.C.74

This quiver shows a man in a broad-
brimmed hat shooting at a hornless
cervid. Although the four animals have
been identified as caribou, the lack of
horns on the doe, and the beard on
the male (despite the faulty rendering
of the horns) suggest a pair of moose
and two fawns.

F. de L.

192 QUIVER
Buckskin, with red pigment, feathers,
 trade beads, braided fiber, twine, and
 wood support
110.5 (43 1/2) LONG
Hamburgisches Museum für
 Völkerkunde und Vorgeschichte,
 37:35:13

The painted decoration indicates a
hunter shooting with a gun at a cari-
bou, and with bow and arrow at a
bear; other animals are presumably
mountain sheep, beaver, fox, wolverine,
or other furbearers.

F. de L.

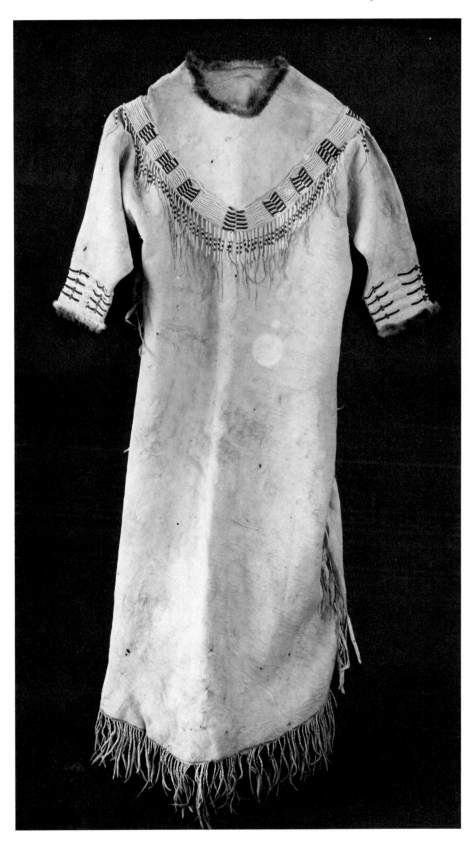

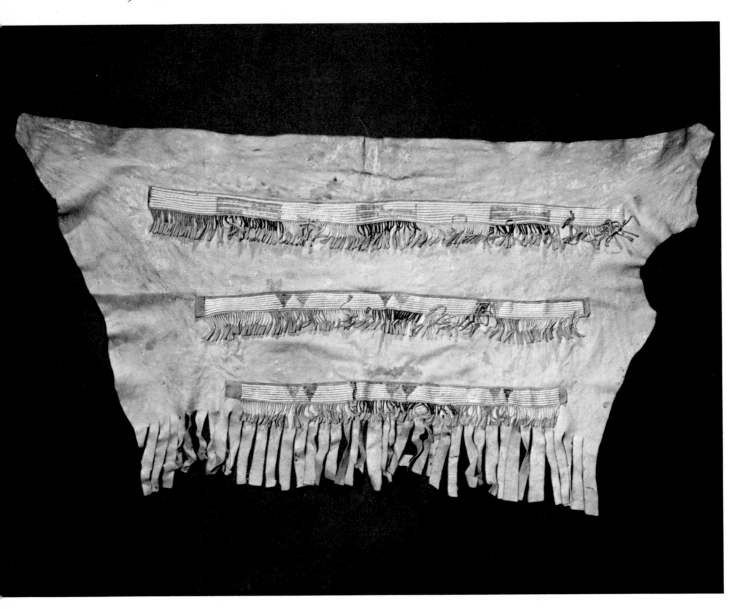

194 DANCE APRON
Buckskin, with white and dyed
 porcupine quills, red pigment, and
 thread
127 (50) LONG
Presumably collected by Rev. Sheldon
 Jackson in the late 19th century
Sheldon Jackson Museum, IV.X.12

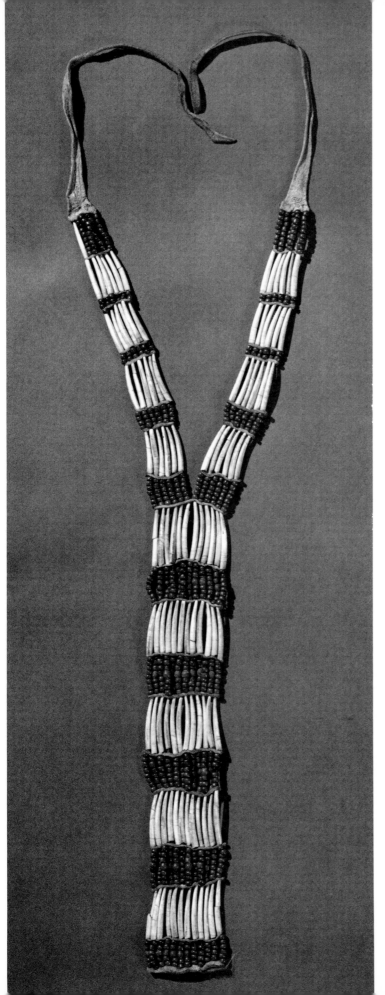

195 GIRL'S NECKLACE
Dentalium, skin strips, braided fiber,
 with trade beads
89 (35) LONG
Koyukon
Collected among the Koyukon Indians
 before 1840
Deutsches Ledermuseum,
 Offenbach, 12149

Arthur Speyer has postulated that this
necklace may have been worn by a
girl during her puberty confinement,
with a bone drinking tube attached
to the end, since she would have been
tabooed from drinking water except
from a tube (Bossert, 1929, p. 231,
no. 11).

Helga Benndorf and Arthur Speyer, *Indianer
 Nordamerikas 1760–1860*, (Offenbach:
 Deutsches Ledermuseum, 1968), p. 40.

F. de L.

198 DECORATED STRAP
Buckskin, with white and dyed
 porcupine quills, trade beads, and
 fiber
74 (29 1/8) LONG
Collected (probably among the
 Kutchin Indians) by Mrs. Cole J.
 Younger
Gift of Mrs. Charles D. Walcott,
 16 October 1940
Smithsonian Institution, 381 085

196 BRACELET OR
 DECORATIVE RING
Buckskin, with white and dyed
 porcupine quills, glass beads, and
 thread
5.4 (2 1/8) HIGH
Collected among the Koyukon or
 Kutchin Indians, perhaps at Fort
 Yukon, by J. W. Chapman, 1903
American Museum of Natural History,
 60/4943

197 PAIR OF BRACELETS OR
 DECORATIVE RINGS
Buckskin, with white and dyed
 porcupine quills, trade beads, and
 thread
5.1 (2) DIAMETER
Probably Kutchin Indian
Collected by W. H. Dall
Smithsonian Institution, 5 608

199 KNIFE SHEATH AND SLING
Buckskin, with white and dyed
 porcupine quills, dyed fibers, trade
 beads, and thread
99 (39) LONG
Collected between 1825 and 1845 by
 the Chichester Museum, England
Museum of the American Indian,
 Heye Foundation, 3/2895

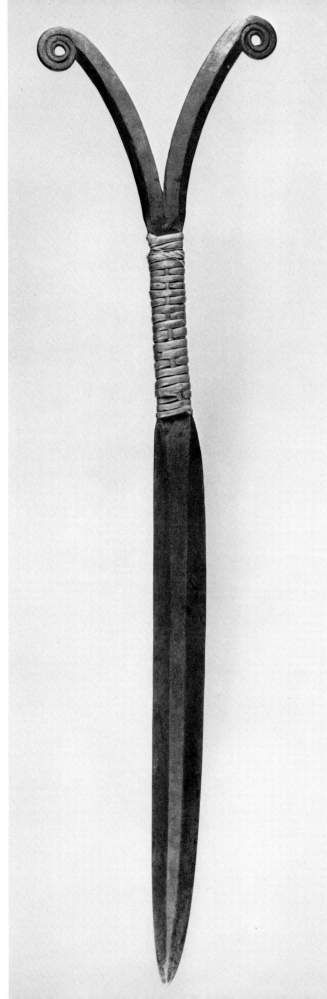

200 KNIFE*
Steel, with vegetable fiber, secured
 by twine
67.3 (26 1/2) LONG
Collected near the Arctic coast by
 Bernard R. Ross
Accessioned 28 December 1866
Smithsonian Institution, 2 024

This knife, inscribed "Esquimaux" on
the back, is one of the largest and
finest examples of the typical volute-
handled knives of the northern
Alaskan (and Canadian) Indians.

C. D. L.

201 KNIFE
Steel, with caribou hide grip, lashed
 with braided fiber
25 (9 7/8) LONG
Formerly in the collection of the
 University of Alaska Museum
 (UA 2033-2B)
Alaska State Museum

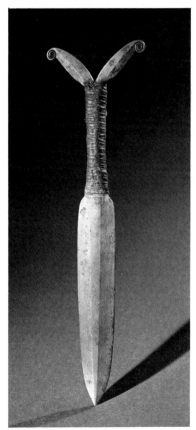

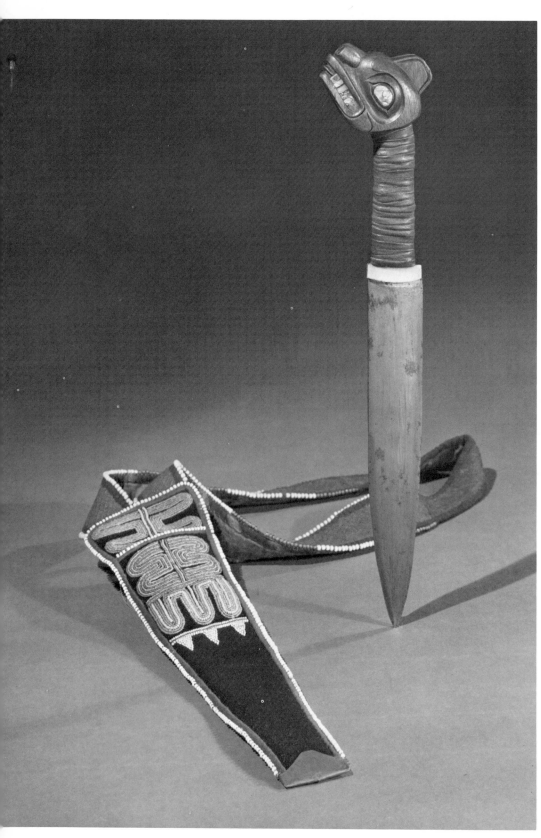

202 BEAR-HEAD DAGGER WITH SHEATH AND SLING

Dagger: Steel, ivory, wood with shell inlays, hide lashing
37.5 (14 3/4) LONG
Sheath: Buckskin back, with trade felt, blanket material with cotton backing and strips of trade gingham, polychrome beads, and copper
68.5 (27) LONG
Private collection, New York City

The appearance of "newness" of this early dagger testifies to the care and respect accorded works of art and historic treasures by the Tlingit, whose master artists worked flawlessly in wood, stone, and later, iron, silver, gold, and slate.

The blade comes from a Russian bayonet; the pommel is English walnut, probably from a musket stock, inlaid with abalone; the ivory guard and walrus hide grip were obtained from the Eskimo. The only material of local origin is deerskin used as backing on the sheath. Yet the entire ensemble is classic Tlingit art.

E. C.

203 OCTOPUS BAG

Trade felt, cotton backing, calico lining, polychrome trade beads, yarns, and thread
56 (22) LONG
Collected presumably among the Athabaskan Indians of Alaska, by Mrs. Charles D. Walcott
Gift of the collector,
20 November 1935
Smithsonian Institution, 373 747

Called octopus bags because of their tentaclelike appendages terminating in eight points, bags such as this and the following example were probably produced by the Athabaskan Indians although they were often collected among the coastal Indians such as the Tlingit, who prized them highly. The distinctive shape of the tentacles finds a documented Tlingit parallel in the ceremonial shirt made for "Sitka Jack" in 1877 (No. 274).

C. D. L.

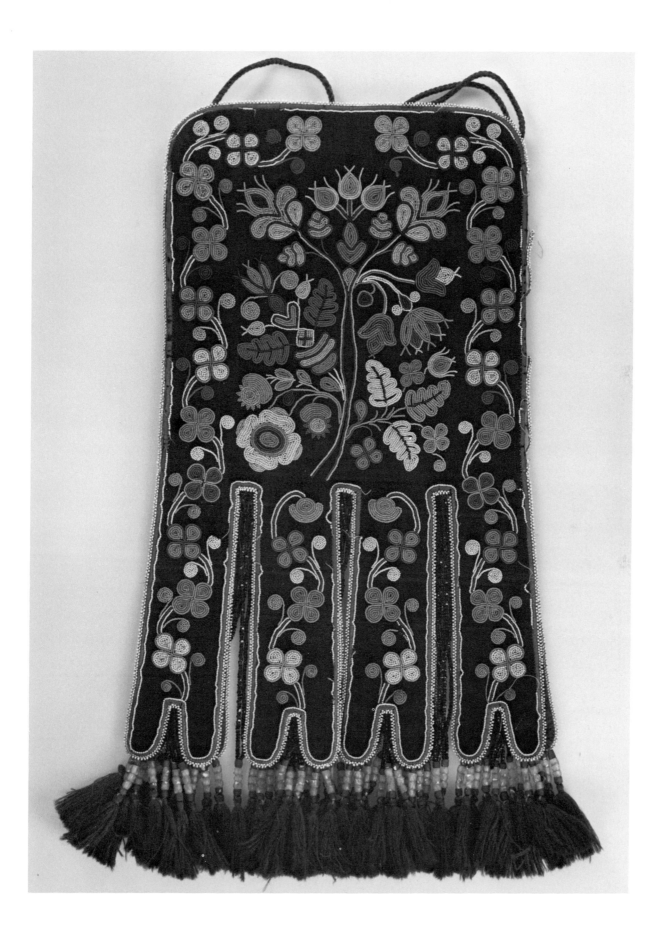

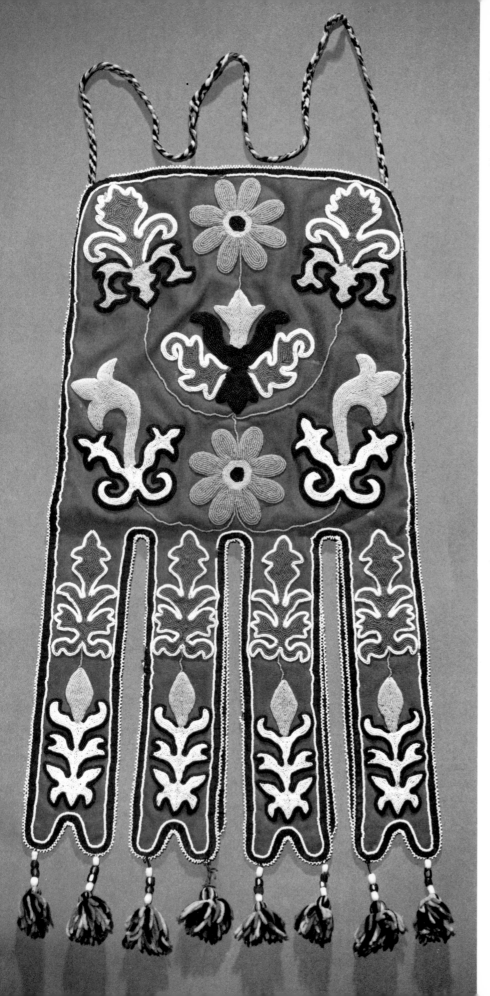

204 OCTOPUS BAG
Trade felt and plaid lining, polychrome
 trade beads and yarn, thread
108 (42 1/2) LONG
Apparently collected among the Tlingit
 (see preceding entry; formerly
 Kettleson Collection)
Sheldon Jackson Museum, I.A.282

205 DECORATED SHIRT
Buckskin, trade felt and polychrome
 beads, bird beaks and other horn
 materials, sinew, and thread
139 (54 3/4) WIDE
Victor Justice Evans Collection
Bequest of V. J. Evans, 26 March 1931
Smithsonian Institution, 357 532

This shirt exemplifies many qualities
of Athabaskan Indian materials and
workmanship, but was almost certainly
made for Tlingit use. A similar shirt
in The University Museum, Philadelphia
(NA 10516), depicts in beadwork
embroidery the specific eagle and
killer whale emblems of this coastal
clan, emphasizing the Tlingit patronage
of this essentially Indian style (fig. g).

C. D. L.

figure g

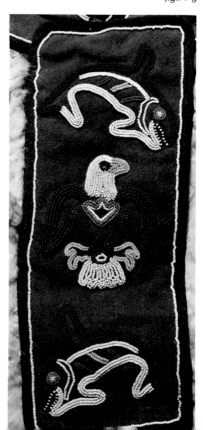

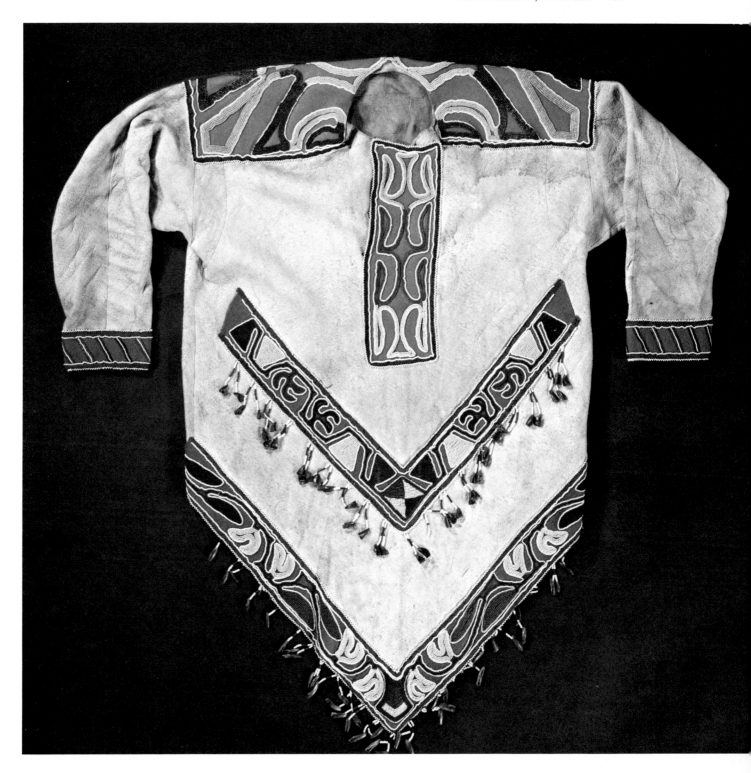

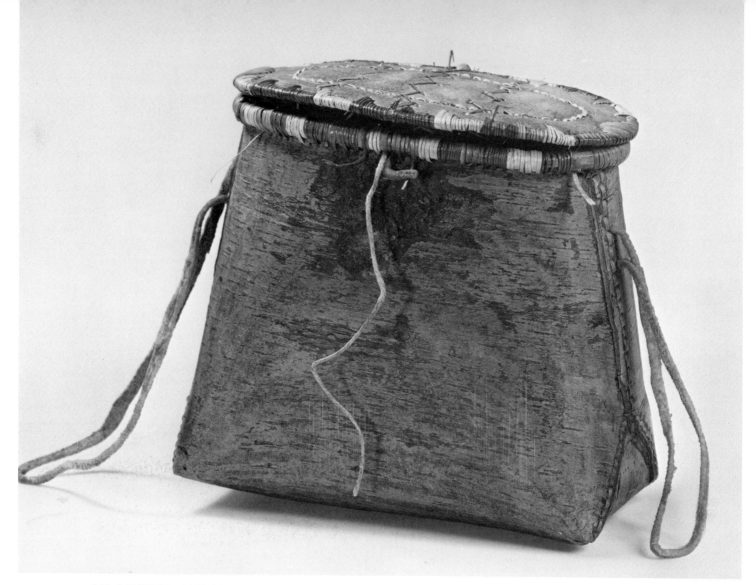

206 COVERED BOX OR BASKET
Birchbark sewn with fiber, willow
 band, white and dyed porcupine
 quills, with rawhide handles
45 (17 3/4) WIDE
Perhaps Kutchin Indian?
Smithsonian Institution, T-1075

Although apparently collected in the
Canadian territories of the Athabaskan
Indians, this box is typical of the
many uses to which shaped and sewn
birchbark was used to make both
covered and uncovered containers
among the Alaskan Indians.

C. D. L.

207 COVERED BOX
Birchbark, covered with white and
 dyed porcupine quills, willow band,
 and thread
8 (3 1/8) DIAMETER
Presumably collected by Rev. Sheldon
 Jackson in the late 19th century
Sheldon Jackson Museum, IV.X.15

The probable collection of this piece
before about 1893 in Alaska poses a
mystery, since its form and technique are
unquestionably representative of Ojibwa
work, from the area south of Hudson
Bay. It may have reached Alaska through
trade, or may have been made there by
an emigrant Ojibwa.

C. D. L.

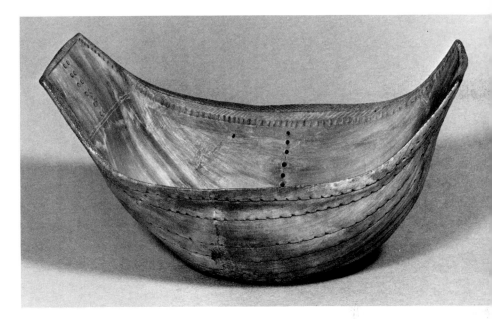

208 COVERED BASKET
Split willow with polychrome dyes
29.5 (11 5/8) HIGH
Ingalik
Made at Shageluk on the Innoko
 River, between 1932 and 1935
Museum purchase, 1970
Alaska State Museum, II.C.113

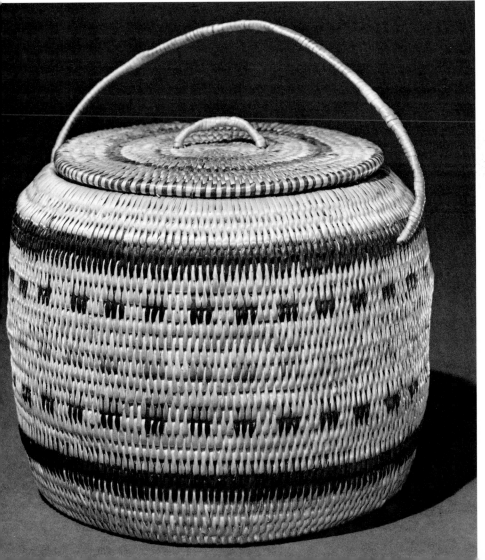

209 GREASE DISH OR BOWL
Mountain sheep horn with red pigment
22.2 (8 3/4) LONG
Royal Scottish Museum U. C. 249

The age of this dish and its exact
provenance are unknown. It formed
part of the collection of the University
of Edinburgh before 1854 and is de-
scribed by the University as "possibly
catalogued by Professor John Walker
in 1785." Such an early date would be
surprising, for one would expect it to
have been collected from a Scottish
factor of the Hudson Bay Company
who obtained the piece in the upper
Yukon or Mackenzie River area.

Grease dishes of this kind were,
however, traded to coastal tribes, such
as the Tlingit, Tsimshian and Haida,
although these peoples usually
decorated them with their own
totemic crests.

Frederic H. Douglas and René d'Harnon-
court, Indian Art of the United States
(New York: Museum of Modern Art,
1941), esp. p. 180.
Erna Gunther, Northwest Coast Indian Art,
An Exhibit at the Seattle World's Fair
(Seattle: World's Fair, 1962) esp. pp. 20,
28.

F. de L.

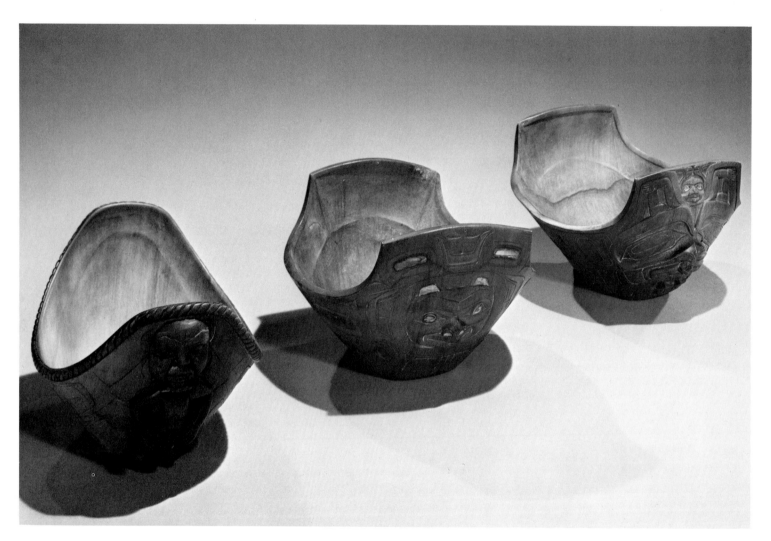

210 GREASE DISH OR BOWL*
Mountain sheep horn
21.6 (8 1/2) LONG
Collected on the Portland Inlet,
 opposite Tongass, by J. G. Swan
Museum collection, 17 January 1876
Smithsonian Institution, 20 613

This carved container shows a human
figure, small animals and abstract
designs.

211 GREASE DISH OR BOWL*
Mountain sheep horn and shell
19 (7 1/2) LONG
Collected by J. G. Swan
Museum collection, 22 January 1876
Smithsonian Institution, 20 856

This container is carved and inlaid
with stylized faces and abstract
designs.

212 GREASE DISH OR BOWL
Mountain sheep horn and shell
21 (8 1/4) LONG
Collected from the artisan, by Rev.
 Sheldon Jackson in the late 19th
 century
Princeton University Museum of
 Natural History, PU 5156

This container is carved and inlaid
with abstract figures and designs. The
general form of these grease dishes
(as well as the following ladle) is
paralleled by similar pieces of wood.

C. D. L.

TLINGIT ART

PETER STONE

THE magnificent artistic tradition that once flourished along the Pacific Northwest Coast was beautifully expressed by its northernmost tribal representatives. These were the Tlingit tribes of southeastern Alaska, culturally unlike any of their northern neighbors, the Eskimo, the Aleut, the Eyak and the Athabaskan tribes of the interior. Unlike the arctic and sub-arctic regions of Alaska, the mountainous coast and rugged off-shore islands of the southeastern "panhandle" are densely covered with a temperate rain forest. Although many of the trees that are found in this area are also found along the northern and more exposed coast of Alaska, this is not true of both the red and yellow cedar. Red cedar in particular may be seen as the *sine qua non* of Northwest Coast art and architecture. It responds to the carvers' tools in a way that has made it justly famous. Even in southeastern Alaska, this tree was not found north of Sitka. The "panhandle" was richly supplied with fish of all kinds and no fewer than five species of salmon came each spring to its coastal rivers to spawn.

At the time of European contact in the late eighteenth century, this was Tlingit country. Their southern coastal neighbors were the Tsimshian from whom their women learned how to make the "Chilkat" blanket. The Haida of the Queen Charlotte Islands were universally recognized as the best canoe makers along the coast. It is on the Queen Charlotte Islands that the largest red cedars grow. During the first half of the eighteenth century a small Haida colony crossed Dixon Entrance and settled throughout the southern half of Prince of Wales Island in Alaska, where they became known as Kaigani or "People of Kaigan Bay." Although the Tlingit and Haida often bitterly fought one another, the Tlingit and Kaigani got on well.

Warmed by the Japanese Current that flows off the western coast of the Alexander Archipelago, the Tlingit's lush territory was protected on its eastern flank by the Coast Mountains that rise abruptly from the inland passage. This great mountain range effectively shuts out the sub-arctic continental climate of the interior while it simultaneously holds in the warm, moist air that comes from the sea to the narrow coastal strip. This mountain range did not, however, effectively shut out all contact with the Athabaskans from the interior, for no fewer than four major rivers cut their way through it to the sea: the Nass, the Stikine, the Taku, and the Chilkat. The importance of these rivers in the life of the Tlingit can be seen in the fact that the Stikine, the Taku, and the Chilkat were all names of tribes. Small bands of Athabaskans are known to have descended these rivers from the interior where they were then

165

rapidly assimilated as Tlingits. Only when the European and American fur trade became fiercely competitive was this trickle of Athabaskans brought to a halt by the Tlingit who soon dominated the interior as fur-trading colonists.

In a rain forest only stone implements can survive the ravages of time and the elements. Totem poles last about seventy-five years in this country. Although it provided the Tlingit with nearly all of their needs, it is not a promising locale for the archaeologist. The Tlingits, however, are not without a sense of history.

Although the Nass River enters the Portland Inlet just south of Alaska, it figured heavily in the traditional history of the Tlingit. The mythical home of their raven creator was at the head of this very river. In the traditional histories of their most powerful clans there is the clear recollection of a Nass River exodus from the interior. The Nastedi ("People of the Nass River") and the Nasahutdi ("People of Nass Lake") were two clans that kept the tradition of this migration alive in their respective clan names. Perhaps of even more importance is the fact that almost all of the earliest Tlingit clan traditions speak of a time when they were settled along the coast of British Columbia between the Nass and Skeena Rivers. This region is still rich in fish and it was occupied by the Tsimshian at the time of European contact. Interestingly enough, these southern coastal neighbors of the Tlingit remember a time when they themselves were an interior people who descended the Skeena River to the coast where they settled. Tsimshian traditions also corroborate the Tlingit claim of a migration down the Nass River. The Tsimshian also remember a protracted period of conflict in which the Tlingit forced them out of their settlements along this coast. For a while the Tsimshian went back up the Skeena in order to be safe from further Tlingit attacks. Shortly before European contact, the Tsimshian fought their way down the Skeena, pushing the Tlingits ahead of them along the coast of southeastern Alaska.

Although Tlingit clan traditions discreetly make no mention of having been expelled from their original coastal home, their genesis myth clearly states that it was at the mouth of the Nass River where they acquired their first clan crests. Were it not for the fact that crests are such an important part of Northwest Coast society and art, there would be no need to include this fact in a creation myth. This Tlingit myth, however, speaks of a time when the world was in darkness and all of the Tlingit clans lived in one village at the mouth of the Nass River. According to the myth, the sun, moon, and stars were kept in boxes by Raven-at-the-head-of-Nass. He was the principal deity of the Tlingit and his sister gave birth to a son who was simply called Raven. The adventures of Raven are clearly those of a trickster-transformer, who, by shamanistic guile, managed to steal the sun from his uncle.

When Raven came to the mouth of the Nass River, the villagers there showed him no respect at all. Even though he promised to exchange daylight for some of their food, they refused his offer and called him a liar. Who did he think he was, they jeered, Raven-at-the-head-of-Nass?

With that, Raven opened the box containing the sun and set it free. It went up into the sky with a blazing roar and so frightened the people that they ran in all directions. Some ran into the sea, some ran into the woods, while still others took flight.

Until that time the furs and feathers of animals were only the names of garments worn by people, since the actual names of animals were then unknown. When the people who wore the skins of fur-bearing sea animals ran into the sea, they became the animals whose garments they wore. This was also true of people who wore the garments of land animals and birds. Those who had been wearing nothing remained human. Consequently, the remaining Tlingit adopted their first crests in memory of their transformed kinsmen. The crests were proudly displayed in their ceremonial art from that time on.

Later, as the Tlingit moved up through southeastern Alaska, their clans continued to acquire new crests. A common theme running through all of these newer crest acquisitions is a continuing interaction with anthropomorphized animals who were either insulted or befriended. Often the same traditional account will be cited by two different clans to justify adopting their respective crests.

In many respects Tlingit art may be seen as a representation of social organization. This is most clearly seen in Tlingit moiety and clan crests. Tlingit society was divided into two matrilineal, exogamous moieties. These moieties were known among the northern tribes as Raven and Eagle, whereas among the southern tribes Eagle was replaced by Wolf. The non-Raven moiety, however, was still seen as a moiety that was simply represented differently. In a matrilineal society, descent is reckoned exclusively from a common ancestress. Every Tlingit is by birth a member of his or her mother's clan and moiety. The two Tlingit moieties may be seen as marriage classes and each one contained about thirty-five matrilineal clans. These clans were scattered throughout the fourteen Tlingit tribes. Each clan of matrilineally related kinsmen owned an inventory of crests, house names, personal names (that were really inherited titles), songs and dances. The minimal unit of a clan in any given tribe was a named house or lineage. Clansmen of the Raven moiety had to marry non-Ravens and vice-versa.

Some of the most frequently represented crests of the Raven moiety are the raven, hawk, puffin, sea gull, land otter, mouse, moose, sea lion, marten, whale, dog salmon, silver salmon, coho salmon, sculpin, starfish, frog and wood-worm. Those of the Wolf-Eagle moiety are the wolf, eagle, murrelet, red-wing flicker, brown bear, killer whale, dog fish, ground shark, and halibut.

Along the Northwest Coast, native society was non-egalitarian or socially stratified, consisting of hereditary nobility and commoners. The term nobility is somewhat misleading since these "aristocratic" chiefs were essentially the spokesmen of their respective clans and the custodians of clan honor. They were always responsible to the clan members they represented. While the differences between clan commoners and nobility were always relative and somewhat blurred, the existence of a class of

slaves was the most obvious expression of social inequality. Slaves were the property of the clan and could not therefore take part in the ceremonial life of the Tlingit—except, of course, when they were sacrificed for clan honor.

Ideally, within each Tlingit tribe at least one clan from each moiety was represented, since marriage was only permitted between opposite-moiety clan members. In addition to this law, however, it was further demanded that marriage partners be recognized as of equal rank. Moiety membership was not arranged but marriages were. Therefore, marriage was the ultimate criterion of rank, since it was through the opinion of opposite-moiety clans that a clan or lineage knew where it stood socially in the ranking system of its own moiety. Marriage alliances, which established opposite-moiety counterparts, were fraught with rank considerations and brought with them a host of obligations in the form of goods and ceremonial services. These obligations provided a potent stimulus to the production of Tlingit art.

Among the Tlingit, every clan had at least one named cedar plank house. This house not only served as a place of residence for the men of the clan or lineage (and their wives and children—all from the opposite moiety), but it was a ceremonial center in which clan feasts and ceremonies were performed. These houses usually faced the sea where they could easily be seen. They were also works of art with their elaborately carved gables. Among the southern Tlingit tribes, where cedar was more common, totem poles often stood as beautiful memorials to the history of the clan. Within the house the main house posts were usually carved and painted, as was the cedar plank screen at the back of the house, behind which the chief and his family resided. In all of this carving and painting, clan crests were proudly displayed. The ceremonial clan property of a high-ranked clan also included carved and painted boxes, ceremonial dancing blankets, the chief's hat which was the insignia of his office, dance canes and masks. The house and all of its ceremonial objects were carved by men of the opposite moiety. Men were the carpenters, carvers and painters. Women were the weavers, and with the exception of the Chilkat blanket, and the spruce root hat of the chief, their utilitarian art was graced only with geometric designs.

Throughout the life cycle of every Tlingit, his or her members from the opposite moiety played an important validating ceremonial part. Nowhere was this more clearly demonstrated than upon the death of a lineage house chief. It was at this time that his successor had to commission the rebuilding of the lineage house by his opposite moiety counterparts in order to validate his position and the honor of his lineage. This "rebuilding" might simply mean the installation of more ceremonial art in the house.

There was once a time when the Tlingit Raven Creator tried to make human beings out of a rock and out of a leaf. Since he found it much easier to work with the leaf, he finished his creation in this perishable medium. "Then he showed a leaf to the human beings and said, 'You see this leaf. You are to be like it. When it falls off the branch and rots

there is nothing left of it.' That is why there is death in the world. If men had come from the rock there would be no death. Years ago people used to say when they were getting old, 'We are unfortunate in not having been made of rock. Being made from a leaf, we must die.'" (Katishan speaking to John R. Swanton)[1]

Like their Raven Creator, the Tlingit of southeastern Alaska were remarkably gifted in working with wood. Although they never worked with leaves as such, they were able to make a soft and durable wood yarn from the stringy inner bark of both the red and yellow cedar. This cedar bark yarn was skillfully woven into rain capes, floor mats and long warm robes that were sometimes trimmed with fur. Water-tight baskets and conical rain-hats were also woven from withe-like strips of spruce and yellow cedar roots that had been peeled and split.

It was in their carving and painting of wood, however, that the Tlingit achieved the highest expression of their aesthetic genius. Fortunately, some of their art has been kept from the elements and still lives with us today.

1. John R. Swanton, *Social Conditions, Beliefs, and Linguistic Relationship of the Tlingit Indians.* Smithsonian Institution, Bureau of American Ethnology, Bulletin 39, (Washington, D.C., 1909), p. 81.

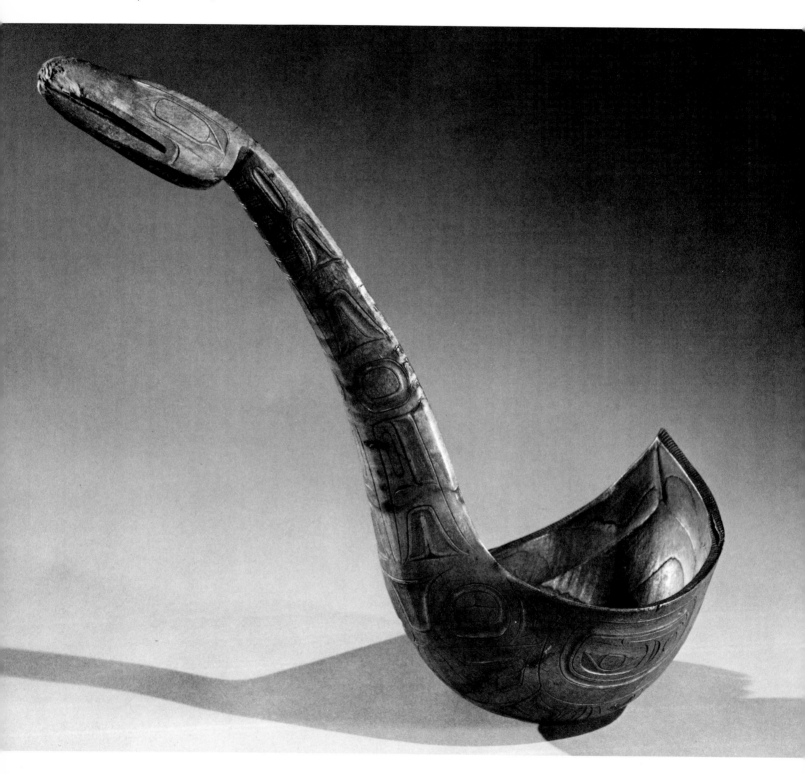

213 LADLE
Mountain sheep horn
54.6 (21 1/2) LONG
Gift of Mrs. Henry L. Corbett
Portland Art Museum, 64.19.3

This ladle represents a raven, un-
doubtedly the totemic crest of the
owner. It is made of mountain sheep
horn, boiled until soft, straightened
and cut roughly to shape, and placed
between two halves of a wooden mold
to dry and harden. The carving and
incising of the decoration is done last.

Such ladles were used for serving
olachen (candlefish) oil at feasts. Some-
times guests at potlatches were forced
to drink a whole ladle or bowl of oil,
so much that they vomited, to be
subsequently rewarded by extra gifts
from their hosts.

While no provenance is known for
this piece, it closely resembles a horn
ladle collected about 1885 by George
T. Emmons from the Chilkat Tlingit
of Klukwan (Douglas and d'Harnon-
court 1941, no. 181), and also a
spoon dating from about 1880, now in
the Denver Art Museum (Malin and
Feder 1962, fig. 10).

F. de L.

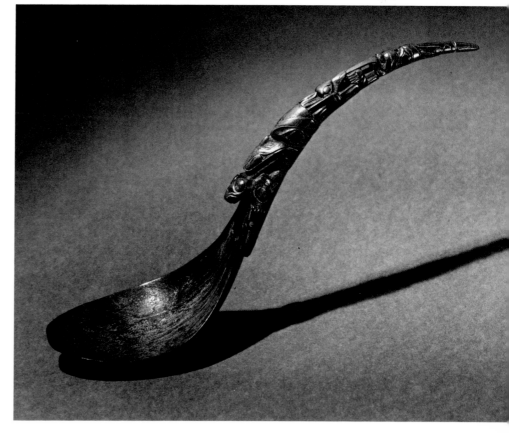

214 CEREMONIAL SPOON
Mountain sheep horn and glue
28.5 (11 1/4) LONG
Southeastern Alaska
Museum purchase, 1904
Royal Scottish Museum, 1904.201

This spoon is carved to represent
animal figures.

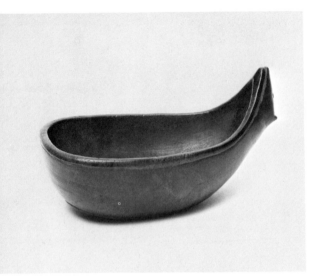

215 SMALL BOWL WITH
 STYLIZED BEAR HEAD
Wood
12.7 (5) LONG
Collected by L. W. Jenkins of Danvers
Peabody Museum of Salem, E 28025

216 GREASE OR OIL DISH*
Wood, impregnated with oil
24.5 (9 5/8) LONG
Smithsonian Institution, 20 857

This container represents the form of
a bird. The fish oil or grease with
which the dish was once filled—to be
eaten with dried fish, seaweed, or
berries—still exudes from the wood.

F. de L.

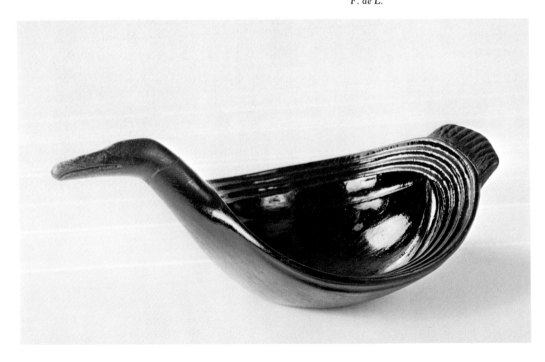

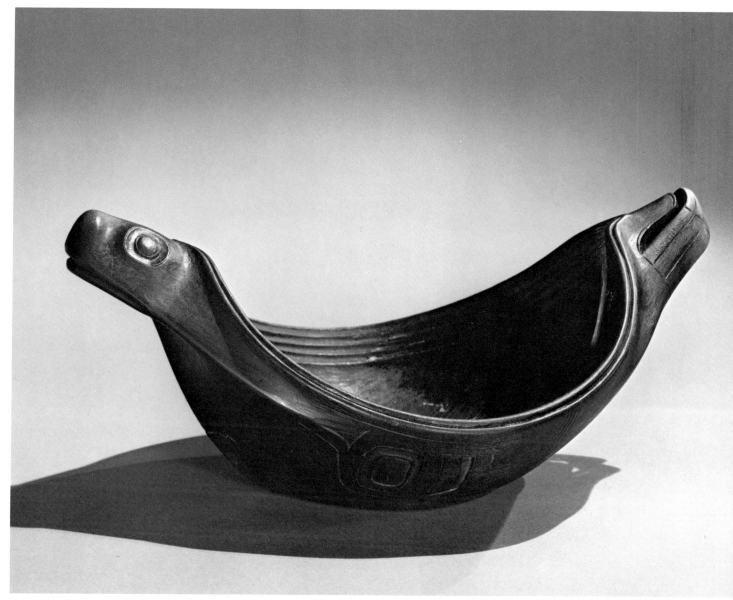

217 GREASE DISH OR FISH
 BOWL
Wood, impregnated with oil
34 (13 3/8) LONG
Collected, probably among the Haida
 Indians, by J. G. Swan
Museum collection, December 1883
Smithsonian Institution, 88 837

This container represents the form
of a seal.

218 OIL OR FOOD DISH
Wood, with red pigment and inlaid
 bone
36 (14 1/8) LONG
Collected at Sitka by W. H. Dall
Smithsonian Institution, 1 144

This dish, carved in the form of a
seal, while similar in form to No. 217,
has carving, coloring, and decoration
that more closely resemble Eskimo
work. As a parallel, the bone-decorated
tobacco box collected by Nelson,
(No. 116) may be cited.

C. D. L.

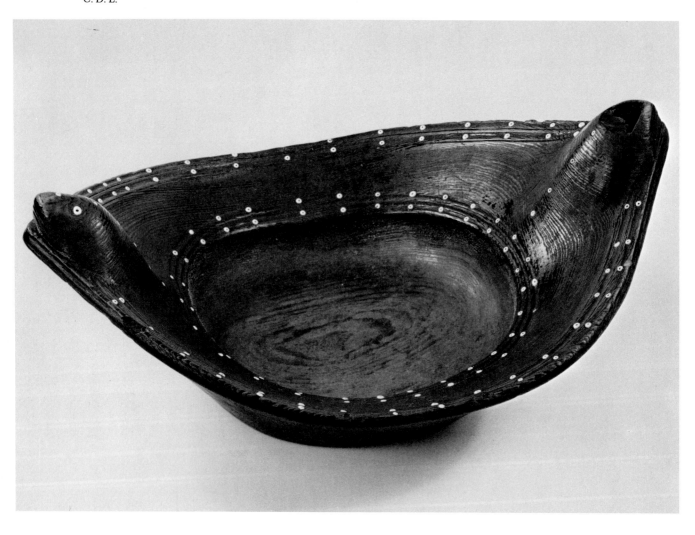

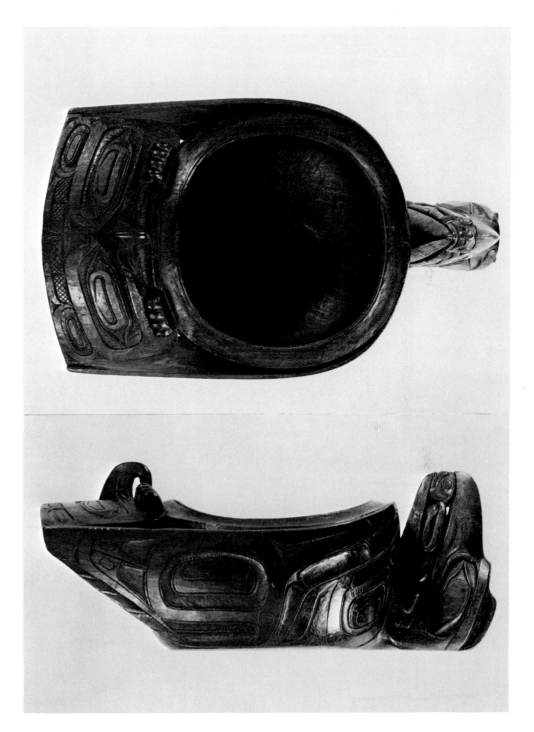

219 BOWL*
Wood
24.8 (9 3/4) LONG
Prince of Wales or Queen Charlotte
 Islands; collected at Skidegate by
 J. G. Swan
Museum collection, January 1884
Smithsonian Institution, 89 136

This bowl represents a crow, with
supplementary figures.

222 CEREMONIAL FOOD BOWL
Wood, inset with operculum
47 (18 1/2) LONG
Collected at Sitka by Dr. A. H. Hoff
 for the U.S. Army Medical Museum
Museum collection, 17 February 1870
Smithsonian Institution, 9 244

Most of the preceding bowls and
dishes were designed for ceremonies
and gifts by Tlingit chiefs at their
potlatch feasts. This last example
depicts the canoes in which guests
would have arrived.

C. D. L.

223 CEREMONIAL FOOD TRAY
Wood, inlaid with operculum
56 (22) LONG
Formerly in the Oldman Collection,
 British Museum
Museum purchase, 1954
Museum voor Land- en Volkenkunde,
 Rotterdam, 34797

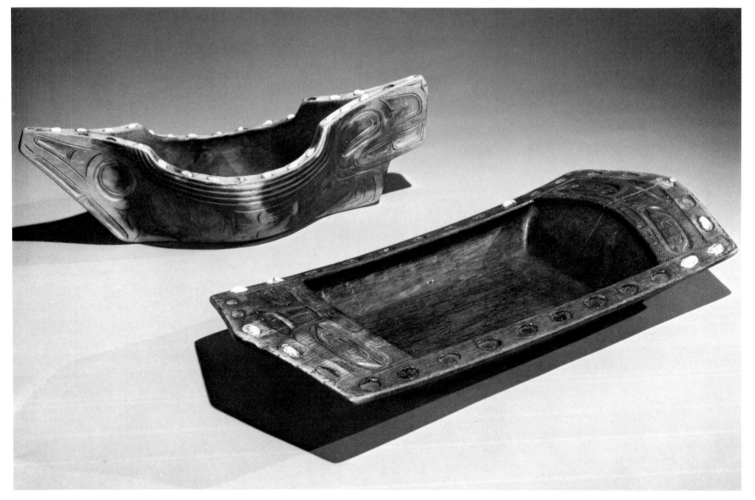

221 FOOD DISH
Wood, with red, black, and green
pigment
48.9 (19 1/4) LONG
Collected apparently by Capt. Ivan
A. Kupreanov, Governor of the
Russian American Colonies from
1836–1840
Museum collection, October 1870
Staatliches Museum für Naturkunde
und Vorgeschichte, Oldenburg, 221

This dish is carved in the form of a
skate.

220 FOOD DISH
Wood, with red, black, green and
white pigment
40 (15 3/4) LONG
Collected apparently by Capt. Ivan A.
Kupreanov, Governor of the Russian
American Colonies from 1836 to
1840
Museum collection, October 1870
Staatliches Museum für Naturkunde
und Vorgeschichte, Oldenburg, 220

This dish represents the form of a bird,
and, like No. 221, may be compared
with similar examples in the Moscow
Museum of Anthropology and Ethnog-
raphy, collected by Lisianski at Kodiak,
probably after the Russians had intro-
duced a substantial Aleut population.
The dishes may represent a kind of
hybrid style, with influences from both
west Alaskan cultures superimposed
upon essentially Tlingit types. Dr. Erna
Gunther has best described their style
as "Tlingit-influenced Aleut," perhaps
for Russian patrons.

C. D. L.

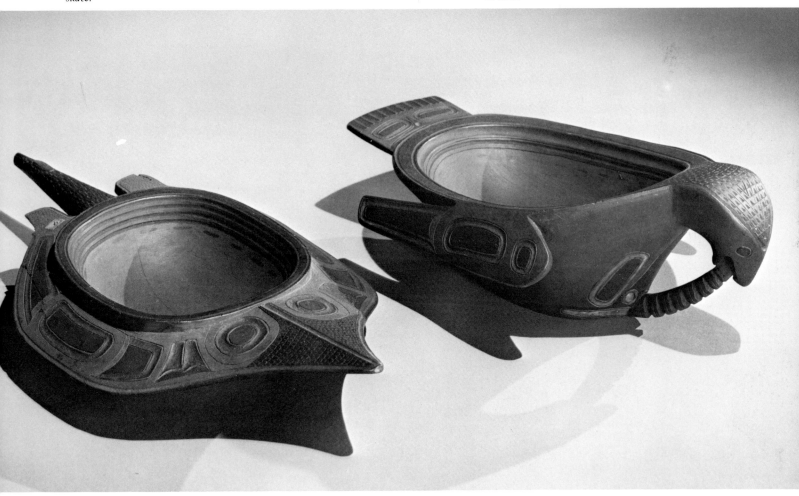

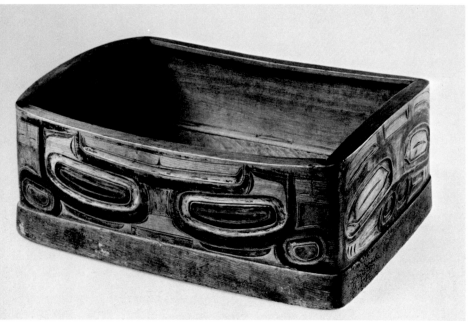

224 OIL OR FOOD BOX
Shaped and carved wood, with
 rawhide lashings
10.5 (4 1/8) LONG
Southeastern Alaska
Museum purchase, 1904
Royal Scottish Museum 1904.200

225 FOOD BOX
Wood, with red, green, and brown
 pigment, fiber lashings
30.5 (12) LONG
Collected at Hoonah, Chichagof
 Island, by P. Schulze, 1882
Berlin Museum für Völkerkunde,
 IV.A.358

226 FOOD BOX
Wood, with traces of polychrome
 pigment, fiber lashings
38 (15) LONG
Collected at Hoonah, Chichagof
 Island, by P. Schulze, 1882
Berlin Museum für Völkerkunde,
 IV.A.357

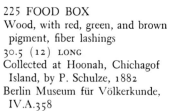

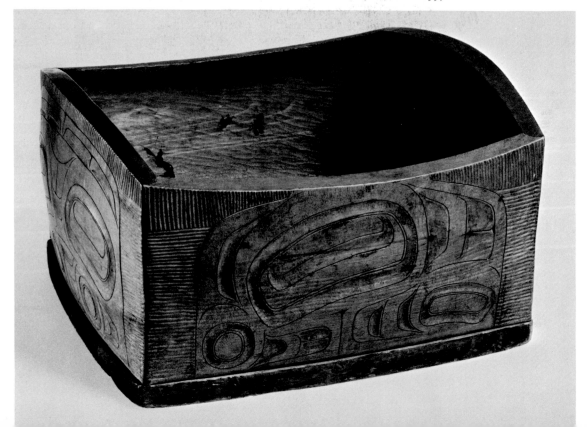

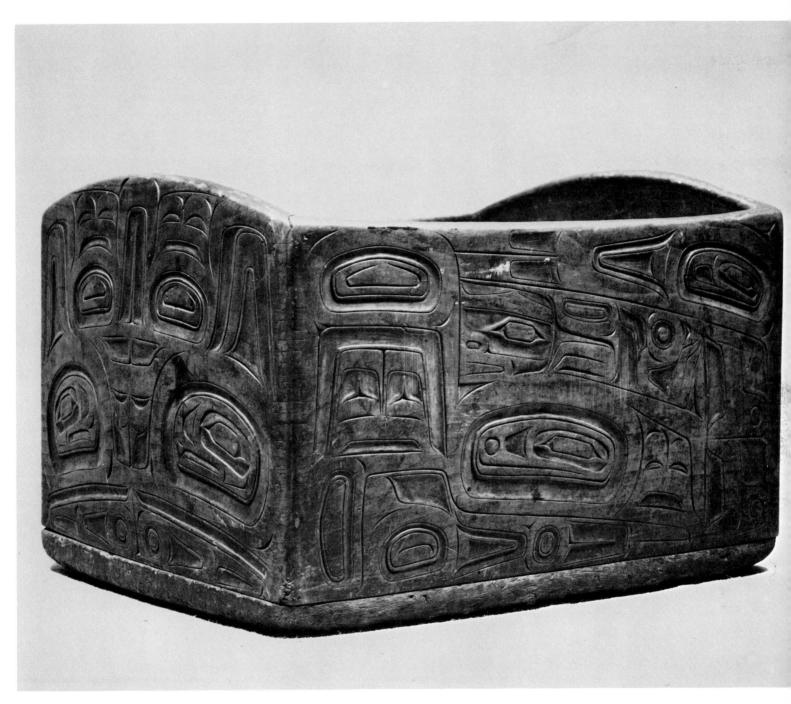

227 FOOD BOX
Wood, with fiber lashings
46 (18 1/8) LONG
Florida State Museum, P 1282

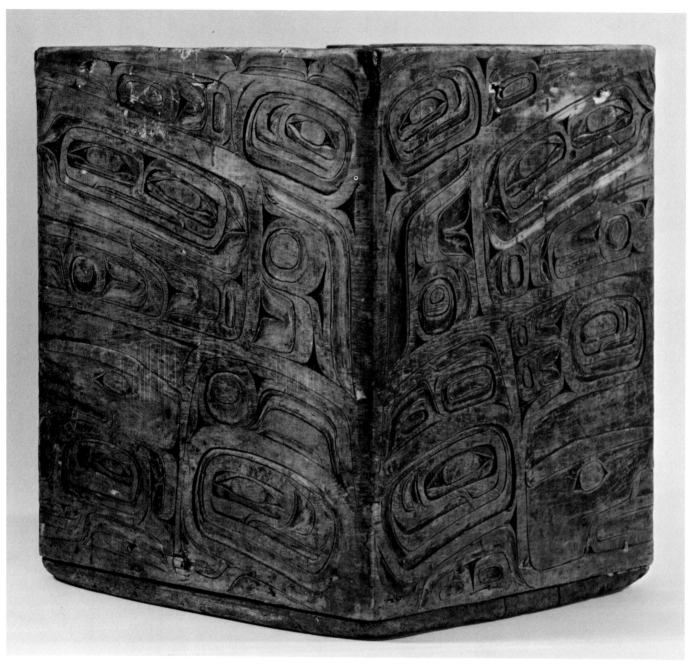

228 STORAGE BOX
Wood, with traces of dark pigment
45 (17 3/4) HIGH
Collected at Sitka by J. J. McLean,
 1884
Smithsonian Institution, 74 400

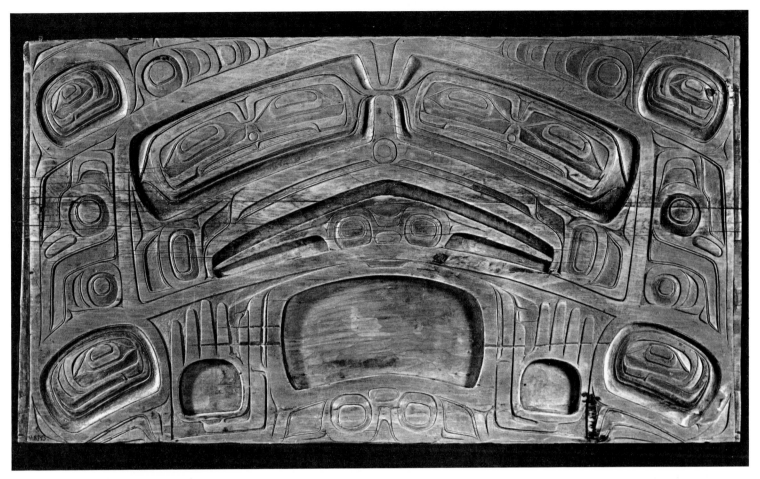

229 FRONT PANEL OF STORAGE CHEST

Wood, with traces of polychrome pigment; probably missing decorations formerly inlaid in six recessed compartments

87.5 (34 1/2) LONG

Graf von Linden Collection

Gift of the collector, 1906

Linden-Museum für Völkerkunde, 48713

The carved front of this chest portrays a totemic animal. The ears (in which the common eye-motif is depicted) are in the upper corners of the board; the paws at the bottom, on each side of a plain oval area. Each eye is itself treated as a face with two eyes above the wide mouth. Figures at the edges presumably symbolize limbs.

Such chests were made with the sides of a single piece of wood, kerfed and steamed to be bent into a rectangle. The two ends are sewn together in such a way that the stitches are invisible. The seams are usually treated with waterproof glue so that such chests can be used to store food. Some are used for water or urine; others for cooking with hot rocks. A finely decorated chest like this example probably held clan or lineage heirlooms: a Chilkat blanket, dance rattles, crest hat, and other related objects.

Many carved chests were obtained by the Tlingit from the Tsimshian, which makes identification of the designs on the sides impossible. The whole chest is usually carved like the body of an animal, its features (face, ears, tail, wings, or limbs) arranged to fit the rectangular spaces.

With the exception of minor details, the design on this box is identical with that on a Tsimshian box illustrated by Boas (1916, fig. 7,b).

Franz Boas, *Tsimshian Mythology*, 31st Annual Report, Smithsonian Institution, Bureau of American Ethnology (Washington, D. C.).

F. de L.

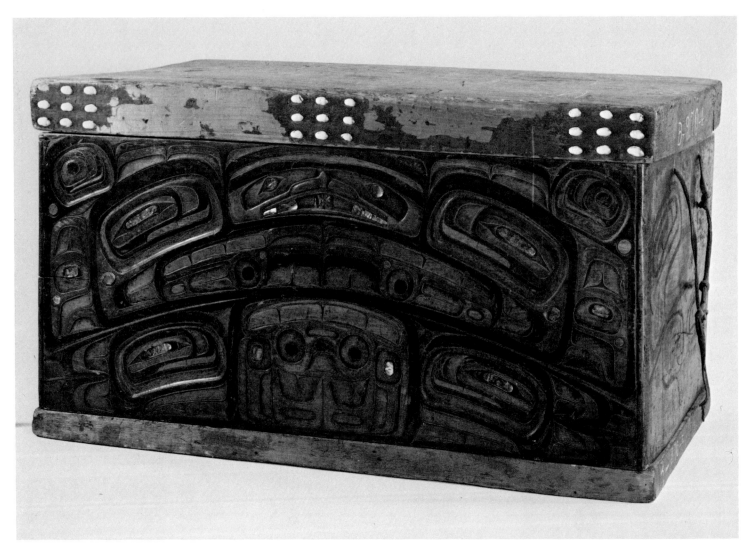

230 STORAGE CHEST*
Wood, with black and red pigment,
 shell and operculum insets, braided
 fiber lashings, and rawhide straps
9 (37 3/4) LONG
Collected by John G. Brady
Gift from the estate of Edward
 Henry Harriman, 7 June 1912
Smithsonian Institution, 274 488

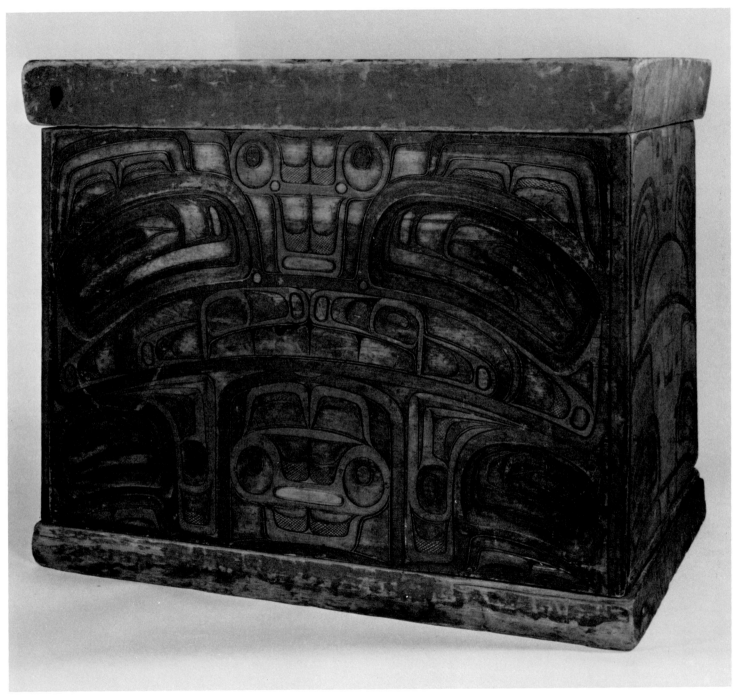

231 STORAGE CHEST*
Wood, with black, red and green
 pigment, and fiber lashings
96.5 (38) LONG
Collected on the Portland Inlet,
 opposite Tongass, by George Gibbs
Deposited by the collector,
 27 May 1862
Smithsonian Institution, 66 638

232 PANEL WITH BEAR CREST
Wood, with red and black pigment
 and inlaid operculum
83.8 (33) LONG
Collected from an old Kar-guan-ton
 House at Sitka by Lt. G. T. Emmons,
 U. S. Navy, 1882–87
American Museum of Natural History,
 E/1385

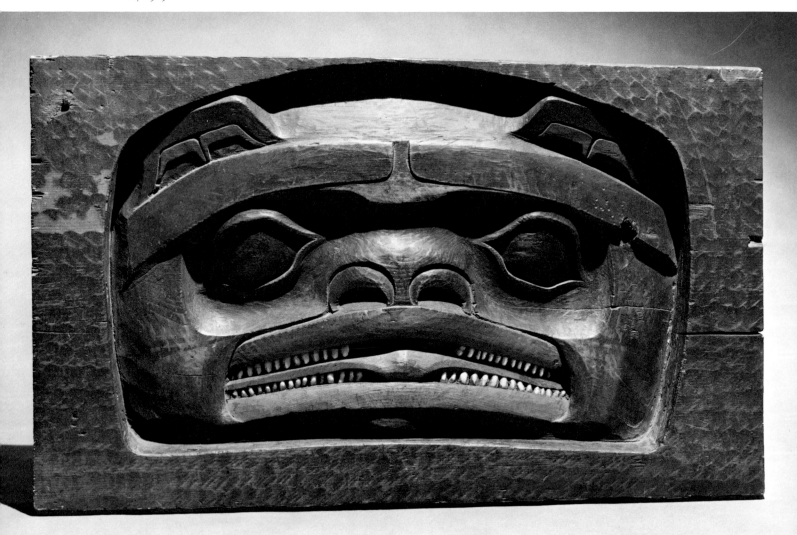

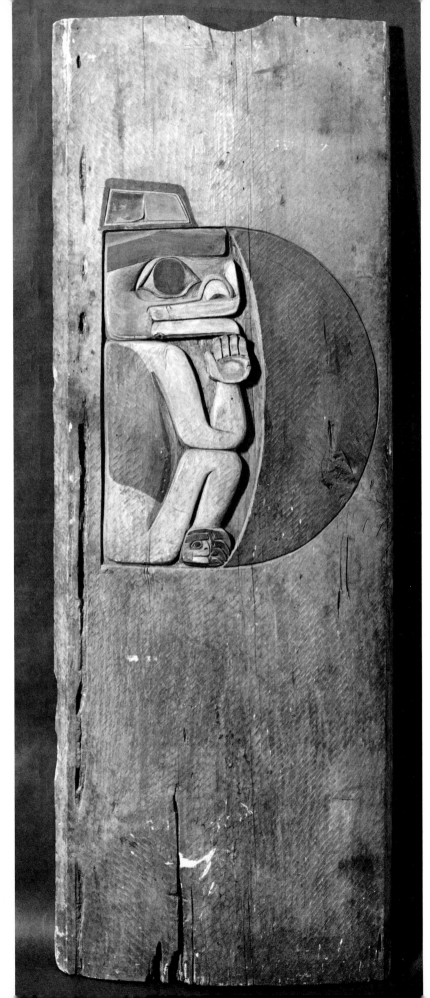

233 HOUSE POST*
Wood, with red, black and green
 pigment, and nails
242 (95 1/4) HIGH
Collected from the Moon House,
 Port Mulgrave, Yakutat, 1916–17
 or thereafter
Museum of the American Indian,
 Heye Foundation, 17/8012

This house post, carved to represent
a moon and the figure of a wolf, is
one of four decorated posts from
Moon House, Yakutat, one of the
houses of the Kwashkan (Humpback
Salmon) clan. It is said that in 1916
or 1917, some of the owners of Moon
House, fearing that the heirloom posts
might be sold, chopped them up and
burned them. This story is evidently
untrue, for at least two posts have
found their way to the Museum of the
American Indian.

F. de L.

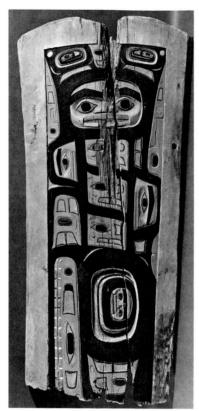

234 FOUR HOUSE POSTS

Wood, with (modern) black, orange and white paint, metal clamps and nails

Collected by Axel Rasmussen

Portland Art Museum: 48.3.529 A, 214.5 (84 1/2) HIGH, 48.3.529 B, 207 (81 1/2) HIGH, 48.3.529 C, 206 (81 1/8) HIGH, 48.3.529 D, 210 (82 3/4) HIGH

The designs are highly abstract renderings of a totemic crest, possibly a killer whale. The head is at the bottom (where the eye is treated as a whole face) and the tail is at the top. Houses bore traditional names, belonging to the clan or lineage, and were decorated with carved and painted posts, painted rear partitions, and sometimes carved and painted fronts that displayed the crest or crests of the owners. The names of the most important houses, occupied by leading chiefs, referred to these totemic crests recently repainted in vermilion, black, and white.

Robert Tyler Davis, *Native Arts of the Pacific Northwest*, (Palo Alto: Stanford University Press, 1949), pl. 106.

F. de L.

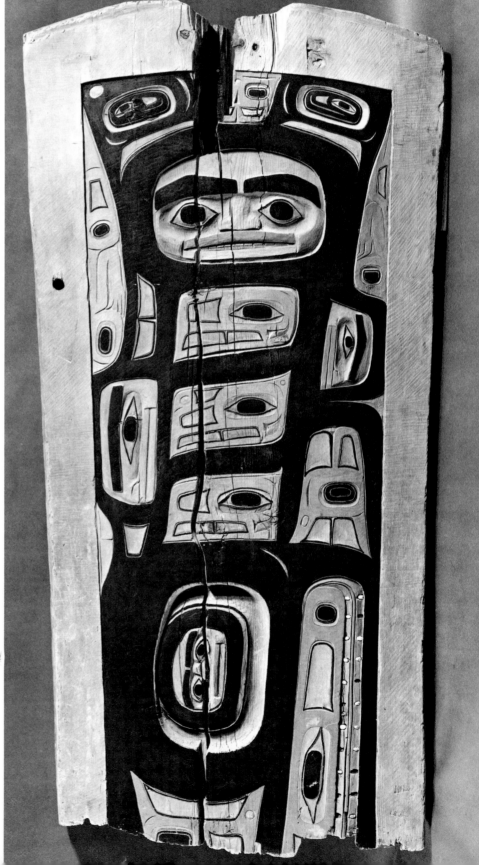

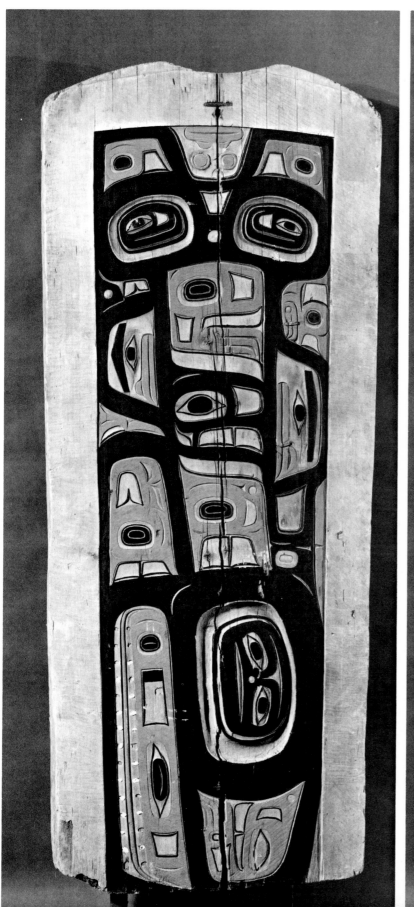
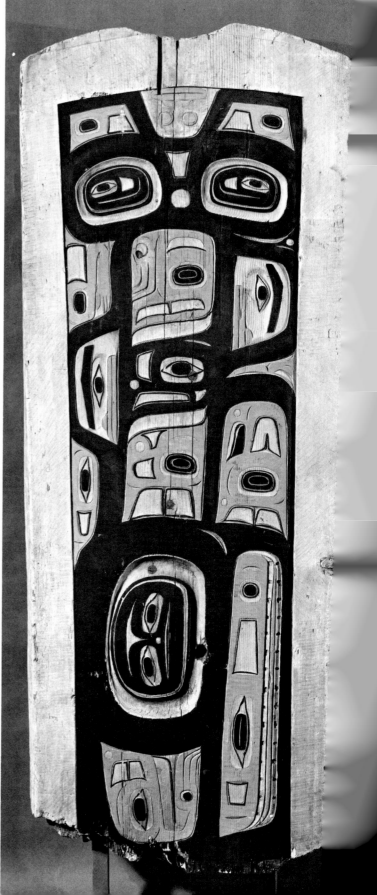

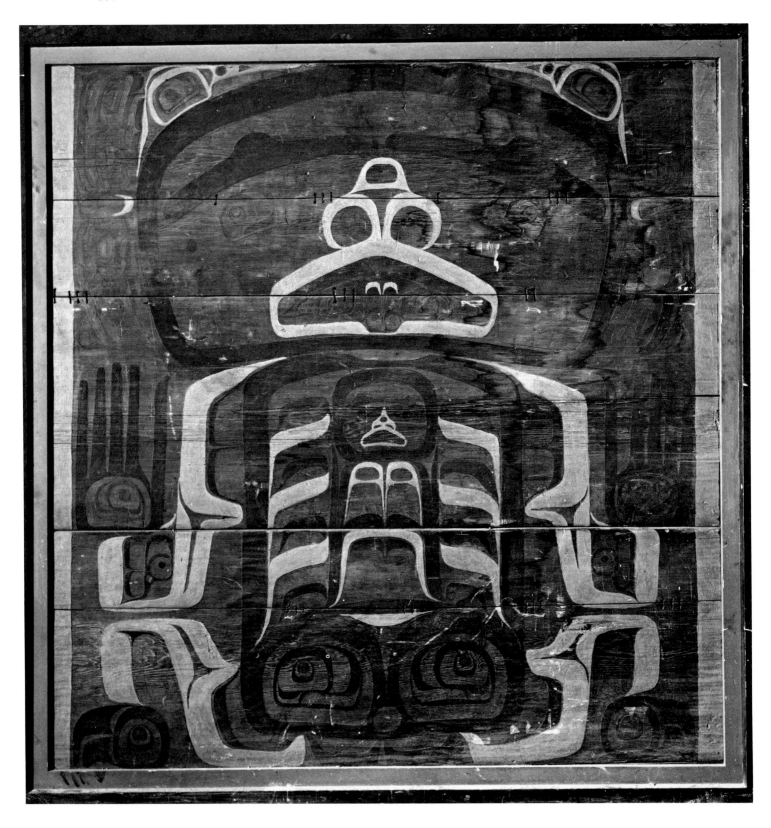

235 FOUR HOUSE SCREENS
 WITH BEAR CREST
Wood, with black and red pigment
 (the borders and red areas renewed
 at a later date), fiber lashings;
 modern frames and hardware
Once thought to have been collected
 by J. G. Swan; more probably collected
 by J. R. Swanton for the Bureau
 of American Ethnology
Transfer from the Bureau of American
 Ethnology, 27 January 1905
Smithsonian Institution: 233 498 A,
 210.5 (82 7/8) WIDE, 233 498 B,
 212 (83 1/2) WIDE, 233 498 C,
 211 (83 1/8) WIDE, 233 498 D,
 215 (84 5/8) WIDE
(All measurements independent of
modern frames)

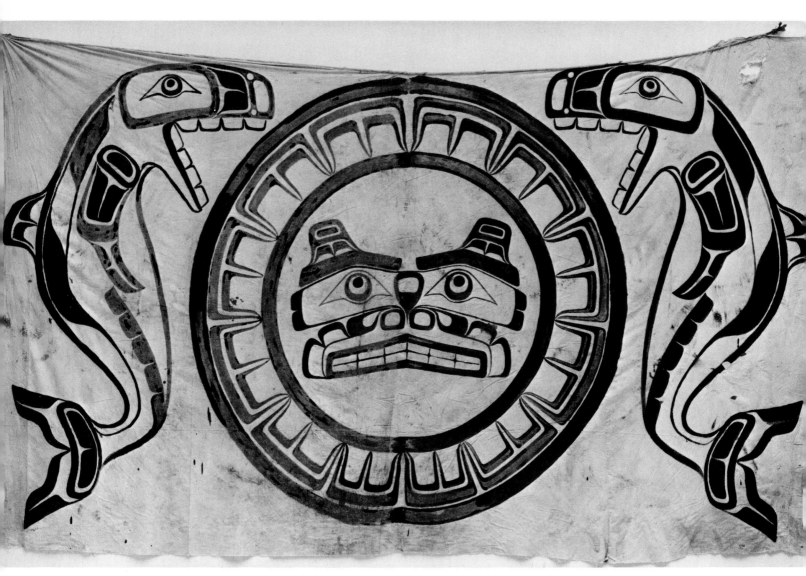

236 DECORATIVE HANGING
White muslin with black pigment,
 fiber rope and thread
427 (168) WIDE
Painted at Sitka by Willie Sewid,
 c. 1925 or thereafter
Museum of the American Indian,
 Heye Foundation, 23/9493

This piece is painted with two killer
 whales flanking a bear face in a
 radiant disc.

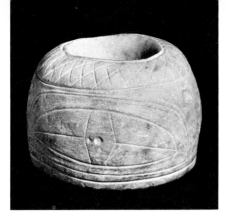

figure h

237 LARGE MORTAR*
Gray stone
31 (12 1/4) DIAMETER
Collected by Lt. G. T. Emmons,
 U. S. Navy
Purchased from the collector,
 30 June 1903
Smithsonian Institution, 220 185

This mortar is carved to represent four stylized heads. A mortar of a more unusual type in the Florida State Museum (Pearsall Collection, P-1859, 9 1/2 diameter), with a more rigidly geometric pattern of carved ornament, may be compared with the preceding and following examples (fig. h).

C. D. L.

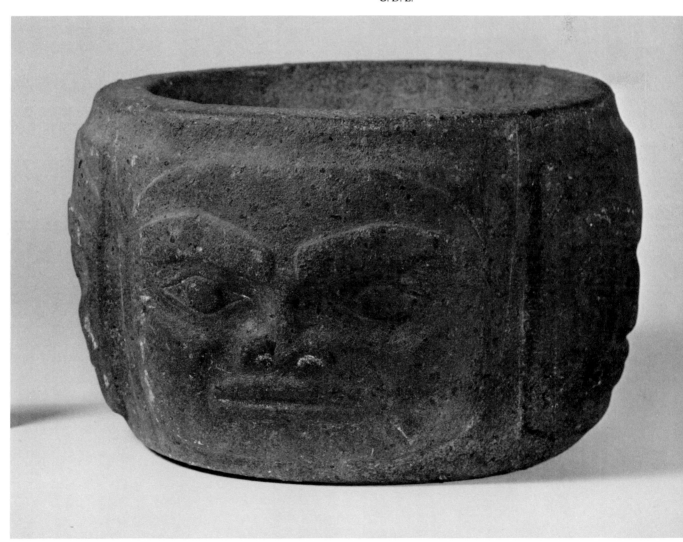

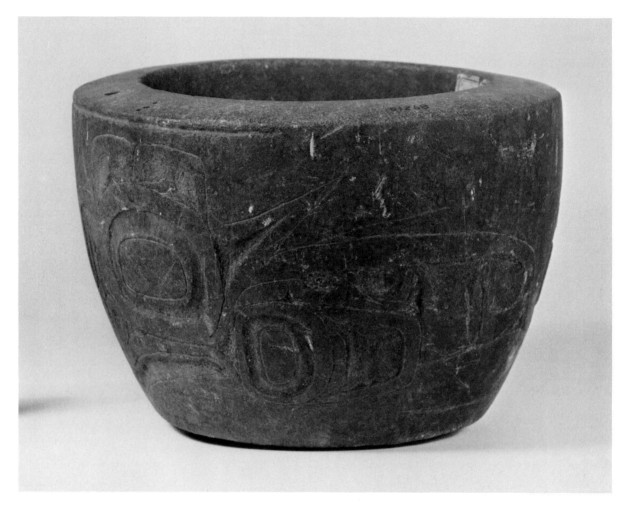

238 MORTAR*
Gray stone
26.4 (10 3/8) DIAMETER
Prince of Wales or Queen Charlotte
 Islands; collected at Skidegate by
 J. G. Swan
Museum collection, October 1883
Smithsonian Institution, 89 210

This mortar is carved to represent a
stylized head with symmetrical side
elements.

239 MORTAR*
Gray stone
23.5 (9 1/4) DIAMETER
Collected by Lt. G. T. Emmons,
 U. S. Navy
Purchased from the collector,
 30 June 1903
Smithsonian Institution, 220 186

This piece is carved with concentric
grooves, leaf forms, and a face.

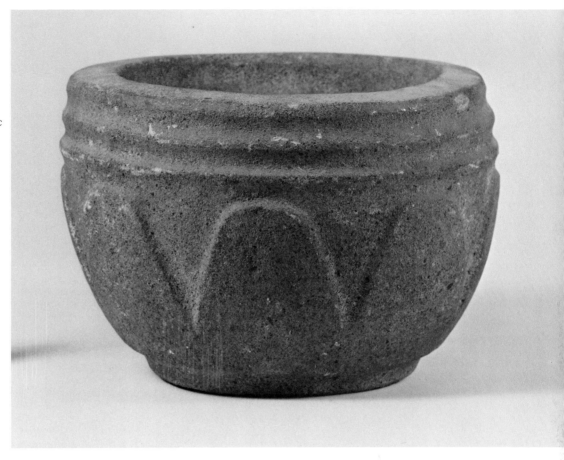

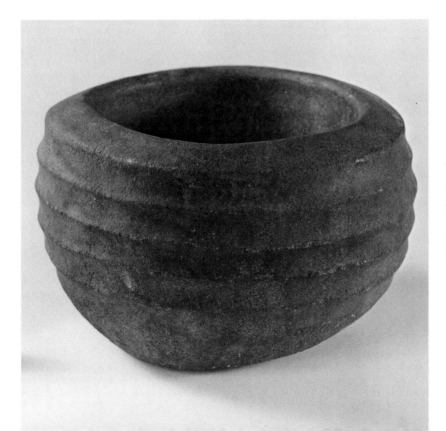

240 MORTAR WITH
 CONCENTRIC GROOVES*
Gray stone
21 (8 1/4) DIAMETER
Collected at Fort Tongass by Lt. F. M.
 Ring, U. S. Army, 1868–70
Museum collection, 1870
Smithsonian Institution, 9 635

243 STIRRUP HAMMER
Gray-brown stone
15.6 (6 1/8) HIGH
Collected from the bed of the Naha
River, Revillagigedo Island, by Fred
Andersen, March 1972
On loan from the collector
Tongass Historical Society, FA 5.11.72

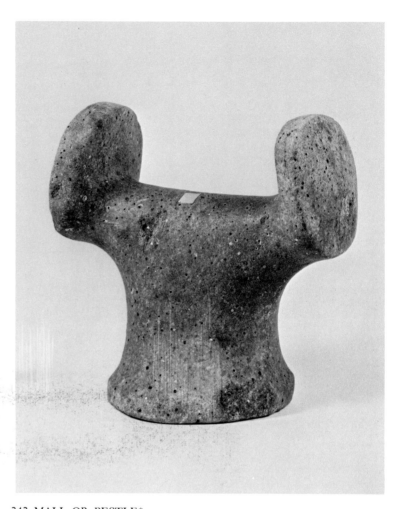

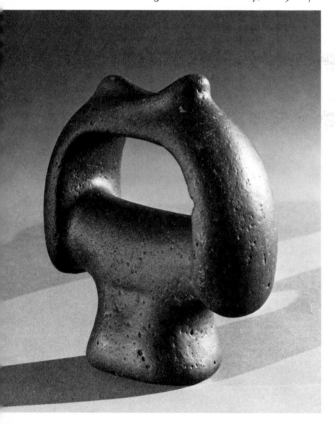

242 MALL OR PESTLE*
Gray-brown stone
14.6 (5 3/4) WIDE
Collected at Fort Tongass by Lt. F. M.
 Ring, U. S. Army
Museum collection, 1870
Smithsonian Institution, 9 640

Nos. 242, 243, and 244, although
intended for pounding or grinding on
flat surfaces rather than in mortars,
may be associated with the fine stone
carving of the preceding mortars.
These are fine examples of their
respective types and show the range
of abstract sculptural form Tlingit
craftsmen were able to give to objects
of everyday use.

C. D. L.

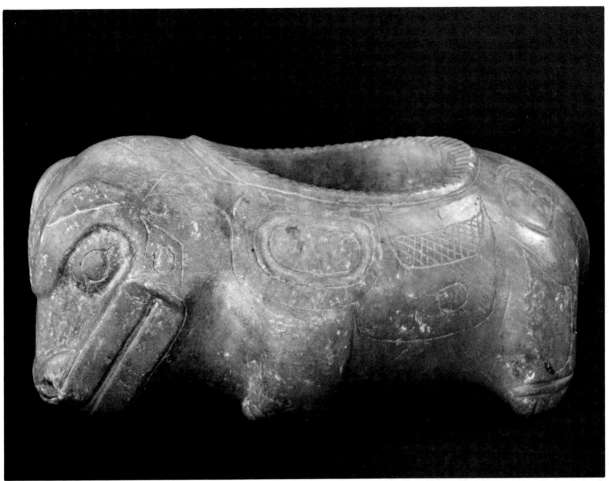

241 CEREMONIAL BOWL OR
 MORTAR*
White stone (probably marble), with
 red pigment
30.5 (12) LONG
Chiefs' heirloom in the Tagwayta
 family of the Hootz-ah-tai-gwan;
 collected at Killisnoo (Admiralty
 Island), by Lt. G. T. Emmons,
 U. S. Navy
Purchased from the collector,
 12 September 1903
Smithsonian Institution, 221 181

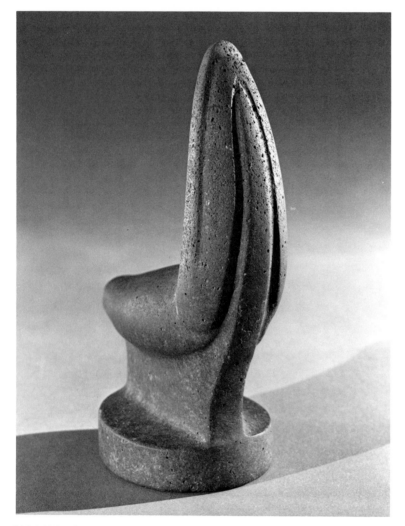

244 MALL WITH HIGH
 FLUTED BACK
Gray-green stone
22.5 (8 7/8) HIGH
Heirloom of the Joe Demmert family
 of Klawock, Prince of Wales Island
Loaned by Dolly Jensen
Tongass Historical Society, DJ x 70

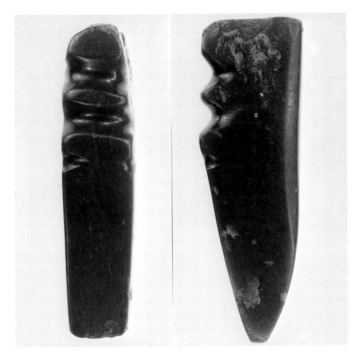

245 ADZE WITH FINGER
 GRIPS
Green stone
16.5 (6 1/2) LONG
Collected at Sitka by J. J. McLean
Smithsonian Institution, 74 987

246 CARVED STONE
 CHOPPER(?)
Gray micaceous schist
21.9 (8 5/8) LONG
Collected at Wrangell by Mrs. Charles
 D. Walcott
Gift of the collector,
 21 November 1936
Smithsonian Institution, 378 200

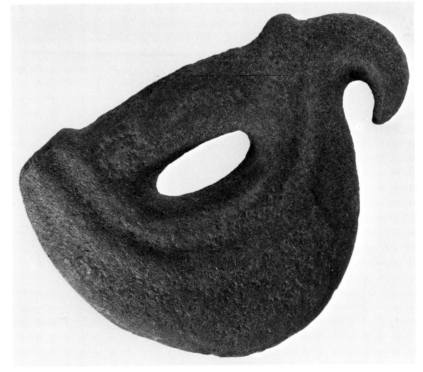

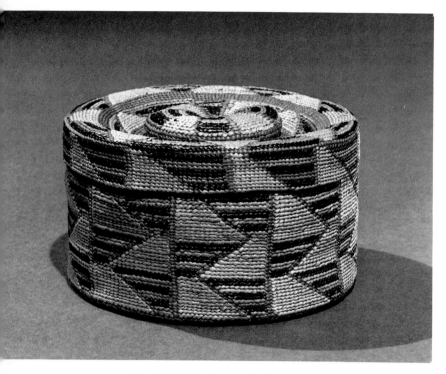

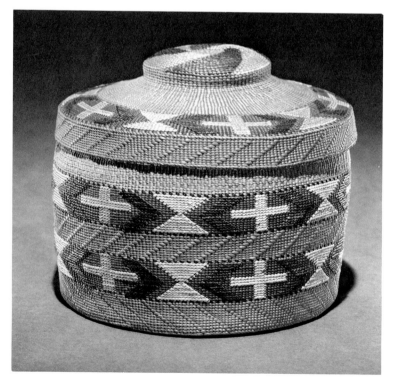

247 COVERED BASKET
Spruce root, with polychrome reed
 decoration and open-work bands
21 (8 1/4) HIGH
Collected by Rev. Sheldon Jackson in
 the late 19th century
Sheldon Jackson Museum, I.A.180
Illustrated in color

248 RATTLE-TOP BASKET
Spruce root, with reed trim, and
 seeds woven into rattle handle
16 (6 1/4) DIAMETER
Collected by Commander William
 McM. Woodworth (or by Jay Backus
 Woodworth) before 1914
Peabody Museum, Harvard University,
 14-29-10/85801

249 RATTLE-TOP BASKET
Spruce root, with reed trim, and seeds
 woven into rattle handle
16.2 (6 3/8) DIAMETER
Collected at Wrangell by
 Margaret Bogue
Loaned by E. Zollman, 11 September
 1968
Tongass Historical Society, 68.9.6.3

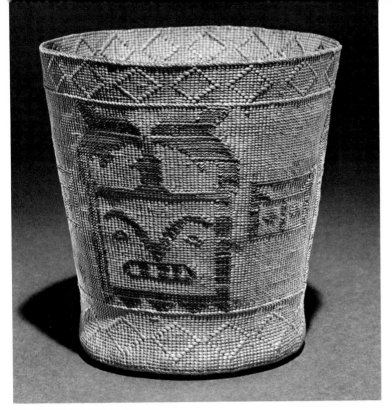

250 OPEN BASKET WITH KILLER WHALES, EAGLE HEAD, AND FACE

Spruce root with reed trim
16.5 (6 1/2) DIAMETER
Collected (at Ketchikan?) by Mrs. Mary Benolkin

Loaned by the collector, 15 August 1962
Tongass Historical Society, 62.12.1.15

251 DECORATED HAT

Woven spruce root, red, black, and green pigment, seal whiskers, trimmed feathers, fiber thread, and trade beads
37 (14 1/2) DIAMETER
Probably collected in the early 19th century
Museum of Anthropology and Ethnography, Leningrad, 5795-22

On the side of the crown the design evidently represents in highly abstract form some unidentifiable crest animal, the body of which has been split in two and draped about the crown of the hat according to the canons of Northwest Coast art. The use of the seal whiskers and beads suggests influence from the Aleuts or from the Pacific Eskimo (Koniag or Chugach).

Siebert, Smirnova, Forman, *North American Indian Art*, pl. 91.

F. de L.

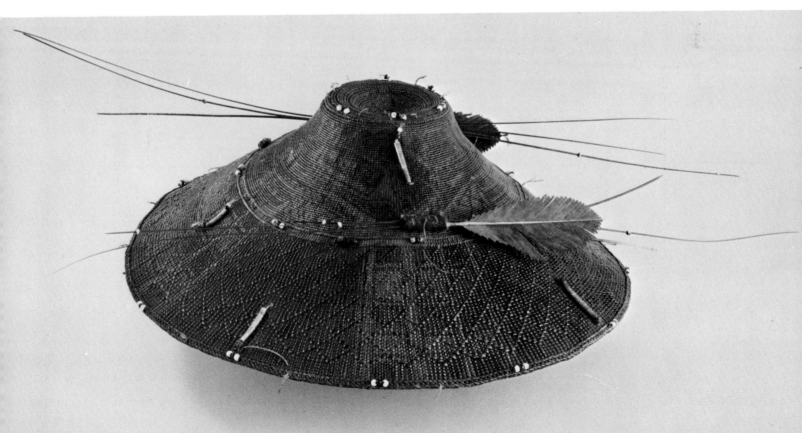

252 DECORATED HAT*

Woven spruce root, with blue, green,
 red and black pigment, seal whiskers,
 dentalium, trade beads and fabrics,
 fiber and modern thread
61 (24) LONG (with bristles)
Collected on Kodiak Island by William
 Fisher, 1884
Smithsonian Institution, 74 720

Another example of the continuing
interaction of native Alaskan cultures
in the transitional area of Kodiak
Island, this hat seems to have been
made by Koniag Eskimos, generally
to the pattern of a standard Tlingit
type. The reduction of the curvilinear
symbols of Tlingit painting to the more
rigid geometric style of this piece,
provides a fascinating example of "the
creative copy" linking two different
cultures.

C. D. L.

253 CREST HAT WITH
POTLATCH RINGS

Woven spruce root, with red and black
 pigment, fiber and trade thread, hair
 plumes, and bird-beak rattles inside
 top ring (woven in one piece with the
 lower rings, and applied to hat)
36 (14 1/8) DIAMETER
Collected at Sitka by Arvid Adolph
 Etholén of Finland, Rear Admiral in
 the Imperial Russian Navy, and
 Administrator of Russian America,
 before 1847
National Museum of Finland, 45C

This ceremonial hat, woven in a
twined technique, has three hollow
basketry rings on top to indicate the
number of potlatches given by the
wearer. The painted crest design on
the crown cannot be identified. The
usual panache of ermine hanging from
the top is missing. The hat might be
protected by wearing a plain un-
decorated hat over it.

F. de L.

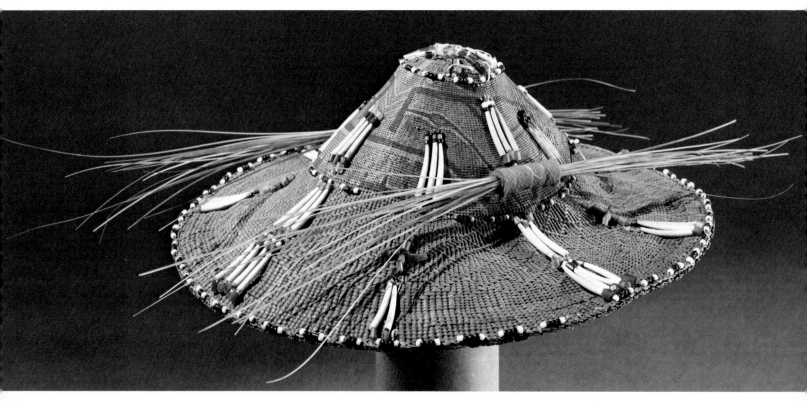

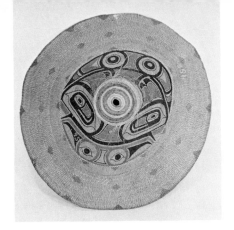

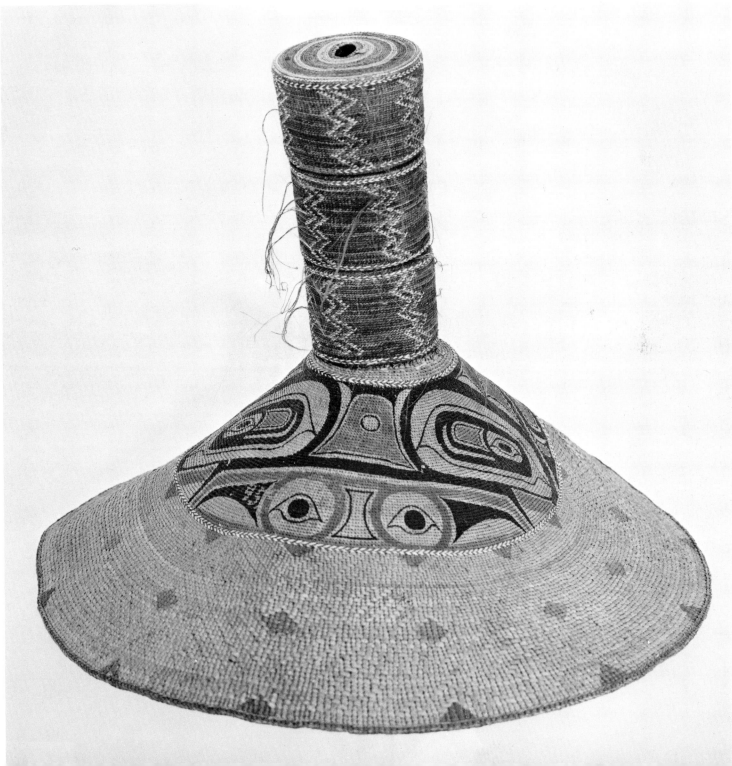

255 CEREMONIAL HAT WITH
WHALE CREST
Woven spruce root, with black and
white pigment, wood with black,
white, red and green pigment, shell
inlays, human hair, fiber lashings and
rawhide strap
36.2 (14 1/4) DIAMETER
Acquired from the Sitka Whale
Collection by Louis Shotridge, 1925
University Museum, Philadelphia,
NA 10512

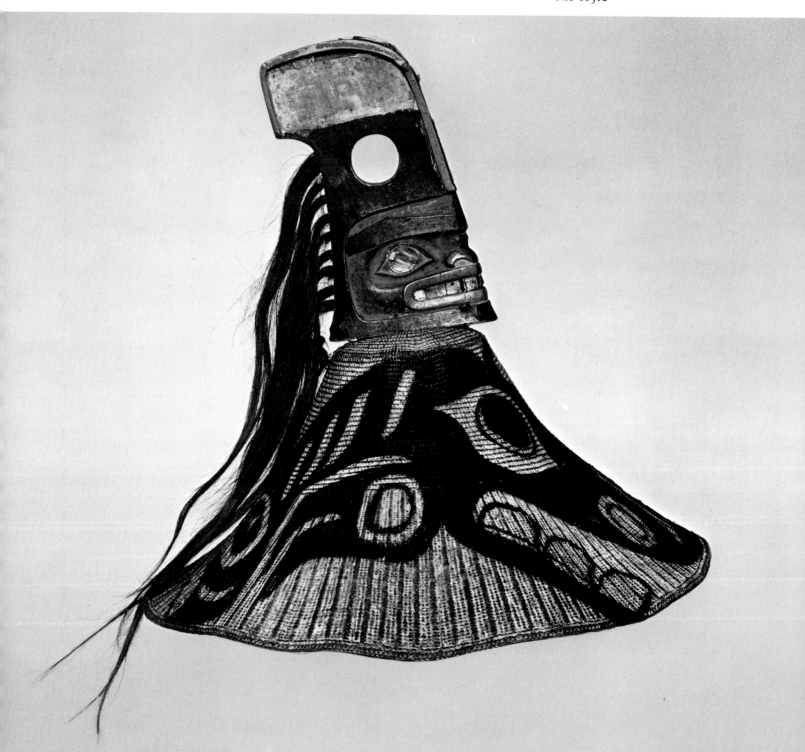

254 CEREMONIAL HAT WITH
POTLATCH RINGS
Brass, steel spring, wire, ermine skin,
and rawhide strap
38.4 (15 1/8) DIAMETER
Collected by Louis Shotridge, 1925
Museum Expedition collection
University Museum, Philadelphia,
NA 6847

While hardly representing a traditional use of native materials, this replica of the classic type of Tlingit chief's hat (represented by the preceding example) in a trade material, and with the insertion of a mechanical spring to simulate the bounce and jiggle of the original basketry, provides a kind of punning reference to the ancient type—while indicating that the patron-chief could now surpass it, through his lavish use of more expensive "modern" materials.

C. D. L.

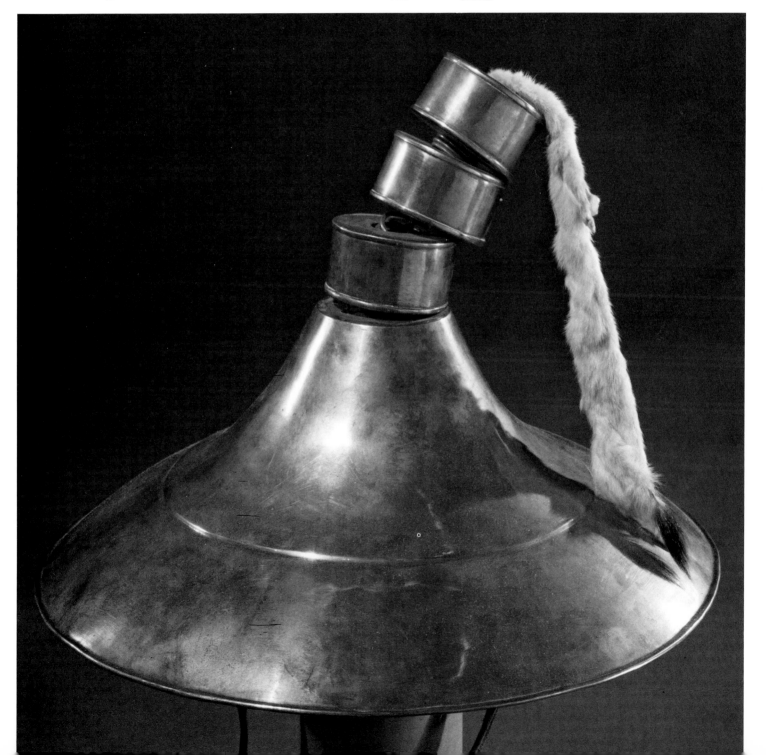

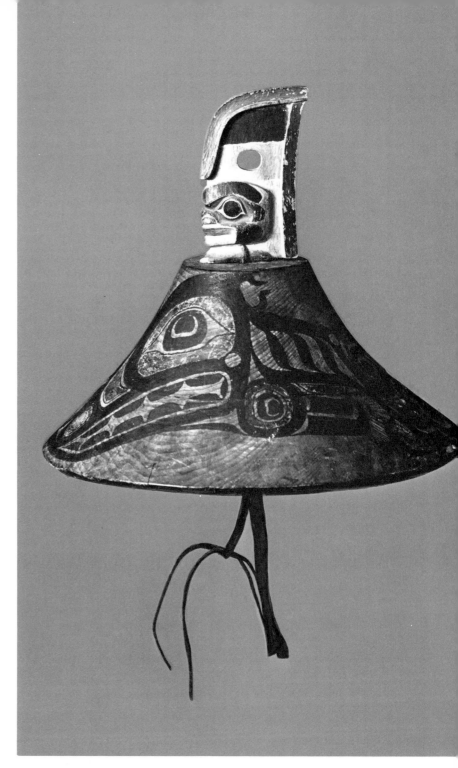

257 CEREMONIAL HAT WITH EAGLE CREST
Wood, with black, green and white
 pigment, copper, iron nails, rawhide
 strap, modern glue and tape
44.5 (17 1/2) DIAMETER
Heirloom of the Williams family,
 Raven clan of the Tongass Tlingit
On loan from the collection of
 Frank Williams, Sr.
Tongass Historical Society,
 FWSr 10.13.67

This hat represents the mountain
eagle Kajuk, clan symbol of one group
of the Tongass Tlingit, with whose
descendants it still remains. It may
represent a surviving reference to their
former function as heavy "armored"
war helmets (see following entry).

C. D. L.
Cover illustration

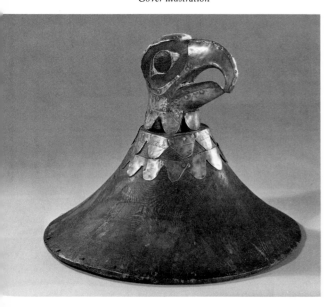

256 CEREMONIAL HAT WITH WHALE CREST
Wood, with black, green and red pig-
 ment, rawhide lashings and straps
38 (15) DIAMETER
Acquired from the Sea Lion House
 Collection, presumably at Sitka, by
 Louis Shotridge, 1918
Museum Expedition collection
University Museum, Philadelphia,
 NA 8503

258 CEREMONIAL HAT WITH
 RAVEN CREST
Wood, with black, red and white pig-
 ment, human hair, and rawhide strap
37 (14 1/2) DIAMETER
Collected, probably at Klukwan, by
 Louis Shotridge, 1917
University Museum, Philadelphia,
 NA 5740

We may assume that this helment,
apparently representing a raven, be-
longed to the Ganaxtedi, an important
Raven clan of the Chilkat Tlingit at
Klukwan, Louis Shotridge's own home.
 Wooden helments were originally
used for protection in war, then
eventually were worn like crest hats
at potlatches. Crest hats and crest
helmets were usually the most valuable
heirlooms of the clan or house-lineage.

F. de L.

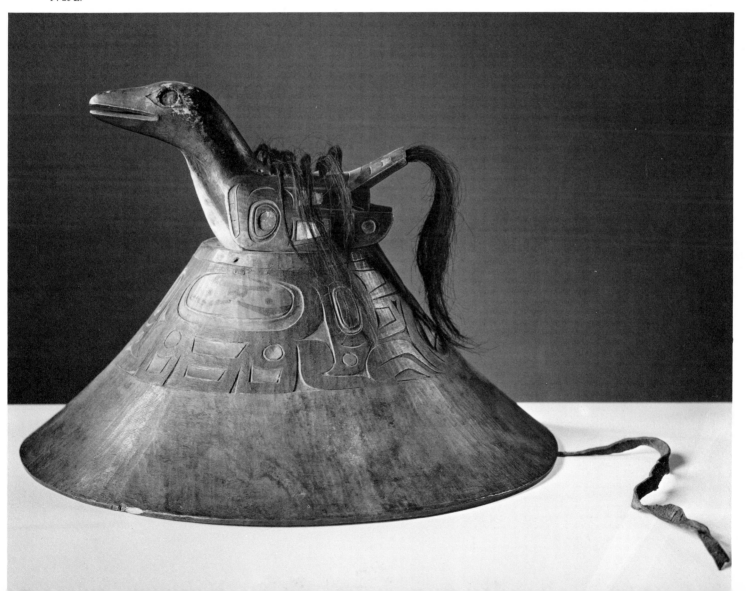

259 HAT OR HELMET REPRESENTING A RAVEN

Wood, and deerskin with black, red, green and brown pigment, copper, iron, woven spruce root, ermine skin, bird-beak and eagle-down pendants, braided fiber, rawhide lashings and straps, and nails
52 (20 1/2) LONG
Acquired from the Sea Lion House Collection, presumably at Sitka, by Louis Shotridge, 1918
Museum Expedition collection University Museum, Philadelphia, NA 8502

This piece probably represents Tuknaxadi the "Silver Salmon People," a Raven clan of the Hoonah, Sitka, and Yakutat Tlingit. The front of the hat is carved to represent the head of a hawk with a sharply recurved bill.

This crest hat was originally made by the Silver Salmon clan. Display of this raven hat at a potlatch provoked a war with the powerful Ganaxtedi (Raven) clan of Chilkat who claimed exclusive rights to make and show a raven hat at a potlatch. They there-

fore seized the raven hat from their rivals. The war lasted five years but was finally ended after Tailless Raven, the Ganaxtedi Chilkat chief married the daughter of Big Raven, the Yakutat Silver Salmon chief. Peace was restored when the raven hat was returned to the Silver Salmon clan, and the latter returned the decorated house post which they had captured to the Chilkat Ganaxtedi. The two chiefs, father-in-law and son-in-law, danced in the peace ceremony. The war was probably in the middle of the 19th century.

John R. Swanton, *Tlingit Myths and Texts*, Bulletin 39, Smithsonian Institution, Bureau of American Ethnology, (Washington, D. C.: 1909), pp. 161–65.
Louis Shotridge, "War Helmets and Clan Hats of the Tlingit Indians," The University Museum *Journal*, 10, (1919), 1–2, pp. 43–8, esp. pl. I and pp. 45–6.

F. de L.

The name for this helmet is taken from an episode in the "Raven-Traveling" myth. When Raven killed a king salmon, a large crowd of small birds and squirrels rushed to the scene. Raven saw that one salmon was not sufficient for them all, so he made them dig a hole large enough for the salmon, and then sent them after skunk cabbage leaves to wrap around the salmon for the barbecue.

They gathered leaves, but Raven said they were unclean, for they had been found where his mother was cremated. He instructed them to go beyond two mountains for the kind he wanted, and they all went.

In the meantime, Raven cooked the salmon in the leaves at hand and ate it all before the crowd returned. When they arrived with the leaves he had ordered, they found him sitting like a virtuous man, pretending he was awaiting the cooking of the salmon.

The interpretation is: "No other [clan] has a right to lay claim to a man's achievement."

E. C.

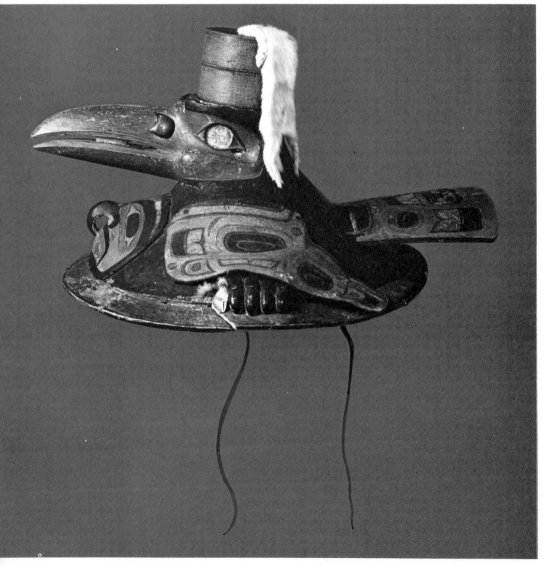

260 HELMET WITH FROG AND RAVEN CRESTS

Wood, with traces of pigment, sealskin, sinew thread, human hair, and nails

35 (13 3/4) HIGH

Collected from the family of the Chilkat chief named "Donawok" ("Silver [Dollar] Eyes") by Stewart Culin, on the John Wanamaker Expedition, 1900

Museum purchase, from Nathan Joseph, San Francisco

University Museum, Philadelphia, NA 37945

The helmet shows the raven's head emerging from the top of the frog's. Both animals were crests of the powerful Ganaxtedi (Raven) clan of Klukwan. The helmet is said to have been 100 years old in 1890.

Gunther, *Northwest Coast Indian Art*, no. 34, p. 60.

Wardwell, *Yakutat South: Indian Art of the Northwest Coast*, no. 87.

F. de L.

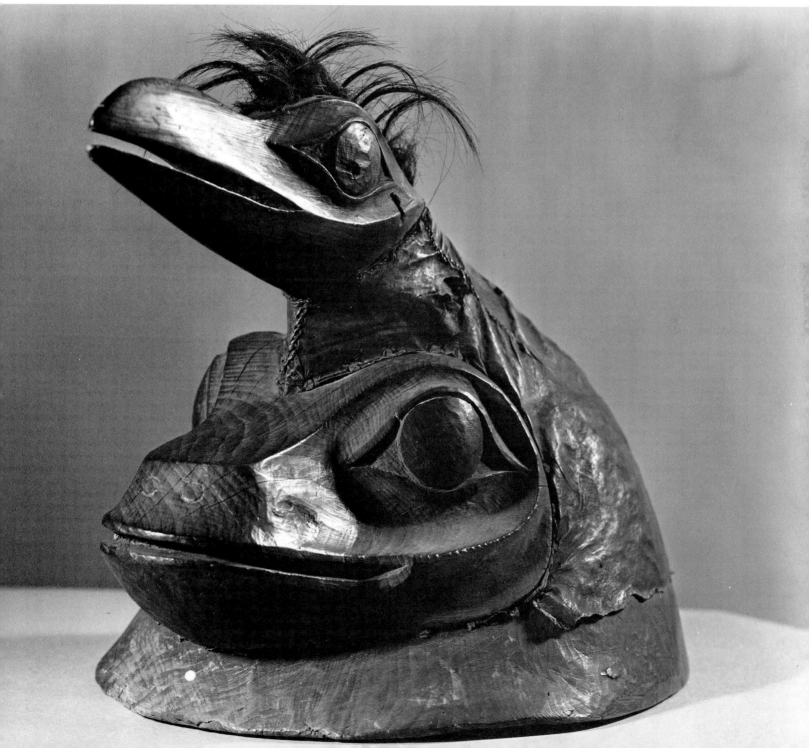

261 HELMET OR FOREHEAD
 MASK: A WOLF'S HEAD
Wood, with green, black, red and white
pigment, copper, operculum, deerskin
with red and black pigment, human
and animal hair, willow band, fiber
lashings, trade fabrics and thread
43 (17) LONG
Collected through Yeesjet of Klukwan,
at Juneau, by Axel Rasmussen,
26 June 1936
Portland Art Museum, 48.3.415

The nostrils and lips of this dance hat
are outlined in copper for which the
owner is said to have paid four slaves.
The hat would have been worn by a
dancer of a clan (probably Teqwedi)
which claimed the wolf as a totemic
crest, who would dance to a special

clan song for the occasion. This piece
represents the transformation of the
old war helmet into a dance headdress.

Davis, *Native Arts of the Pacific Northwest*,
 pl. 22.
F. *de L.*

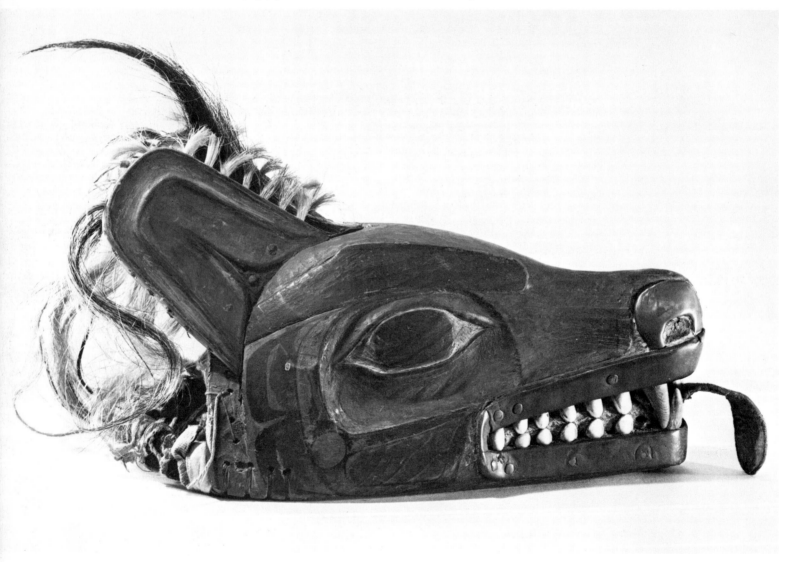

262 HELMET OR FOREHEAD MASK: A WOLF'S HEAD WITH CREST

Wood, with green, red and black pigment, shell and bone inlays, cormorant and ermine skins, human hair, deerskin, and nails
45 (17 3/4) LONG
Collected on Admiralty Island by Lord Bossom, late 19th century
National Museum of Man, Ottawa, VII-A-320

Besides the moveable tongue, an unusual feature of this mask—perhaps indicating shamanistic use—is the series of ten cavities bored into the thickness of the crown from below, and hidden by an inset circle of brown-painted deerskin; another larger cavity, bored through from the top, is also masked on the inside by a smaller ring of painted deerskin.

C. D. L.

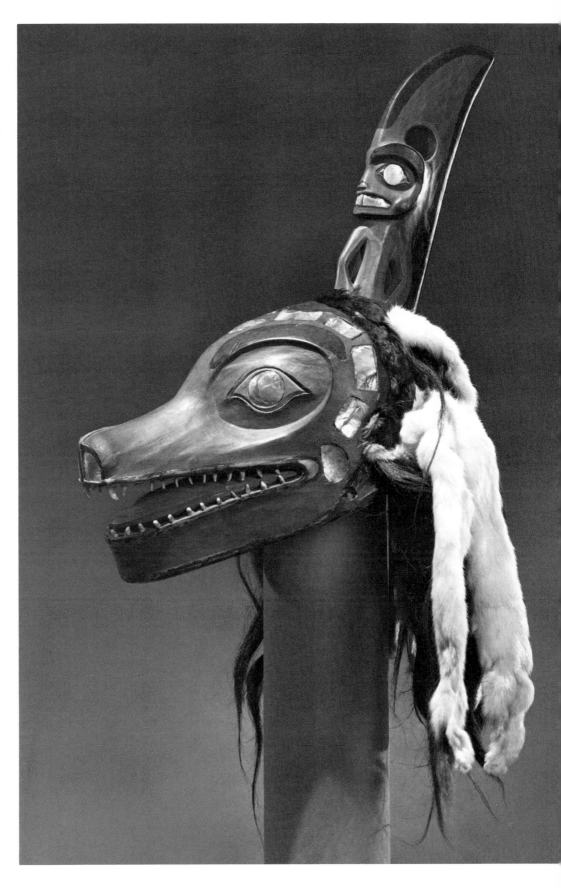

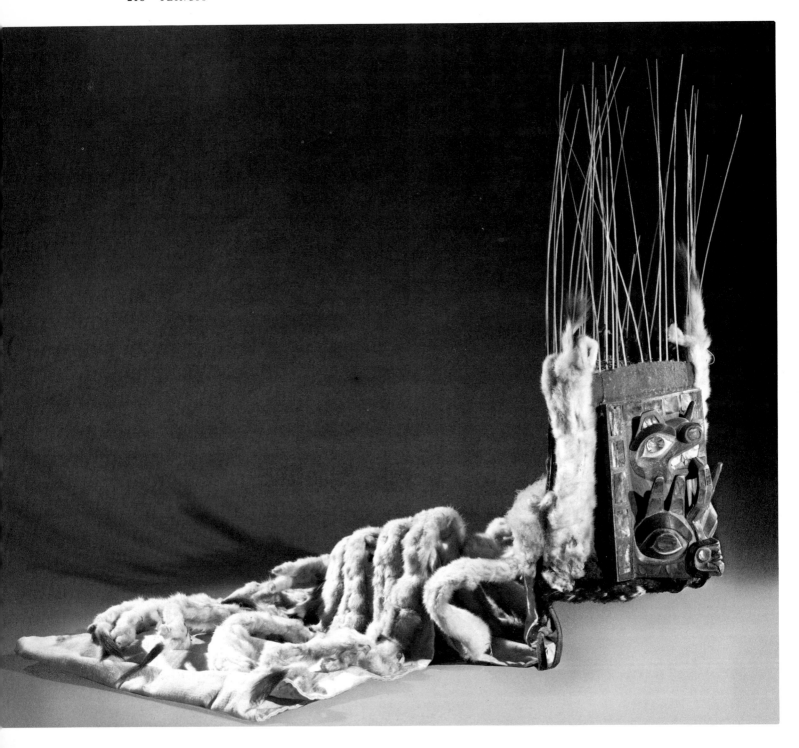

263 CEREMONIAL HEADDRESS,
WITH A MARMOT
HOLDING A BAT
Wood, with red, green, black and
white pigment, shell inlays, willow-
band and stake frame with shaped
deerskin crown, trade fabrics, flicker
feathers, eagle down, sea lion
whiskers, ermine skins, rawhide
straps, and thread
151.4 (59 5/8) HIGH
Acquired from the Eagles' Nest House
Collection at Klukwan, by Louis
Shotridge, 1918
Museum Expedition collection
University Museum, Philadelphia,
NA 8498

Headdresses of this kind, called in
Tlingit "something on the head," are
worn by persons of rank on ceremonial
occasions. Some have the masklike
frontal piece carved to represent the
totemic crest of the clan, but in this
case neither the marmot nor its prey,
the bat, is a Kagwantan crest. Probably
the hat was made simply for show, to
be worn by a woman of rank.

The style of headdress is believed by
the Tlingit to have been copied from
the Indians of British Columbia, espe-
cially the Kwakiutl, who, the Tlingit
said, used to flatten the heads of their
children to fit these ornaments. (The
belief is obviously untrue, since the
back of the headdress is of skin or
cloth and fits the natural shape of the
Tlingit head perfectly.) These head-
dresses were also worn by chiefs, and
also sometimes by young men while
dancing at potlatches.

Shotridge, "War Helmets and Clan Hats
of the Tlingit Indians," pp. 43–8, pl. v.
F. de L.

264 CEREMONIAL HEADDRESS
Wood, with red, blue-green and black
pigment, shell inlays, willow-band
and stake frame, raven feathers, sea
lion whiskers, deerskin cap, rawhide
straps and thread
56 (22) HIGH
Collected by Peter P. Doroshin in
1847–48 or after
Museum of Anthropology and
Ethnography, Leningrad, 2448-19

This headdress has a forehead mask
in red and blue-green to represent the
raven, the totemic crest of the owner.
The eyes and other parts of the mask
are inlaid with haliotis shell. Instead
of the usual cape of ermine fur, the
back of this headdress is made of a
basketry frame of willows, like that of
a fish trap, to which cut raven feathers
and sea lion whiskers are attached.
The latter are also set into the top of
the mask. Below the headdress is a
hide bib or collar, painted orange-red
inside. It is not clear whether any of
this covered the face when the head-
dress was worn.

Siebert, Smirnova, and Forman, *North
American Indian Art*, figs. 7 & 8, pls. 29–31.
F. de L.

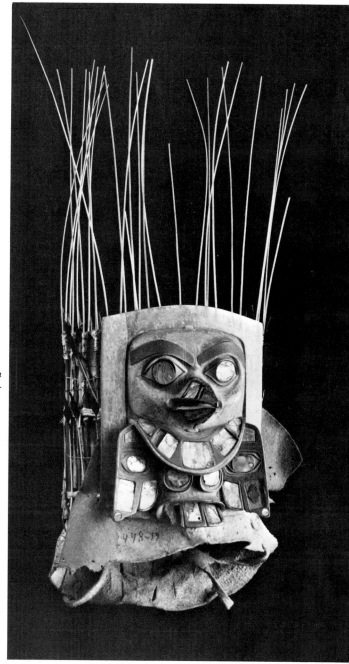

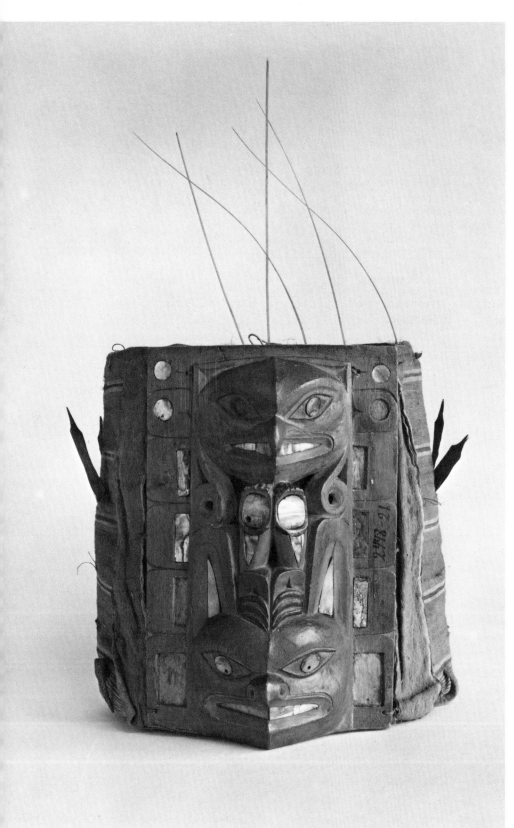

265 CEREMONIAL HEADDRESS, WITH FRONTLET REPRESENTING AN ANIMAL AND A BIRD
Wood, with red, green and black pigment, shell inlays, willow-band and stake frame covered with skin and matting, sea lion whiskers, feathers, and fiber thread
43 (17) HIGH
Probably collected in the early 19th century
Museum of Anthropology and Ethnography, Leningrad, 2448-21

The design seems to represent not "two bird masks," but rather a raptorial bird like the eagle or hawk (above), and some land animal with long ears (below). Instead of the usual cape of ermine fur behind, the back of the headdress is a wicker frame covered with fine matting.

Siebert, Smirnova, and Forman, *North American Indian Art*, fig. 9, pl. 34.

F. de L.

266 CEREMONIAL HEADDRESS WITH TWO BIRDS
Wood, with red, green and black pigment, shell inlays, willow-band and stake frame with trade cloth and canvas, flicker feathers, sea lion whiskers, ermine skins, colored yarns, thread, deerskin panel and rawhide strap
127 (50) HIGH
Collected from Chester Worthington at Yakutat, by Axel Rasmussen, 1933
Portland Art Museum, 48.3.433

An interesting parallel to the ermine train behind this headdress is provided by the Tlingit ermine shirt acquired from the Sitka Whale Collection by Louis Shotridge in 1925, for The University Museum (NA 10516, cited in No. 205), with the same decoration of tufts of polychrome commercial yarns, sewn on as color accents to the white skins.

C. D. L.

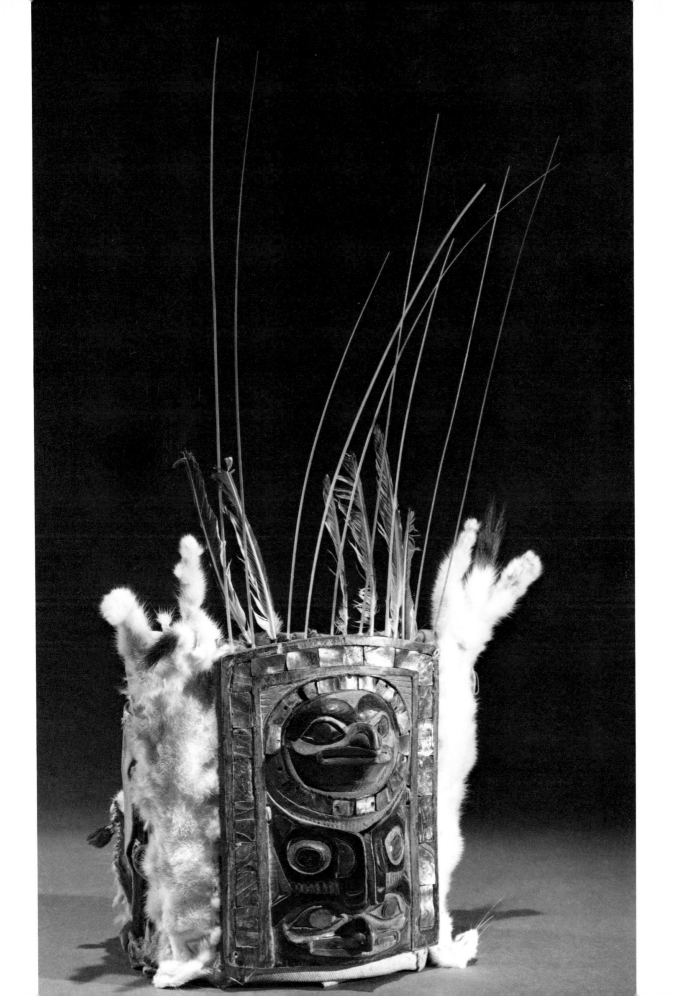

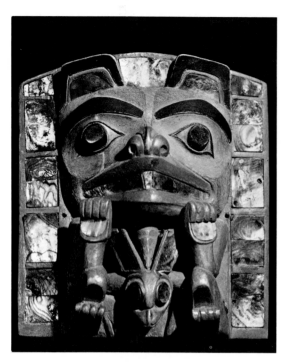

267 HEADDRESS FRONTLET
WITH A BEAR AND
ANOTHER ANIMAL
Wood, with red, green and black pig-
ment and shell inlays; traces of
braided fiber lashings
15.5 (6 1/8) HIGH
Gift of Princess Gourielli, 1950
The Brooklyn Museum, 50.158

268 CEREMONIAL HEADDRESS
Wood, with red, black and green poly-
chrome, shell and mirrored glass
inlays, willow-band and stake frame
with trade cloth, canvas, and buttons,
sea lion whiskers, rabbit fur, eagle
down, ermine skins, thread and
modern string, wire and nails
188 (74) HIGH
Collected by George Terasaki
Glenbow-Alberta Institute,
 AA-1006-111

This elaborate headdress is unusual in
the length of the cascading ermine that
falls like a cape down the back of the
wearer. Such a headdress was tradi-
tionally worn at potlatches by men
and women of noble birth. The
animal or bird figures on the front
supposedly represented the crest of
the wearer.

F. de L.

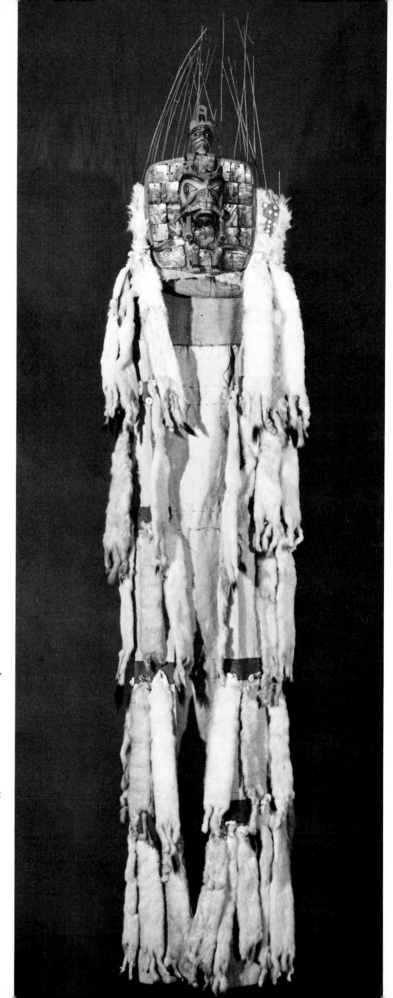

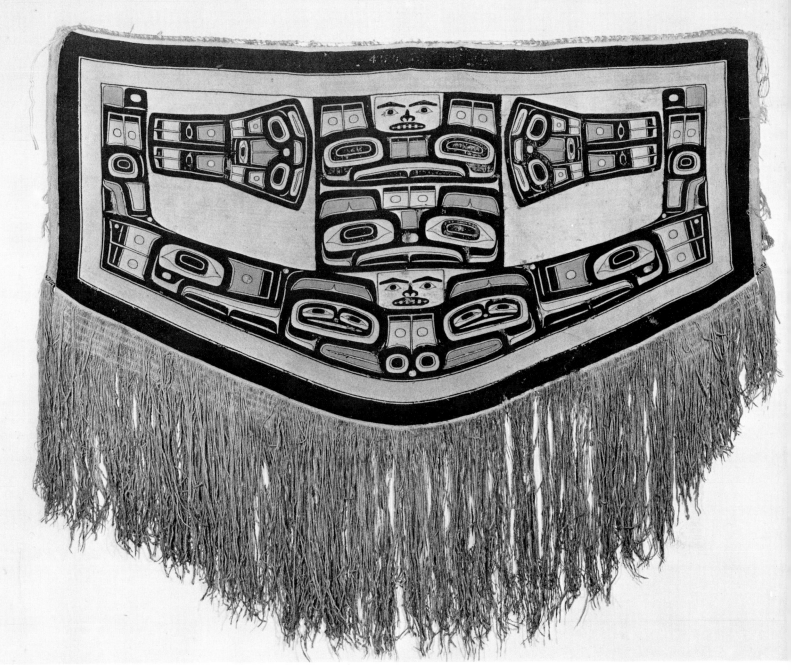

269 MANTLE

Mountain goat wool, dyed brown,
yellow, green and white, on a warp of
braided cedar-bark fiber, thread,
and rawhide tying strap
170 (67) LONG
Chilkat
Collected by Capt. Robert Bennet
 Forbes
Museum collection, 1832
Peabody Museum of Salem, E 3648

One of the oldest surviving examples
of this classic type of "Chilkat
blanket," this specimen was probably
already an heirloom when collected
during the first third of the 19th
century. Its design is unusual in de-
picting, at left and right top center,
two of the trapezoidal objects called
"coppers," hammered sheets of that
metal sometimes worked in low relief
(but more often painted) with de-
signs such as these, and said to have

formed a medium of exchange be-
tween Tlingit chiefs. The only large
"copper" surviving in good condition
and with designs as elaborate as those
reproduced here, however, seems to be
the one collected at Sitka by J. G.
Swan before 1876 for the Smithsonian
Institution (No. 20 778, 37 in. long),
and now on permanent exhibition at
the National Museum of Natural
History.

C. D. L.

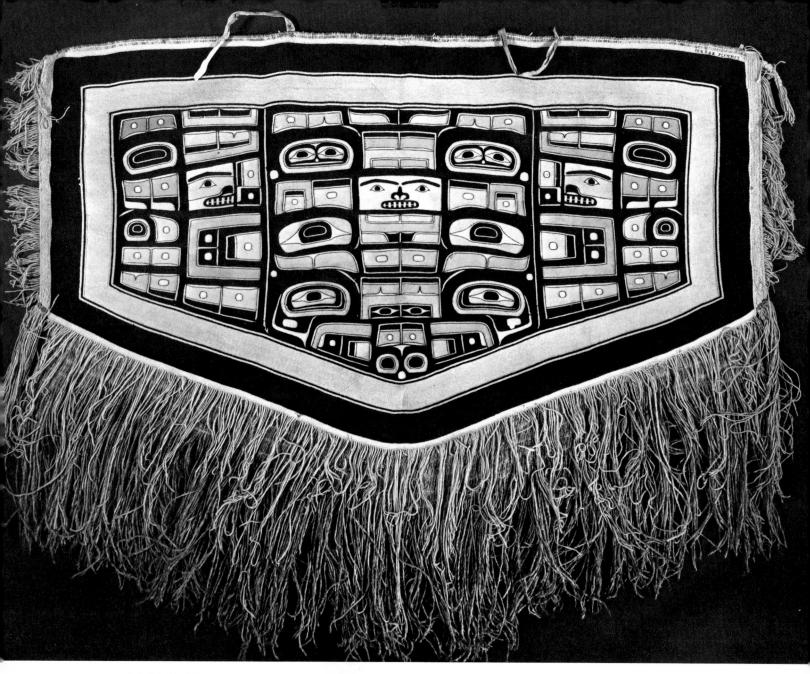

270 MANTLE*

Mountain goat wool dyed brown,
 yellow and blue, woven on a warp
 of wool and braided cedar-bark fibers;
 deerskin tying straps
170 (67) LONG
Chilkat
Collected by Lt. G. T. Emmons,
 U. S. Navy
Presented to the Museum by F. W.
 Clarke, agent of the Interior De-
 partment, 1894
Smithsonian Institution, 168 292

This beautifully preserved "Chilkat
blanket," with its natural colors only
slightly faded, may be compared for
the greater subtlety and refinement of
its designs with the similar but more
recent example following.

C. D. L.

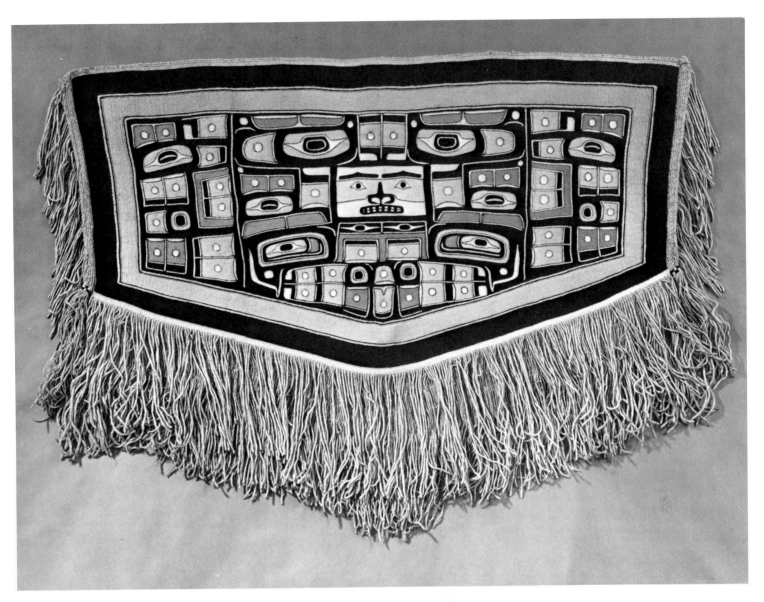

271 MANTLE WITH KILLER
 WHALE CREST DESIGN
Mountain goat wool dyed brown,
 yellow and blue, woven on a warp of
 wool with braided cedar-bark fibers
170 (67) WIDE
Collected by Louis Shotridge, 1923
Museum Expedition collection
University Museum, Philadelphia,
 NA 9484

272 MANTLE WITH TWO
 MONSTERS AND CREST
 DESIGNS*
Buckskin, with red and black pigment,
 skin and fur, sinew threads, and
 rawhide tying straps
160 (63) WIDE
Kaigani Haida, Prince of Wales Island
Smithsonian Institution, 20 807

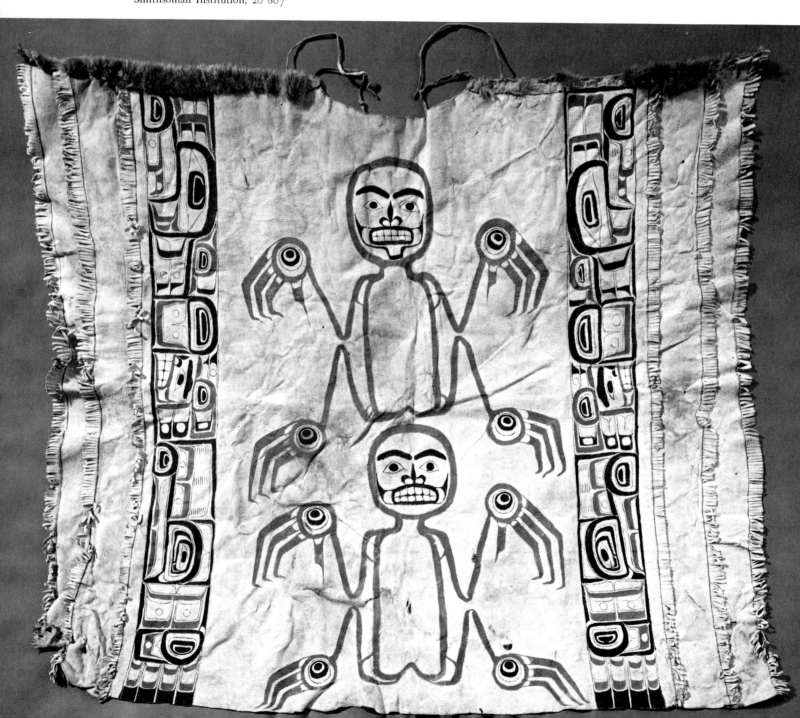

273 MANTLE WITH PAINTED
 BORDER OF EIGHT
 ANIMALS
Buckskin, with red, green and black
 pigment (integral tying straps)
155 (61) WIDE
Collected by Edward G. Fast,
 1867–68
Museum purchase, 1869
Peabody Museum, Harvard University,
 69-30-10/2081

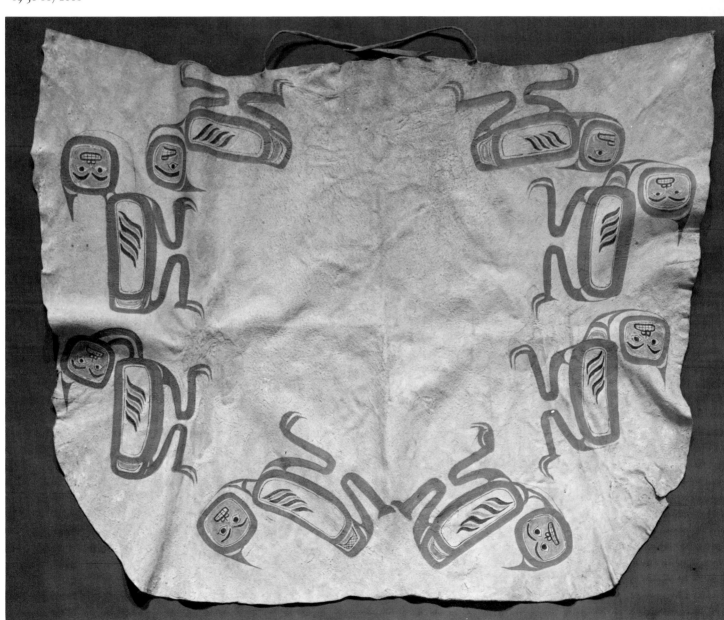

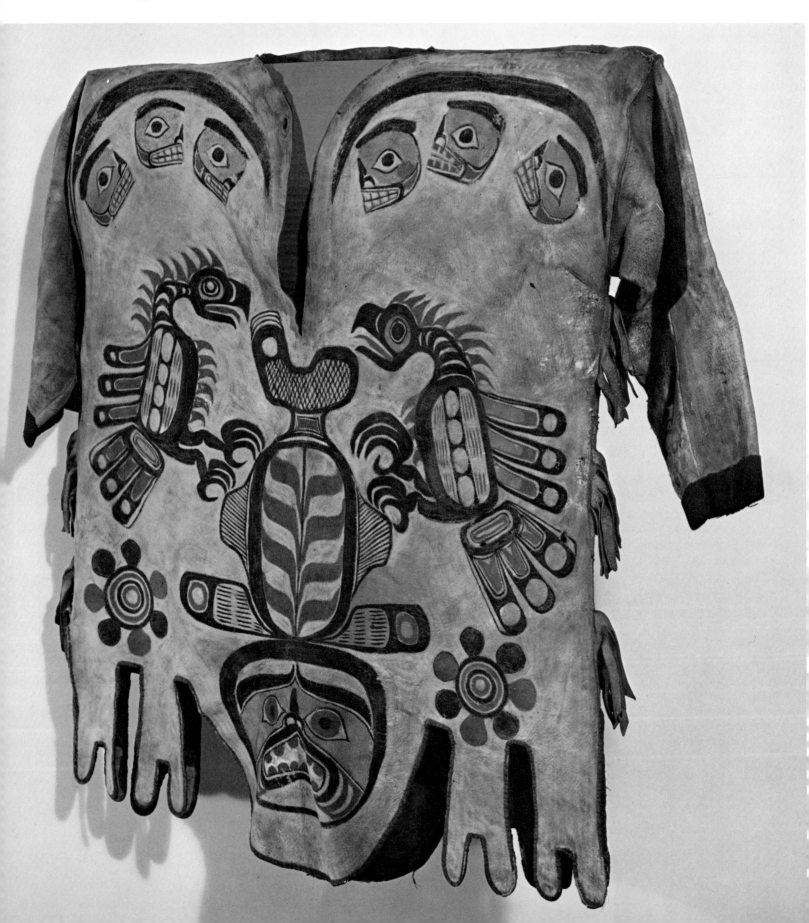

274 CEREMONIAL SHIRT WITH
GEOMETRIC AND CREST
DESIGNS

Buckskin, with red, green, black, and
white pigment, sinew and fiber thread,
and trade cloth
155 (61) WIDE
Collected by Miss Grace Nicholson
Gift of Lewis H. Farlow, 1904
Peabody Museum, Harvard University,
04-10-10/62978

Said to have been worn by "Sitka
Jack" at his potlatch in 1877, this
shirt is of unusual interest both for
the elaboration of its painted crest
designs and also for the similarity of
its eight-pointed pendants, front and
back, with those of the octopus bags
collected at about this time among the
Tlingit (see Nos. 203 and 204).

C. D. L.

275 CEREMONIAL SHIRT OR
ARMOR

Doubled layers of buckskin, the outer
with black, red and green pigment,
the two joined by rawhide lashings
and straps
93 (36 5/8) HIGH
Collected at Sitka by J. J. Bischoff
Donated by the collector in 1859
Bernisches Historiches Museum, A1-20

This sleeveless vest or mantle has been
identified both as armor and as a
ceremonial costume; possibly it func-
tioned as both.

The painted decoration clearly
portrays a jumping killer whale,
probably the crest of the Kagwantan
or Wushkitan (*Wuckitan*), both
clans of the Wolf moiety. The human
face below may be simply the
anthropomorphized rendering of a
rock.

Feder, *Two Hundred Years of North Ameri-
can Indian Art,* no. 40.

F. de L.

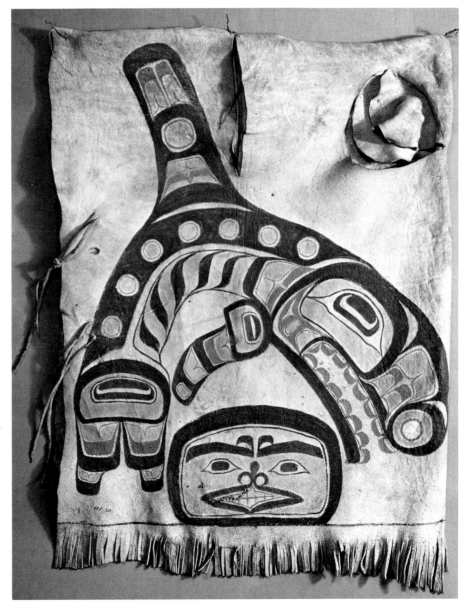

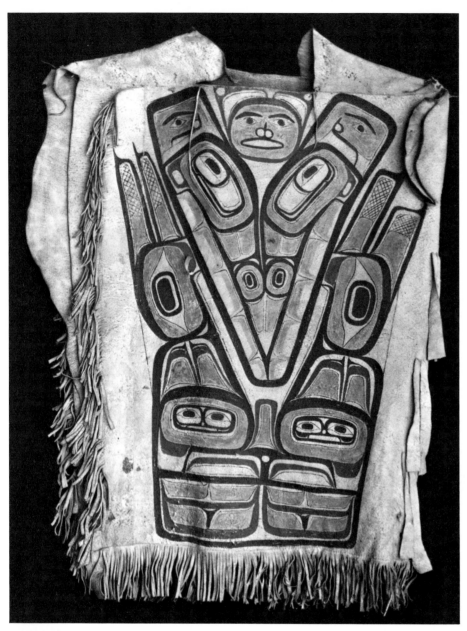

276 CEREMONIAL SHIRT OR ARMOR WITH CREST DESIGN

Doubled layers of buckskin, black, blue-green and red pigment, the two joined by sinew threads and rawhide straps

97 (38 1/4) HIGH

Collected at Sitka by Ilia G. Vosnesenski, 1843–44

Museum of Anthropology and Ethnography, Leningrad, 2454-10

This shirt may represent the raven, although identification is uncertain. The fringing suggests an Athabaskan origin for the material, or perhaps simply Athabaskan influence; the shirt may, therefore, have come from the Chilkat.

Siebert, Smirnova, and Forman, *North American Indian Art*, pl. 96.

F. de L.

277 CEREMONIAL MANTLE WITH CREST ANIMAL

Buckskin, with black, green and red pigment, dyed porcupine quills, and fiber

64.5 (25 3/8) HIGH

Collected, possibly from Klukwan, by Louis Shotridge, 1917

University Museum, Philadelphia, NA 5770

The mantle is painted to represent the crest animal of the wearer, so that the head and forelimbs fall on the chest, while the tail and fins or wings fall on the back. The crest cannot be identified, being possibly a composite creature like a sea wolf.

F. de L.

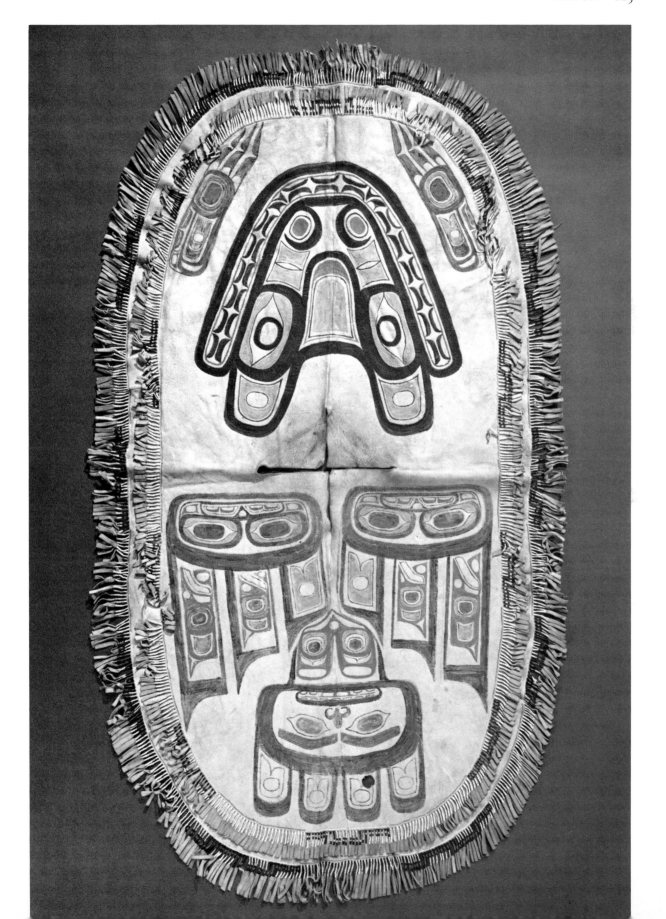

278 MANTLE WITH STYLIZED FACES

Woven cedar bark, with black, green and red pigment

90 (35 1/2) WIDE

Prince of Wales or Queen Charlotte Islands; Victor Justice Evans Collection

Bequest of the collector, 26 March 1931

Smithsonian Institution, 361 033

279 CEREMONIAL COAT

Mountain goat wool, dyed black, blue and yellow, land otter fur, commercial yarn and thread

155 (61) WIDE

Collected from "Situk Jim" at Yakutat by Axel Rasmussen, apparently before 1912

Portland Art Museum, 48.3.548

Two gussets of land otter fur have been let into the sides of the coat because it was too small for the wearer. This use of land otter fur in a garment is most unusual, since the animal is feared for its evil supernatural powers, and to wear even a small piece of its hide or sinew is to risk being captured by a Land Otter Man.

The design as a whole represents the Brown Bear, the most important crest of the Tekwedi clan. The three central faces are those of the Bear, of the Tlingit woman who married the Bear, and, below, their cub child. On the back of the coat is an inverted face which signifies that the wearer will soon invite his hosts to a potlatch. Thus, this garment would be one worn by the Tekwedi chief when he was a guest at a potlatch given by a Raven clan.

Davis, *Native Arts of the Pacific Northwest*, no. 25.

de Laguna, *Yakutat Tlingit*, pl. 145.

F. de L.

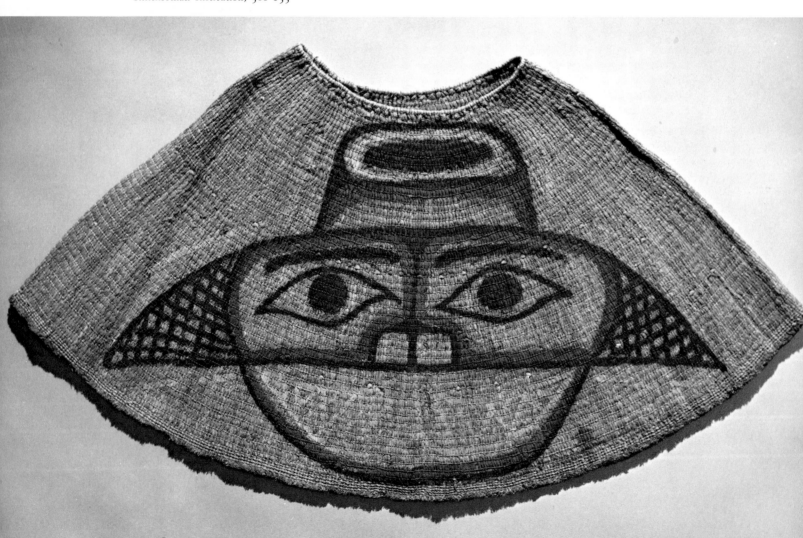

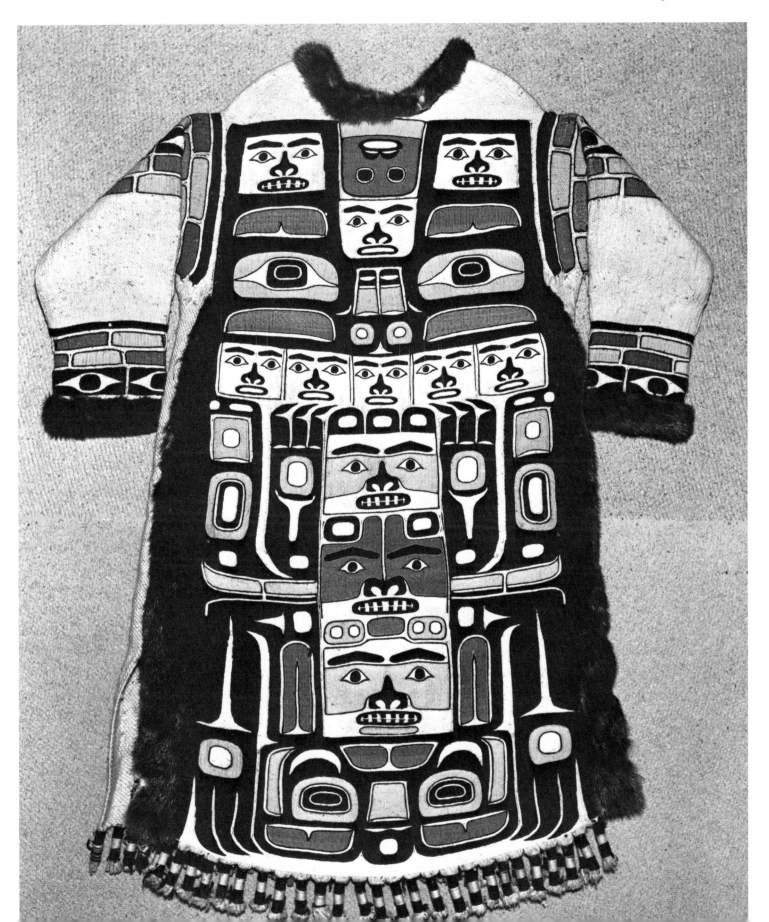

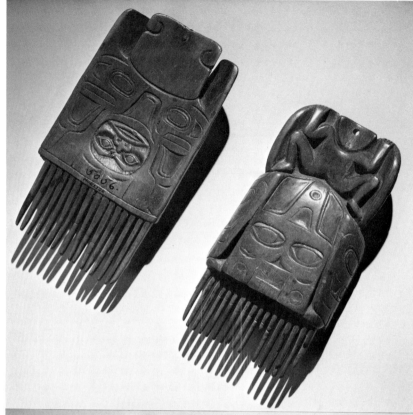

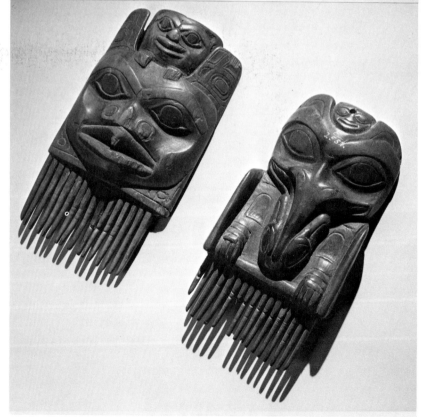

280 SHAMAN'S COMB WITH ANIMAL SPIRITS

Wood

14.6 (5 3/4) HIGH

Collected near Yakutat by Professor William S. Libbey of Princeton University, 1886

Princeton University Museum of Natural History, PU 5056

The spirit face carved in low relief on the back of the comb, as opposed to those in high relief on the front, is represented upside down, on both this and the following example; it may be compared also with the inverted spirit or human face on the front of the Leningrad collar, No. 330.

C. D. L.

281 SHAMAN'S COMB WITH FIGURES AND FACES OF ANIMAL SPIRITS

Wood, with traces of dark pigment

14.3 (5 5/8) HIGH

American Museum of Natural History, E/2557

TLINGIT SHAMANS

THESE "doctors" were the intermediaries between ordinary men and the forces of nature. The shaman could control the weather, bring success in war or on the hunt, find lost persons, and cure the sick. The latter was accomplished by exposing the witch responsible for the illness and forcing him to undo his spell. Each shaman was aided by several familiar spirits (*yek*) that might appear to him in animal or bird form while he was fasting in the woods during his novitiate. There is some reason to believe that these creatures were actually ghosts in animal form. The most powerful were the land otter, bear and octopus, as well as spirits in the sky, mountains or glaciers.

A shaman inherited these spirits and powers from a precedessor in his clan, usually a mother's brother. It meant death to refuse the call. A dead shaman was never burned, as were ordinary persons, but his corpse and outfit were set in a gravehouse or box, far from the village, beside which a figure of a guardian spirit was set. The new shaman might use all of his predecessor's masks and other ceremonial attire or have new articles made for himself. When performing, the shaman was possessed by one or another of his spirits in turn, speaking in its voice and language, and wearing the mask, forehead mask, or special facepaint appropriate to each one. He usually was naked, except for an apron and a necklace of rattling charms; but since he had to fight witches or even shamans from an enemy tribe he sometimes wore armor, a war bonnet, and carried knives or war clubs. A Tlingit war party was always accompanied by its shaman.

The shaman's power was bound up in his long, unkempt hair which, if cut, meant he would lose it and perhaps die.

Most of the shamans' material in this exhibition was obtained from heathen priests after baptism, or from shamans' graves which were looted by foreign collectors.

227

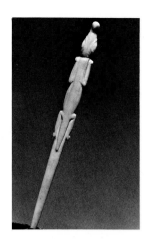

282 SHAMAN'S HAIRPIN: A LAND OTTER

Ivory
11.5 (4 1/2) LONG
Rautenstrauch-Joest-Museum,
 Cologne, 6509

This ivory pin is carved to represent a
land otter, one of the animals most
commonly associated with the shaman.
It was probably used to pin up his
long, uncombed, ropelike locks. These
he would let down during shamanistic
rituals, when they were believed to
move of themselves, as if endowed
with separate lives. At other times,
and as he lay in death, his hair was
pinned up.

F. de L.

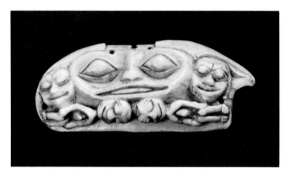

284 SHAMAN'S CHARM: PECTORAL ORNAMENT

Ivory
11.7 (4 5/8) LONG
Collected in Port Frederick near
 Hoonah, Chichagof Island
Museum of the American Indian,
 Heye Foundation, 9/7953

Although no exact provenance is
given for this piece, it resembles the
bone and ivory charms collected by
George T. Emmons from shamans'
graves in the Yakutat and Dry Bay
areas, before 1888. Such carvings
represented the spirits which the
shaman may have seen in dreams; they
were attached to his necklace or dance
cape, or hung at his neck. Sometimes
he touched them to the patient's body
when attempting a cure.

The way in which this charm was
usually worn is illustrated by the
central neck ornament with subsidiary
pendants belonging to a Tsimshian
shaman (Feder 1971, no. 33). Tlingit
shamans often had Tsimshian-speaking
spirits and so imported such
Tsimshian charms.

de Laguna, *Yakutat Tlingit*, pls. 182, 183.
F. de L.

283 SHAMAN'S CHARM: KILLER WHALE WITH SPIRIT FACE

Walrus ivory
13.5 (5 5/16) LONG
Collected by Lord Bossom, c. 1900
Museum collection, 1955
National Museum of Man, Ottawa,
 VII.A.252

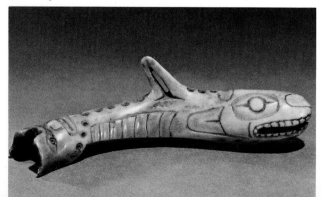

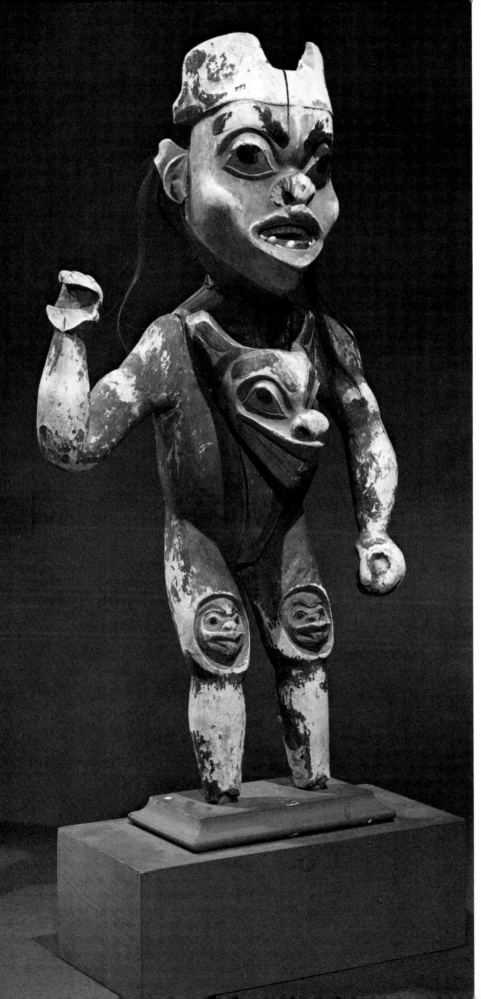

285 SHAMAN'S GRAVE
 GUARDIAN: A SPIRIT-
 FIGURE OR *YAKE*
Wood, with brown, green, red, and
 black pigment, opercula teeth, human
 hair and eagle down
59.7 (23 1/2) HIGH (above modern
 base)
Collected from a shaman's grave near
 Yakutat by Lt. G. T. Emmons,
 U. S. Navy, 1882–87
American Museum of Natural History,
 19/378

This figure originally gripped spirit
knives or wands in the act of striking.
Placed at the head of a shaman's
corpse, it served as a private guard or
yake. It protected the grave from
hostile spirits and was considered so
powerful that only a few Tlingit, and
only those who had taken up European
ways, dared approach it. The wolf's
head protruding from the figure's
chest and the bears' heads on each
knee symbolize subsidiary protective
powers. The figure wears a shaman's
war hat, and the base on which he
stood, now missing, is described as
carved like a seal, indicating that the
spirit did not walk, but could glide
through the air as easily as a seal
through water.

de Laguna, *Yakutat Tlingit*, pl. 169; Fraser,
 Primitive Art, pl. 179; Harner and Elsasser,
 Art of the Northwest Coast, fig. 61.

F. de L. and E. C.

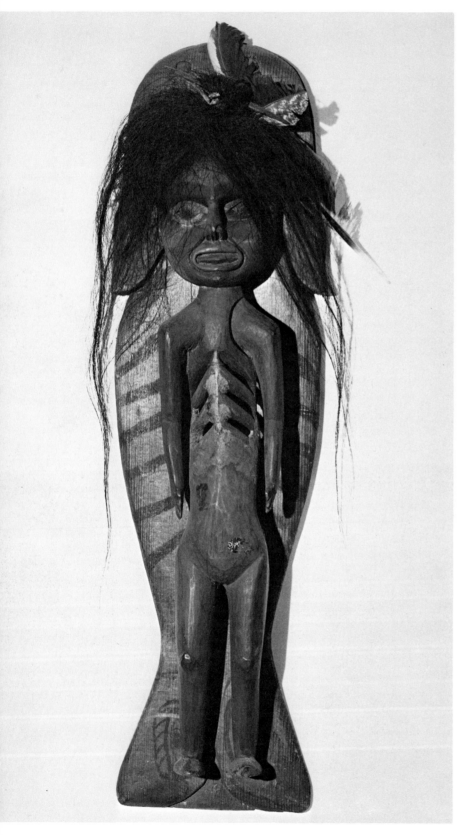

286 SHAMAN'S SPIRIT-FIGURE
Wood, with brown and black pigment,
 human hair, feathers, and twine;
 modern repair to exposed rib cage
42 (16 1/2) LONG
Museum purchase, Frank L. Babbott
 Fund
The Brooklyn Museum, 62.82

The supporting panel in the shape of
a wide-mouthed fish preserves traces
of a pencil inscription in a 19th-
century hand, with extensive comment
on the skeletal spirit-figure and fish
iconography, now mostly indecipher-
able.

C. D. L.

287 FIGUREHEAD OF A WAR CANOE

Cedar, with black, green and red pigment, shell inlays, and human hair; strengthened with wood and metal
99 (39) LONG
Carved as the prow figure for the canoe of Jinsatiyi of the Land Otter House; collected from the Eagles' Nest House at Sitka by Louis Shotridge, 1918
Museum Expedition collection
University Museum, Philadelphia, NA 8500

The figure represents the dreaded Land Otter Man, a creature that "captures" or "saves" those who drown or are lost in the woods, transforming them into land otters like themselves. The land otter is considered the most powerful source of shamanistic power.

This prow ornament was made to decorate the canoe of Jinsatiyi, a brave warrior of the Tluknaxadi (Silver Salmon), a Raven clan of Sitka. All canoes of important persons, such as house chiefs, have personal names and are decorated with totemic crests. Thus, the Sitka guests came to Klukwan in Chilkat country in the Sea Lion canoe of the Tluknaxadi, the Frog Canoe of the Kiksdi, and the Coho Salmon Canoe of the Katka'ayi —all Raven clans and guests. Jinsatiyi was given the Land Otter Man Canoe, with this emblem, to commemorate his brave deeds, rights to which would be inherited in his maternal line.

Louis Shotridge, "Land Otter-Man," The University Museum *Journal*, 13, (1922), pp. 55–9.
Gunther, *Northwest Coast Indian Art*, no. 41, p. 63.
Dockstader, *Indian Art in America*, see #81, a figure of the Land Otter Man.
F. *de L.*

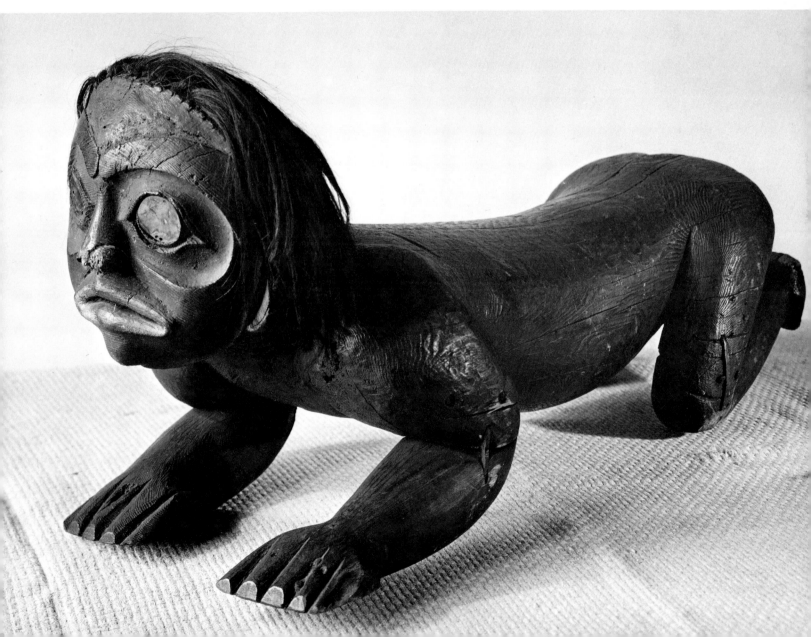

288 FROG, CLAN EMBLEM OF
 THE LUKNAXADI (COHO
 SALMON CLAN)
Wood, with black and white pigment
134.5 (53) LONG
Carved at Sitka for the Coho Salmon
 clan, 1902
Long-term loan from the Luknaxadi
 clan
Sitka National Monument, 762

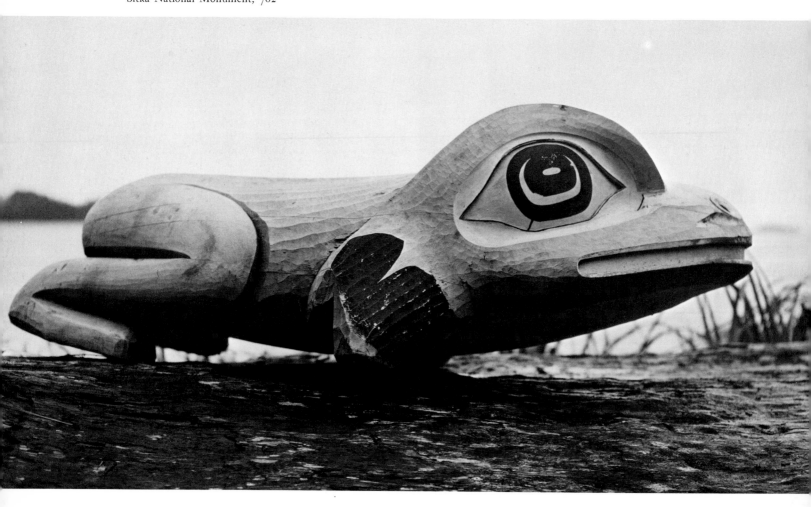

289 SCULPTURAL GROUP:
OWL MAN PERCHED IN
THE SIDE OF A CROW
Wood, with red, green, black and
white pigment, human hair
49.5 (19 1/2) HIGH
Carved at Yakutat c. 1891; collected
there from Billy Jackson of the
Kwashkwan clan, by W. J. Carruthers,
1936; Axel Rasmussen Collection
Portland Art Museum, 48.3.354

This image was carved to commemo-
rate the death of a Yakutat man
killed about 1891 at Icy Bay when a
tree fell on him. His body was found
when someone noticed the gathering
of crows.

The victim evidently belonged to
the Kwashkwan (*Kwackqwan*)
(Humpback Salmon) clan, for the
human image has the body of an owl
and perches on a crow or raven, both
crests of his clan. The image was
carved from the tree that killed him.
At each of several feasts given in his
memory, this Owl Man, decorated with
a new ribbon, was placed on the table.

Davis, *Native Arts of the Pacific Northwest*,
pl. V in color.
Dockstader, *Indian Art in America*, frontis-
piece in color.
de Laguna, *Yakutat Tlingit*, pl. 167.

F. de L.

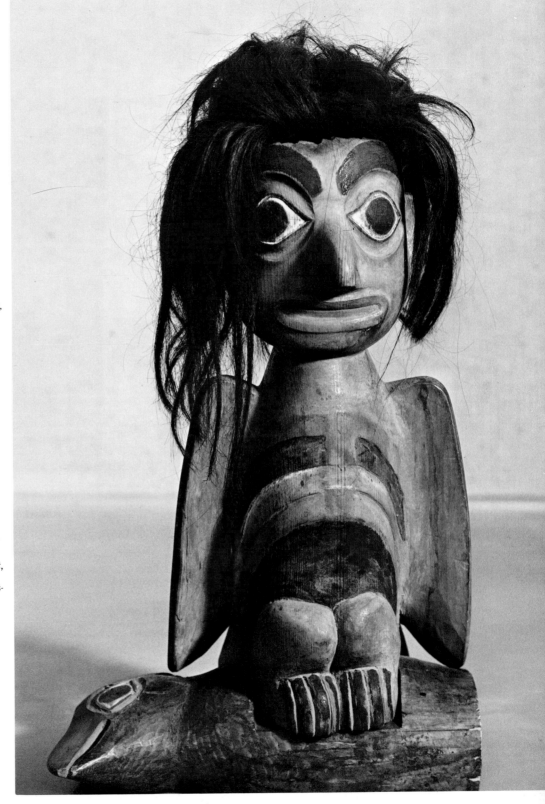

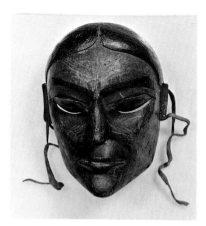

291 MASK OF A GIRL WITH MOVEABLE EYES

Wood, with red and black pigment
26.7 (10 1/2) HIGH
Perhaps Tsimshian or Haida, made for
Tlingit use? (See No. 295 below)
Museum voor Land- en Volkenkunde,
Rotterdam, 34789

This remarkable mask is apparently a
portrait of a young girl. What is most
unusual about it is that the eyes are
moveable, a feature not typical
of Tlingit masks, although a few ex-
ceptions are known. Masks with
moving parts, elaborately manipulated
by strings are characteristic of the
Kwakiutl, and are used especially in
secret society dances. Some features of
these dances have been adopted by
both the Tsimshian and southern
Tlingit, as special performances put on
at potlatches. Since the Tlingit ad-
mired Tsimshian woodcarving, indeed
all Tsimshian art, it is never possible
to be sure that a piece collected from
the Tlingit was actually made by them.
Possibly this mask was actually of
Tsimshian manufacture, since the
latter were noted for their portrait
masks. The Haida, however, are also
known to have made at least one
realistic mask of a non-Indian woman
with moveable eyes, a mask which
closely resembles the present specimen.
The Haida mask was collected at
Masset, Queen Charlotte Island, before
1890. (Lowie Museum of Anthropol-
ogy, No. 2-15549).

Harner and Elsasser, *Art of the Northwest
Coast*, p. 106.

F. de L.

Illustrated in color

290 CROUCHING HUMAN FIGURE

Wood, with green, red, and black pig-
ment, human hair, fox fur, metal
rings, glass beads with polychrome
metal or foil inlay
86 (33 7/8) HIGH
Collected by the Alaska Commercial
Company before 1898
Robert H. Lowie Museum of
Anthropology, 2-4814

The exact provenance of this piece is
unknown, but it resembles closely in
style the Sitka canoe prow ornament
representing the Land Otter Man
(No. 287). The fur wristlets, the
crouching position, suggestive of an
animal, and especially the clawlike
fingers suggest that this represents an
unfortunate human being transformed
into a Land Otter Man, but his body
is not yet covered with fur.

Harner and Elsasser, *Art of the Northwest
Coast*, p. 95.
Drucker, *Cultures of the Northwest Coast*,
pl. 13 (in color).

F. de L.

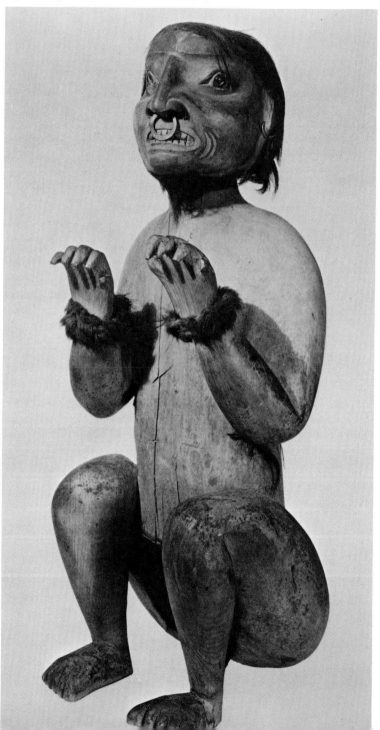

292 MASK OF A WOMAN
Wood, with red, brown, black and
 traces of white pigment and rawhide
 strap
22.2 (8 3/4) HIGH
Collected by Rev. Sheldon Jackson,
 1882
Princeton University Museum of
 Natural History, PU 3924

A very similar mask in the same
collection (PU 3961), with com-
parable red foliate tattoos in a simpler
pattern, displays the same sensitivity
and realistic modeling as the present
example (fig. i).

C. D. L.

figure i

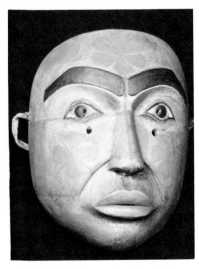

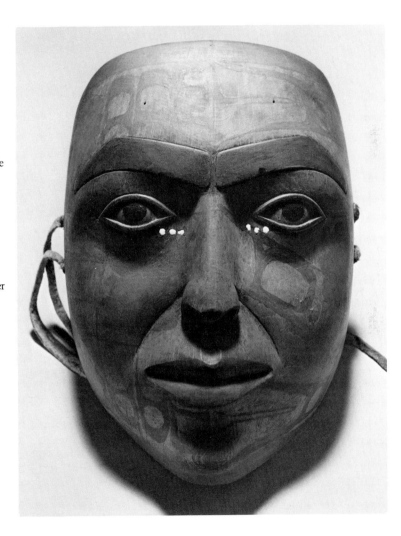

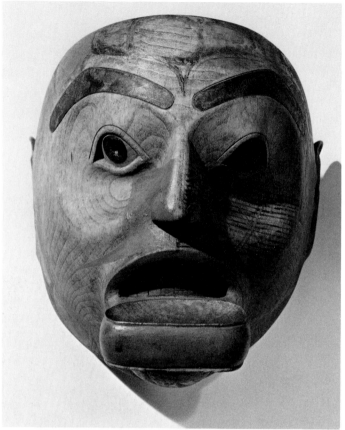

295 MASK OF A WOMAN
WITH LABRET
Wood, with red, green, and black
pigment
19 (7 1/2) HIGH
Collected by Lt. Wilkes, U. S. Navy
Exploring Expedition, 1838–42
Smithsonian Institution, 2 666

Although Lt. Wilkes is not recorded
as having collected specimens in
Alaskan territory, the close similarities
of this mask with the three cited in
No. 294 (which have been variously
identified as Tlingit or Haida, and
one of which is inscribed with the
name presumably of a Tlingit woman)
would suggest that the present piece
was produced in the same area, and
perhaps by the same master carver.
The fame of such masters and the
degree to which their best works were
prized would not make it surprising
that this mask might have been traded
or presented as a gift, and migrated

from its point of origin, to "N. W.
Coast Am." where Lt. Wilkes
collected it according to the inscription
on the mask. It is in fact postulated
here that the present mask may
represent a later phase in the personal
style of a Tlingit or Haida master
carver, whose works were already being
collected by Yankee voyagers in
1826–27.

Smithsonian Institution, Bureau of American
Ethnology, *3rd Annual Report*, 20, fig. 45,
p. 185.
C. D. L.

294 MASK OF A WOMAN
WITH LABRET:
"JENNA CASS"
Wood, with red, green, black and
slight traces of white pigment
25.4 (10) HIGH
Collected by J. Goodwin, 1826
Exchange from the American
Antiquarian Society of Worcester,
1910
Peabody Museum, Harvard University,
10-47-10/76826
Inscribed in ink within, presumably
by the collector, and with his
autograph:

A correct likeness of
Jenna Cass, a high chief woman
of the North west Coast
J. Goodwin Esq.

The inscription inside this mask, pre-
sumably in Goodwin's hand, together
with the coincidence of its date of
collection within a year of the preced-
ing example (No. 293), and their
similarity in material, execution,
physiognomy and color; and the
slightly different but closely related
Smithsonian example (No. 295) and
a virtually identical example in the
British Museum (55.12-20.195), may
elucidate some of the problems posed
by this extraordinary group. Are these
four masks all shaman's emblems of
female spirits, or are they portraits?
In what sense and to what degree are
they "correct likenesses" of a "high
chief woman?" Or are they composite,
generalized or idealized? The differ-
ences in their tattooed decoration,
symbolic animal forms on the Salem
and British Museum examples and
more simple geometric stylizations on
the Harvard and Smithsonian pieces,
may represent variations in clan
markings, as Professor de Laguna has
postulated above. The Salem and
British Museum examples are nearly
identical in decoration, but not in
size, the latter being slightly larger,
and whereas the size and carving of
the Salem and Harvard examples are
very close, they differ somewhat in
painted decoration.

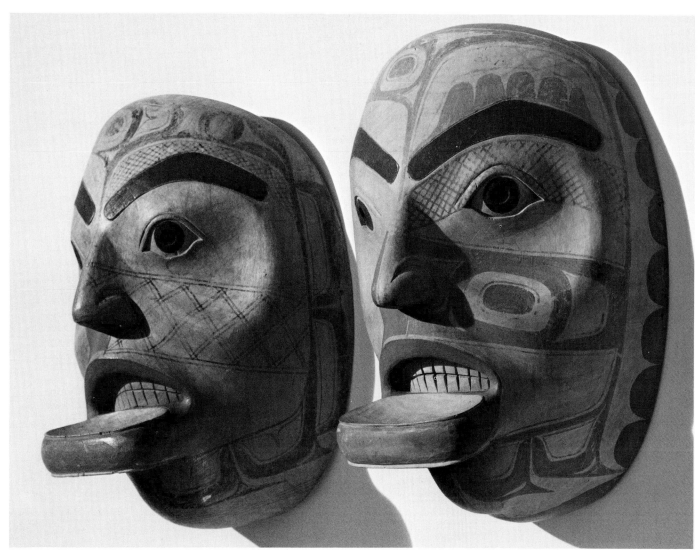

With the unusual opportunity of this exhibition to place the masks from Salem and Harvard side by side, it is hard to resist the conclusion that they may have been carved by the same master.

A comparison with parallel examples, such as the women's masks from Princeton immediately preceding this series (No. 292), indicates that the group here assembled does not derive its impression of stylistic unity simply from stock responses to a prescribed pattern. Its quality seems to derive from the personal synthesis of one master carver, and its separate pieces reflect his own solutions to this series of individual characterizations.

C. D. L.

Illustrated in color

293 MASK OF A WOMAN
Wood, with red, green, black and
traces of white pigment
26 (10 1/4) HIGH
Collected by Capt. Daniel Cross, 1827
Peabody Museum of Salem, E 3483

This is probably a shaman's mask, representing a female spirit wearing a large labret in the lower lip. The face is decorated with stylized painting. If the mask represents a deceased person, these designs would be the symbolic totemic emblems of the dead woman's clan. On the other hand, since spirits often appeared to the shaman in both animal and anthropomorphic guise, the design may symbolize the animal form in which the shaman first encountered this woman.

Female spirits are often said to be those dwelling in the sky, the clouds, and glaciers. Also, see the comments under Nos. 294 and 295.

F. de L.

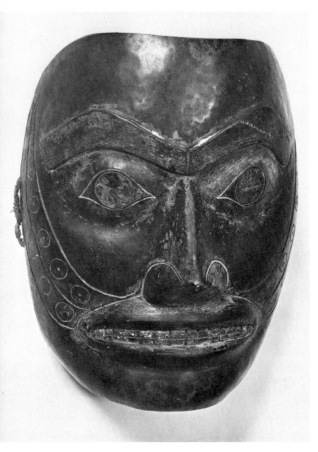

**296 MASK OF A MAN WITH
 TATTOOS**
Copper, with shell inlays and natural
 verdegris, rawhide strap
20.4 (8) HIGH
Collected by B. A. Whalen, c. 1850
Museum of the American Indian,
 Heye Foundation, 2146

Frederica de Laguna has postulated
that this piece may have been pro-
duced as a potlatch dance mask.

**297 MASK OF A MAN WITH
 TATTOOS AND PAINTED
 CREST**
Wood, with red, black, green and
 white pigment, bearskin, operculum,
 copper, rawhide strap, and nails
24.8 (9 3/4) HIGH
Collected at Sitka, c. 1883
Taylor Museum, Colorado Springs
 Fine Arts Center, TM 5006

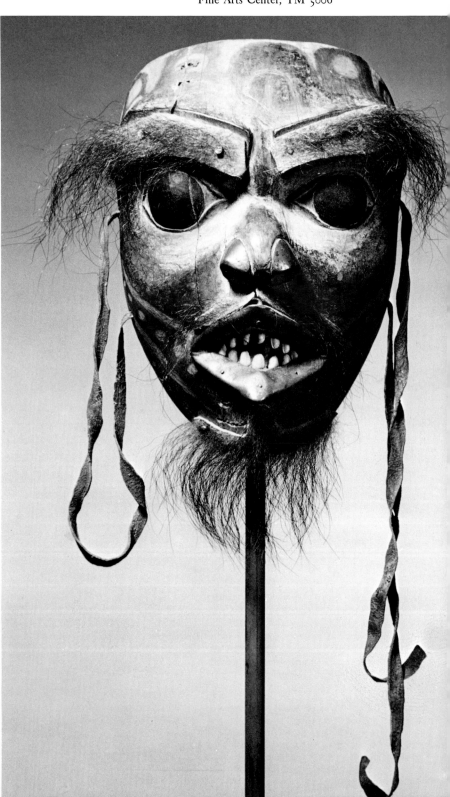

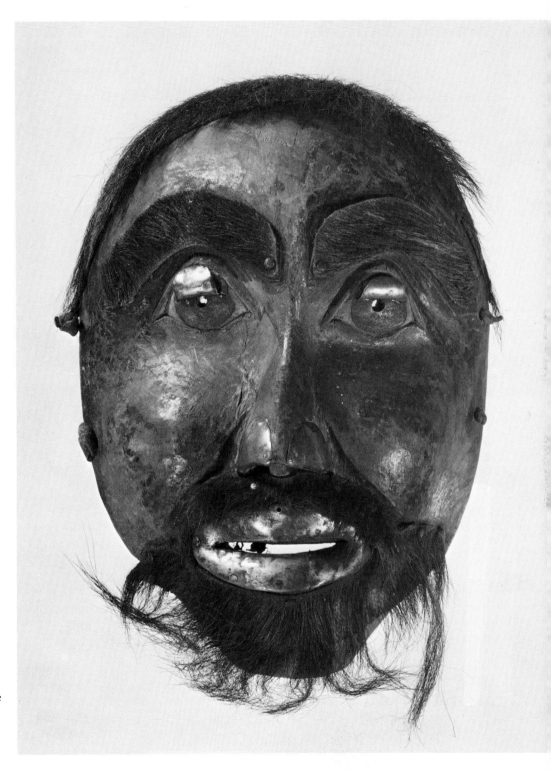

298 SHAMAN'S SPIRIT MASK:
 HUMAN FACE WITH
 ANIMAL HAIR*
Wood, with blue-green and black
 pigment, copper, animal fur, rawhide
 straps, and nails
32 (12 5/8) HIGH
Collected at Sitka by J. G. Swan
Smithsonian Institution, 18 929

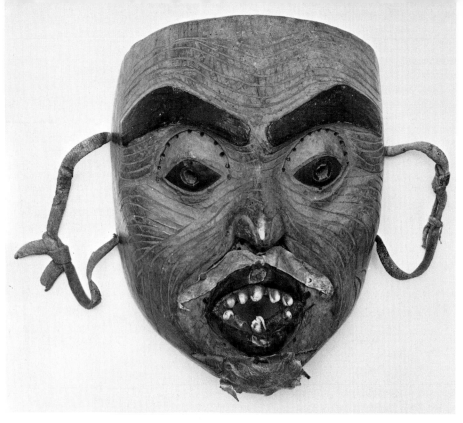

300 SHAMAN'S SPIRIT MASK
Wood, with blue-green, brown, and
 black pigment, operculum, copper,
 and skin, with rawhide strap
21 (8 1/4) HIGH
Greenough Collection
Museum acquisition, 1908
Peabody Museum of Salem, E 16700

Of the original fur moustache and
goatee only the bare skin remains.
 This mask was undoubtedly that
of a shaman who represented one of
his familiar spirits as a man with
deeply wrinkled face, or perhaps as
one already dead with greenish pallor.

Gunther, *Northwest Coast Indian Art*, p. 37.
F. de L.

299 SHAMAN'S SPIRIT MASK
Wood, with blue, red, white, and
 black pigment, bearskin, human hair,
 rawhide strap, and nails
28 (11) HIGH
Angoon
Collected from the Angoon Tlingit on
 Admiralty Island by G. Chudnovsky,
 1890
Museum of Anthropology and
 Ethnography, Leningrad, 211-7

The open mouth, the hair on the face,
and the blue color of the face all
suggest that this mask represents a
drowned man who is gradually assum-
ing the animal shape of the Land
Otter Man. Such a creature was often
the shaman's strongest spirit helper.

Siebert, Smirnova, and Forman, *North
 American Indian Art*, pl. 6.

F. de L.

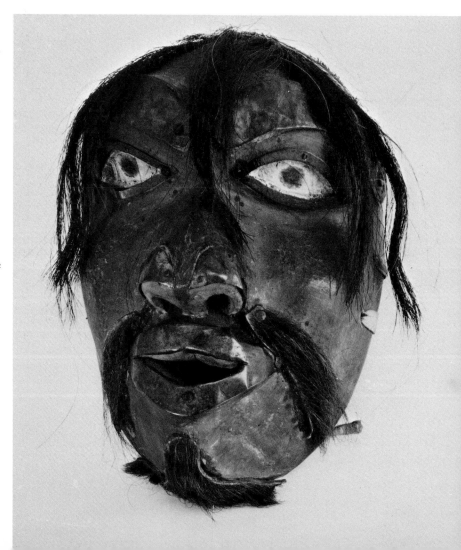

301 MASK
Wood, with blue, green, brown, white
and black pigment, copper, animal
skin, rawhide straps, nails and glue
24.7 (9 3/4) HIGH
Collected from a shaman's grave near
Port Mulgrave, Yakutat, by Professor
William S. Libbey of Princeton
University, 1886
Princeton University Museum of
Natural History, PU 3923

This shaman's spirit mask, the one
following, and the maskette and rattle,
Nos. 310 and 349, were all collected
from the same shaman's grave. This
mask depicts a man with octopus face
tattoos.

F. de L.
Illustrated in color

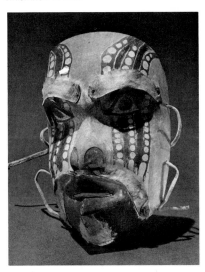

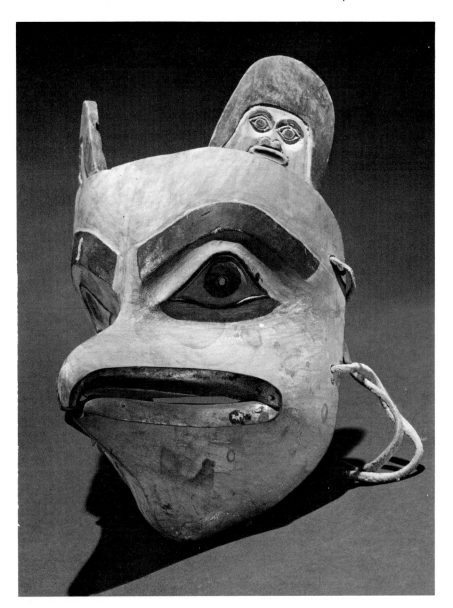

302 SHAMAN'S MASK: A HAWK
Wood, with black, brown, red, and
greenish-white pigment, copper, raw-
hide strap, and glue
26.6 (10 1/2) HIGH
Collected from a shaman's grave near
Port Mulgrave, Yakutat, by Professor
William S. Libbey of Princeton
University, 1886
Princeton University Museum of
Natural History, PU 3911

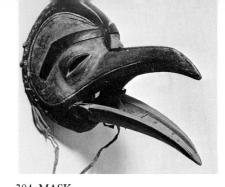

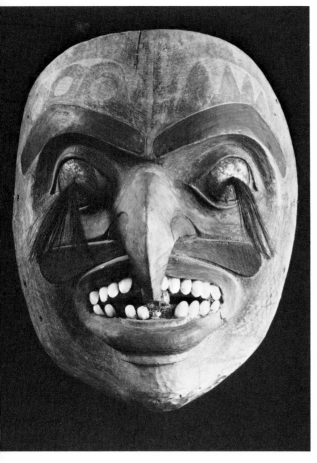

303 SHAMAN'S MASK: A HAWK

Wood, with red, green, brown and
 black pigment, operculum, copper,
 and human hair
22.5 (8 7/8) HIGH
Museum of Anthropology and
 Ethnography, Leningrad, 5795-26

This shaman's spirit mask, like
No. 302, is carved to represent the
spirit of a hawk. The face is largely
human, although the nose is a hawk's
beak. The teeth are opercula; the lips
are painted red, the lower lip being
made of a separate piece.

Siebert, Smirnova, and Forman, *North
 American Indian Art*, pl. 11.

F. de L.

304 MASK

Wood, with blue-green, black, white
 and tan pigment, black-painted
 leather, braided fiber, and rawhide
 straps
31.1 (12 1/4) LONG
Collected at Klukwan, on the Chilkat
 River, from Steve Sheldon by Axel
 Rasmussen, 1931
Portland Art Museum, 48.3.393

This mask was the property of the
Ganaxtedi (Raven clan) chief,
(*Yetxak*) "Yealh-hak," i.e., "Raven
Odor," a name used by the most
powerful Chilkat chiefs since 1788.
The mask represents a young raven
with moveable bill. The lower part
of the bill is hinged so that it can
be opened and closed by pulling a
sinew cord. Such a mask would be
worn in a potlatch, not used for a
shamanistic performance.

Harner and Elsasser, *Art of the Northwest
 Coast*, p. 93.
Erna Gunther, *Indians of the Northwest
 Coast*, Taylor Museum, Colorado Springs
 Fine Arts Center.
Gunther, *Northwest Coast Indian Art*, no.
 60.
Wardwell, *Yakutat South*, no. 73.

F. de L.

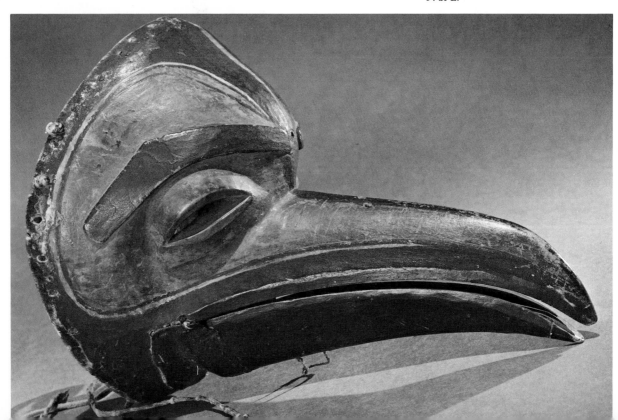

305 MASK
Wood, with green, red, black and
 white pigment, rawhide straps
20 (7 7/8) HIGH
 Eyak Indian
Probably from the village of Alaganik,
 mouth of the Copper River; collected
 by Capt. Johan A. Jacobsen, 1882
Museum für Völkerkunde, Berlin,
 IV.A.6579

This dance mask probably represents
the eagle, an important totemic crest
of the Eyak. There are no eyeholes for
the wearer of the mask, a common
feature of Tlingit dance masks used in
potlatches, when the confined space
in the house permits little movement
other than motions imitating the
crest bird or animal portrayed by the
mask. Often the dancer stands on a
bench, his body hidden by a blanket,
and dances by moving his head.

 The Eyak, never a large tribe and
now all but extinct, were already
decimated by disease as early as 1882.
Since the 18th century they had
adopted many customs from their
more powerful Tlingit neighbors on
the coast to the east. These included
many features connected with cere-
monialism, perhaps crests and masks of
this type. Both tribes were divided
into "Eagles" (or "Wolves") and
"Ravens," names for their main
totems. Ravens and Eagles performed
ceremonial services for each other,
especially at funerals. At such affairs
both Eagles and Ravens displayed
their totemic crests. The last Eyak
potlatch was held about 1910 or 1912.
This mask is precious because it is
one of the few surviving works of this
small tribe.

Captain Johan A. Jacobsen, *Reise an der
 Nordwestküste Amerikas*, ed. A. Woldt,
 Leipzig, 1884.
Kaj Birket-Smith, and Frederica de Laguna,
 *The Eyak Indians of the Copper River
 Delta, Alaska*, Copenhagen: Det Kgl.
 Danske Videnskab. Selskab, 1938.

F. de L.

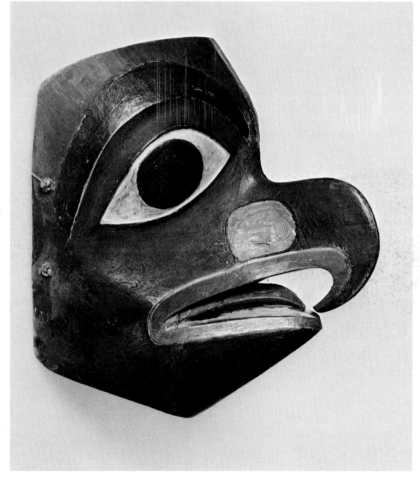

307 SHAMAN'S HEADDRESS
Wood, with blue-green, black, red,
tan pigment, and shell inlays, black-
painted skin, walrus whiskers, feathers,
eagle down, and rawhide strap
50 (19 3/4) LONG
Collected at Sitka by Ilia G.
Vosnesenski, 1843
Museum of Anthropology and
Ethnography, Leningrad, 571-20

This shaman's headdress with mask
represents the spirit of a mosquito.
Curiously enough, the mosquito was a
familiar of many Tlingit shamans,
perhaps because the voracious blood-
sucking insect was believed to have
sprung from the ashes of a cannibal
monster that had been killed and
cremated. The mosquito spirit might
be represented by a mask for the face,
anthropomorphic in form except for
the long proboscis with curved tip or,
as in this case, it might be rendered
as a maskette, attached to the shaman's
headgear.

Siebert, Smirnova, and Forman, *North
American Indian Art*, fig. 4, pls. 18 & 19.
F. de L.

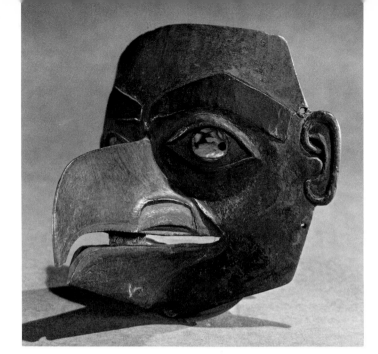

306 MASKETTE: AN EAGLE
SPIRIT
Wood, with green, black and red
pigment, shell inlays
13.6 (5 3/8) WIDE

Found in a shaman's grave near
Yindastuki, mouth of the Chilkat
River; collected by Lt. G. T.
Emmons, U. S. Navy, 1882–87
American Museum of Natural History,
19/918

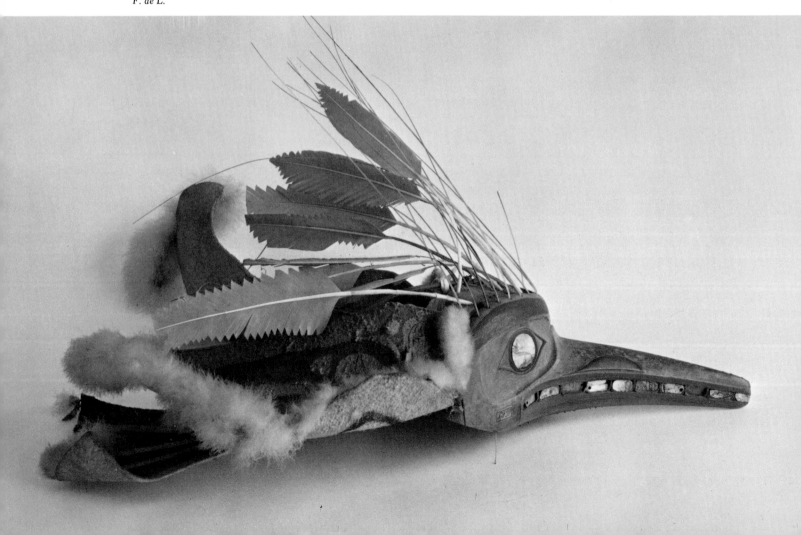

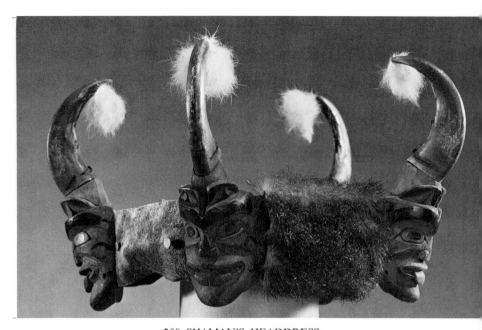

309 SHAMAN'S HEADDRESS FRONTLET

Wood, with blue-green, red, and black
 pigment, shell inlays, hair, black-
 painted skin, rawhide straps, and nails
35 (13 3/4) WIDE
Museum of Anthropology and
 Ethnography, Leningrad, 2448-16

For some ceremonial performances
or healing activities, the Tlingit
shaman did not wear a mask, especially
since the mask was without openings
for eyesight. Every shaman, therefore,
had a series of headdresses, sometimes
little more than skin headbands, to
which a small mask was attached. As
these small masks also represented
familar spirits, the shaman would be
inspired by whichever one symbolized
the maskette on his headdress. The
headband was sometimes embellished
with additional decoration, or covered
with swansdown. The figure repre-
sented here is that of a bear, one of
the most powerful of spirits a shaman
might acquire. This maskette was
probably attached to a shaman's
headband.

Siebert, Smirnova, and Forman, *North
 American Indian Art*, pl. 15.

F. de L.

308 SHAMAN'S HEADDRESS

Wood, with black, red and brown
 pigment, sealskin, fur, bear claws,
 eagle down, and nails
28 (11) DIAMETER
Collected by Kashavarof from Mrs.
 Mary Ross of Sitka
Museum purchase, Rausch Fund, 1937
Alaska State Museum, II-B-1301

This shaman's headdress shows four
 faces surmounted by bear claws.

(Juneau) *Alaska Daily Press,* 2 October
 1937, p. 8.

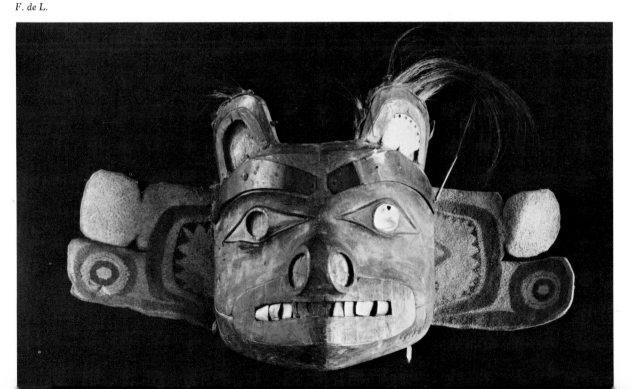

310 SHAMAN'S HEADDRESS
 MASKETTE
Wood, with green, reddish-brown, and
 black pigment, with operculum inlays
14 (5 1/2) HIGH
Collected from a shaman's grave near
 Port Mulgrave, Yakutat, by Professor
 William S. Libbey of Princeton
 University, 1886
Princeton University Museum of
 Natural History, PU 3919

An associated maskette from the same
collection (PU 3916) representing a
spirit with a weeping face, is similar
in its anthropomorphic conception to
the following example (fig. j).

C. D. L.

311 SHAMAN'S HEADDRESS
 MASKETTE
Wood, with green, red, and black
 pigment, bone or bead inlays, and
 metal (copper?) eyes
9.5 (3 3/4) HIGH
Collected from the Hoonah Tlingit on
 Chichagof Island by P. Schulze, 1882
Museum für Völkerkunde, Berlin,
 IV.A.353

This shaman's headdress maskette
represents an anthropomorphic bear
face.

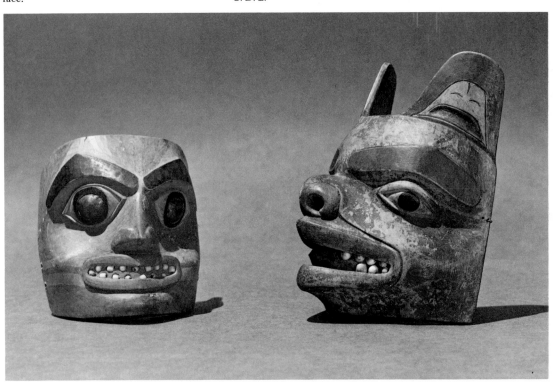

312 MASK
Wood, with green, red, tan, brown,
and black pigment, operculum and
copper inlays
24 (9 1/2) HIGH
Collected presumably from
"Schwatka," brother of the shaman
artist, probably at Klukwan or Haines
St. Joseph Museum, Missouri,
143/5608

This mask represents a bear, evidently
one of the spirits of the famous
Chilkat shaman, Dr. Skundoo or Skun-
doo-ooh, who acted as a guide to the
first explorers penetrating the interior
via the Chilkat and Chilkoot passes.

While the face is somewhat anthropo-
morphized, the erect ears indicate
that an animal is represented. Each
ear is treated as if it were a whole
face. This mask is somewhat similar
to another bear mask at the same
museum (145-5364).

For a similar but more elaborate mask: cf.
Dockstader, *Indian Art in America*, no. 86.
For a portrait of the shaman in action (with-
out a mask): Keithahn, *Monuments in
Cedar*, p. 18.

F. de L.

313 SHAMAN'S MASK
Wood, with green, black, and red
pigment, operculum inlays and raw-
hide strap
27 (10 5/8) HIGH
Collected by Edward G. Fast, 1867–68
Museum purchase, 1869
Peabody Museum, Harvard University,
69-30-10/1609

This elaborate mask is carved to
represent a bear, undoubtedly a
shaman's spirit. From the cheeks and
forehead issue three smaller bears or
cubs, probably ancillary spirits.

Feder, *Two Hundred Years of North Ameri-
can Indian Art*, no. 35.

F. de L.

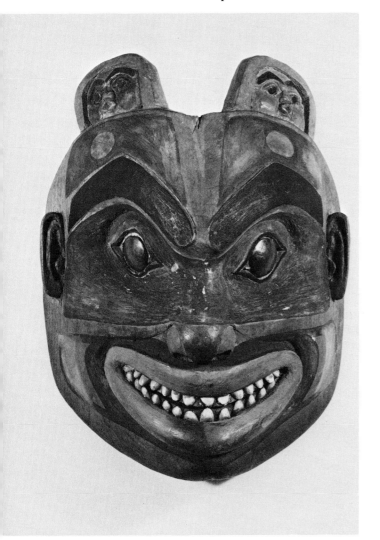

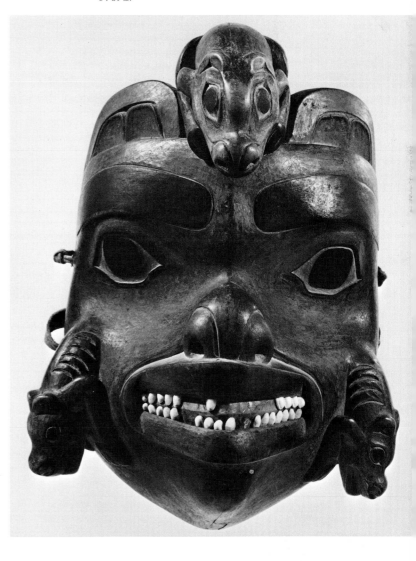

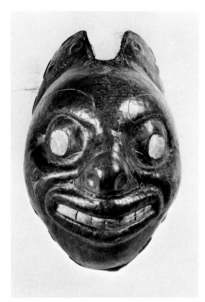

315 SEA BEAR MASK
Copper, shell inlays, skin hood and
 lining encircling the ears and back,
 (with fur projecting), sinew thread
 and rawhide lashings
29.8 (11 3/4) HIGH
St. Joseph Museum, Missouri,
 143/5364
Illustrated in color

**314 BEAR MASK: A SHAMAN'S
 SPIRIT(?)**
Wood, with green, red, black, silver-
 gray, and white pigment, natural
 bristles, skin painted with black, green,
 and red pigment, braided fiber, and
 rawhide strap
60 (23 5/8) HIGH
Collected by Edward G. Fast, 1867–68
Museum purchase, 1869
Peabody Museum, Harvard University,
 69-30-10/1608

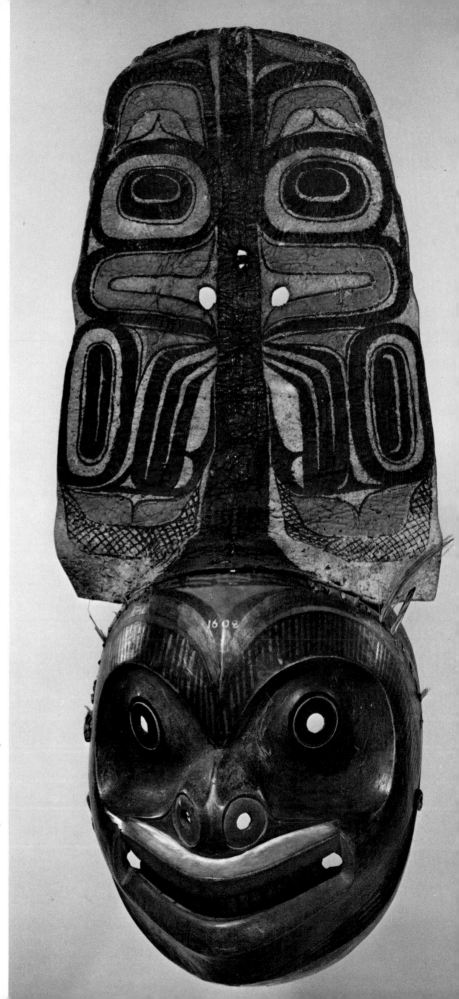

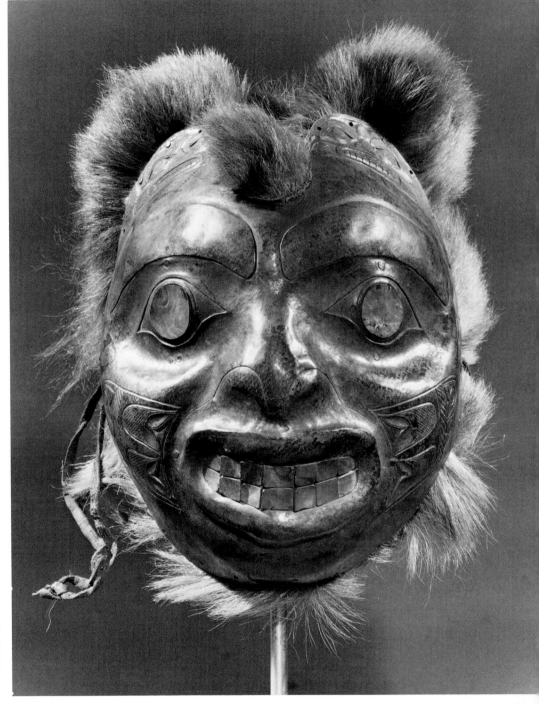

316 SEA BEAR MASK
Copper, with shell inlays, skin lining
 with projecting fur, and rawhide strap
30.5 (12) HIGH
Formerly in the collection of Mrs.
 Belle Simpson
Museum of Primitive Art, 58.329

Since the sea bear is a Haida crest,
not Tlingit, this mask is probably of
Haida manufacture. Nevertheless, such
objects were often given by chiefs to
noble guests at potlatches and it may
well have come to be a treasured
heirloom of some Tlingit lineage. No
information is available about the place
and date of collection.

Gunther, *Northwest Coast Indian Art*, p.
 69, no. 63.
Wardwell, *Yakutat South*, pl. 141, p. 31.
Harner and Elsasser, *Art of the Northwest
 Coast*, p. 63.
R. T. Coe, "The Imagination of Primitive
 Man," *Nelson Gallery and Atkins Museum
 Bulletin*, (Kansas City, 1962), 161, p. 98,
 VI (1).

F. de L.

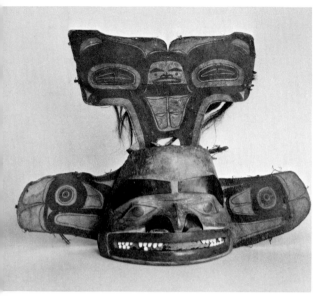

319 FRONTLET MASK
Wood, with blue-green, black and red pigment, copper, operculum inlays, skin with blue-green and black pigment, human hair, braided fiber, rawhide straps, and nails
20 (7 7/8) HIGH
Museum of Anthropology and Ethnography, Leningrad, 2448-17

This mask is carved to represent a hawk with recurved bill. Since this is no ordinary hawk, but the anthropomorphized representation of a hawk spirit, it is quite possible that the mask was worn by a shaman, and attached to a headdress or to a helmet.

Siebert, Smirnova, and Forman, *North American Indian Art*, pls. 13 & 14.

F. de L.

318 WAR HELMET: A BEAR'S HEAD
Wood, with red pigment, copper, operculum and shell insets, sealskin and sinew thread, and nails
21 (8 1/4) HIGH
Probably collected in the early 19th century
Museum of Anthropology and Ethnography, Leningrad, 5795-10

The helmet reminds us of one apparently covered with bear skin and representing the grizzly bear. This hat belonged to a Wrangell man of one of the Raven clans, a group which normally would never dare to use the bear as a crest. It was said that the owner's grandfather (possibly his mother's father) had obtained the exclusive right to use this crest because he had killed a grizzly with an ax after it had destroyed many people. The gash made by the ax is represented in the helmet.

Siebert, Smirnova, and Forman, *North American Indian Art*, pl. 51.
John R. Swanton, *Social Condition, Beliefs, and Linguistic Relationship of the Tlingit Indians*, Bureau of American Ethnology, 26th Annual Report, (Washington, 1908), pp. 391–485; p. 419, fig. 105.

F. de L.

317 WAR HELMET
Wood, with black, white and red pigment, sealskin (?), operculum, sinew thread, braided fiber, and rawhide strap
21 (8 1/4) HIGH
Museum of Anthropology and Ethnography, Leningrad, 5759-11

This war helmet represents the head of an animal possibly a bear or seal.

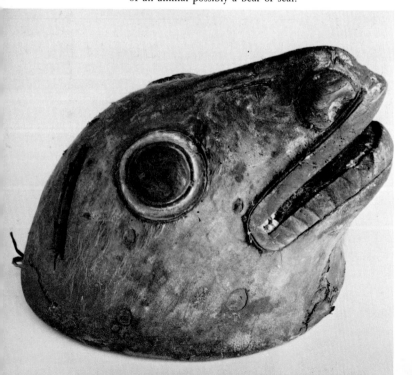

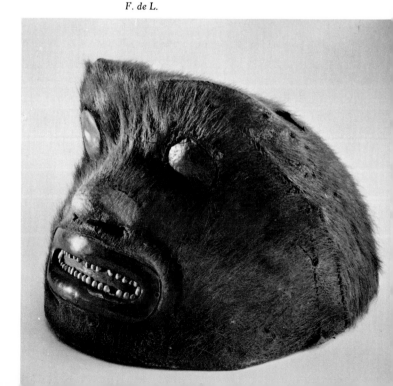

321 WAR HELMET
Wood, with red, gray-green, and black
 pigment, human (and animal?) hair,
 and braided fiber
48 (18 7/8) HIGH
Collected by George Davidson before
 1911
Robert H. Lowie Museum of
 Anthropology, 2-19081

This helmet shows a human face with
tattooed features.

320 WAR HELMET
Wood, with red and black pigment,
 and hair tufts pegged into crest
28 (11) DIAMETER
Presented to Mrs. F. E. Aspinwall by
 a government official in Alaska, 1879
Florida State Museum, 32713

This helmet, a slightly expanded
version of the preceding example,
shows a stylized face.

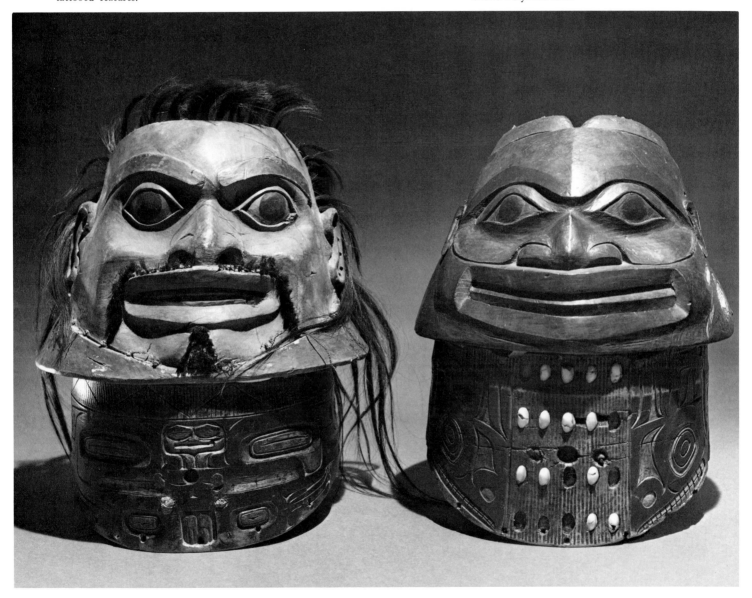

328 DEFENSIVE COLLAR OR
 VISOR

329 DEFENSIVE COLLAR OR
 VISOR*

322 HELMET
Wood, with blue-green, red, black, and
 white pigment, operculum inlays, skin,
 fur, and human hair
28 (11) DIAMETER
Probably collected in the early
 19th century
Museum of Anthropology and
 Ethnography, Leningrad, 2454-12

This helmet, carved to represent a
man's head, with forehead painting in
red and blue, is suggestive of a crest
design. The man, however, wears a
ferocious mask, probably that of a
shaman representing one of his spirits.
In this case, the anthropomorphic
spirit has deep wrinkles at the corners
of the mouth, while the nose suggests
a beak. Between the teeth of the
monster, protrude the heads of two
little men being bitten to death by
the cannibal spirit.

Siebert, Smirnova, and Forman, *North
 American Indian Art*, pl. 37.

F. de L.

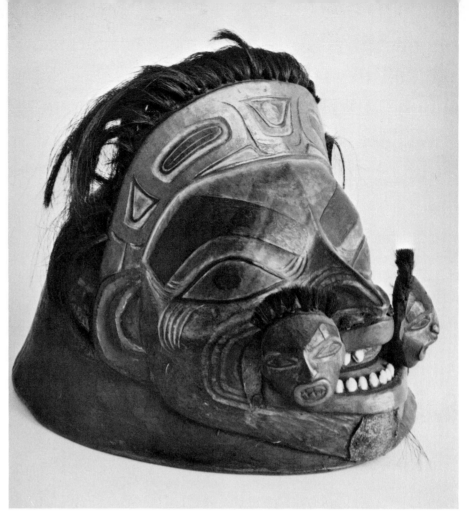

323 WAR HELMET
Wood, with red and black pigment,
 operculum inlays, and hair
34.5 (13 5/8) LONG
Museum of Anthropology and
 Ethnography, Leningrad, 633-8

This helmet is carved to represent a
fierce warrior, perhaps an anthropo-
morphized animal. The moustache and
beard are possibly bear fur. The hair
and feathers formerly attached to the
crest on the head are now missing.
When complete, the specimen may
have resembled the helmet now in the
Lowie Museum of Anthropology,
(No. 2-19081), although the latter is
human in appearance.

Siebert, Smirnova, and Forman, *North
 American Indian Art*, pl. 41(a) and pl. 42.
Inverarity, *Art of the Northwest Coast
 Indians*, no. 99.

F. de L.

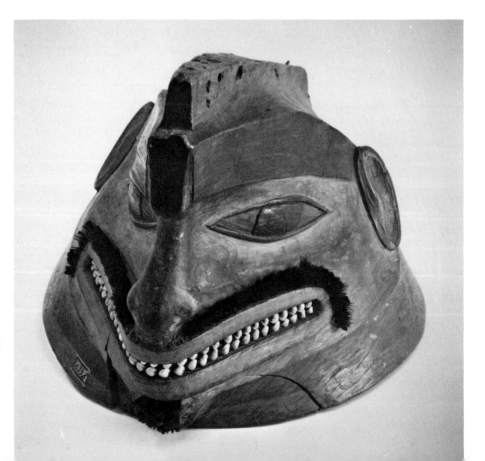

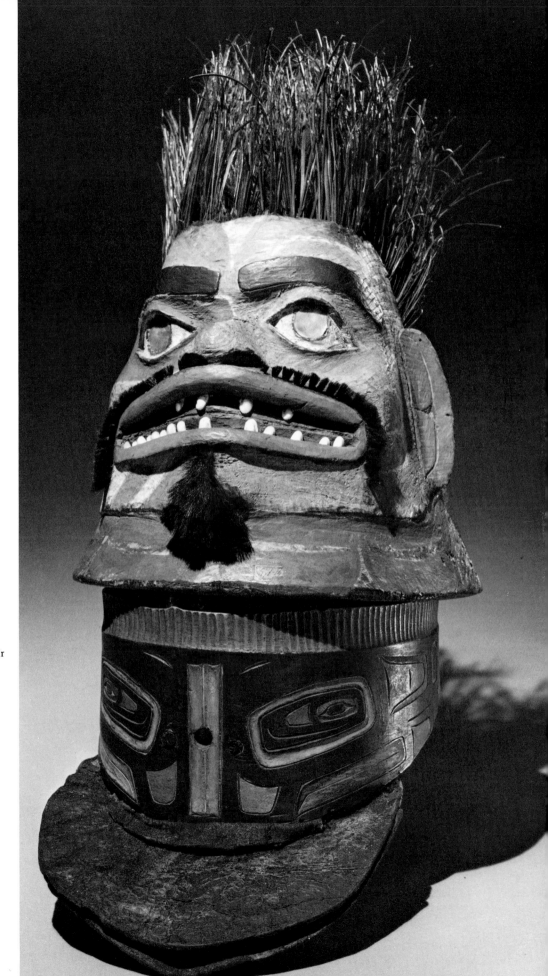

324 WAR HELMET WITH THE
 FACE OF AN EVIL SPIRIT
Wood, with red, black and white pig-
ment, operculum and shell inlays, hair
and fur, and walrus-whisker bristles
38 (15) HIGH
Collected at Sitka by Ilia G.
 Vosnesenski, 1843
Museum of Anthropology and
 Ethnography, Leningrad, 571-14

325 DEFENSIVE COLLAR OR
 VISOR
Wood, with black, red, green and
 white pigment, deerskin flap, sinew
 and fiber threads, and rawhide straps
27 (10 5/8) DEEP
Probably collected in the early
 19th century
Museum of Anthropology and
 Ethnography, Leningrad, 2454-22

326 SLAT ARMOR

Wood, with black, red, green and
 white pigment, elk skin, rawhide
 lashings and straps, braided fiber twine
 54 (21 1/4) HIGH
Possibly collected at Sitka by Capt.
 Urey T. Lisianski of the Imperial
 Russian Navy, 1804–5
Museum of Anthropology and
 Ethnography, Leningrad, 2454-4

These pieces do not form an actual
set, but are here arranged to show how
they were once worn.

The heavy helmet, worn high on
the head, causing the warrior to
appear very tall and formidable, is
carved to represent an evil spirit.
Tlingit warriors went into battle in full
armor, but as battles became less fre-
quent it became more of a costume
for ceremony. The masklike helmet
became the ceremonial headdress of a
chief, like his basketry hat. Eventually,
instead of being carved like evil spirits,
ceremonial dance helmets were carved
to represent clan crests.

Below the helmet, protecting the
lower half of the face and neck is the
visor, a heavy wooden collar fastened
behind the neck with cords. The front
is carved to suggest a face. The wearer
actually peers out of slits formed by
irregularities which produce narrow
openings between the top of the
visor and the bottom of the helmet.

The wooden slat armor, made in
several parts to protect the front, the
back, and the lower part of the body,
permits limited movement. Early ex-
plorers compared such armor to ladies'
stays. The painted designs on the
armor suggest the wolf, possibly the
owner's totem. The wooden armor is
worn over an elk skin shirt.

Siebert, Smirnova, and Forman, *North
 American Indian Art*, fig. 12, p. 18.
de Laguna, *Yakutat Tlingit*.

F. de L.

E. C.

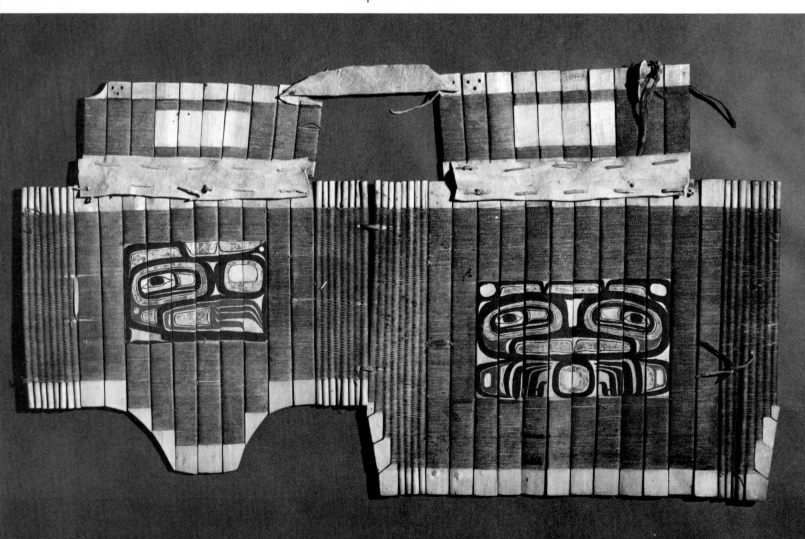

327 SLAT ARMOR
Wood, with red, black and brown
 pigment, elk skin, rawhide lashings
 and straps, braided fiber twine, and
 wire

54 (21 1/4) HIGH
Collected by Edward G. Fast, 1867–68
Museum purchase, 1869
Peabody Museum, Harvard University,
 69-30-10/2058

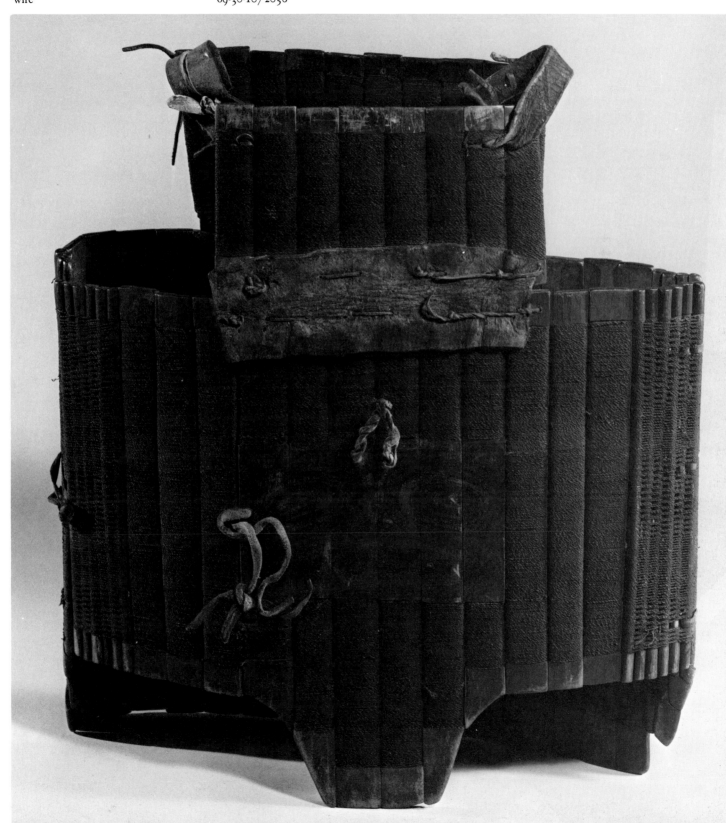

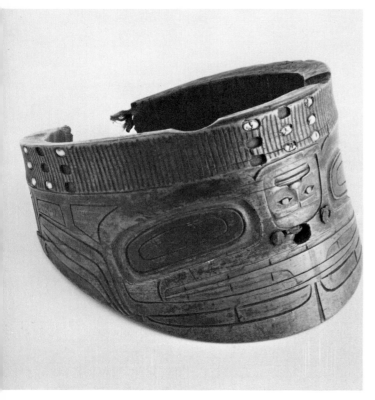

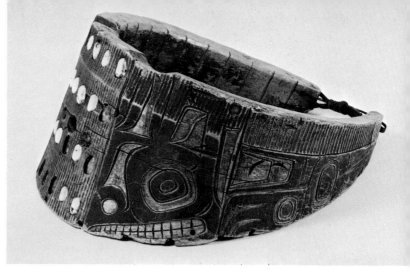

329 DEFENSIVE COLLAR OR VISOR*

Wood, with black, green and brown pigment, operculum inlays, rawhide teeth-clamp and rawhide lashing
28.5 (11 1/4) DEEP
Collected at Sitka by W. H. Dall
Smithsonian Institution, 16 222

Like the preceding and following examples, this collar was made from a single straight piece of wood, notched on the inside, steamed and bent into its present shape.

C. D. L.

330 DEFENSIVE COLLAR OR VISOR

Wood, with red, black and green pigment, operculum inlays, fiber teeth-clamp, and lashings
14 (5 1/2) HIGH
Museum of Anthropology and Ethnography, Leningrad, 2454-21

This heavy collar was worn around the neck of the Tlingit warrior, covering his throat and face as high as the eyes. The grooved rim, apparently forms the top of the collar, for one can see cut across its edge the two grooves through which the wearer could peer when his head was covered with the solid wooden helmet. Curiously enough, the face on the front of the collar is carved upside down. Just below it is the opening through which the wearer could breathe. The collar was fastened at the back of the neck with cords.

Siebert, Smirnova, and Forman, *North American Indian Art*, pl. 52.

F. de L.

328 DEFENSIVE COLLAR OR VISOR

Wood, with black, red and green pigment, fiber teeth-clamp, elk skin strap, and rawhide lashings
26 (10 1/4) DEEP
Collected by Edward G. Fast, 1867–68
Museum purchase, 1869
Peabody Museum, Harvard University, 69-30-10/1597

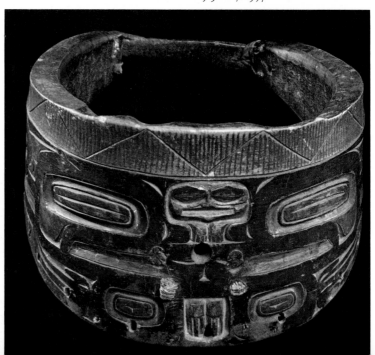

331 WAR SHIRT
Moose skin, sinew threads and rawhide
 lashings, wooden toggle
77.5 (30 1/2) HIGH
Collected by Miss Grace Nicholson
 and C. Hartman, 1874
Gift of Lewis H. Farlow, 1910
Peabody Museum, Harvard University,
 10-21-10/76432
This war shirt was worn beneath
slat armor.

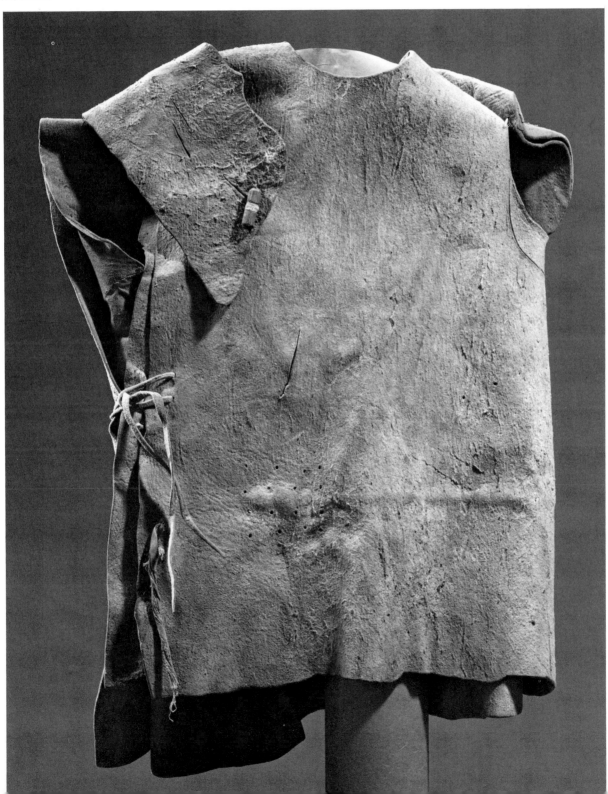

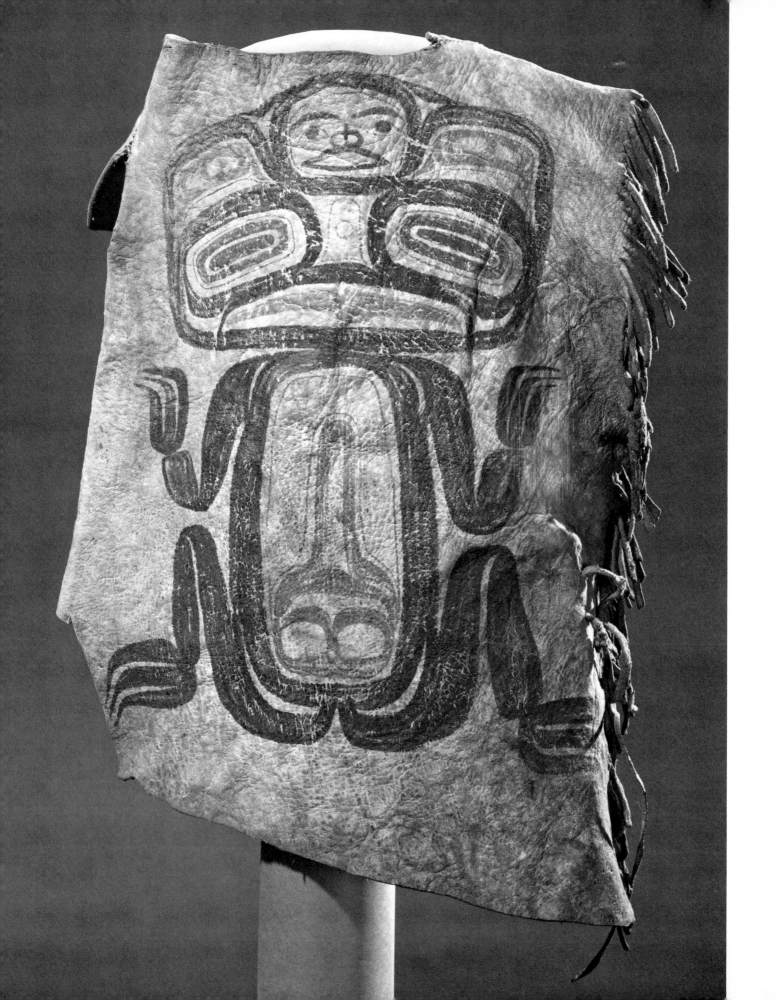

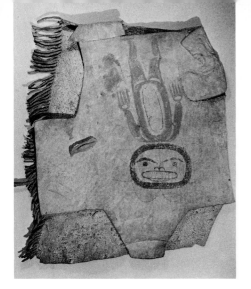

front

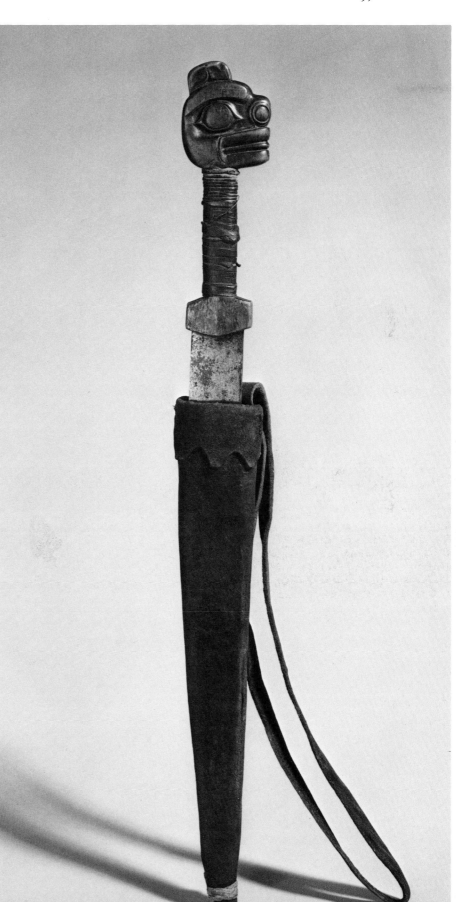

332 WAR SHIRT
Walrus hide (?), with red, black and
green pigment, sinew threads, and
rawhide lashings
80 (31 1/2) HIGH
Stolper Galleries, Munich
Museum purchase, 1 December 1965
Deutsches Ledermuseum, Offenbach,
11721

333 BEAR-HEAD DAGGER
334 SHEATH AND CARRYING
SLING
Wood and steel, with rawhide lashings,
elk or moose skin
Dagger: 47 (18 1/2) LONG
Sheath and sling: 82.5 (32 1/2) LONG
Museum acquisition, probably from
the Edward G. Fast Collection, 1869
Peabody Museum, Harvard University,
69-30-10/2168

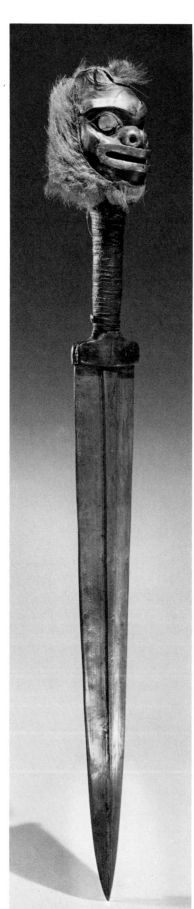

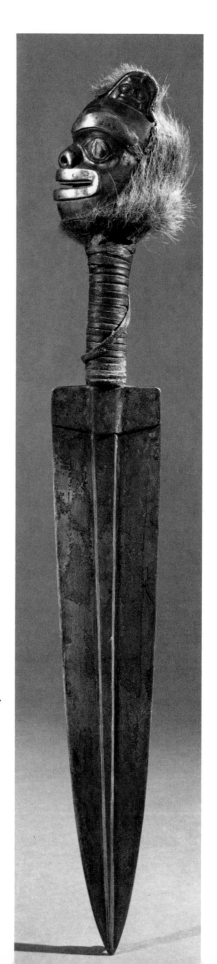

335 BEAR-HEAD DAGGER
Copper, musk-ox horn, shell inlays,
 copper, bearskin and rawhide lashing
54.5 (21 1/2) LONG
Collected by Miss Grace Nicholson
Gift of Lewis H. Farlow, 1904
Peabody Museum, Harvard University,
 04·10·10/64029

336 BEAR-HEAD DAGGER
Copper, wood, shell inlays, baleen,
 skin, and rawhide lashing
52 (20 1/2) LONG
Collected at Klukwan by G. B.
 Gordon, 1905
University Museum, Philadelphia,
 NA 1287

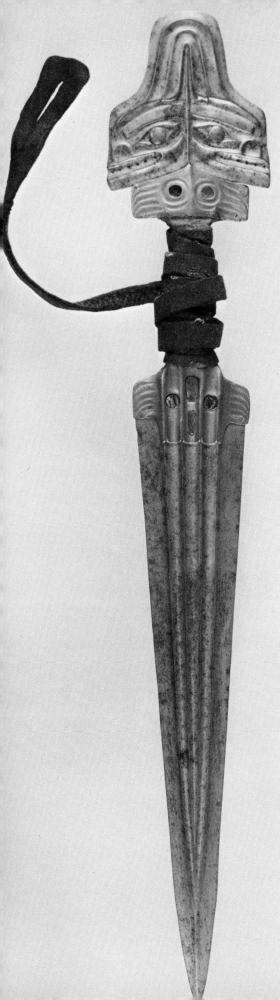

338 TWO-BLADED DAGGER*
Steel, shell inlays, elk skin, and
 heavy twine
40.6 (16) LONG
Collected at Sitka by Capt.
 Henriques
Smithsonian Institution, 9 936

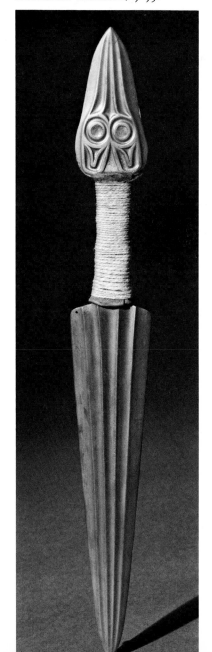

337 DOUBLE-BLADED DAGGER*
Steel, copper, shell inlays, rawhide
 lashings, and elk skin strap
60.3 (23 3/4) LONG
Collected at Killisnoo on Admiralty
 Island by Lt. G. T. Emmons, U. S.
 Navy
Purchased from the collector,
 12 September 1903
Smithsonian Institution, 221 184

This elaborate example of Tlingit
metalwork exhibits the stylized face
of a crest animal on the upper blade,
as does No. 338.

C. D. L.

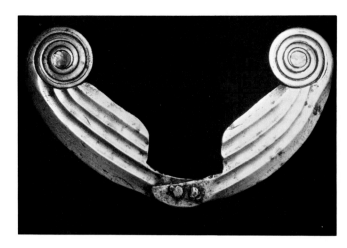

339 ORNAMENT
Steel, shell inlays
16.2 (6 3/8) WIDE
Collected by Rev. Sheldon Jackson,
 1882
Princeton University Museum of
 Natural History, PU 5118
This ornament presumably was made
for a totemic crest.

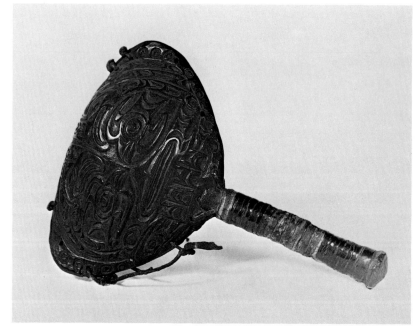

341 WAR RATTLE (?)
Mountain sheep horn, wood,
 vegetable fiber and rawhide lashings,
 pebbles
17.2 (6 3/4) HIGH
Formerly in the Oldman Collection,
 British Museum
Museum purchase, 1954
Museum voor Land- en Volkenkunde,
 Rotterdam, 34818

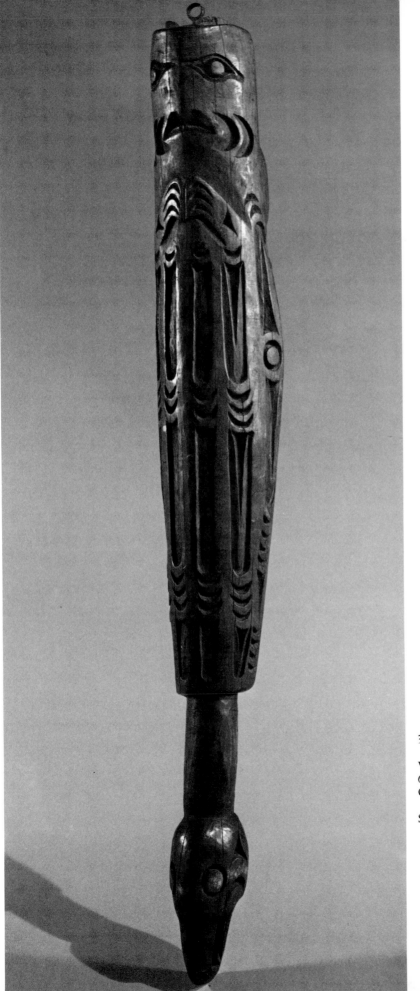

340 WAR CLUB OR
 "SLAVE-KILLER"*
Wood
66 (26) LONG
Collected by the U. S. War
 Department
Smithsonian Institution, 2 644

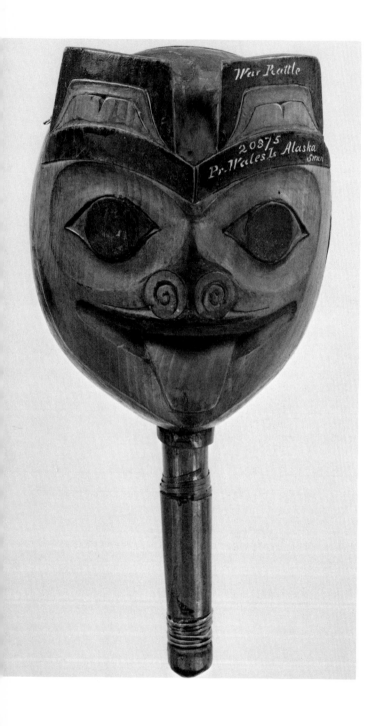

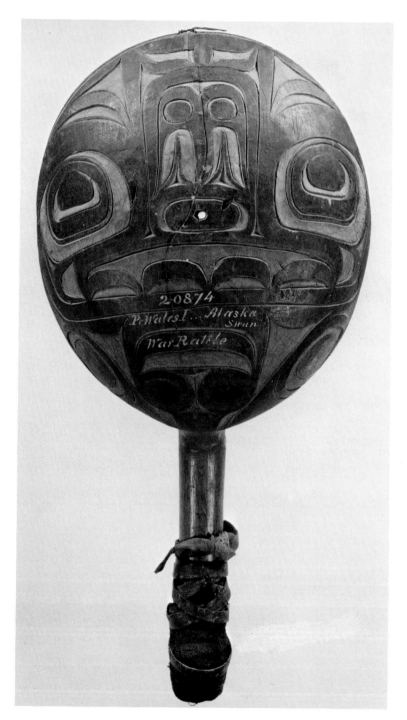

342 WAR RATTLE*
Wood, with black, red, and brown
 pigment, vegetable fiber lashings, and
 pebbles, wire
33 (13) HIGH
Collected presumably on Kootznahoo
 Inlet, Chatham Strait, Admiralty
 Island, by J. G. Swan
Purchased from the collector, 1875
Smithsonian Institution, 20 875

This rattle with bear face, is from the
vicinity of Angoon, as is No. 343.
However, both were mistakenly labeled
by their 19th-century cataloger as
deriving from Prince Wales Island
to the south.

C. D. L.

343 WAR RATTLE*
Wood, with black and red pigment,
 rawhide lashings, pebble rattle, and
 wire
35.5 (14) HIGH
Collected presumably on Kootznahoo
 Inlet, Chatham Strait, Admiralty
 Island, by J. G. Swan
Purchased from the collector, 1875
Smithsonian Institution, 20 874
J. G. Swan

The reverse side of this rattle with
stylized crest faces is inscribed
"Klemmakoon" (?).

C. D. L.

344 RATTLE
Wood, with red and black pigment,
 pebble rattles
28 (11) HIGH
Collected by Lt. G. T. Emmons,
 U. S. Navy, 1882–87
American Museum of Natural History,
 E/1371
This round rattle shows a bird's face.

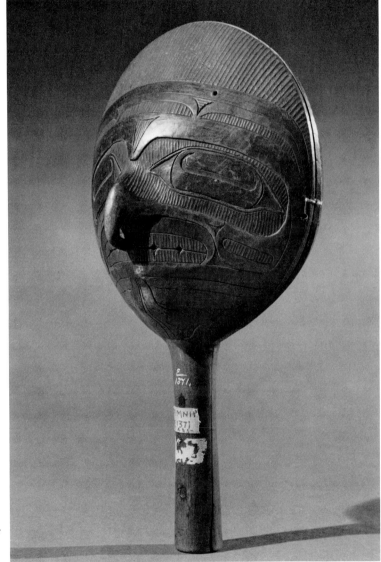

346 RATTLE*

Wood, with traces of green, red, and
 black pigment, braided fiber, rawhide
 lashing, and ermine skins
40 (15 3/4) LONG
Collected at Hoonah, Chichagof
 Island, by Lt. T. D. Bolles,
 U. S. Navy
Gift of the collector, 1884
Smithsonian Institution, 73 851

This rattle is in the form of a raven
with a hawk face carved on its belly
and human figure with animal spirit
on its back.

345 RATTLE

Wood, with red, green, black and
 brown pigment, vegetable fiber
 lashing, seed or pebbles
22.3 (8 3/4) HIGH
Royal Scottish Museum, 1929.312

This rattle, appears to represent a
raven perched on the handle. The
carving on the bird's belly suggests
the traditional hawk's face. Such
rattles are said to have been used
by Tlingit chiefs, as well as by
shamans, to emphasize important
pronouncements.

F. de L.

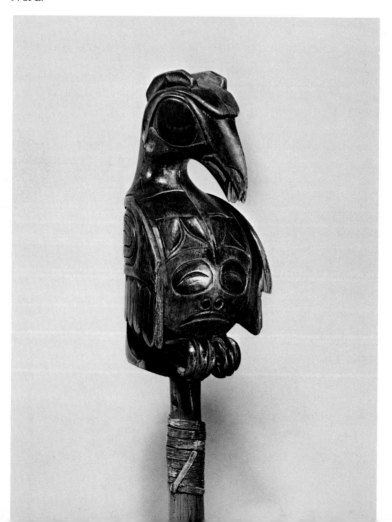

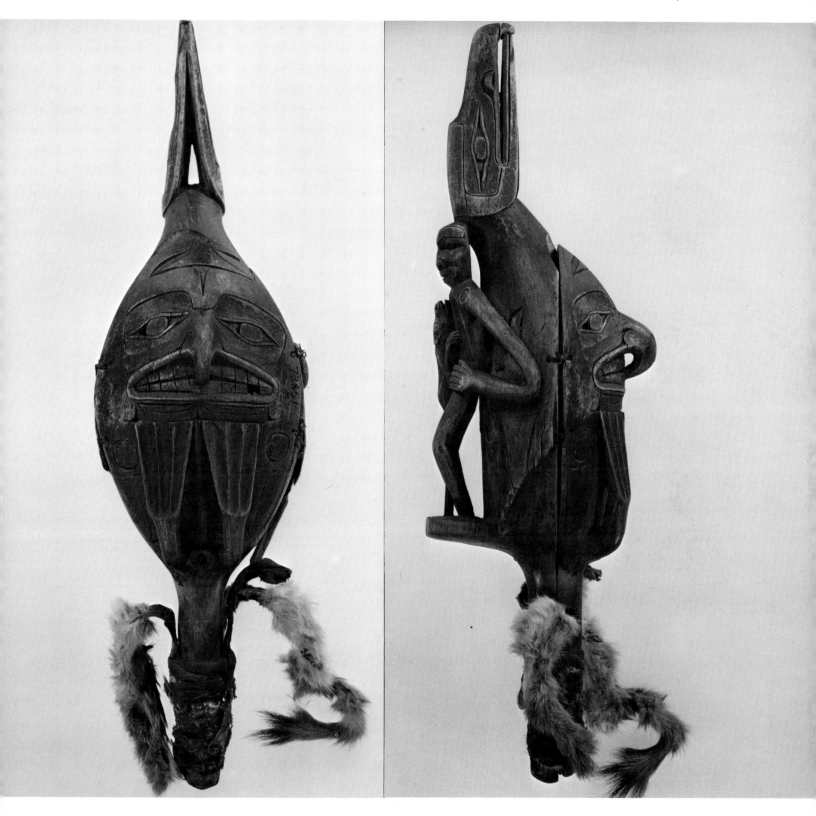

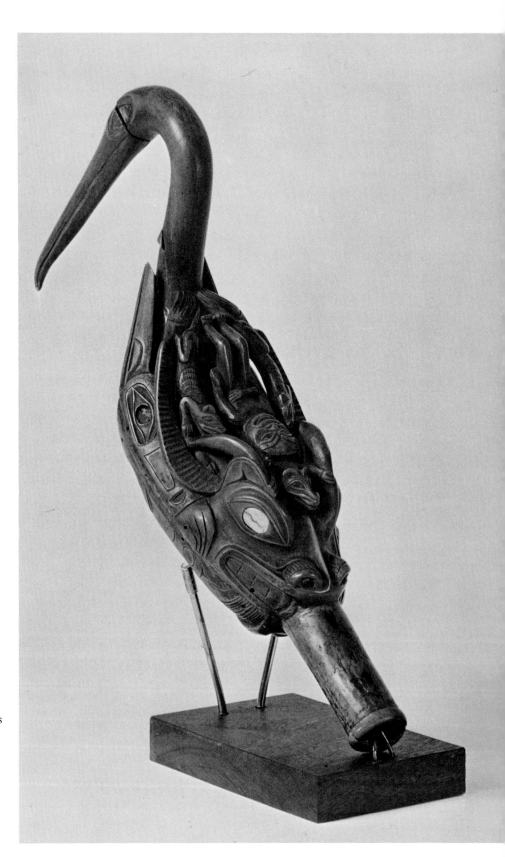

347 RATTLE
Wood, with black and red pigment,
 shell and mirrored glass inlays, seed
 or pebble rattles, modern glue
33 (13) LONG
Collected by Stewart Culin
The Brooklyn Museum, 05.588.7294

Said to represent the legend of
Ka-Ka-Tete, the whistling demon, this
rattle in the form of an oyster
catcher, has a hawk face on the belly
and various figures on its back.

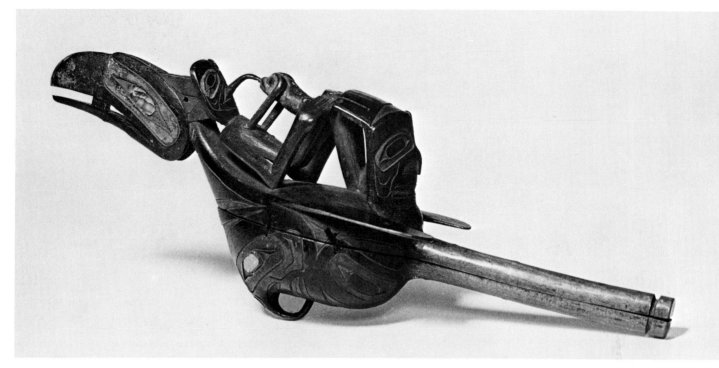

349 RATTLE

Wood, with black, green, and red
 pigment, bone, ermine and swan skin,
 pebble rattles, fiber and rawhide
 lashings
33 (13) LONG
Collected from a shaman's grave near
 Port Mulgrave, Yakutat, by Professor
 William S. Libbey of Princeton
 University, 1886
Princeton University Museum of
 Natural History, PU 5153

This apparently very early rattle, in
the form of an oyster catcher, with
elaborate skin ornaments but not the
typical hawk's face on the belly, pro-
vides another version of the familiar
scene of a man torturing a witch (as
for example No. 363).

C. D. L.

Illustrated in color

348 RATTLE

Wood, with black, red, green, and
 brown pigment, shell inlays, seed or
 pebble rattles, thread
35 (13 3/4) LONG
Museum voor Land- en Volkenkunde,
 Rotterdam, 34817

Wooden rattles in the shape of a
raven are often called chief's rattles,
because they might have been used by
chiefs as well as shamans. Rattles of
other shapes seem to have been used
only by shamans.

On the back of the raven is shown a
recumbent man, undoubtedly a
shaman, holding a frog's tongue in
his mouth from which he sucks the
"poison" supposedly used by shamans
in casting some of their spells. The
frog emerges from the back of a
hawk. As is customary, the belly of
the rattle is carved to represent a
hawk with recurved beak.

F. de L.

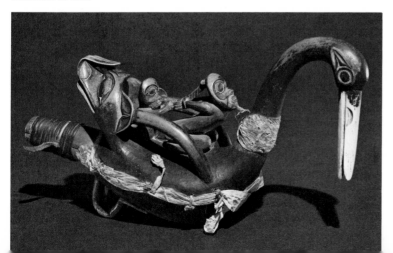

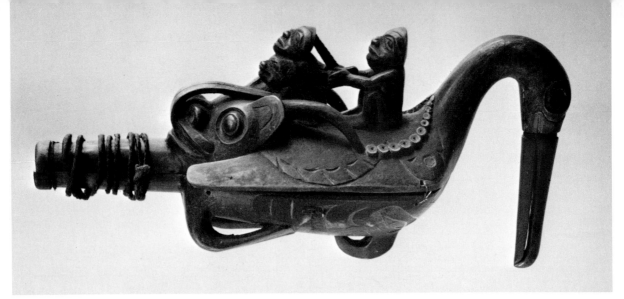

350 RATTLE
Wood, with black, red, blue and green
pigment, seed or pebble rattles, wire
33 (13) LONG
Collected by Ilia G. Vosnesenski, 1843
Museum of Anthropology and
Ethnography, Leningrad, 2448-25

From the shape and color of the red
bill, this rattle would appear to be in
the form of an oyster catcher. The
webbed feet are folded back over the
belly, although on most rattles of this
kind the belly of the bird is carved
to represent the head of a hawk. On
the back of the bird two small human
figures, with reddish bodies, blue faces
and black brows, sit or crouch between
the horns of a mountain goat head.
This scene certainly refers to some
shamanistic activity.

Siebert, Smirnova, and Forman, *North
American Indian Art*, pl. 56.

F. de L.

351 RATTLE
Wood, with red, black and green
pigment, seed or pebble rattles,
rawhide lashings, wire
29 (11 3/8) LONG
Collected on Admiralty Island by
G. Chudnovsky, 1890
Museum of Anthropology and
Ethnography, Leningrad, 211-2

This wooden rattle is carved in the shape
of a crane (possibly an oyster catcher
because of the red bill). The webbed
feet are folded back onto the belly of
the bird, but the breast is carved with
the traditional hawk's head with re-
curved bill. On the bird's back, facing
the handle, is the head of a mountain
goat, with large ears, long curved
horns, and a long tongue. The body
seems to end in octopus tentacles (a
common shamanistic theme). Be-
tween the horns of the goat a shaman is
torturing a witch. The animal figure
below the witch may be one of the
shaman's familiar spirits in the shape
of a land otter, or even a dog, since a
shaman's spirit dog was often used to
detect witches.

Siebert, Smirnova, and Forman, *North
American Indian Art*, pls. 57 and 58.

F. de L.

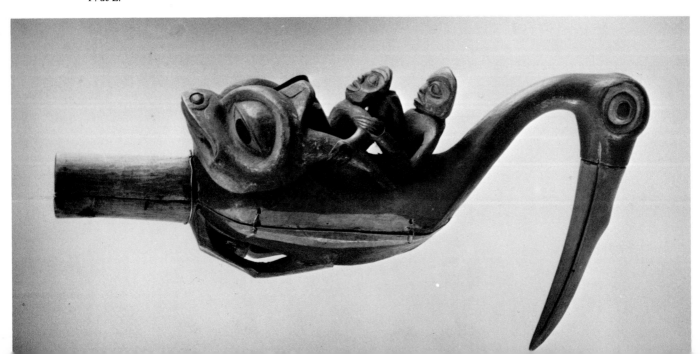

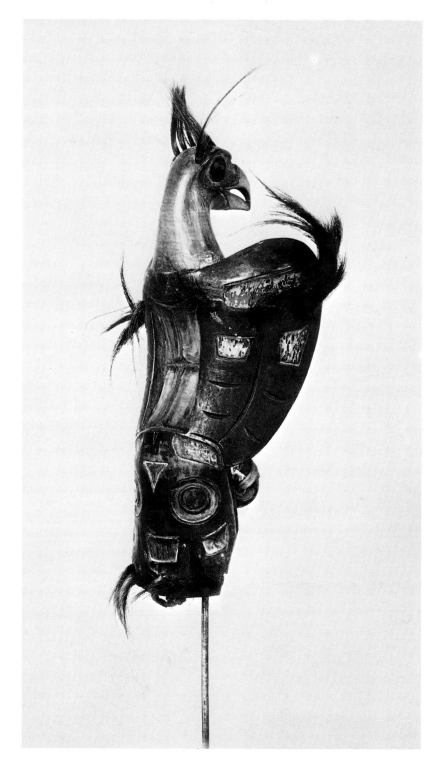

352 EAGLE CREST

Wood, with black, green, and white
 pigment, human hair, and rawhide
 thongs
27 (10 5/8) HIGH (independent of
 modern staff)
Chiguea, Klukwan; collected in use as
 clan crest by Louis Shotridge, 1923
Museum Expedition collection
University Museum, Philadelphia,
 NA 9468

This carving of an Eagle, totemic
crest of the Shankukedi (Cankuqedi)
clan (or Wolf moiety), ornamented
the top of a chief's staff. The figure
was reportedly taken from slaves killed
at potlatches where the staff was
displayed.

According to the tradition related to
Louis Shotridge (himself a Chilkat
Indian), this eagle emblem had been
originally used by his ancestor,
Youwok, then living at Clay Point
Fort, a settlement on the shore of
Icy Strait. The young chief, Youwok,
felt that his people did not have a
firm claim to the use of the Eagle as
a totemic crest. As a consequence he
traveled to Gitxala, on Dolphin Island
near the mouth of the Skeena River,
in British Columbia, to purchase rights
to the Eagle crest from Chief
Ku-haedgu, a Tsimshian leader of the
Eagle phratry, who was felt to have
had some Tlingit ancestry. The young
Tlingit chief was not only successful
in this, but received from the
Tsimshian chief an honorable name
meaning "wise man" or "absolute
man," rendered in Tlingit as Stuwuka,
the native name which Louis Shotridge
himself bore.

Louis Shotridge, "The Emblems of the
 Tlingit Culture," *The University Museum
 Journal*, (Philadelphia, December 1928),
 pp. 350–77.
Gunther, *Northwest Coast Indian Art*, no.
 42, frontispiece.

F. de L.

353 CHIEF'S STAFF*
Wood, with dark pigment; stained
 with preservative
82.5 (32 1/2) LONG
Prince of Wales or Queen Charlotte
 Islands; collected at Masset by
 J. G. Swan
Museum collection, July 1883
Smithsonian Institution, 88 833

Although collected from the Haida
Indians around Masset, opposite
Prince of Wales Island across the
Dixon Entrance, this staff appropriately
represents the delicate style of wood-
carving practiced also by the Alaskan
Haida on the latter island (the
Kaigani). The collector's original notes
call this staff a "Taski," or ceremonial
baton held by a chief while distributing
presents at his feasts. According to
Swan's notes, the creatures repre-
sented, from the top, are a whale and
crow, a sparrowhawk ("Skamison")
and a beaver eating a mouse.

C. D. L.

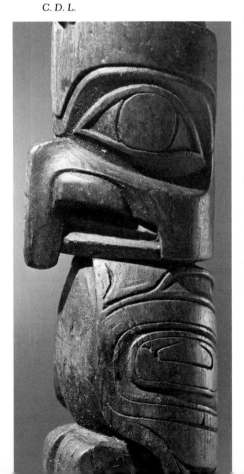

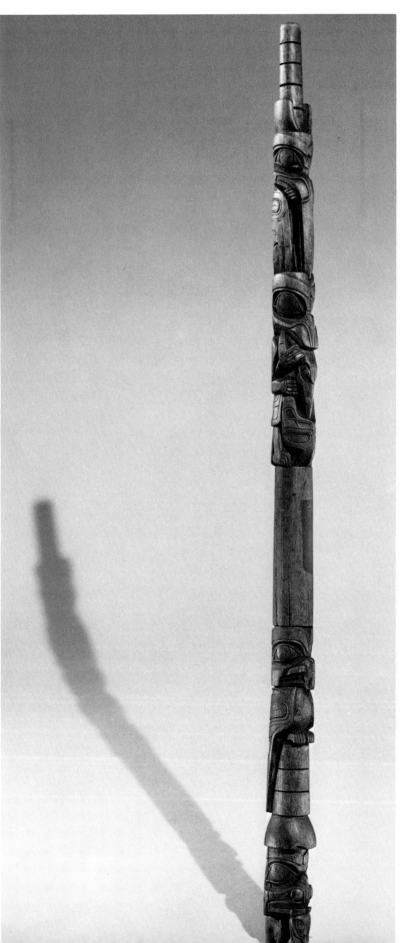

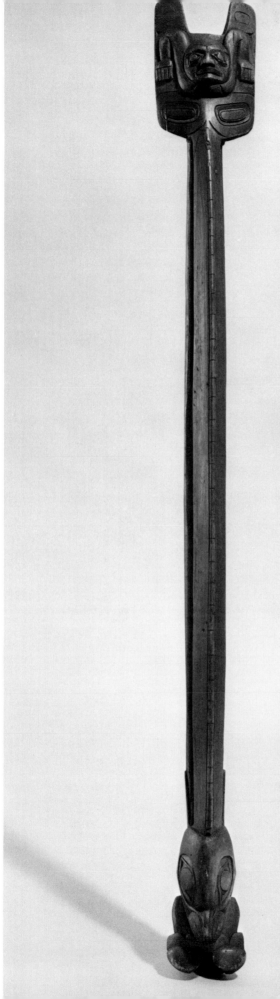

354 CHIEF'S STAFF
Wood, with dark pigment; stained
 with preservative
122.5 (48 1/4) LONG
Prince of Wales or Queen Charlotte
 Islands; collected at Skidegate by
 J. G. Swan
Museum collection, 30 August 1883
Smithsonian Institution, 89 099

This staff shows a beaver head and
eagle crest.

Similar in function to the preceding
example, this "Taski" is reported to
have been used to provide emphatic
punctuation to the chief's distribution
of presents, by being thumped down
when the name of each recipient was
called—traces of which usage are still
visible on its lower end.

Similar staffs or wands would also
have been used by a shaman in his
ritual dances: see U. S. National
Museum *Annual Report*, 1888,
pl. XVI, fig. 54, p. 270.

C. D. L.

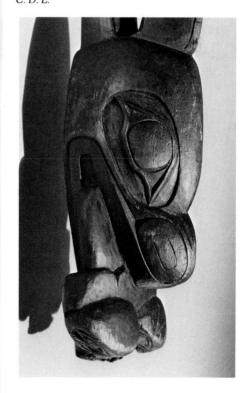

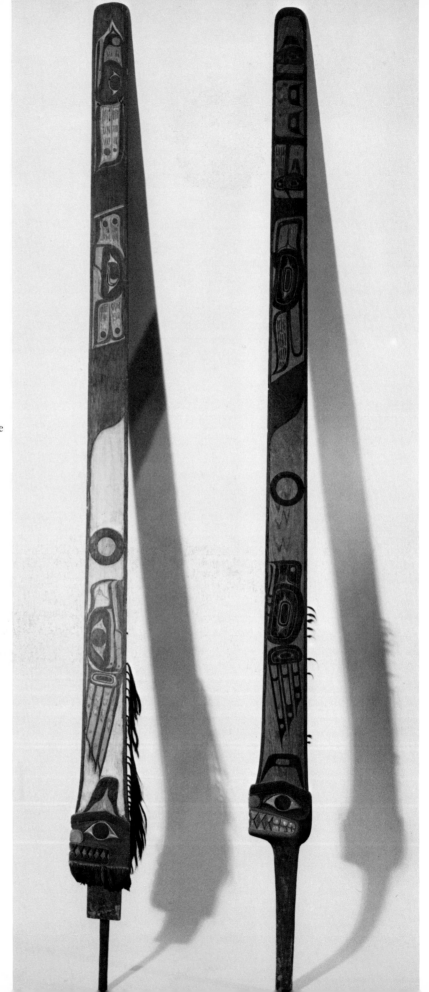

355 DANCE BATON
Wood, with blue, red, black and white
 pigment, human hair, mountain
 goat wool on trade cloth backing,
 rope, and nails
371 (146) HIGH
Collected at Sitka by Louis Shotridge,
 1918
Museum Expedition collection
University Museum, Philadelphia,
 NA 8495

356 DANCE BATON
Wood, with dark green, red, black
 and white pigment, human hair
369.5 (145 3/8) HIGH
Collected by Louis Shotridge, 1923
Museum Expedition collection
University Museum, Philadelphia,
 NA 9494

Both pieces apparently represent the
tall closed fin of the killer whale and
would be used in potlatches by the
song leaders of the Kagwantan or
Shankukedi (Cankuqedi) of Tekwedi
(Teqweki) clans (Wolf moiety), all
of whom claim the killer whale as a
crest.

F. de L.

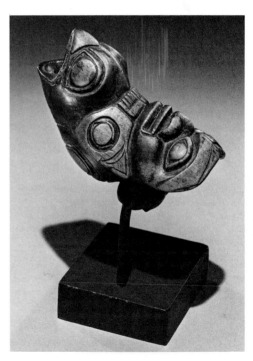

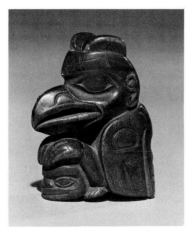

357 PIPE BOWL*
Wood and nails
8.6 (3 3/8) HIGH
Collected by Thomas S. Forsyth of
 Portland, Maine
Museum purchase from the collection
 of Capt. Frederic Forsyth,
 13 July 1927
Smithsonian Institution, 337 354

Smithsonian Institution *Annual Report*,
 1930, pl. 17, p. 556.

358 PIPE BOWL
Wood
10.2 (4) LONG
Collected by Edward G. Fast in
 1867–68
Collected by Edward G. Fast, 1867–68
Museum purchase, 1869
Peabody Museum, Harvard University,
 69-30-10/1862

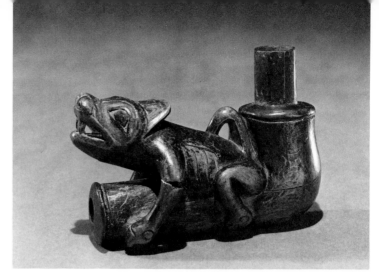

360 HALIBUT HOOK
Wood, metal, vegetable fiber lashing
39.5 (15 1/2) LONG
Probably collected in the early
 19th century
Museum of Anthropology and
 Ethnography, Leningrad, 2539-3

This hook, although said to represent
a sculpin, is obviously carved to repre-
sent a mythical beast, the head like
that of a wolf, the body hollowed out
like a canoe in which are two prone
human figures, one of which is a
woman.

 Hooks of this kind are used in pairs
for bottom fishing. Each halibut hook
has a personal name, represented by
the decoration, and is addressed by the
Tlingit fisherman as part of his good
luck magic.

Siebert, Smirnova, and Forman, *North
 American Indian Art*, pl. 73.

F. de L.

359 PIPE WITH THE FIGURE
 OF A DOG
Wood, with black, red, and green
 pigment, iron and copper
12.8 (5) LONG
Collected by Edward G. Fast, 1867–68
Museum purchase, 1869
Peabody Museum, Harvard University,
 69-30-10/1866

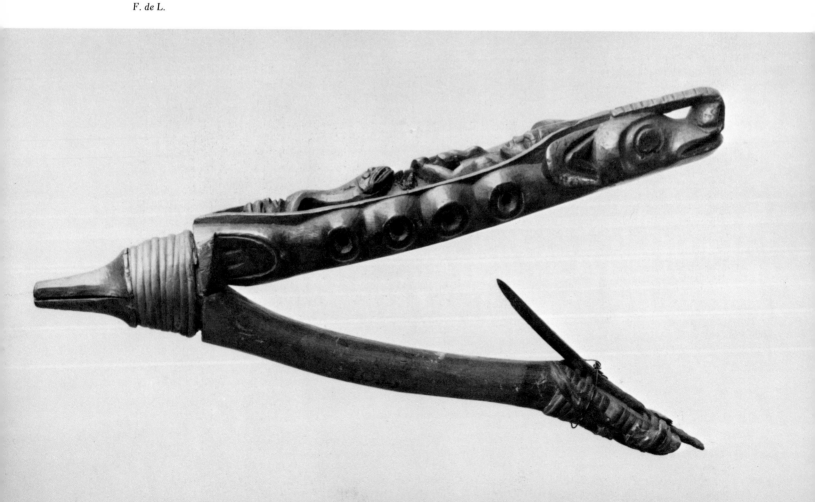

362 BOUND FIGURE OF A
 WITCH
White stone
4.8 (1 7/8) HIGH
Collected by Rev. Sheldon Jackson for
 the Bureau of American Ethnology
Transfer from the Bureau of American
 Ethnology, 22 July 1921
Smithsonian Institution, 316 943

This same image of the ritually bound
witch (compare following example)
recurs on Tlingit shaman's rattles
(see Nos. 349–351).

C. D. L.

361 HALIBUT HOOK
Wood, bone, vegetable fiber lashing
29 (11 3/8) LONG
Collected by Roderic McKenzie before
 1819
Gift of the American Antiquarian
 Society of Worcester, 1895
Peabody Museum, Harvard University,
 95-20-10/48387

This halibut hook shows a bound
witch or slave on an animal's head.

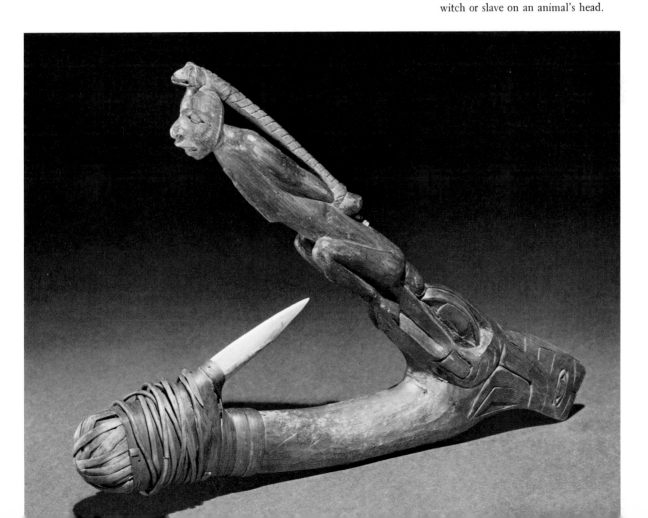

363 MAN (SHAMAN?)
TORTURING A WITCH
Alder wood, with black, brown and
red pigment
29.5 (11 5/8) LONG

Possibly carved near Sitka; collected
(in the late 19th century?) by Bob
Gray of Yakutat; presented by the
collector to Barrett Willoughby
Gift of Barrett Willoughby
Alaska State Museum, II-B-801

364 FIGURE OF A CHIEF
Wood
15.5 (6 1/8) HIGH
Formerly in the Oldman Collection,
British Museum
Museum purchase, 1954
Museum voor Land- en Volkenkunde,
Rotterdam, 34831

This seated figure depicts a chief with
ceremonial hat.

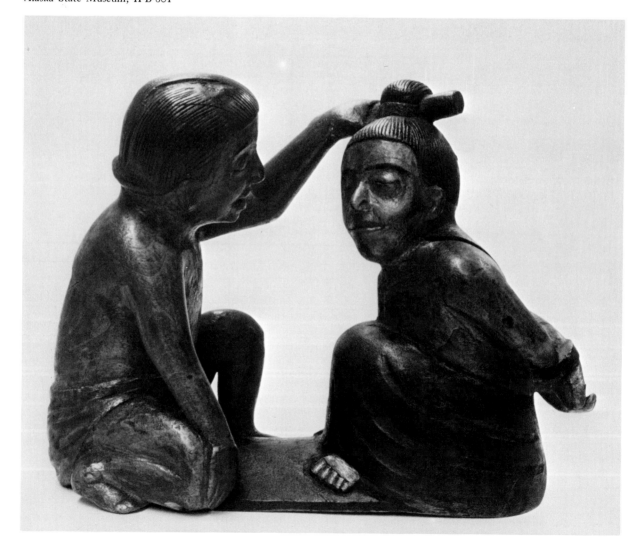

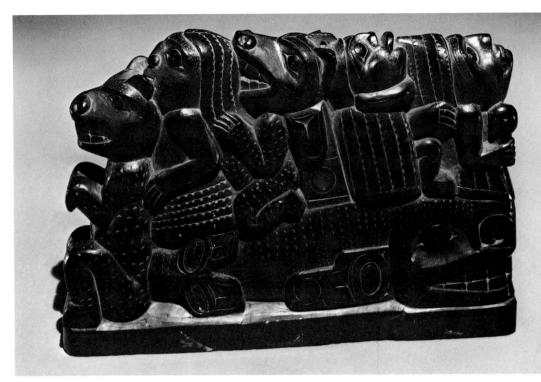

365 STORYMASTER PLAQUE
Argillite
24.7 (9 3/4) LONG
Collected by Charles Jennings
Alaska State Museum, II-B-823

Representing one of the last phases of
indigenous Alaskan art, this famous
style of soft-stone carving was de-
veloped just before the end of the
last century. This elaborate example
depicts, from front to back, the figures
of bear, woman, shaman, and
killer whale.

C. D. L.

REFERENCES

Benndorf, Helga, and Arthur Speyer. *Indianer Nordamerikas
1760–1860. Aus der Sammlung Speyer.* Offenbach a. M.:
Deutschen Ledermuseum angeschlossen Deutsches Schumu-
seum, 1968.

Boas, Franz. *Primitive Art.* Oslo: Institutet for Sammenlingnende
Kulturforskning, Series B, 8, 1927, (Reprinted: Dover Publica-
tions). (esp. pp. 183–298).

Davis, Robert Tyler. *Native Arts of the Pacific Northwest.* From
the Rasmussen Collection of the Portland Art Museum. Stan-
ford University Press, California, 1949.

Dockstader, Frederick J. *Indian Art in America,* Greenwich, Con-
necticut: New York Graphic Society, 1960.

Douglas, Frederic H., and René d'Harnoncourt. *Indian Art of the
United States.* New York: Museum of Modern Art, 1941.

Drucker, Philip. *Cultures of the Northwest Coast.* San Francisco:
Chandler Publishing Co., 1965.
———. *Indians of the Northwest Coast.* American Museum of Na-
tural History, Handbook No. Ten. New York, London, Toronto:
McGraw-Hill Book Co., 1955.

Feder, Norman. *Two Hundred Years of North American Indian
Art.* New York, Washington, London: Praeger Publishers in
association with the Whitney Museum of American Art, 1971.

Fraser, Douglas. *Primitive Art.* Garden City: Doubleday and Co.,
1962, (esp. pp. 304–7, pls. 179, 180).

Gunther, Erna. *Northwest Coast Indian Art.* An Exhibit at the
Seattle World's Fair. April 21–October 21, 1962.

Harner, Michael J., and Albert B.Elsasser, *Art of the Northwest
Coast.* An Exhibition at the Robert H. Lowie Museum of
Anthropology of the University of California, Berkeley. March
26–October 17, 1965.

Holm, Bill. *Northwest Coast Indian Art.* Seattle: University of
Washington Press, 1965.

Keithahn, Edward L. *Monuments in Cedar.* Seattle: Superior
Publishing Co., 1963.

Inverarity, Robert Bruce. *Art of the Northwest Coast Indians.*
San Francisco and Los Angeles: University of California Press,
1950.

de Laguna, Frederica. *Under Mount Saint Elias: The History and
Culture of the Yakutat Tlingit, Alaska.* Smithsonian Contribu-
tions to Anthropology, No. 7 (in 3 parts). Washington, D. C.,
1972.

Malin, Edward, and Norman Feder. "Indian Art of the Northwest
Coast." *Denver Art Museum Quarterly,* Winter, 1962.

Miles, Charles. *Indian and Eskimo Artifacts of North America.*
Chicago: Henry Regnery Co., 1963.

Siebert, Erna, and N. Smirnova. *North American Indian Art:
Masks, Amulets, Wood Carvings, and Ceremonial Dress from
the North-West Coast.* Translated by Philippa Hentgès. Photo-
graphs by Werner Forman. London: Paul Hamlyn Ltd., Drury
House, 1967.

Wardwell, Allen. *Yakutat South: Indian Art of the Northwest
Coast.* Chicago: The Art Institute of Chicago, 1964.

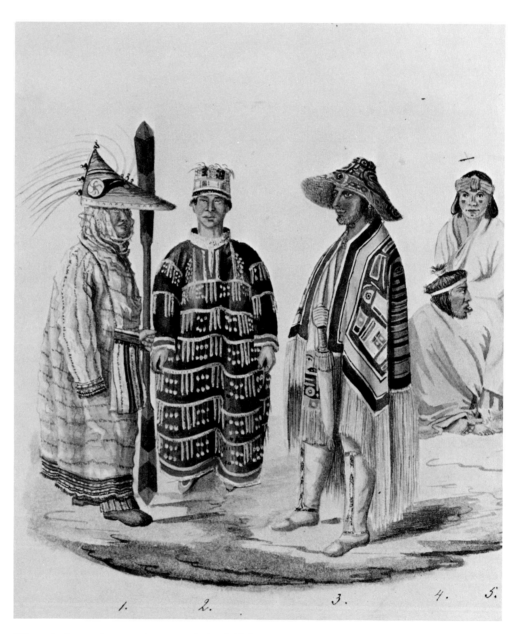

*Watercolor by an unknown 19th-century artist (probably Russian) of
Indians in their tribal dress: (1) Aleut, (2) Tlingit and (3) Haida.
The two figures in the background are slaves.
Private Collection*

SOME NOTES
ON THE SEPARATE REALITIES
OF ESKIMO AND INDIAN ART

EDMUND CARPENTER

A NORTHWEST Coast Indian, whom the anthropologist Franz Boas "sometimes invited to New York to serve him as an informant, was indifferent to the spectacle of skyscrapers and streets lined with automobiles. He reserved all his intellectual curiosity for the dwarfs, giants, and bearded ladies which were at that time exhibited in Times Square, for automats, and the brass balls decorating staircase bannisters. . . . All these things challenged his own culture, and it was that culture alone he was seeking to recognize in certain aspects of ours."[1]

Whenever people meet the unfamiliar, they at once translate it into something they already know, and that means they never face the unfamiliar. The only person who dares is the artist.

To experience the unfamiliar in tribal art, we must step outside the patterns of perception of our culture and explore new worlds of images, new realities. We must study alien perceptions and codifications by experiencing them. Anything less merely confirms previous convictions.

I accept that there are great differences between people. I was once very close to several Eskimo friends, but their thinking was fundamentally different from mine. I gave up hope that we would ever really come to know each other completely. If I had come to know them completely, I would have become an Eskimo; I would have lost my own identity, and this I did not choose to do. "We wed ourselves to the mystery," not to conquer it or be conquered by it, but to greet it.

I also accept the old-fashioned notion that the ethnologist is the twice-born spiritual adventurer whose fieldwork is nothing less than the spirit quest; that he exposes his dearest beliefs and habits to doubt and diversity, and returns changed by this intellectual ordeal.

I do not agree with those who see this hard-won insight as a means to intellectual detachment. To me, the experiencing of man is an end in itself.

For some anthropologists, the real world is not what is lived, but rather the underlying structures (laws) that govern appearances. Thus they are bent on making anthropology a science of the same type as the physical sciences, for these, too, reject appearances and insist that reality is not in them but in the laws that govern them.

What disturbs me about the scientific approach, when pursued exclusively, is that it leads to a rejection of the sensate world. Flowers, after all, do have beautiful colors, whatever the explanation.

I find this true of most books on tribal art. Their intellectual detach-

ment separates them from the essential reality—the *human* reality. Their gravity and jargon erode the living edge. I have to strain my powers of sensitivity to establish with them the human intimacy they fail to establish with me. I find most of them far secreted from the original artistic experience, in an area that would be unjust to call private, because their authors try to inhabit them with officialness.

This is the dilemma of those seeking a way to grasp the reality of art scientifically, yet familiarly and directly. The very passion to attain to full consciousness and articulate appreciation of this reality has induced human beings, especially those in whom the passion is most restive, to put what seem to be equivalents of the reality in its place. With the "equivalents," which have an easier graspability than the reality, they feel they are giving their passion an objective within reach—the reality itself having an appearance of inaccessibility often at the mind's closest approaches: and they come to identify the "equivalent" with the reality.

The field of art teems with "equivalents" to the reality, and the activity devoted to them is as intense, often, as if it were devoted to the reality itself.

People supply themselves with substitutes for the reality as a subject of preoccupation and with compensations for the missing satisfaction of a grasp of it. I mean here neither substitutes nor compensations, but something into the quest for which is poured the ardor of the pursuit of reality. And I put aside here also the vulgar equivalents, which are mere emotionalisms, and not difficult to identify as such. It is the intellectually adopted and supported equivalents that I mean: what might be called the superior equivalents. These are the dangerous deceivers. Yet it might be said of them that, without them, the spiritual history of human beings would be a history of poverty. My notion is that human beings have to achieve a certain recognition of their poverty in the spiritual respect, in order to grasp the human reality—have to rid themselves of false riches accumulated in pursuit of false equivalents.

To study tribal art, we must first ask: What did it mean to the people for whom it was originally intended? To experience it, we must first accept its rules governing thinking, feeling, sensing. We cannot—rather we should not—borrow and apply rules from our own culture. We demean our subject, and deceive ourselves, when we call such imperialism "scientific."

Many, perhaps all, symbolic systems are implosive, and therefore must be experienced from within. Alaskan tribal arts are no exception. They offer no windows facing in. A detached observer may possess them, even "know" them, but he will never experience them.

Only the person who avails himself of their methods, aims at their goals, and assumes their sensory profiles, can enter these realities. For others, their visible forms remain mere trophies—loot displayed in a pirate's wardroom. Some may exploit them as exotic variations of our own art: they are the plagiarists. Others, too sensitive for such imperialism, yet unable to encounter these arts on their own terms, will find the exhibit vaguely unsatisfying. They will be bored. They will have come,

not merely to study man, but in the hopes of experiencing man, yet they will fail to encounter him.

That will not be because he is absent. He is here, waiting to greet us. Within his home.

To the non-player, chess and checkers look much alike. They are even played on a common field of sixty-four squares of alternate black and white. Yet their rules differ and do not mix. Each set of rules creates its own reality.

The tribal groups in this exhibition—Aleut, Eskimo, Indian—had much in common. One cannot pass from object to object without noting parallels. Two hundred years ago one might even have formed this same impression from a casual visit to their villages. Intertwined ancestries, much trade, and shared life styles in a northern environment created similarities. This should not mislead us. These groups differed from one another and these differences were vital to each, not simply for identity, but for life itself.

Behind any genuine art lies an "intelligence," that is, a limited set of rules which permit the mind and emotions to operate—innovatively, creatively—within an enormously manifold, complex "reality." This is not content, which is mere façade, nor is it context, which is mere association. Rather it is that process, that experience, made possible by the relations, resonances, between the elements, the "bricks," employed in any art and the rules governing them. Such models don't *produce* art, of course, but without them, there is no art, no experiencing of art. Only when its rules are obeyed does such a system "work": only then can it be lived.

Thus this exhibition is not concocted out of unrelated bits and pieces stolen from the dead, but assembled in an effort to reconstruct certain lost "realities" so that such realities can once more be experienced.

Let me illustrate what I have been saying; let me mention a few things I have noticed, and come to love, about these different arts.

ESKIMO Two Kuskowim masks, exhibited here, come from a fascinating group of over thirty sold by an Alaskan trader to the Museum of the American Indian many years ago. In 1943–45, the Museum, desperately short of funds, sold fifteen. Most of these were immediately acquired by a group of refugee artist-scholars associated with surrealism: André Breton, Max Ernst, Roberto Matta, Yves Tanguy, Kurt Seligmann, Enrico Donati.

The story of the cubists' discovery of West African art is familiar. The story of the surrealists' discovery of American Indian art, and especially Eskimo art, is equally important.

Eskimo carvings of animals are often so accurate, so detailed, one can tell at a glance not only species, but sub-species: a Red-throated Loon from a Common Loon. But when that same artist chooses to depict the world of dream and séance, he replaces realism with surrealism, and structures space with the ear, not the eye.

In Eskimo thought, where spirit is regarded as separable from flesh, and each man has many helping spirits, the lines between species and

283

classes, even between man and animal, are lines of fusion, not fission, and nothing has a single, invariable shape.

Eskimo artists—both in ancient and recent times—often depict these diverse characteristics *simultaneously*. One striking type of mask is a great composite visual pun: the same lines serve to depict walrus-caribou-man; turned this way, walrus stands out; turned another way, caribou predominates. But, though other features regress, they never wholly disappear. There is no need for shape-shifting: all relevant forms are always present.

And so it is in Eskimo mythology: not a concept of becoming, not even a concept of metamorphosis or coming to be, but rather a sense of being, where each form contains multitudes.

Such a mask expresses the variety and infinite subtlety of personality; its power lies in preserving due proportions between diverse and opposite elements.

When Eskimo artists make these elaborate mobiles, they do not work within borders, but let each mask assert its own dimensions.

The familiar Western notion of enclosed space is foreign to the Eskimo. They do not regard space as static and therefore measurable: hence they have no formal units of spatial measurement, just as they have no uniform divisions of time.

The carver, when he chooses, is indifferent to the demands of the eye: he lets each piece fill its own space, create its own world, without reference to background or anything external to it. Each carving lives in spatial independence. Size and shape, proportions and selection, these are set by the object itself, not forced from without.

Like sound, each mask creates its own space, its own identity; it makes its own assumptions.

HAIDA Haida artists sometimes make visual puns, but a more distinctive feature of their art is the mask that changes: *e.g.*, eagle suddenly opens to reveal a manlike spirit. This is not simultaneity, but metamorphosis. And so it is in many Northwest Coast Indian legends. One tells of a mythic hero who appears first as a whale, but later approaches the shores as a man disembarking from the whale, which is no longer himself but his canoe. When he meets the local chief and his daughter, whom he wishes to marry, he presents them, at a feast, with the whale, which has now returned to its animal nature at the end of its third transmutation.[2]

No objects illustrate the conventions of this art better than the carved and painted boxes: "The ornamentation seems purely decorative. A rigid conformism obeying fundamental rules permits, however, the representation of a bear, a shark, a beaver, without any of the limits which elsewhere confine the artist. The animal is represented altogether in full face and in profile, from the back and at the same time from above and from below, from without and from within. A butcher draftsman, by an extraordinary mixture of convention and realism has skinned and boned, even removed the entrails, to construct a new being, coincident by all points of

284

its anatomy with the parallelepiped or rectangular surface, and the object created is at once a box and an animal—many animals, and a man. The box speaks, it actually guards the treasures entrusted to it in the corner of a house where all proclaim that it is, itself, the inner part of some more enormous animal which one enters by a door which is a gaping jawbone. . . ."[3]

Unlike the Eskimo artist, the Haida artist, with these boxes, doesn't create space; he *fills* space. He works within borders, even accents borders with color or copper or abalone. He fills space *totally*. When he redesigns the animal he has chosen to reproduce, his main concern, apparently, is to cover the surface. If that animal doesn't provide him with enough parts to fill that space, he simply adds more parts, without reference to anatomy.

Though rectangles play an extremely important part in this culture, lines don't meet abruptly. They approach each other, at 90° angles, but then, just before they collide, they turn away.

Bill Holm writes: ". . . The constant flow of movement, broken at rhythmic intervals by rather sudden, but not necessarily jerky changes of motion-direction, characterizes both the dance and art of the Northwest Coast."[4]

Holm, himself a dancer-singer-carver, tells of "a certain physical satisfaction from the muscle activity involved in producing the characteristic line movement of this art" and the fact that "some of the most skillful artists of the southern Kwakiutl are among the best dancers and song composers."[5]

Bill Reid, a Haida carver, offers a very lucid description of this experience. It is, he says, "a controlled and mannered process, determined by rules and conventions so strict that it would seem individual expression must be stifled. But it is the conflict between this rigid discipline and the genius of the great artists which gives such dynamic power to the images. If every line must flow in a preordained course, and no matter how it swells and contracts, must eventually turn again upon itself, and each part of that line wide or narrow, straight or curved, has equal strength, the tension produced is enormous. If every structure, be it box or totem, spoon handle or rattle, must have for every thrust a counter thrust, then each object becomes a frozen universe, filled with latent energy. The basic lines of a box design start with a major image, rush to the limits of the field, turn back upon themselves, are pushed and squeezed towards the center, and rippling over and around the internal patterns, start the motion again. Where form touches form, the line is compressed, and the tension almost reaches the breaking point, before it is released in another broad flowing curve. In totem pole or spoon handle, the upward or outward thrust inherent in the shape of tree or horn is exactly balanced by the downward flow of the design. All is containment and control, and yet always there seems to be an effort to escape. The rules were there, and they were a part of the pattern that went far beyond the conventions of art, were more than a part of the life of the people, were the very essence of their lives."[6]

ATHABASKAN Athabaskan art confronts us with a paradox. Most of it, by any standard, especially Athabaskan, is so poorly executed, so uninspired, so graceless, one wonders: was it honestly come by?

Yet these ugly efforts, often no more than poor imitations of inspired work by neighboring Eskimo, exist side-by-side with Athabaskan art of stunning workmanship and beauty.

Athabaskan carvers copied Eskimo masks without understanding the rules Eskimo carvers obeyed. They knew this art only as outsiders and they knew it only after it had been reduced to a souvenir level, produced for relic hunters in the late 19th century, without strict obedience to traditional conventions.

Most Eskimo masks which have been exhibited are actually souvenirs, designed for tourists. They serve to remind us of the distinction between genuine and spurious cultures. Genuine culture, wrote Edward Sapir, is the expression of a "consistent attitude toward life, an attitude which sees the significance of any element of civilization in its relation to all others. It is, ideally speaking, a culture in which nothing is spiritually meaningless."[7]

Such masks, though they may have "meaning" to those who collected them and to those who exhibit them, were spiritually meaningless to those who carved them.

"It's the power of belief," writes Froelich Rainey, "which makes all the difference between original native art and contemporary native crafts."[8]

By contrast, consider what the Dene, an Athabaskan group living in the barren spruce-forest interior, did with metal: "Every copper piece of theirs," write Witthoff and Eyman, "is delicate, thin, and light. The metal has been greatly modified from its native state, highly forged, with frequent welds and forging folds. It is entirely unlike the stone age technology of the Tlingit and Central Eskimo, entirely unlike the trade tools of the Bering Strait people. It shows a full Chalcolithic technology, not one derivative from the Stone Age or from the Steel Age.

"Steel tools, made by the Dene mainly from files, had replaced copper daggers before 1850. They show equal control of the forge and of the hammer. . . . Dene daggers, in copper and steel, show both heat treatment and stress hardening as methods for controlling strength and edge-hardness of tools."[9]

The Dene use of metals was perhaps the most sophisticated in native North America.

In this exhibition there are also hints—no more, alas—of painted motifs once both widespread and common. I have in mind, particularly, motifs where parallel, straight lines predominate.

In the basement of the Musée de l'Homme in Paris there is a collection of painted skin robes assembled in the 18th century for the education of the palace princes. Several of these robes bear such motifs, though they must come from far to the east of the Athabaskan.

In English and Irish castles, German collections, and Scandinavian

churches are other early pieces sent home by soldiers as trophies. A few bear such motifs.

Later, complex floral designs—partly, perhaps wholly—in imitation of French fashions, replaced these earlier motifs. But among the Athabaskan, they survived quite late. They could be very ancient. Similar designs existed in Siberia.

I do not know of any moose hair or porcupine quill embroidery, from any tribe in America, superior to that produced, until fairly recently, by Athabaskan women. Late 18th-century Iroquois examples may be equal, but are never superior.

Their late survival among the Athabaskan gives us a brief glimpse of an art that probably goes far back into prehistory. Its designs (as with much Aleut art) appear, to the uninitiated, as no more than abstract, geometric patterns. Yet, to their makers, they were representational. They could be "read" as easily as we read ski-lift passes with their multi-colored symbols.

It remains to explain why the Athabaskan, living in this harsh—really brutal—land, went to such "impractical" efforts.

I have often wondered if the answer can't be found in an event which occurred in the mid-winter of 1772, in the desolate tundra, when Samuel Hearne and his native companions came upon the track of a strange snowshoe. They followed it to a little hut where they discovered a young girl sitting alone. She told of her capture by a hostile band, of the murder of her parents, husband and infant, and of her escape nearly seven months before. Living alone, without seeing a human face, she supported herself by snaring small game.

"It is scarcely possible to conceive," observed Hearne, "that a person in her forlorn situation could be so composed as to contrive, or execute, anything not absolutely essential to her existence. Nevertheless, all her clothing, besides being calculated for real service, showed great taste, and no little variety of ornament. The materials, though crude, were very curiously wrought, and so judiciously placed as to make the whole of her garb have a very pleasing, though rather romantic appearance."[10]

The mystery is not, as André Malraux points out in a similar context, that someone should be tossed by chance into this desolate waste: it is, rather, that within this prison of ice and wind, she was able to call from within herself images powerful enough to deny her nothingness.

In addition to these brief comments, I have written catalog entries on about a dozen objects in this exhibition. These notes come directly, often verbatim, from the sources cited, the principal source being Louis Shotridge, son of the Master of the Whale House at Klukwan and grandson of a famed Tlingit noble.

Shotridge collected, for The University Museum in Philadelphia, some of the Tlingit's greatest treasures, an effort he paid for with his life. If this were all, if the story were really that simple, we might condemn him in our thoughts, as his kinsmen condemned him in life. But he left behind, in notes and publications, an unparalleled record of the meaning

these objects had for the Tlingit. Without this record, we would never really be able to enter the Tlingit world, at least not to the depths his writings permit.

The view he offers, from inside the Tlingit world, is unique. The information he offers, on the routes he employed to reach that world, are invaluable. Shotridge, raised a Tlingit but converted to anthropology, had to become a Tlingit once more before he could experience Tlingit life.[11]

George Foster Emmons served on the 1837 Wilkes Expedition, raised the U.S. flag at Sitka in 1867, and commanded the U.S. Naval Hydrographic Survey. Specimens he collected are included in this exhibition. An even larger number come from his son, George Thorton Emmons, who is "the" name in Tlingit studies. Emmons married a Tlingit, built a gracious home in Sitka and devoted his long life to placing on record the meaning of Tlingit life. Some 20,000 pages of his handwritten notes survive.[12]

It would be difficult to exaggerate the importance of naming among the Tlingit. In a culture where everything related to everything else and nothing was spiritually meaningless, names not only classified, they defined social roles, conferred mythic significance, and, they were often lovely.

Among the neighboring Tsimshian, as Wilson Duff points out, a child's name was chosen from the stock of names owned by his lineage, that is, the lineage of his mother. Once a person's name was known, there was seldom doubt as to his lineage. His name also identified the phratry, and often the specific lineage, of his father. Thus *Ni' Gamks*— a well-known girl's name belonging to one of the Frog-Raven "Houses" at Kitsegula—means "on-sunshine," which by itself fails to make sense, because it lacks reference to the father's phratry. If the father was a member of Fireweed phratry, which owned as one of its crests the killer whale, the complete name might be "on-sunshine dorsal fin killer whale," or in free translation "sunshine glinting on the wet dorsal fin of the emerging killer whale." The same name used for a girl whose father belonged to the Eagle phratry might be "sunshine glinting on the white head of the eagle."

Each name conjured up a striking image of a crest animal: "misty spout of the killer whale," "raven flying out to sea cawing in the early morning," "grouse making a robe for itself with its tail feathers." Each conveyed its image by clever, economical use of language, and each rolled pleasingly off the tongue. These were one-line poems, and may be considered one of the art forms of the Northwest Coast.

Those wishing to pursue this subject further—to enter these other worlds—might profitably read *Northwest Coast Indian Art* by Bill Holm, who learned Kwakiutl and became, himself, a dancer-singer-carver. For an account of the great totem poles, I recommend *Out of the Silence* by the photographer Adelaide DeMenil and the Haida carver, Bill Reid, whose works rival the finest ever made by his forebears.

All Eskimo studies begin, and sometimes end, with the writings of Knud Rasmussen, especially his *Reports of the Fifth Thule Expedition*.[13] Rasmussen's mother was Eskimo; he himself, by temperament, was all Eskimo. I also recommend my own *Eskimo Realities*.

All this is supplemental to the objects themselves. I suggest that the visitor concentrate on a few pieces, preferably one. Do what an Eskimo carver does when he encounters a piece of unworked ivory. He holds it lightly in his hand, turning it this way and that, whispering, "Who are you? Who hides there?" And then: "Ah, Seal!"

He rarely sets out to carve, say, a seal, but picks up the ivory, examines it to find its hidden form and, if that's not immediately apparent, carves aimlessly until he sees it, humming or chanting as he works. Then he brings it out: Seal, hidden, emerges. It was always there: he didn't create it. He released it: he helped it step forth.

1. Claude Lévi-Strauss, "The Scope of Anthropology," *Current Anthropology*, 7, no. 2 (1966), p. 121.

2. Kwakiutl legend recorded by Franz Boas and summarized by Claude Lévi-Strauss in "The Art of the Northwest Coast at the American Museum of Natural History," *Gazette des Beaux-Arts*, 24, (1943), p. 181.

3. Lévi-Strauss, "The Art of the Northwest Coast at the American Museum of Natural History," p. 181.

4. Bill Holm, *Northwest Coast Indian Art: An Analysis of Form*, (Seattle: University of Washington Press, 1965), pp. 92-3.

5. Holm, *Northwest Coast Indian Art*, pp. 92-3.

6. Bill Reid, "The Art—An Appreciation," *The Arts of the Raven*, (Vancouver: The Vancouver Art Gallery, 1967).

7. Edward Sapir, *The Selected Writings of Edward Sapir in Language, Culture and Personality*, ed. David G. Mandelbaum, (Berkeley and Los Angeles: University of California Press, 1949).

8. Froelich Rainey, "The Vanishing Art of the Arctic," *Expedition*, 1, no. 28, (1959), pp. 3-13.

9. John Witthoff and Frances Eyman, "Metallurgy of the Tlingit, Dene and Eskimo," *Expedition*, 11, no. 3, (1969), p. 21.

10. Samuel L. Hearne, *A Journey from the Prince of Wales in Hudson's Bay to the Northern Ocean*, (London: A. Strahan and T. Cadell, 1795).

11. A book on the writings and life of Louis Shotridge is now in preparation.

12. Xerox copies of these notes will shortly be made available in a number of libraries.

13. These reports are difficult to locate except in large reference libraries, and the popularized versions are often unsatisfactory. However, a new paperback edition is in preparation and will soon be available.

Save for those listed below, all the photographs appearing in this catalog were provided by the lenders to the exhibition, who are noted in each entry. For their assistance and cooperation we are most grateful.

The photographic staff of the National Gallery (Henry B. Beville, chief, and Stanley T. Manzer, supervisory photographer) provided color photographs for entries 21, 55, 58, 160, 170, 178, 247, 257, 294, 301 and 349; and black and white photographs for entries 1–3, 5–7, 13–17, 19, 23–27, 45, 49, 52, 54–60, 63, 65, 70, 73, 74, 80, 81, 84, 86, 87, 98, 102, 105, 107–111, 122, 128–131, 133, 134, 136–138, 147, 151, 157, 162, 168, 172, 177–180, 182, 185, 186, 192–194, 196–199, 202, 204, 207, 208, 210–214, 220–224, 232–234, 236, 243, 244, 248–250, 252, 254, 257, 261–263, 266, 268, 271, 273, 277, 280, 281, 283, 285, 292–295, 301, 302, 304, 306, 308, 310, 311, 321, 326, 328, 329, 331, 333–336, 340, 349, 353–356, 358, 359 and 361.